BARBARA HEPWORTH

Writings and Conversations

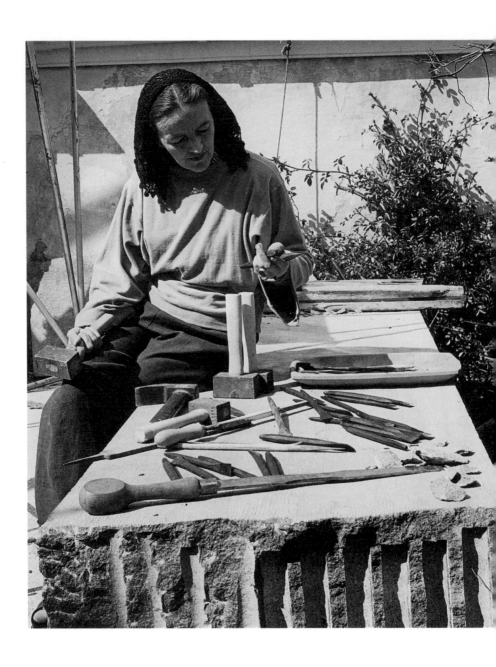

Edited by
SOPHIE BOWNESS

BARBARA HEPWORTH
Writings and Conversations

Tate Publishing

First published 2015 in a hardback edition. This paperback edition first
published 2017 by order of the Tate Trustees
by Tate Publishing, a division of Tate Enterprises Ltd,
Millbank, London SW1P 4RG
www.tate.org.uk/publishing

A catalogue record for this book is available from the British Library
ISBN 978 1 84976 562 6

Distributed in the United States and Canada by ABRAMS, New York

Library of Congress Control Number applied

Designed by Lewis Hallam Design
Colour reproduction by DL Imaging, London
Printed & bound by TJ Books, UK

FRONT COVER: Hepworth in the Mall Studio, London, 1933.
Photograph: Paul Laib
FRONTISPIECE: Hepworth with marble and tools in the stone yard,
Trewyn Studio, St Ives 1950. Photograph: Peter Keen
PAGE 6: Hepworth at work on the plaster prototype for the bronze
Single Form (Memorial), Palais de Danse, St Ives, January 1962.
Photograph: Studio St Ives
PAGE 12: Hepworth in the Mall Studio, London, 1933.
Photograph: Paul Laib
PAGE 30: Hepworth with *The Cosdon Head* 1949.
Photograph: Hans Wild
PAGE 44: Hepworth in the garden of Trewyn Studio, St Ives, 1957.
Photograph: Studio St Ives
PAGE 132: Tate Gallery retrospective, 1968
PAGE 220: Hepworth in July 1972, St Ives. Photograph: Peter Kinnear
BACK COVER: Hepworth speaking at the unveiling of the United Nations
Single Form, New York, June 1964. Photograph: Teddy Chen

CONTENTS

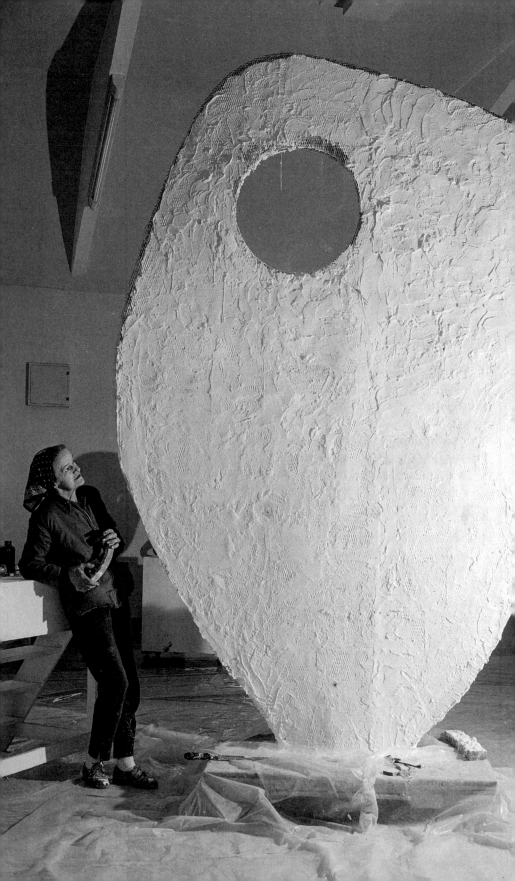

INTRODUCTION

Sophie Bowness

'IT WOULD BE VERY DIFFICULT to explain in words the full content of a sculpture,' Barbara Hepworth observed in 1952: 'you can open the door, however, to a fuller understanding.'[1] Hepworth's own gift for language is evident throughout this book, which brings together her published writings with a significant number of unpublished texts, both manuscripts and typescripts, as well as selected broadcasts and interviews.[2] Her work and ideas are illuminated in her lucid and eloquent words. Hepworth's manuscripts show a fluent, bold hand, indicative of the enjoyment she took in writing as a creative activity in parallel to her art (a number of poems and poetic writings feature in the collection).[3] It is a surprisingly large body of work, and it spans almost the whole of her artistic life.

Hepworth's published writings are gathered together here for the first time in their entirety, with the exception of her *Pictorial Autobiography*, which has been in print continuously since its publication in 1970 and has therefore not been included.[4] It reprinted a number of earlier texts that are here in their original contexts. This publication makes available much that is out of print and inaccessible, and brings to light overlooked or unpublished material.[5] The manuscript pieces have been chosen for their interest and degree of finish (Hepworth's working papers and notebooks are in the Tate Archive). The texts range from sustained pieces to brief paragraphs written for specific occasions, often on individual works of art.

Alongside the writings are Hepworth's lectures and speeches, a selection of interviews and conversations with writers and critics, radio and television broadcasts, and contributions to films. Her public image was established in part through them. Hepworth's earlier lectures and occasional speeches were considered, formal, prepared pieces (she was a very reluctant speaker). They give way, however, to unscripted conversations, printed or broadcast (she was a willing and highly articulate interviewee): the spoken word gradually becomes dominant in later years, as Hepworth wrote less. Recordings, where they survive, have been favoured over some newspaper and magazine interviews, in which the accuracy of the transcription of Hepworth's words is uncertain. At the end of the book is a further selection from interviews with journalists and writers, more anecdotal in character. Although of variable quality and reliability, the conversations with Hepworth contain revealing insights into her character, her life and opinions, her position as a woman

artist, her political engagement, her working practice. Personal letters, which have a very different quality, have not been included in the collection.

The arrangement is a chronological one, according to the date of writing (rather than of publication), to allow for the natural unfolding of Hepworth's ideas and to preserve the integrity of the pieces. The emergence of her commitment to abstraction can be traced in the first texts of the collection, for example, or her adoption of bronze in 1956 after initial resistance. She returns to familiar themes – for instance the relationship of sculpture and architecture, questions of scale in sculpture, the display of sculpture in exhibitions, in the landscape and in civic settings – offering variants and developments, but exhibiting an exceptional consistency of thought. The Chronology can be read in conjunction with the writings; in those instances where, in later years, Hepworth occasionally misremembered dates, it provides the corrective. (Her first holed sculpture, *Pierced Form*, was probably carved in 1932 rather than 1931, for example.) The detailed index allows the reader to search by themes, individual sculptures, proper names and so on.

The four earliest texts in the book were paired with ones by Hepworth's partners, firstly John Skeaping and then Ben Nicholson. The progress of Hepworth's and Nicholson's contributions to the *Unit 1* book, edited by Herbert Read, at the end of 1933 is unusually well documented, as Nicholson was in Paris and there are frequent references in the letters between them. Hepworth approached the writing of her piece with characteristic deliberation. It evolved slowly and with help from their friend the writer Adrian Stokes. 'Yes my article is very solemn & serious – carving is you know compared with ptg,' she wrote to Nicholson from London.[6] 'The words have been found with the aid of a dictionary to get at what is the real meaning.'[7] The passage in her *Unit 1* piece on their visit to St Rémy reveals Hepworth at her closest to Nicholson, just as the drawings they made side by side there are almost indistinguishable (figs 4 and 5). For his part, Nicholson chafed at writing: 'It is not my job to write,' he noted with irritation.[8] In fact, Nicholson was a very perceptive and incisive writer on art, especially in his 'Notes on Abstract Art' of 1941 (revised 1948), though a far less prolific one than Hepworth.[9] He was also a wonderful and inveterate letter-writer, as was she. Annotations on a number of Hepworth's manuscripts show that Nicholson continued to comment on her writing until the mid-1950s. Hepworth had a stronger impulse to communicate to a public, without simplifying her thought, and she had wider intellectual interests.[10] While deriving inspiration from Nicholson, Stokes and Read, she was already an accomplished writer with an independent voice and purpose in 1930, before meeting any of them.

Hepworth's friendship with Herbert Read, the most influential British writer on art of the period, informed her ideas very deeply. Read's work was the most important point of reference for her own writing. 'I admire Herbert's poetry more than anybody else's – for a very long time it has meant a great deal to me,' she wrote to a friend, the critic E.H. Ramsden,

in 1942.[11] The first major monograph on her work, *Barbara Hepworth: Carvings and Drawings*, published in 1952, is at the heart of this collection. The texts she wrote for it were her most extended and significant writings. In his introduction to the book, Read praised the 'incomparable subtlety and self-understanding' with which she had traced her development as an artist. Hepworth reciprocated in her appreciation of his introduction in a letter of October 1952: 'Your prose gives me such intense pleasure & the ideas you express are tremendously nourishing in the way they lead me on to new ideas & work.'[12] That it was an equal exchange of ideas is evident from the letters between them. Hepworth's independence of mind is shown in her strongly argued criticisms and suggestions on a draft of Read's introduction – for example, his reference to Kandinsky ('I cannot stand his painting or his point of view'), his reasoning on a number of points and his use of certain words (such as 'decorative' in relation to the sculpture *Rock Form (Penwith)* 1951) – all of which he corrected as a result of her comments.[13]

In counterpoint to Hepworth's reflections on the creative process, the writings and interviews reveal an artist who had an extensive engagement with contemporary politics and society, from the United Nations to St Ives. She was deeply interested in world affairs, and from the later 1950s her political convictions and affiliations strengthened. A passionate supporter of the United Nations, Hepworth joined the Labour Party at the time of the Suez Crisis and campaigned for nuclear disarmament, against apartheid and against the death penalty, for example. New light is cast on her commitments in a range of texts collected here, from her letters to newspapers, to a submission to a public inquiry concerning the reopening of a tin mine near St Ives, to interviews with journalists.[14] For instance, the statement she wrote in 1961 protesting against the immorality of contemporary power politics and the proliferation of nuclear weapons is published here in full for the first time (see pp. 149–51, together with her manuscript, fig.41).

The integration of the artist in society was of great importance to Hepworth. She had a profound sense of identification with St Ives, where she lived and worked from 1939 until her death in 1975, and repeatedly declared her need to belong to a community and to play a part in its development. Hepworth was also a highly effective campaigner for the preservation of St Ives and the landscape of West Penwith. She and the painter Patrick Heron formed a formidable alliance on a series of campaigns.[15]

In 1966 Herbert Read observed that Hepworth's writing possessed the 'lyrical passion' of the poet.[16] This collection reveals the clarity and vitality with which she expressed her ideas, and the remarkable consistency and distinctiveness of her vision.

1 *Ideas of To-Day*, London, November–December 1952, p.95; see p.76.

2 She might have applied to study English at Cambridge if she had not gone to art school. See *Barbara Hepworth: Early Life*, Wakefield 1985, p.10 (family recollections).

3 For example, 'Feed the Flame' (p.28), written at a time of mounting political tension in the immediate pre-war period, or the poetic writing of the 'Greek Diary' of 1954 (pp.101–8).

4 Barbara Hepworth, *A Pictorial Autobiography*, Bath 1970; extended edition 1978; reprinted since by Tate Publishing, London.

5 The Hepworth bibliography compiled by Meg Duff is an invaluable source (published in *Barbara Hepworth Reconsidered*, ed. David Thistlewood, Liverpool 1996). A significant number of publications have been added to this in the present collection.

6 Letter of 'Tues' [19 December 1933], Nicholson archive (TGA 8717/1/1/166).

7 Letter of 'Tues. night' [19 December 1933], Nicholson archive (TGA 8717/1/1/167).

8 Letter of 'Tues. morning' [12 December 1933], Hepworth archive (TGA 20132/1/144/57).

9 A collection of Nicholson's writings on art was made in *Ben Nicholson: A Studio International Special*, edited by Maurice de Sausmarez, London and New York 1969.

10 The latter was Nicholson's own appraisal in a letter to Hepworth of 18 May 1968, Hepworth archive (TGA 20132/1/144/232).

11 Letter of 8 January 1942 (TGA 9310/1/1/8).

12 Letter of 23 October 1952 (Read archive, McPherson Library, University of Victoria, British Columbia).

13 Letter to Herbert Read, 19 July 1952 (Read archive).

14 See especially *Peace News*, London, 16 January 1959 (pp.119–22), and *The Daily Express*, London, 3 October 1961 (pp.265–7).

15 They campaigned against, for example, mining at Carnelloe (see p.167) and against the Admiralty's use of moorland at Zennor for troop training. Heron referred to Hepworth's campaigning to save the unparalleled landscape of Penwith in the appreciation he wrote after her death (*The Observer*, London, 25 May 1975).

16 Preface to the catalogue of the exhibition *Barbara Hepworth*, Marlborough-Gerson Gallery, New York, April–May 1966.

ACKNOWLEDGEMENTS

My father Alan Bowness gave me advice throughout the preparation of this collection. Its publication accompanies the gift to the Tate Archive of Barbara Hepworth's writings and notebooks, which she bequeathed to him.

I am very grateful to Roger Thorp and Chris Stephens for their early encouragement of the project at Tate. Annette Brausch made many of the transcriptions and I am especially indebted to her. For their permission to reprint texts, I am grateful in particular to Annabelle Hodin and Edwin Mullins. The archivists at the Tate Archive have provided much patient assistance.

I would like to thank all those at Tate Publishing and Tate Photography who have contributed to the book, particularly Nicola Bion, Christopher Mooney and Emma O'Neill, as well as the book's designer, Philip Lewis.

EDITORIAL NOTE

THE TEXTS IN THIS COLLECTION are printed as they were first published, in principle. They are presented with minimal editing. The ordering is chronological, according to the date of writing (so, for example, the Greek Diary is placed under 1954 when it was largely written, rather than 1965 when it was published). Full details for each piece are found in the Bibliography at the end of the book. Hepworth's dates are occasionally incorrect and the reader is referred to the Chronology. Small typographical or spelling slips in the originals have been corrected. Usages in individual texts have been preserved. All footnotes are my own. Texts based on tape-recorded conversations have been given in their edited form. Where these recordings survive, this is noted. The Index contains a complete listing of sculptures referred to.

[. . .] indicates an omission or cut. Square brackets indicate a word, phrase or sentence that is uncertain, or has been inserted, where there is variation between versions.

Abbreviations

TGA Tate Archive
LMA London Metropolitan Archives
BH numbers refer to those given in the catalogue raisonné of Hepworth's sculptures, published in two volumes (see Catalogues of Hepworth's Work, p.298)

All written archival material referred to is in the Tate Archive unless otherwise noted.

1930s

Text by Hepworth in the series 'Contemporary English Sculptors',
The Architectural Association Journal, London, April 1930,
vol.xlv, no.518[1]

Carving to me is more interesting than modelling, because there
is an unlimited variety of materials from which to draw inspiration.
Each material demands a particular treatment and there are an infinite
number of subjects in life each to be re-created in a particular material.
In fact, it would be possible to carve the same subject in a different stone
each time, throughout life, without a repetition of form.

If a pebble or an egg can be enjoyed for the sake of its shape only, it
is one step towards a true appreciation of sculpture. A tree trunk, with its
changing axis, swellings and varied sections, fully understood, takes us a step
further. Then finally it is realised that abstract form, the relation of masses
and planes, is that which gives sculptural life; this, then, admits that a piece
of sculpture can be purely abstract or non-representational.

There are, however, degrees between pure representation and the abstract.
Generalisation, by which I mean an accumulative assertion of the emotion
of a thing, is nearer to the abstract than particularisation, which is a faithful
portrayal of an individual object.

My trend is towards generalisation; but I have not dispensed with
representation entirely; as I find that it is possible to take a pebble of fine
and simple shape and carve in addition a sequence of planes suggestive of
the human form, thus giving it an added significance of emotional value.

1 John Skeaping also wrote a text in the series, published in February 1930 (no.516).

'The Aim of the Modern Artist: Barbara Hepworth, Ben Nicholson',
Studio, London, December 1932, vol.104. Interview with Hepworth,
subtitled 'The Sculptor carves because he must'

*Following upon the discussions so much in evidence to-day regarding the
arts of painting and sculpture and their place in everyday contemporary
life, the Editor has asked two artists of the younger modern British school
to state their aims in answer to the questions which are often propounded
by the general public.*

*The artists we have asked thus to present their viewpoint are
Mr. Ben Nicholson, well known as a painter of 'abstract pictures' in the
modern manner, and Miss Barbara Hepworth, the sculptor. The works
reproduced are among those shown in their exhibition at Messrs. Tooth's
Galleries, New Bond Street, open till December 3.*

1. Hepworth carving *Head*,
Cumberland alabaster, BH 32,
in 1930

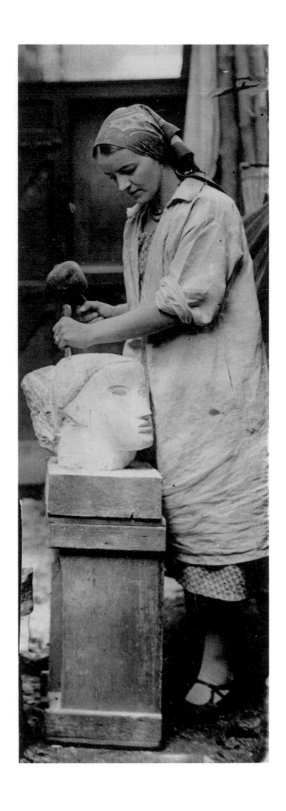

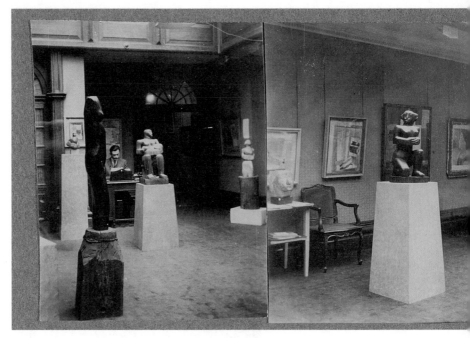

2. *Carvings by Barbara Hepworth, Paintings by Ben Nicholson*, Arthur Tooth and Sons'
Galleries, London, November–December 1932. Photographs by Hepworth and Nicholson
mounted in Hepworth's photograph album of the 1930s (detail)

QUESTION: *Do you consider sculpture as an art to be practised separately or in conjunction with architecture?*

MISS HEPWORTH: If sculpture was an art to be practised in conjunction with architecture, the sculptor would find other work to do. Architecture does not need sculpture for its construction, nor should the architect be dependent on sculpture for the complete realisation of his idea in building. Sculpture is an additional decoration to the building, and is only lovely when the architect's idea and the sculptor's are in harmony and both architect and sculptor fully realise the abstract meaning of form.

The sculptor carves because he must. He needs the concrete form of stone and wood for the expression of his idea and experience, and when the idea forms the material is found at once.

QUESTION: *What is the place of sculpture such as yours in modern life?*

MISS HEPWORTH: The place of sculpture in modern life is made by the beholder or purchaser, who is receptive to the idea and life in the sculpture and desires himself and others to experience it.

QUESTION: *Why do you prefer direct carving to modelling?*

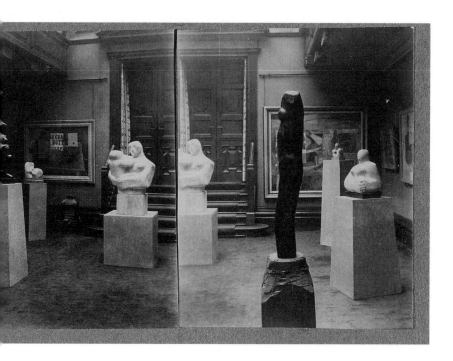

MISS HEPWORTH: I have always preferred direct carving to modelling because I like the resistance of the hard material and feel happier working that way. Carving is more adapted to the expression of the accumulative idea of experience and clay to the visual attitude. An idea for carving must be clearly formed before starting and sustained during the long process of working; also, there are all the beauties of several hundreds of different stones and woods, and the idea must be in harmony with the qualities of each one carved; that harmony comes with the discovery of the most direct way of carving each material according to its nature.

QUESTION: *Many arts are developing with what appears to be a public need, e.g., interior decoration, poster design, etc. Is the work of an artist such as yourself apart from this – in a separate category? Is there a relation between modern sculpture and modern painting?*

MISS HEPWORTH: If a sculptor is really able to express his idea with all simplicity and a perfect realisation of form in the round, in addition to the freedom of form in space, the balance of one form against another form, and all with an axial rhythm of growth and life, then he is contributing to all arts and giving to all who are willing to receive. Beethoven, Bach, Cézanne and Picasso, negro carvings, all give infinitely because of their life force. The best carvings are necessarily both abstract and representational, and if the sculptor can express his vision in the right medium, the abstract conception of form imbued with that life force, then he is at one with all other artists.

Translation of an untitled text in *Abstraction-Création: art non-figuratif*, Paris, 1933, no.2

Hepworth's own text does not survive; the new translation published here has been made from the French[1]

Our fated era has witnessed the birth and rise of a small number of 'initiates' who, having definitively reached 'understanding', are in turn acting as true 'architects of the universe'.

Here, as before, it is not a matter of Greece, or of Germany, or of France, or indeed of anywhere else ...

Johann Sebastian was 'transcendent and objective'.

Thought will always be 'transcendent and objective', beyond time.

And since music is abstract art by definition, there can be no true art unless it strives for 'perfect' realisations of rhythm (in the beginning was rhythm), order, composition, harmony, and above all of 'definitive' lines.

Painters today are growing more like musicians, just as musicians have always borne a similarity to architects – and as architects are, in turn, becoming closer to mechanical engineers . . .

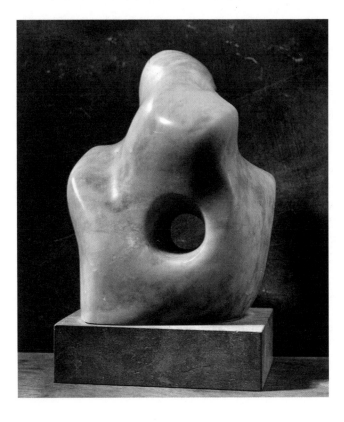

3. *Pierced Form* 1932, pink alabaster, BH 35 (destroyed in the Second World War). Photograph: Paul Laib

This is not in order for them to create a materialistic, utilitarian or pathetically futile art; on the contrary it is so that, through forms generated from scientific data and spiritual conjecture, they can move towards the absolute nature of numbers, and be transported at last by the 'music' of these numbers.

Johann Sebastian Bach, and the rigorous heights to which his genius led him, perhaps unwittingly, call upon not only musicians, but all the artists of today, to 'create' by 'carrying on', through a new leap across the centuries, in accordance with visions that are both more generous, human and fertile and equally more mathematical and rationalised.

Truth and justice can largely be achieved in this way – Bach, as the 'message', being less an individual occurrence than a 'state' of mind.

The most abstract moments in the oeuvre of Richard Wagner – whose works were generally romantic, but sprung from the mind of one who was both an initiate and a revolutionary, and frankly more conscious than Bach – are those in which the wilful and non-'representational' music sets out to convey to us his optimistic-idealist understanding of the world, through negating pessimism.

When compared to such yearnings for the idea alone – despite their lack of artistic refinement – what can the purely impressionistic work of Debussy and his imitators be worth?

Evocations of the sea, moonlight, rustling trees ... Reflections and images that can never match up to nature in its divine imperceptibility and superior creativity ...

Can the image of a locomotive, or its evocation through sound, ever be preferred to the locomotive itself?

So? ... Why? ...

Line, colour, sound and numbers possess their own beauty – a pure, eternal and all-powerful beauty that should never stoop so low as to serve other ends than those of the spirit.

Reality exists only within ideas; and all tangible or acoustic forms strive 'invisibly' for dimensions that our spirits alone can understand. The work comes before the theory.

Let us, then, extract the eternal laws of nature and of the harmony of the spheres, which are as simple as they are endlessly multifaceted; let us above all 'create' plans, the figurative and expressive counterpoint of ideas and lines. In all the arts, let us be 'musicians' of numbers; we will then become pure spirits that are not only liberating but, necessarily and above all, liberated.

1 The French text, which can be found on p.290, has been translated by Abigail Grater. Hepworth was responding to a questionnaire which asked: Why don't you paint nudes? What influence have trees had on your work? Is a locomotive a work of art? Does resemblance to a machine or to an animal add to or detract from the power of a work of art? Her text was illustrated with two photographs of *Pierced Form* (1932, pink alabaster, BH 35), including fig.3. Hepworth and Nicholson joined the Paris-based group of international abstract artists, Abstraction-Création, in April 1933.

The present moment is the only real time. Tradition is no longer a day-dream and things that have been made seem like the unfolding and development of one idea, the growth of some great tree. There is freedom to work out ideas and today seems alive with a sense of imminent new discovery.

In an electric train moving south I see a blue aeroplane between a ploughed field and a green field, pylons in lovely juxtaposition with springy turf and trees of every stature. It is the relationship of these things that makes such loveliness –

The sounds of unseen birds and droning aeroplanes in the sky, part hidden by the leaves of a tree so very much older than I am, the feeling of easy walking down the street with green red traffic lights, the earth revealing its shape to the feet and eye as I once walked up a long white road between trees and saw a stone arch two thousand years old standing on green flat space of earth against stony mountains, olives quietly growing in obeisance at their feet and Café Robinson hidden by trees, the wireless filling the air with music from some foreign station; we can dance at the feet of these lovely undulating stony hills –[1]

It is the relationship and the mystery that makes such loveliness and I want to project my feeling about it into sculpture – not words, not paint nor sound; because it cannot be a complete thought unless it could have been done in no other way, in no other material or any different size.

It must be stone shape and no other shape.

Carving is interrelated masses conveying an emotion; a perfect relationship between the mind and the colour, light and weight which is the stone, made by the hand which feels. It must be so essentially sculpture that it can exist in no other way, something completely the right size but which has growth, something still and yet having movement, so very quiet and yet with a real vitality. A thing so sculpturally good that the smallest section radiates the intensity of the whole and the spatial displacement is as lovely as the freed and living stone shape.

I do not want to make a stone horse that is trying to and cannot smell the air. How lovely is the horse's sensitive nose, the dog's moving ears and deep eyes; but to me these are not stone forms and the love of them and the emotion can only be expressed in more abstract terms.[2] I do not want to make a machine that cannot fulfil its essential purpose; but to make exactly the right relation of masses, a living thing in stone, to express my awareness and thought of these things.

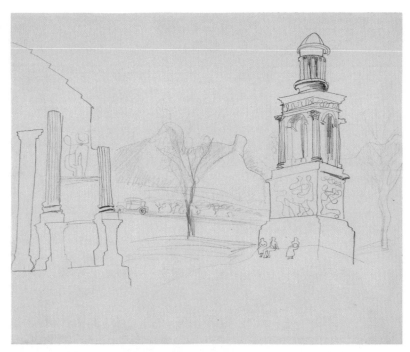

4. *St Rémy, Tower* 1933, graphite on paper

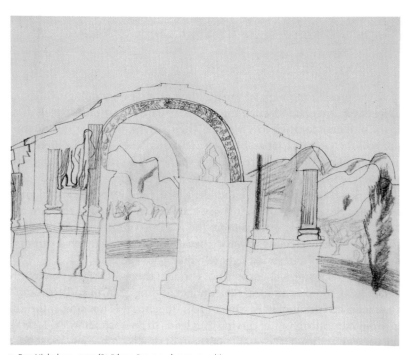

5. Ben Nicholson, *1933 (St Rémy, Provence)* 1933, graphite on paper

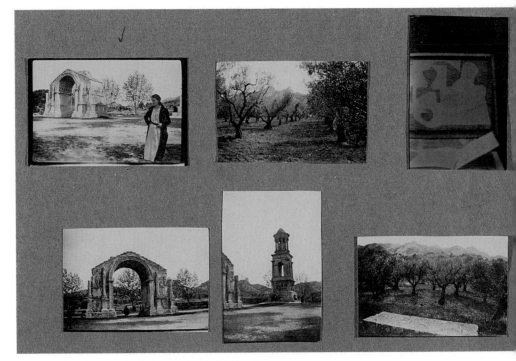

6. Photographs taken at St Rémy by Hepworth and Nicholson, Easter 1933.
Detail of a page from Hepworth's photograph album of the 1930s

At the present moment we are building up a new mythology which is more easily understood when the things we care for are seen. Small things found and kept for their lovely shape, their weight, their texture and intense pure colour. Objects that we place near to each other, in their different aspects and relationships create new experience. A scarlet circle on the wall, a slender white bottle on a shelf near it, a bright blue box and lovely-shaped fishing floats that rest in the hand like a bird, weighty pebbles, dull grey, some gleaming white, all these move about the room and as they are placed, make the room gay or serious or bright as a frosty morning and nearly always give a tremendous feeling of work – because they are so much a part of the different seasons and varied light and quality of each day.

The predisposition to carve is not enough, there must be a positive living and moving towards an ideal. The understanding of form and colour in the abstract is an essential of carving or painting; but it is not simply the desire to avoid naturalism in the carving that leads to an abstract work. I feel that the conception itself, the quality of thought that is embodied, must be abstract – an impersonal vision individualised in the particular medium.

[1934]

In the contemplation of Nature we are perpetually renewed, our sense of mystery and our imagination is kept alive, and rightly understood, it gives us the power to project into a plastic medium some universal or abstract vision of beauty.

1 Hepworth and Nicholson had travelled to Provence at Easter 1933. Both drew the Roman Arch and Mausoleum at St Rémy (figs 4 and 5, Hepworth, *St Rémy*, *Tower* 1933, graphite on paper, and Ben Nicholson, *St Rémy, Provence* 1933, graphite on paper; fig.6, album with photographs of St Rémy taken by Hepworth and Nicholson).
2 A direct repudiation of her own earlier carvings, for example the Blue Hornton stone *Dog* (1929), and of John Skeaping's animal carvings.

'Sculpture', *Circle: International Survey of Constructive Art,* edited by J.L. Martin, Ben Nicholson and Naum Gabo, London 1937

I

Full sculptural expression is spatial – it is the three-dimensional realization of an idea, either by mass or by space construction. The materials for sculpture are unlimited in their variety of quality, tenseness and aliveness. But for the imaginative idea to be fully and freely projected into stone, wood or any plastic substance, a complete sensibility to material – an understanding of its inherent quality and character – is required. There must be a perfect unity between the idea, the substance and the dimension: this unity gives scale. The idea – the imaginative concept – actually *is* the giving of life and vitality to material; but when we come to define these qualities we find that they have very little to do with the physical aspect of the sculpture. When we say that a great sculpture has vision, power, vitality, scale, poise, form or beauty, we are not speaking of physical attributes. Vitality is not a physical, organic attribute of sculpture – it is a spiritual inner life. Power is not man power or physical capacity – it is an inner force and energy. Form realization is not just any three-dimensional mass – it is the chosen perfected form, of perfect size and shape, for the sculptural embodiment of the idea. Vision is not sight – it is the perception of the mind. It is the discernment of the reality of life, a piercing of the superficial surfaces of material existence, that gives a work of art its own life and purpose and significant power.

One of the most profound qualities of sculpture is scale – it can only be perceived intuitively because it is entirely a quality of thought and vision. Sculpture does not gain or lose spiritual significance by having more or less of physical attributes. A vital work has perfect co-ordination between conception and realization; but actual physical contours do not limit a perfected idea.

It does not matter whether a sculpture is asymmetrical or symmetrical – it does not lose or gain by being either: for instance, it can be said that an asymmetrical sculpture has more points of view. But this is only one aspect

of the sculptural entity – asymmetry can be found in the tension, balance, inner vital impact with space and in the scale.

The fact that a plastic projection of thought can only live by its inner power and not by physical content, means that the range for its choice of form is free and unlimited – the range of many forms to one form, surprising depths and juxtapositions to the most subtle, very small to very large. All are equal, and capable of the maximum of life according to the intensity of the vision.

Scale is not physical size, because a very small thing can have good scale or a very large thing poor scale – though often large sculptures achieve good scale because the artist approaches their conception with a greater seriousness and thought. Size can be emphasized by the juxtaposition of the very large to the very small; but this is only one side of sculptural relationships. There is the sculpture which has magnificent scale because of its precise and exact relationship between dimension and idea – it creates space for itself by its own vitality. There are two main sculptural identities – one which comes within the embrace of our hands and arms, and the other which stands free and unrelated to our sense of touch. Both have their distinct and individual quality of scale which makes an expansion and spaciousness in everything surrounding them. Scale is connected with our whole life – perhaps it is even our whole intuitive capacity to feel life.

II

The most difficult and complicated form relationships do not necessarily give a sculpture the fullest spiritual content. Very often, as the thought becomes more free the line is purified, and as principles – the laws which contain lesser laws – are comprehended, the forms become simplified and strengthened. In the physical world we can discover in the endless variations of the same form, the one particular form which demonstrates the power and robustness of the simplified structure – the form is clear and every part of it in precise unity with the whole. It is not the accidental or casual, but the regular irregularity, the perfect sequence which gives the maximum expression of individual life. In the three-dimensional realization there is always this exact form, or sequence of form – which can most fully and freely convey the idea. But there is no formula that can reveal the sequence; the premise is individual and the logical sequence purely intuitive – the result of equilibrium between thought and medium.

The perception of these differences, imperfections and perfections help us to understand the language the sculptor uses to convey the whole feeling and thought of his experience. It is the sculptor's work fully to comprehend the world of space and form, to project his individual understanding of his own life and time as it is related universally in this particular plastic extension of thought, and to keep alive this special side of existence. A clear social solution

7. *Single Form* 1935, sat. wood, BH 74.
Photograph by Barbara Hepworth
(reproduced in *Circle*)

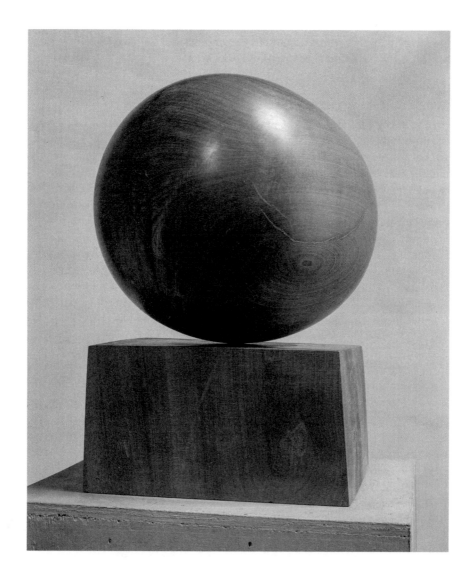

can only be achieved when there is a full consciousness in the realm of thought and when every section constitutes an inherent part of the whole.

The sculptural elements have long been neglected and unconsidered, the form consciousness of people has become atrophied; but now much is being done by a more balanced and free education – a greater co-ordination between hand and head – that will keep alive the intuitive form perceptions of the child. A world without form consciousness would scarcely be alive at all. The consciousness and understanding of volume and mass, laws of gravity, contour of the earth under our feet, thrusts and stresses of internal structure, space displacement and space volume, the relation of man to a mountain and man's eye to the horizon, and all laws of movement and equilibrium – these are surely the very essence of life, the principles and laws which are the vitalization of our experience, and sculpture a vehicle for projecting our sensibility to the whole of existence.

III

The whole life force is in the vision which includes all phantasy, all intuitive imagination, and all conscious selection from experience. Ideas are born through a perfect balance of our conscious and unconscious life and they are realized through this same fusion and equilibrium. The choice of one idea from several, and the capacity to relate the whole of our past experience to the present idea is our conscious mind: our sensitivity to the unfolding of the idea in substance, in relation to the very act of breathing, is our unconscious intuition.

'Abstract' is a word which is now most frequently used to express only the type of the outer form of a work of art; this makes it difficult to use it in relation to the spiritual vitality or inner life which is the real sculpture. Abstract sculptural qualities are found in good sculpture of all time, but it is significant that contemporary sculpture and painting have become abstract in thought and concept. As the sculptural idea is in itself unfettered and unlimited and can choose its own forms, the vital concept selects the form and substance of its expression quite unconsciously.

Contemporary constructive work does not lose by not having particular human interest, drama, fear or religious emotion. It moves us profoundly because it represents the whole of the artist's experience and vision, his whole sensibility to enduring ideas, his whole desire for a realization of these ideas in life and a complete rejection of the transitory and local forces of destruction. It is an absolute belief in man, in landscape and in the universal relationship of constructive ideas. The abstract forms of his work are now unconscious and intuitive – his individual manner of expression. His conscious life is bent on discovering a solution to human difficulties by solving his own thought permanently, and in relation to his medium. If we had lived at a time when animals, fire worship, myth or religion

were the deepest emotional aspects of life, sculpture would have taken the form, unconsciously, of a recognizable god; and the formal abstract relationships in the representation would have been the conscious way of vitalizing these ideas; but now, these formal relationships have become our thought, our faith, waking or sleeping – they can be the solution to life and to living. This is no escapism, no ivory tower, no isolated pleasure in proportion and space – it is an unconscious manner of expressing our belief in a possible life. The language of colour and form is universal and not one for a special class (though this may have been in the past) – it is a thought which gives the same life, the same expansion, the same universal freedom to everyone.

The artist rebels against the world as he finds it because his sensibility reveals to him the vision of a world that could be possible – a world idealistic, but practical – idealistic, inclusive of all vitality and serenity, harmony and dynamic movement – a concept of a freedom of ideas which is all-inclusive except to that which causes death to ideas. In his rebellion he can take either of two courses – he can give way to despair and wildly try to overthrow all those things which seem to stand between the world as it appears to be and the world as it could be – or he can passionately affirm and re-affirm and demonstrate in his plastic medium his faith that this world of ideas does exist. He can demonstrate constructively, believing that the plastic embodiment of a free idea – a universal truth of spiritual power – can do more, say more and be more vividly potent, because it puts no pressure on anything.

A constructive work is an embodiment of freedom itself and is unconsciously perceived even by those who are consciously against it. The desire to live is the strongest universal emotion, it springs from the depths of our unconscious sensibility – and the desire to give life is our most potent, constructive, conscious expression of this intuition.

1) Feed the flame with head & heart & hands.
 The singing of the sap in lively timbers
 is the dirge for curling fingers
 clutching the light.
 Feed the flames & make a mountain
 of the ashes which can feed the sorrowing earth.
 Out of the ashes rises
 a glowing heart with wings
 to soar in the transparency
 of impenetrated space.

2) Dull beats the heart,
 darkly in the softening shadows
 walks the ghost of liberty.
 The pallid air of dawn is on his lips –
 out of the deep pools of history
 gleam the eyes that pierce
 the act of self-deception.

3) Things are the same – are not the same:
 The mind of man is but the penetration
 of the martyrdom of light and shade.
 Full concentric force of brooding forest stands
 with inner tension.
 The thrusting & expanding equipoise
 defeats the aggressor; and
 in darkness from the root springs circular expansion
 of concentrated power –
 delicately concealed in tonal grace, evolving substance
 now from yesterday.

1938-39.

Feed the flames with head & heart & hands.
the singing of the sap in lively timbers
is the dirge for curling fingers
clutching the light.
Feed the flames & make a mountain
of the ashes which can feed the sorrowing earth.
Out of the ashes rises
a glowing heart with wings
to soar in the transparency
of ~~im~~ **mutinable** space.
 ~~implentrated~~

Dull beats the heart.
Darkly in the **softening** shadows
walks the ghost of liberty.
the pallid air of dawn is on his lips—
out of the **deep** pools of history,
gleam the eyes that pierce the act
of self deception.

Things are the same - are not the same.
the mind of man is but the penetration
of the martyrdom of light & **shade**
~~full~~ concentric force of brooding forest stands
with inner tension.
the thrusting & expanding equipoise
defeats the aggressor
In darkness from the root springs circular expansion
of concentrated power
delicately concealed in tonal grace, evolving substance
 now from yesterday.

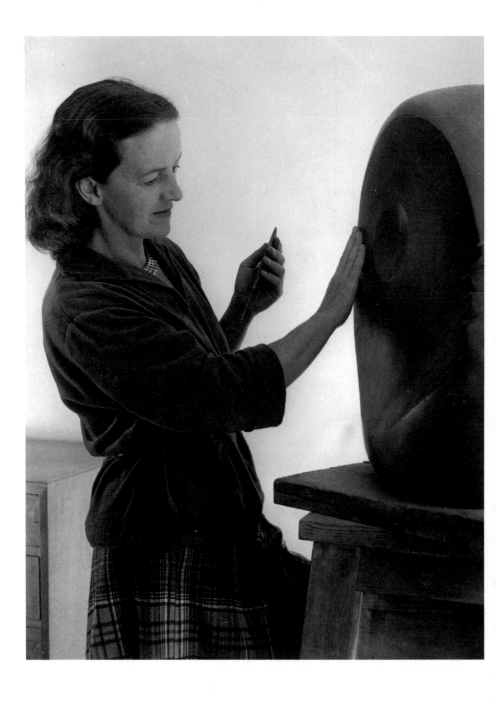

1940s

'Approach to Sculpture', *Studio*, London, October 1946, vol.132, no.643

Miss Hepworth answers questions, put to her by the Editor, on her work,
which will be on view during October at the Reid and Lefevre Galleries.

Are you self-taught, or have you had tuition? If so, by whom?

I was at Leeds School of Art for one year and the Royal College of Art
for three years, on County Scholarships; at the end of this time I went
to Italy on a travelling scholarship.

Direct carving was not a definite part of the curriculum at that time; but
I feel that with carving, as with painting, the craft has to be rediscovered by
each artist afresh, and that technique is just the outcome of this particular
and very personal discovery.

I owe a debt to an Italian master-carver, Ardini, whose remarks on the
approach to marble carving, when I was in Rome, opened up a new vista for
me of the quality of form, light, and colour contained in the Mediterranean
conception of carving.

The real value of an Art School lies in the opportunity it gives to the
student to work with his contemporaries, to be provided with models in
the life room, to have free materials to experiment with and access to books,
lectures, and museums; but tuition should be offered rather than administered
so that every student can exercise and strengthen his sense of discovery.
Unfortunately so many children are spoiled in their approach to painting and
carving in adolescence, long before they reach an Art School, because of the
past misconception of the qualities necessary to a good art teacher.

Which of the world's sculptors do you most admire?

I cannot really answer this question in a direct way. When I think of the many
great cultures of the past it becomes impossible to think of any one sculptor,
or any one sculpture – the richness and diversity is so great. But thinking
contemporaneously it is possible to see the continuity in direct line with the
past – the real sculptural principles kept alive by a few sculptors in Europe –
and to feel sad that world conditions obstruct and obscure a re-awakened
understanding of architecture and sculpture.

Has your preference always been for abstract form?

No – my work was representational at first and has gradually become more
and more abstract.

For how long have you been interested in, may I say, 'Ovoid' shapes as a basis
for sculptural form?

I have always been interested in oval or ovoid shapes. The first carvings
were simple realistic oval forms of the human head or of a bird. Gradually my
interest grew in more abstract values – the weight, poise, and curvature of the

ovoid as a basic form. The carving and piercing of such a form seems to open up an infinite variety of continuous curves in the third dimension, changing in accordance with the contours of the original ovoid and with the degree of penetration of the material. Here is sufficient field for exploration to last a lifetime. Actually one cannot, however, be thinking about ovals and ovoids all the time, and their fascination comes in cycles. Every sculptor needs to turn from one basic form to another; the spontaneity of the carving stimulus demands this. The 'aggressive weight' of a sphere, the 'massive' quality of a cube, and the 'upward growth' of a cylinder – all play their part. These are basic concrete forms – vehicles by which emotional interest in the standing figure or seated figure, the group or the head, finds its outlet. Inevitably interest in one leads to interest in another. The satisfaction to be found in carving is in the pleasure of fresh impact of shape and in the joy of attack on different material.

To what extent is the form dictated by the nature of the wood or stone?

I like to have a lot of material lying about the studio for a long time – even for years – so that I feel intimate with each piece. An idea comes and the right piece of wood or stone – the absolutely right piece – must be found for it, and it is the greatest hardship for a sculptor to be short of material.

Before I can start carving the idea must be almost complete. I say 'almost' because the really important thing seems to be the sculptor's ability to let his intuition guide him over the gap between conception and realization without compromising the integrity of the original idea; the point being that the material has vitality – it resists and makes demands. The idea makes demands also; and the 'life' of the finished carving depends on how successfully the demands of both are met and how sensitively adjustments take place during the process of working.

I think a new discipline has to be discovered with each new sculpture, and that is why I do not feel in sympathy with any theories and disciplines imposed from outside.

What woods do you most frequently use?

I prefer the foreign hardwoods with their great variety of colour and surface finish. The war stopped all imports of foreign timber, and I have been seasoning my own logs from trees felled in the Cornish woods. I have enjoyed carving English timber; but after so many years of restriction I long for the excitement of 'blackwood', 'lignum-vitae', 'greenheart', and 'ivory-wood', to mention only a few of the wonderful foreign hardwoods.

From what sources does your inspiration derive? I ask this in case fruit, negro sculpture, the human figure, aerodynamics, or dreams might have some connection.

The main sources of my inspiration are the human figure and landscape; also the one in relation to the other.

*Have you any special technique for achieving such smoothly textured surfaces;
particularly the concaves?*

I have never really thought much about technique – it seems to me to be a
very personal thing which each artist discovers for himself, perhaps almost
unconsciously. The degree of finish or polish should be intuitive. It varies
with each sculpture.

I do not like using mechanical devices or automatic tools. Even if the
work was done ten times more easily I should miss the physical pleasure
of direct contact with every part of the form from the beginning to the end.
Generally speaking I prefer using an adze or gauge for wood, a puncher or
'bouchard' for stone and marble, and then a rubbing-down process rather
than using the chisel.

*Is your work polychromatic? If so, how and where is the pigment applied and
what are its nature and colour?*

I have been deeply interested during the last ten years in the use of colour
with form. I have applied oil colour – white, grey, and blues of different
degrees of tone. Except in two instances I have always used colour with
concave forms. When applied to convex forms I have felt that the colour
appeared to be 'applied' instead of becoming inherent in the formal idea.
I have been very influenced by the natural colour and luminosity in stones
and woods, and the change in colour as light travels over the surface
contours. When I pierced the material right through a great change seemed
to take place in the concavities from which direct light was excluded. From
this experience my use of colour developed.

One can experience the colour change in nature in a cave, a forest or a
pool and sense similar change in the emotional effect of all forms when the
quantity and quality of light playing upon it changes.

*Do you take into consideration the effect of any specific lighting arrangement
when designing the work and have you any strong feelings about appropriate
settings: colour and texture of backgrounds, bases, etc.?*

The photographs shown here were taken in my studio, which is only a
workshop, or in my small garden which is the only place I can use to show
a carving out of doors. The photographs are a record and do not attempt
to show what the carvings could look like placed in a perfect architectural
setting, on a specially designed or well-made base or surface.

I have always felt that there were three different degrees of size in sculpture.
Roughly they are: first, the small intimate 'hand sculpture', small enough to
carry about, appealing to the sense of touch as well as to the eyes and finding
its position in a house very easily. Secondly the 'arm' sculpture: that is a
sculpture which falls into the span of one's arms. Such a sculpture, however,
does require some thought in placing in a house or garden, as it demands a

[1946]

9. *Single Form (Dryad)* 1945, Cornish Elm, BH 132. Photograph taken by Studio St Ives, June 1945, in the garden of Chy-an-Kerris, reproduced in Hepworth's October 1946 *Studio* article

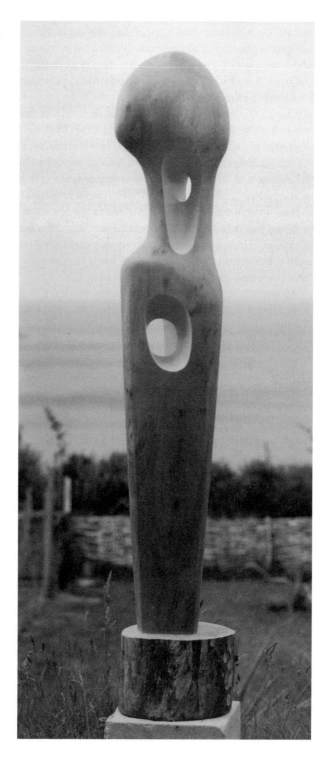

certain kind of space and a particular elevation. Finally there is the large sculpture: the size of the human figure. This remains static in its setting and commands us to move round it. It is seen at its best when it is in the place for which it is designed and which is always a site related to landscape or architecture.

One of the functions of sculpture is to fulfil the demands and conditions of a given site. Present conditions restrict this idea so that the sculptor works mainly in his studio and eventually, if he is fortunate, a suitable place is found for the sculpture by somebody who has the money to buy it. This means that the creation of large sculptures is restricted; but it is partly compensated for by the growth among all kinds of people of a love for sculpture and the desire to have a small sculpture in their home or garden – not placed on a pretentious pedestal but cared for in a more intimate way. This kind of appreciation will help to develop the sense of form (nearly atrophied in Western civilization) until it becomes a part of our life in a way that poetry, music, and painting have been and are increasingly part of our life.

As regards lighting and setting for my work, I like as much light as can be obtained, and I like a feeling of space. This does not mean actual physical area; but more the feeling that one gets near a window where the eye travels outwards, or a perpendicular clear space where there is a sense of upward growth.

I have never felt that sculpture was too formidable to live with. The chief error in the past has been the pretentious way of showing it and the conventional habit of associating sculpture with symbolic or commemorative monuments, and very rarely for the purpose of enjoying its inherent qualities. Quite large sculptures can be placed in small rooms where their presence gives a new sense of enjoyment – a new aesthetic experience which cannot be got through any other art.

Some simple architectural feature as a site for sculpture does seem necessary in our houses and gardens of the future. A cube or rectangular form in the architecture of a room which gives a clear, stable, horizontal surface on which to place a sculpture. It is one of the rare pleasures of this life to have a carefully conceived space on which to place some chosen object (found or made) in order to enjoy it in all its aspects.

What preliminary plans or designs do you make before actually starting on the wood or stone and what is the proportion of time spent in conceiving, planning, and designing a project in ratio to that spent in its execution?

I rarely make drawings for a particular sculpture; but often scribble sections of form or lines on bits of scrap paper or cigarette boxes when I am working. I do, however, spend whole periods of time entirely in drawing (or painting, as I use colour) when I search for forms and rhythms and curvatures for my own satisfaction. These drawings I call 'drawings for sculpture'; but it is in a general sense – that is – out of the drawings springs a general influence.

Only occasionally can I say that one particular drawing has later become one particular sculpture. I like to think of the drawings as a form of exploration and not as a two-dimensional representation of a particular three-dimensional object. They are abstract in essence – relating to colour and form but existing in their own right.

It is difficult to say how much time is spent in conceiving a project. I like to work all day and every day; the major part of the time is spent in actually carving, but all the time I am not working I am thinking about sculpture. Looking out of a window or walking down the road it is impossible not to be aware of form and colour. Then a new project suddenly appears, and demands realization as a result of accumulated emotional experience. The carving process is a slow process and the conceiving of a project seems to spring more out of a general and sustained experience than one particular incident. Consequently the carrying out of one idea and the conception of new ideas usually run concurrently.

I have gained very great inspiration from Cornish land- and sea-scape, the horizontal line of the sea and the quality of light and colour which reminds me of the Mediterranean light and colour which so excites one's sense of form; and first and last there is the human figure which in the country becomes a free and moving part of a greater whole. This relationship between figure and landscape is vitally important to me. I cannot feel it in a city.

Text on Ascher scarf design, *Landscape Sculpture*, June 1947, manuscripts[1]

Textile designing is more than patterning. Colour and form go hand in hand – brown fields and green hills cannot be divorced from the earth's shape – a square becomes a triangle, a triangle a circle, a circle an oval by the continuous curve of folding: and we return, always, to the essential human form – the human form in landscape.

1 Zika Ascher commissioned both Hepworth and Nicholson to design a scarf in the series of silk Ascher Squares. Each artist was asked to write a short text for a book Ascher was planning on the Squares (unrealised).

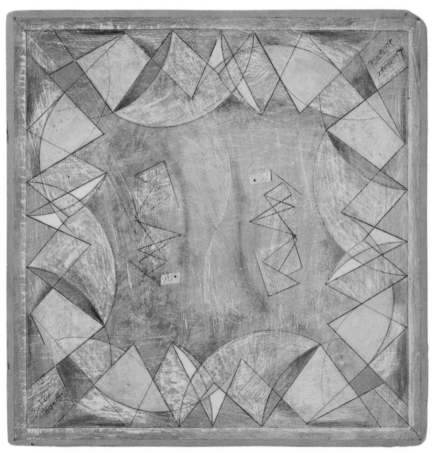

10. *Landscape Sculpture* 1947, oil paint, graphite and gouache on card.
Design for an Ascher scarf

Letter to Sigfried Giedion in reply to Giedion and Arp's questionnaire
concerning collaboration between artists and architects for the 1947
CIAM VI conference at Bridgwater, Somerset; published in Giedion (ed.),
A Decade of New Architecture, Zurich 1951[1]

Questionnaire by Giedion and Arp, 'Relation between architects, painter and sculptor'

*1. What do you consider could be the function of painting and sculpture
in the domain of architecture?*
*2. Do you believe that cooperation between architect, sculptor and painter
is really possible, in the present stage of development? And if so what new results
might be achieved from this?*
How in your opinion could this practical cooperation be achieved?
*a) Should the architect, painter and sculptor cooperate from the very
beginning, so as to strengthen the emotional and symbolic content of architecture?*
*b) If so, how do you propose to overcome the obvious difficulties resulting from the
present day separation of the three arts?*
*c) To what extent, if at all, should the initiative be given on particular
projects to the painter or sculptor, rather than to the architect?*

Our attitude towards problems of aesthetics
Giedion

*CIAM is concerned with those problems that are just emerging
over the horizon. [. . .] Now we consciously promote another step. A step towards a
rather intangible subject: aesthetic problems or, you may prefer
to say, emotional expression. [. . .]*

*If we really agree the right of the emotional world to exist in this
sphere, then architecture and town planning can no longer be regarded
in isolation from their sister arts. Architecture can no more be divorced
from painting and sculpture as it has been during one and a half centuries and as
it is to-day.*

*The problem is clear but not at all its solution. There is no doubt that
most of the contemporary architects and most of the modern painters and sculp-
tors have lost the capacity or even the will to work together.*

*A few days ago, in Cornwall, I gave the questionnaire to Barbara Hepworth to
get the point of view of a sculptor. May I be permitted to read her fine
letter which, with a few words, illuminates the whole situation and hits
the problem on the mark:*

Chy-an-Kerris, Carbis Bay
September 10th, 1947

Dear Giedion,

I was immensely interested in what you had to say during your short visit the other day, but I was left with a very sad feeling that the gulf between architects and sculptors is a very large one and that it can only be bridged by a change of heart in the architects. I felt that the questions to be asked should not be 'should the architect and sculptor collaborate from the beginning?' but 'why do the architects and sculptors not collaborate from the beginning!'

To all the questions relating to sculpture and painting I felt that the answers lay implicitly in the work done during the last 25 or 30 years by the sculptors and painters. I feel as a sculptor that we have said what we have to say and played our part and that architecture, as the co-ordinating part of our culture, has failed so far, to unite (and even to understand!) the work that has been done in our time by painters and sculptors. Without this unity we cannot achieve a robust culture.

During my last exhibition I found there was a keen sense, among all kinds of people, of the part that sculpture plays in life, *except* among the architects. They all stood with their backs to the sculpture and bewailed their lot, or chattered about new materials. I was shocked by this attitude because we are working, all of us, for something much greater than planning. We are working for a spontaneous sense of life, a unity of purpose which will give heart to the nature of our own living. I cannot say anything new of great importance[:] the answers are all there, in the history of architecture.

New conditions, new materials cannot alter the basic principles.

It is then up to the architects.

I could not write before, I find it so difficult to find words when I am carving.

I hope great things will come out of your meeting at Bridgwater.

ever, Barbara Hepworth

This letter mirrors the present situation: the architects with their backs turned to the sculptor, chattering about new materials, and the only possible solution of the whole problem is expressed in the few words:
 'Why do the architects and sculptors not collaborate from the beginning?'

1 The Swiss architectural historian, Sigfried Giedion, was a founder member of CIAM (Congrès Internationaux d'Architecture Moderne) in 1928 and its first general secretary. CIAM VI, the first post-war conference, took place at Bridgwater, Somerset, 7–14 September 1947. Giedion was the leading proponent of the unity of the arts at the conference and, with Jean Arp's help, he had prepared a questionnaire on the collaboration between artists and architects. Le Corbusier's response followed Hepworth's in Giedion's publication (Giedion, ed., *A Decade of New Architecture*, Zurich 1951; reprinted with slight variations in translation in Giedion, *Architecture, You & Me: The Diary of a Development*, Cambridge, Mass., and London 1958).

Report submitted with Hepworth's designs for sculptures for Waterloo Bridge, 1947, unpublished manuscript (not in Hepworth's hand)[1]

REPORT

THE THEME IS " THE BRIDGE "
THE 4 GROUPS ARE 4 VARIATIONS ON THE
THEME — " THE RIVER "
" THE HILLS "
" THE SEA "
AND " THE VALLEYS ", AROUND
WHICH THE LIFE OF LONDON SPRINGS
AND RECEIVES VITALITY.

"THE RIVER" (CARVED MODEL) TO BE PLACED IN
FRONT OF SOMERSET HOUSE.

"THE HILLS" (DRAWING) TO BE PLACED IN FRONT
OF LANCASTER HOUSE[2]

"THE SEA" " ⎫ TO BE PLACED ON THE
 ⎬ PLINTHS ON THE SOUTH
"THE VALLEYS" " ⎭ EMBANKMENT.

THE GROUPS HAVE BEEN CONSIDERED IN RELATION
TO THE SUN, THE ARCHITECTURAL AND NATURAL
BACKGROUND AND THE DIVERSE LEVELS FROM
WHICH THEY WOULD BE SEEN.
WEATHERING AND DRAINAGE HAVE BEEN GIVEN
CAREFUL CONSIDERATION.
THE TOP COURSES OF STONE TO BE REMOVED
EXCEPT IN THE CASE OF THE PLINTH IN
FRONT OF LANCASTER HOUSE.

SCULPTURES FOR WATERLOO BRIDGE.

1 Hepworth's first designs for public sculptures were submitted for the invited competition, launched by the London County Council, to design four sculptures, two on either side of Waterloo Bridge. The competition required the submission of three drawings and a scale model, and could be accompanied by a short report. None of the designs was selected and the plinths remain empty today. Sketches beside the four subjects on Hepworth's Report identify them (see figs 11, 12, 13, 14, the carving and three drawings that were submitted to the competition). The Report is in the Tate Archive (TGA 20132/3/12).
2 Lancaster Place, on the north-west side of the Bridge, facing Somerset House.

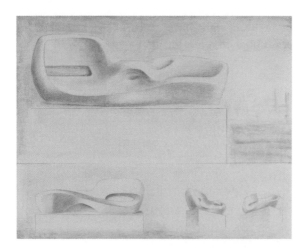

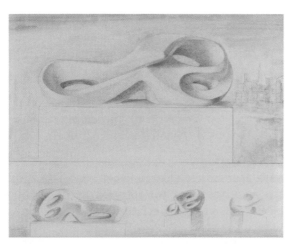

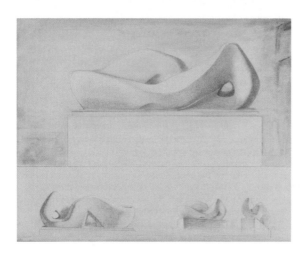

Hepworth's submissions
for the competition to design
sculptures for Waterloo Bridge.

11, 12, 13. *Projects for Waterloo Bridge
– 'The Valleys', 'The Sea', 'The Hills'*
1947, oil paint, watercolour, coloured
pencil and graphite on paper, Tate

14. (opposite) *Model for Sculpture
for Waterloo Bridge* [*'The River'*] 1947,
Portland Stone, BH 144

Extract from a letter to Herbert Read of 6 March 1948, quoted in Read's article 'Barbara Hepworth: A New Phase', *The Listener*, London, 8 April 1948, and in Read's *The Meaning of Art*, revised 1949 edition[1]

Working realistically replenishes one's *love* for life, humanity and the earth. Working abstractly seems to release one's personality and sharpen the perceptions, so that in the observation of life it is the wholeness or inner intention which moves one so profoundly: the components fall into place, the detail is significant of unity.

1 Hepworth was responding to Read's request for her thoughts on the meaning and interrelations of realism and abstraction (letter to Hepworth, 3 February 1948, TGA 20132/1/167; Hepworth's reply is in the Read Archive, McPherson Library, University of Victoria, British Columbia). Their exchange informed the article Read published in *The Listener* on 8 April on her recent figure studies and hospital drawings. Hepworth returned to these ideas in her essay of 1966 'A Sculptor's Landscape' (see pp.191–7) and in her *Pictorial Autobiography* (p.93).

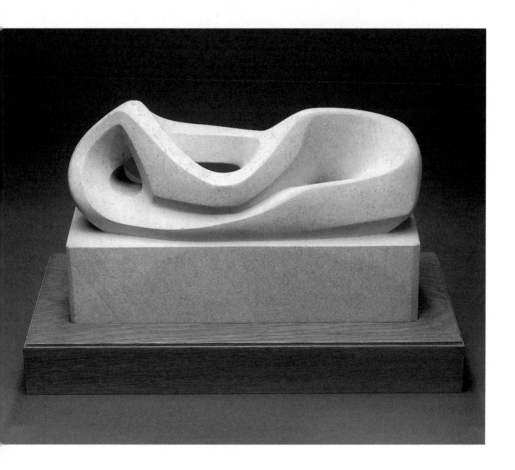

1950s

Quotations from Hepworth in J.P. Hodin, 'Portrait of the Artist, No.27: Barbara Hepworth', *Art News and Review*, London, 11 February 1950, vol.II, no.1[1]

Without real affection life would be quite extinct. – Barbara Hepworth

[. . .] [Brancusi's] miraculous studio made a lasting impression on her, but as she says: 'They are complete, these masters, they have said their things and one cannot share in it. It is more exciting to meet, in one's decisive years, people of one's own age with whom one can share any sort of discovery.'

The most decisive discovery in Barbara Hepworth's career was direct carving and with it the abstract quality of art. It is necessary to repeat here that her first work was naturalistic, representational: figures, groups, portraits. It was a part of her training.

'Study from life is absolutely essential,' she says, 'but if one has to carve directly, one has to discover what part of one's experience one can put into wood or stone. It really means not only to interpret one's medium but also to find oneself individually, one's style. If an ivory carving looks like lace it is false. I am not interested in modelling in clay or in work executed in concrete, perspex or metal. There is life in stone and in wood. Direct carving is so exciting because in sculpture there is a quality through touch, which is as important as the vision itself. I respect the material. Stone cannot produce the effect of soft flesh; it keeps its hardness. Therefore abstraction! Abstract sculptural qualities are found in good sculpture of all times; in the works of the Aztecs, the Sumerians, the Neolithic, the Cycladic, the Etruscan periods – but it is significant that contemporary sculpture and painting have become abstract in thought and concept. It is not simply the desire to avoid naturalism in the carving that leads to an abstract work.'

[. . .] 'For sculpture one needs a general culture with a basis in architecture and a great sense of line. Our time does not give the sculptor a place in society. Before the war there was every sign that architects would use sculptors from the first development of their ideas. The war has broken it entirely. Let us project our time 500 years forward. What is to show the culture of this modern buildings [sic]. There is a complete misunderstanding in this machine-age of cultural requirements. An artist nowadays must create himself an oasis and keep alive.'

[. . .]

1 J.P. Hodin (1905–1995), writer on art and friend of Hepworth's.

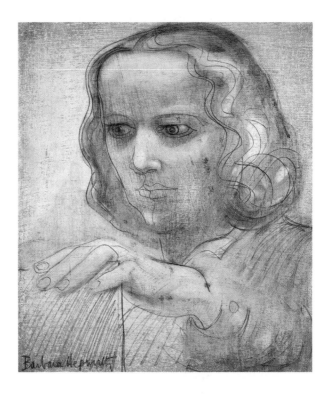

15. *Self-Portrait* 1950, oil paint and graphite on board, National Portrait Gallery, London

Text for a broadcast to the USA, 1950-51, unpublished in part; manuscript drafts and typescripts, together with a recording[1]

FESTIVAL

We are all fortunate to be living at a time when new forms are being created in architecture, sculpture, painting and music – new forms which not only derive from the basic nature of life, but which at the same time come to terms with the particular difficulties which our civilisation presents. These new forms and new sounds, apparent in the cultural pattern of today, are the very core of our life tomorrow and they are the forms which often provoke the greatest resistance on account of their force which strikes and moves our deeper level of consciousness. They are in this sense in true accord with past tradition – springing from a profound response to life itself – from our common roots.

Living here in Cornwall as I have done for eleven years – very near to the tip of the peninsula of Land's End, facing the Atlantic with all its splendour of sea and sky – a conviction has been growing in me that some new apprehension of basic life forces is necessary if we are to survive the mechanical destructiveness of our time. It seems to me urgent that we in Europe and you

in America should, through an understanding of the art of our time as well as the art of past cultures, join hands in the great endeavour to regain our touch with the simple primeval forces which nourish mankind and which prepare the ground for a healthy vital culture.

These forces <u>are</u> simple and the artist is constantly aware of them; but they are forces of passionate intensity, from the impact of which our civilisation has been shrinking. The visionary capacity of human beings gives great strength, and I think we are becoming more aware of the necessity for an aesthetic approach to life and the need for greater balance between head and hand, mind and body. But it needs more than a knowledge of form, colour, sound, movement and gesture – it demands a tremendous effort of reassessment, revaluation of our position to understand the primary needs of man in order to release all those sensibilities which would make each one of us desire to create and understand more of the beauty of life and so make our humble praise whether we work in field or factory, office or studio.

You in America understand the position of the artist in society, you understand the importance of the activity of creation as well as the part played in the social structure by the capacity to receive creatively – a full interchange.

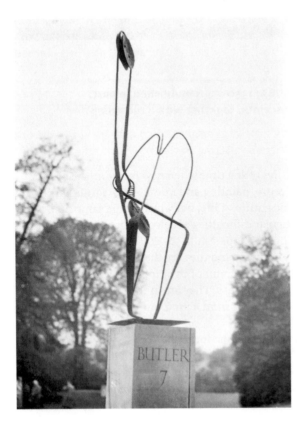

16. Reg Butler, *Torso* 1949–50, forged and welded iron, Albright-Knox Art Gallery, Buffalo, at the London County Council open air sculpture exhibition, Battersea Park, summer 1951

[1950-51]

A Festival of Art allows the impact to be made upon the social structure, breaking the crust of resistance and allowing a new free growth, of interplay between the practising artist and the rest of society, an absolute necessity if we are to maintain a proper articulation between members both of communities and of nations.

1 This is a transcription of the recording of this untraced broadcast (Tate Archive). An extract in a variant form was published in the 1954 Whitechapel catalogue (p.21). The reference appears to be to the Festival of Britain.

Conversation with Reg Butler recorded on 28 September 1951 and broadcast on 26 August 1952 on the BBC Third Programme, 'Artists on Art'; unpublished[1]

ARTISTS ON ART
Barbara Hepworth and Reg Butler

HEPWORTH: When we talked in the garden everything came alive – all the trees and everything else. If you remember when . . .

BUTLER: *Yes.*

HEPWORTH: . . . we were listening to that contemporary music.

BUTLER: *Yes, yes, quite.*

HEPWORTH: I had – I think it was music which we both rather cared for, but I had a curious image of your sculptures stalking in the garden, walking, dancing round solid lumps of rock in my yard, all waiting to be carved, and – but both points of view are so valid and so different that it opened up a whole new idea of sculpture – that is, there's no limit to the materials one can use, but the great thing is to make this live image.

BUTLER: *I agree with you. I mean, that is the point of absolutely common contact we have – we're both trying to make a living image – something that isn't a substitute for something we meet in the world around us – we're trying to create an image or a thing that lives in its own right – we have different ways of approaching it – approaching the problem. I don't think the differences are technical so much as that we live, in one sense, in different environments because we see what we – our personalities – enable us to see and we ignore many things which are nevertheless there. Your approach is optimistic, you're creating forms which are tranquil, remote, linked in some subtle way with antiquity and, to my mind, much more reminiscent of nature in the terms of the sea and the land than the rattle and dynamic of the human being in the 20th century.*

HEPWORTH: Well, perhaps I am convinced that in this 20th century we shall all become extinct unless we re-stress the living values of what are really primitive instincts in man and are the only things which really keep him alive. And that we shall lose our capacity to live unless we feel at one with all the rocks and the timelessness of life with its perpetual movement and re-birth.

BUTLER: *Are you talking, when you say 'we', about we as artists or all of us?*

HEPWORTH: All of us as living human beings.

BUTLER: *Why I ask that is because, to me, that seems to be the thing that makes an artist an artist – this awareness of his surroundings, but the clang and noisiness, the frustration and the anxiety – the fugitive, ephemeral quality of existence for me is just as much a part of nature as the remoteness of sea and rocks – the thing that presses on us, surely, is far more the tension of man-made anxiety than the tranquility of the sea and the stones on the seashore, and the things which, as I see it, are the point of departure for your sculpture. I feel, you see, that your sculpture primarily belongs to an age of greater stability than the one in which I live. I do feel, very much, that the conviction of optimism which comes from cultures which evolve slowly, lends form to the kind of sculpture we associate with ancient Egypt and ancient Mexico, that the sculpture which arises naturally out of conditions in Western Europe today has got to be very different. It's got to be more tense. It's got to be a reflection – an intense reflection of the pressure that we feel all around us. Contemporary music, contemporary painting, contemporary sculpture, I see as one manifestation – one temperature chart – of this contemporary environment, and I feel the rocks and the sea, however much we may think how nice it would be to live a pastoral existence in relation to them, we can't anymore – we've lost our innocence.*

HEPWORTH: I don't think so at all, and in any case, I don't think that they're tranquil. When I go out to try and draw landscape, I never can draw it because as soon as I sit down I immediately become a person in relation to a landscape, a seascape which has endured for hundreds of thousands of years. I have some kind of sculptural relationship to it and the forms I begin drawing then are usually ideas for a new sculpture, that is me in relation to this extraordinarily ancient landscape which is completely consistent with sculpture of all times, and I feel sculpture of the future. It may take on a new kind of shape, but its meaning is very much the same to me. And it's terribly urgent and necessary for us all to be aware of the meaning of form, just as you see in Cornwall a ploughman ploughing round his field – round a stone – he's fully aware of that stone as a person.

BUTLER: *But is he? I really doubt that. I mean, I would like to think so – I would like to see all these husky Cornish ploughmen stopping in the midst of their furrow and looking at the stone and saying, '[Nice] little fellow there', sort of thing.*

HEPWORTH: Yes, but you see, I always think when I go to the British Museum that there's a complete language – it doesn't matter what period of sculpture one's looking at – it's a completely valid language which touches, deep down, our whole feeling, inside ourselves and our whole sense of movement, everything – every gesture – within us, how we stand, the laws of gravity, what it feels like to shake somebody by the hand, so that all we think about this living world in three dimensions, comes out, and we start working.

BUTLER: *Yes, I imagine all sculptors do that, but what I'm trying to say is that I think the language of today is not the language of ancient Egypt, that it's a language of tension, a language of fugitiveness and that the sculptor must find techniques to express an entirely different environment from the slow, rhythmic, perhaps cheerful carving of the sculptor in the second Egyptian dynasty. I feel, you see, that all these techniques such as stone carving and wood carving, spring from the cultural environment which is absent today. That the development of more fugitive techniques – the use of plaster, the use of wax, and so on, hasn't come about purely from the cleverness of invention but is a symptom of the world in which we live.*

HEPWORTH: But I can't see – you haven't explained to me why – an image in stone is less valid than a plaster or a metal ephemeral object, as you call it, we are still human beings, we still desire to go on living, to have our homes, to feel moved by the landscape, to feel that we're going to have our feet on the ground and not be shot off into space. Why is one more valid than another?

BUTLER: *The kind of confidence, the kind of constant social pattern which was a characteristic of slower moving cultures, I feel bred the techniques of carving. One could devote thirty years to the carving of a head in a very hard stone, because in a sense the aesthetic criteria which operated when one started on that work were still in operation thirty years later, but this is – this civilization in which we live is one of flux, complete change, complete interpenetration of forces from all directions, and I feel that the works of contemporary sculptors, such as Giacometti, are an example of the reflection of that state of mind. Now, I know that an artist can either, as it were, works with his environment or, as it were, in direct opposition to it, and I think a lot of the appeal, for instance, of your work, and Moore's work, lies in this reminder of the roots in which our particular species has its birth – this reminder of our continuity with the past. But I feel that reminder has been achieved – we are reminded of that – we can't go on reminding ourselves of that – it doesn't help us out of our difficulties.*

HEPWORTH: I think it helps enormously – I think one has to go on reminding oneself for ever and ever and ever that the world is a tremendous spread in time – something beyond one's comprehension. The most tangible and lasting things like rocks and sea and land are the things out of which life sprang and life can be maintained, and I can't see why carving is any more important in one era than another because it's a perfectly natural medium,

it's a perfectly natural feeling to wish – to take a rock and turn it into life and to make, in that way, an image which has a magic to preserve life in one's own personality. I like your work because it walks about the place – *it is a live image* and it's true to its medium, it's wonderful metal, the way it's made, I like its craft, its vitality. But it doesn't mean to me just 1951 and the disturbed life, it means to me the extraordinary confidence in living things.

BUTLER: *Well, I'm glad you feel that way – I wish I could feel that way myself. I don't, and I tried to explain why.*

HEPWORTH: Don't you long to put something there – contribute something which would go on and on and on past yourself?

BUTLER: *Not really, because I feel I am a child of this particular environment. I see no point in going on . . .*

HEPWORTH: But we all are, because we cannot possibly live now without reading the newspapers and knowing what is going on, in fact, we know everything, we've got to digest it as best we can and still go on reiterating these constant values.

BUTLER: *The constant values for me are the facts of existence. The facts of existence in one kind of world or another kind of world. The reiteration of the facts of existence which are a common point between us and ancient Mexico for me aren't very exciting. I don't feel that they are the things I want to say. I agree with you that it would be very nice to live in a tranquil, pastoral civilization.*

HEPWORTH: I don't think anyone's lived in a very tranquil, pastoral civilization. I think that those times, that each time of living people must have been beset by the most urgent and terrifying problems. Ours are different because there are an accumulation of these problems – but we're still human beings with very definite reaction to human beings moving about this world and living and dying and as sculptors we want to say something about it and make our image. Also, as sculptors, we know that all these three-dimensional forms, these symbols which touch human beings in a way that words and music and colour cannot do, they are terribly real – as real as when a child starts feeling and walking about and finding that things have a solid substance.

BUTLER: *I know what you mean, at least I think I do, but you see, for me we aren't made of solid substance. The concept of solid substance ended with the end of the 19th century. We no longer see ourselves as masses in space. We are a mere interplay of patterns – we're something much less permanent, much less important perhaps in the world, in the universe, than we thought we were, and I feel that contemporary developments in space – in space in the sculptural sense, this inter-penetration of outsides and insides, this denial of the value of mass, as such – is part of this whole problem of awareness of the world in which we live. In science,*

in physics particularly, the concept of unbreakable elements constituting matter has broken down completely now – we live in an age in which the concept of fission, of the smallest particles of matter as matter is a day-to-day awareness.

HEPWORTH: Well, would you then have all sculpture be kinetic sculpture – why have the more solid properties of stone or wood become invalid? It seems to me that it's the idea that matters, not the material. I think sculpture can be expressed in absolutely any material.

BUTLER: *I think there is a right material for any particular kind of ideas, and I feel that a sculptor's life is the search for that right material.*

HEPWORTH: Oh well I would agree there, that each one of us chooses the material which will fit an idea. One might move from one material to another, but I don't see how you can say that certain materials are not valid any longer.

BUTLER: *Well, I feel all those materials which involve slow, steady, as James Stephens might say, 'loving chipping', belong to an age when that was an appropriate activity.[2] One lives in a tumult of grinders and welders and roaring fires and a kind of manifestation of anxiety through life.*

HEPWORTH: I don't think it's any more anxious than moving great rocks and trying to make them stand up and come down again, or making a hole right through, making a hole right through a stone so that you reveal its depth and its inner tension, and the space in relation to a human being, is just as exciting from the inside point of view as building up a form with its spaces, or making a kinetic sculpture in which new forms are created, as it is twirled round by the slightest breeze.

BUTLER: *Well, you're quite right to say that it is as exciting for you – for me I can only say it isn't, and you're rather more broad-minded than I am because I'm, as it were, trying to generalise from my own experience, which is an unsatisfactory thing to do anyway, but I feel that it's wider than my own experience, that there is something essentially contemporary about the hollow form, about the form which has no surface in the accepted sense of the word. The form which in point of fact does not exist except in relation to the things it suggests. You see, as a sculptor, I'm not interested in making things, I'm not interested in the process of finishing an object – a magical object. The best I can do to explain myself is to say that I try to create a personage. Now a personage for me is a rather intangible something – a pattern rather than a thing. A centre of activity, rather than a centre of mass, and I think that's as far as I can go in explaining why for me the solid object, the impervious object, doesn't belong to the world in which I live any more; it's pre-nuclear fission if you like. Your approach to form, the carving off of surfaces, the shaving down of surfaces, the cutting through of holes, and so on, reproduces much more the processes of time and weather and volcanic movement of earth, and so on, than the technique which I seem to have grown into and which I use, as I see it, for much more personalised images.*

HEPWORTH: No, I don't think really my shapes are formed because of the wear and tear of the elements. I think they're more the sort of forms which express my fundamental sensitivity to my position in landscape. If I stand on a cliff, say at Zennor, and look at the most extraordinarily turbulent sea, I am, as a human being, extraordinarily frail but related to that form of landscape and everything which the sea is doing and has done to it, and I have then a series of reactions – emotional reactions – which produce an idea of a shape – not just sea-worn shapes, but the kind, if I felt with my eyes shut, which would evoke my very human feeling about it. It's not quite the same thing.

BUTLER: *No, I'm sure it isn't and it is very difficult to find a verbal explanation for something which can only justify itself, by itself.*

HEPWORTH: I want very much when the sculpture is done for it to conjure up again all that I felt in a particular place in time, in relation to my surroundings.

BUTLER: *Yes. But that is really what I mean, in other words, place.*

HEPWORTH: Place – yes.

BUTLER: *Place and time are important elements, more important to you than to me, and in the same way person and personage is perhaps to me the most important thing.*

HEPWORTH: Yes, but if – A landscape to me hardly exists without a human being in it.

BUTLER: *True, I think that's characteristic of all sculpture.*

HEPWORTH: The minute the human enters everything becomes ordered in its exciting volume and scale and gesture.

BUTLER: *Quite.*

HEPWORTH: And it is really man's relation to the landscape and time in history that matters to me. But the rocks I choose or the wood I choose is merely because I happen to like chipping bits off rather than using a welder.

BUTLER: *No, no, I don't agree.*

HEPWORTH: You don't agree?

BUTLER: *No you see, I think that your sculpture is very often more a sculpture of landscape than it is a sculpture of the person.*

HEPWORTH: It isn't a landscape – it's me in the landscape.

BUTLER: *No, I'm not quite sure what you in the landscape means, because it's a nice phrase but rather difficult to understand completely. I mean, there's not quite that complication with my own work in – as far as I see it, because the majority of*

my sculptures are people, many of them individual people or types or individual things like that.

HEPWORTH: Well, I feel that in sculpture or anything else the excitement of the individual is just as exciting as the properties which are constant throughout all individuals. For myself, on the whole, I like to find those constants because those are the things which I like seeing again ten years hence rather than the individual – that is just for myself.

BUTLER: *Yes, I mean that does fit in with the –*

HEPWORTH: With a magical constancy.

BUTLER: *– general pattern doesn't it?*

HEPWORTH: Yes, I think I'm always amazed by the persistence of life.

BUTLER: *Quite. Whereas perhaps I'm, at the moment, anyhow, more interested in the shifting pattern of experience, the essential temporariness of the human personality as I see it –*

HEPWORTH: But I still cannot understand, if you apply your ideas, stone not being a valid medium for this present life, I can't see what – how you'd develop it in relation to architecture or our form of living.

BUTLER: *Well, I don't think sculpture is very significant in relation to architecture. Sculpture is an art like painting, at various times –*

HEPWORTH: There I'd agree.

BUTLER: *– at various times historically, it has fused with the architect's intention and has produced buildings of great beauty and meaning, but I don't think that sculpture is approachable other than as sculpture.*

HEPWORTH: I'd agree there – I don't think it is approachable in any other way because I think it touches a whole world which is quite different to architecture. I think it's a sort of introduction to architecture. It's a link between man and his surroundings. I always feel that sculpture outside a building conditions man to his position in the landscape, his position in relation to the architecture in which he's going to enter, and as such it's tremendously important in relation to architecture, but never as a decoration or as an addition, and that's why I think that sculptors and architects should get together to work out the proper spacing and the proper placing of sculpture.

BUTLER: *I think it would be a nice idea, but I think it's rather unreal. I think the sculptor, like the painter today, is concerned with his inward eye. I don't think his approach is conscious enough to make him a good element in an architectural team. I think that may come, and I hope it will come, but for the moment I think the sculptor is concerned, just as a painter, like Sutherland, is concerned, with the problem of releasing these demands which he feels about him, and using his*

technique, his mechanism of sculpture, as a way of doing that. It's his way of being vocal, it's his way of commenting on what's going on, and I think we may move into a period in which a natural co-operation may spring up between the production of buildings and the production of sculpture. I think there are signs of it [– I think architects have got][3] through this castor oil period of stripping their buildings down to the barest fundamentals and reconsidering design from the beginning again, and I think architects are showing an increased interest in the other visual arts, but I don't feel that the sculptor can worry overmuch about that now, I think his job is with his sculpture in his studio. If he starves as a result of that, well, it's too bad, but that is where it is – as I see it.

HEPWORTH: But he's been more or less starving, I mean that has been his fate for quite a long time, he's been working in his studio trying to solve imaginary problems, trying to make sculptures for imaginary places, bringing them –

BUTLER: Oh no, surely not.

HEPWORTH: I think every sculpture that's made must have some relation to a place. I don't think you can make it in a vacuum – at least, I can't. It always has some kind of position in the landscape or in architecture, in one's imagination.

BUTLER: Well, I think that is part of this solid approach as it were, this conception of a piece of sculpture being primarily a thing. I regard sculpture as being something closer to painting which, as it were, creates its own environment within its own terms, and I feel that it may well be a very long time before we see sculpture which has the kind of relevance to architecture that we associate with Renaissance and Egyptian and Mexican periods of development. I feel there is such a difference that sculpture today stands in relation to the human experience in much the same way as painting has almost always stood, and I feel that the problems that faced a sculptor in his studio are the problems of sculpture, and although his natural interest in space will always ensure that he does think of his piece of sculpture in relation to masses around, it's very likely to be his own studio. In an odd sort of way, you know, I think the activity of sculpture is the activity of filling one's studio or of making in one's studio something that the mass and shape of one's studio demands.

1 This is the broadcast version of the conversation, a recording of which is in the British Library Sound Archive and the Tate Archive. In preliminary discussions leading up to the recording in London, Hepworth had described the interaction with Butler as provocative and exciting, writing to the BBC radio producer Leonie Cohn: 'I don't mind a controversy but I should not wish it to be personal in any way as I admire him & his work – & my intention was to bring forward important things relevant to sculpture as a whole & its relation to society.' (Letter of 26 April 1951, BBC Written Archives Centre.) Cohn cut down the recorded conversation, which was unscripted, for broadcast. While she liked the spontaneity of the broadcast talk, Hepworth thought the full-length transcript 'terrible' and transcribed by somebody who 'didn't understand the sort of vocabulary artists use'. (Letter to Cohn, 1 December 1951; a copy of this unreliable, unedited transcript is in the Tate Archive.)
2 Probably a reference to James Stephens (1880–1950), Irish poet and novelist, also known for his broadcasts on the BBC.
3 Lost in the broadcast; taken from the unedited transcript.

Statements by Hepworth in six autobiographical sections in
Barbara Hepworth: Carvings and Drawings, with an introduction by
Herbert Read, London 1952

Preface

I have called this book *Carvings and Drawings* quite deliberately because
I have always been primarily concerned with the nature of carving.

The word sculpture denotes all those known (and unknown) ways of
dealing with the expression of the sculptural idea. I should like to emphasize
how fundamentally important the 'idea' of sculpture is to me; every facet
of the whole idea, whether it be carving or modelling, hammered metal
or wrought iron, space sculpture or mobile is equally valid and equally
important as an experience; but I refute absolutely the recent tendency to
discount the act of carving as being out of date or not contemporary.

Carving is to me a necessary approach – one facet of the whole idea which
will remain valid for all time. It is, in fact, a biological necessity as it is
concerned with aspects of living from which we cannot afford to be deprived.
It seems to me to be as absurd to refute the validity of carving in 1952 as to
refute the necessity of understanding soil productivity or any of the factors
which determine health in human beings. I regard the present era of flight

BARBARA HEPWORTH

CARVINGS
AND DRAWINGS

17. Dust jacket for *Barbara
Hepworth: Carvings and
Drawings*, Lund Humphries,
London 1952, showing
Curved Stone with Yellow
1946, white stone with paint,
BH 142

and projection into space and time as a tremendous expansion of our sensibilities, and space sculpture and kinetic forms are an expression of it; but in order to appreciate this fully I think that we must affirm some ancient stability – a stability which is inherent in land and rocks and trees, inherent in our capacity to stand and move and feel – in order to assess our true physiological responses to our poise in the landscape as well as to our position in space and time.

[. . .] The years seem to fall naturally into six divisions. Before each period, I will write a brief note indicating the main events and describing the nature of the problems which I am seeking to resolve in my studio.

January 1952

1

the excitement of discovering the nature of carving 1903–1930

During the first years of my life I do not think I ever saw real country or landscape. Whether with my parents in Wakefield or with relatives in Dewsbury the whole scene appeared to me as a curiously rhythmic patterning of cobbled streets, stunted and most ungracious houses dominated by the structure of mills, works' yards, mines, slag heaps, warehouses, noise, dirt, and smell – the whole disorderly pattern of an industrial area.

My first few journeys by tram or train revealed stunted grass, collieries, more slag heaps, pit ponies, foundries by the railway lines, distant hills wreathed with indigo smoke which the very earth seemed to be exhaling. This was my visual background. It was pierced, in my earliest memory, by the incredible magic of a musical box owned by the people next door; later, by astonishment when I first went to school and saw on every classroom wall reproductions of the work of old masters; and by a lecture which I attended at the age of seven given by the headmistress on Egyptian sculpture. I remember sitting quite rigid – it was the first time I had seen a lantern slide, and both sculpture and architecture seem to exert some special kind of compulsion when thrown up on the screen – they have a very different quality from painting, because space and volume are enormously tangible and enveloping in a spot of brilliance in surrounding darkness.

Soon after this I sensed the geography of the West Riding. My father in the course of his work motored all over the county, and when not at school I was allowed to go with him. He was a wonderful companion on these journeys as he spoke little. Perched up in front of one of the early types of car I followed the contours of the superb Yorkshire dales. Here was deep true landscape – the real source of man's energy. Every hill and valley became a sculpture in my eyes, and each landscape was intrinsic in the astonishing 'architecture' of the industrial Pennines which spread west, north, and south of us.

Later still I discovered the North and East Ridings, when my parents took all of us to the coast in the summer. The drawing and painting I had done at school became at that time directly applied to my experience and I got up very early in the mornings and painted out of doors. There was in particular a funnel-like cave in the cliffs along the deserted beach, which I painted at daybreak with my back to the sea.

The whole of this Yorkshire background means more to me as the years have passed. I draw on these early experiences not only visually, in texture and contour, but humanly. The importance of man in landscape was stressed by the seeming contradiction of the industrial town springing out of the inner beauty of the country. This paradox expressed for me most forcibly the fundamental and ideal unity of man with nature which I consider to be one of the basic impulses of sculpture. In a great producer county such as the West Riding, man has had to come to terms with himself and his land – I felt quite early that the dignity and kindliness of the Yorkshire people as a whole demonstrated this, and wherever I have found myself since those childhood days I have tended to measure all gesture, movement, proportion, and rhythm (either as properties of sculpture or as significances in human behaviour) by the measure of what was so profoundly important in childhood.

I went to Leeds School of Art when I was approaching seventeen on a Junior County Art Scholarship. I was determined to be a sculptor, and I was fortunate enough to win a major art scholarship and enter the School of Sculpture at the Royal College of Art within a year. Henry Moore, whom I had met at Leeds School of Art, went to the Royal College at the same time, and three years later we were each granted a West Riding Scholarship for one year's travel abroad and I chose to go to Italy. Later, when I returned from Italy with my first husband, the sculptor John Skeaping (whom I had married in Florence), we met Henry Moore and his wife Irena frequently and many discussions took place. We were all at that time facing the general antagonism to 'direct carving' as it was called in the late 'twenties, and this gave us a sense of united purpose.

The travelling scholarship provided my most formative year by far. There had been something lacking in my childhood in Yorkshire, and that was *light*. In my early experiences the sun never shone enough, the atmosphere rarely cleared, shadows were never sharp, surfaces never brilliant. Italy opened for me the wonderful realm of light – light which transforms and reveals, which intensifies the subtleties of form and contours and colour, and in which darkness – the darkness of window, door, or arch – is set as an altogether new and tangible object. To my northern conception it added a knowledge of the grace of the Mediterranean approach which imparts a richness and gaiety into the 'living' material of marble and stone.

During this year I did no sculpture. I made my headquarters in Florence. I explored the whole of Tuscany; Romanesque architecture in landscape and sunlight; Masaccio; Michaelangelo; Cimabue; Giotto; Assisi; Siena, and

Perugia. I looked over and over again – relating all I saw to the events in Yorkshire in the earlier years. And when this scholarship year was over I remained in Italy for a further eighteen months, working in Rome.

A chance remark by Ardini, an Italian master carver whom I met there, that 'marble changes colour under different people's hands' made me decide immediately that it was not dominance which one had to attain over material, but an understanding, almost a kind of persuasion, and above all greater co-ordination between head and hand.

This thought has recurred again and again ever since – and has developed my greatest interests; the reason why people both move differently and stand differently in direct response to changed surroundings; the unconscious grouping of people when they are working together, producing a spatial movement which approximates to the structure of spirals in shells or rhythms in crystal structure; the meaning of the spaces between forms, or the shape of the *displacement* of forms in space, which in themselves have a most precise significance. All these responses spring from a factual and tactile approach to the object – whether it be the feeling of landscape which one feels beneath one's feet or the sensitivity of the hand in carving, or in surgery, or music, and they have an organic and perceptual purpose.

The importance of light in relation to form will always interest me. In sculpture it seems to be an extension of the stereognostic sensibility and through it I feel it ought to be possible to induce those evocative responses which seem to be part of primeval life and which are a vital necessity to a full apprehension of space and volume.

There is an inside and an outside to every form. When they are in special accord, as for instance a nut in its shell or a child in the womb, or in the structure of shells or crystals, or when one senses the architecture of bones in the human figure, then I am most drawn to the effect of light. Every shadow cast by the sun from an ever-varying angle reveals the harmony of the inside to outside. Light gives full play to our tactile perceptions through the experience of our eyes, and the vitality of forms is revealed by the interplay between space and volume.

I had my first exhibition in June 1928 with John Skeaping. In June 1929 our son Paul was born.[1] At this time all the carvings were an effort to find a personal accord with the stones or wood which I was carving. I was fascinated by the new problem which arose out of each sculpture, and by the kind of form that grew out of achieving a personal harmony with the material. By 1930, I felt sure that I could respond to all the varieties of wood growth or stone structure and texture. The *Head* carved in 1930 expressed that feeling of freedom, and a new period began in which my idea formed independently of the block. I wanted to break down the accepted order and rebuild and make my own order.

[1952]

2

the breaking up of the accepted sculptural order, and the poetry of the figure in landscape 1931–1934

In trying to find a new way of composing forms other than by the accepted order of human anatomy or by my own experience of the special forms induced by carving direct into the material, and feeling in harmony with the properties of wood or stone, I discovered a new approach which would allow me to build my own sculptural anatomy dictated only by my poetic demands from the material.

In 1930 I saw the paintings of Ben Nicholson (whom I later married) and Frances Hodgkins for the first time. To find an equivalent movement in painting to the one of which I was a part in sculpture was very exciting, and the impact of Ben Nicholson's work had a deep effect on me, opening up a new and imaginative approach to the object in landscape, or group in space, and a free conception of colour and form. It often happens that one can obtain special revelations through a similar idea in a different medium. The first exhibition which I saw of his work revealed a freedom of approach to colour and perspective which was new to me. The experience helped to release all my energies for an exploration of free sculptural form, rather than being expended, as they had been until then, in breaking with an accepted order of teaching and tradition.

In 1932, Ben Nicholson and I visited the Rumanian sculptor Constantin Brancusi in his Paris studio. I took with me to show to Brancusi (and Arp, and Picasso the next day) photographs of my sculptures including ones of the *Pierced Form* in alabaster 1931 [fig.3], and *Profile* 1932.[2] In both these carvings I had been seeking a free assembly of certain formal elements including space and calligraphy as well as weight and texture, and in the *Pierced Form* I had felt the most intense pleasure in piercing the stone in order to make an abstract form and space; quite a different sensation from that of doing it for the purpose of realism. I was, therefore, looking for some sort of ratification of an idea which had germinated during the last two years and which has been the basis of my work ever since.

In Brancusi's studio I encountered the miraculous feeling of eternity mixed with beloved stone and stone dust. It is not easy to describe a vivid experience of this order in a few words – the simplicity and dignity of the artist; the inspiration of the dedicated workshop with great millstones used as bases for classical forms; inches of accumulated dust and chips on the floor; the whole great studio filled with soaring forms and still, quiet forms, all in a state of perfection in purpose and loving execution, whether they were in marble, brass, or wood – all this filled me with a sense of humility hitherto unknown to me.

I felt the power of Brancusi's integrated personality and clear approach to his material very strongly. Everything I saw in the studio-workshop itself

demonstrated this equilibrium between the works in progress and the finished sculptures round the walls, and also the humanism, which seemed intrinsic in all the forms. The quiet, earthbound shapes of human heads or elliptical fish, soaring forms of birds, or the great eternal column in wood, emphasised this complete unity of form and material. To me, bred in a more northern climate, where the approach to sculpture has appeared fettered by the gravity of monuments to the dead – it was a special revelation to see this work which belonged to the living joy of spontaneous, active, and elemental forms of sculpture.

I think Brancusi's understanding of these timeless elements of sculpture is very close to Stravinsky's understanding of rhythm – they are elements which belong to the primeval forces activating man's sensibilities; but they are, at the same time, sophisticated in the sense that they apprehend contemporary needs and passions and reaffirm the continuity of life.

The following day a visit to Meudon to see Jean Arp in his studio presented an experience of quite another kind. We were disappointed to find that Arp was not there, but his wife, Sophie Taeuber-Arp showed us his studio. It was very quiet in the room so that one was aware of the movement in the forms. All the sculptures appeared to be in plaster, dead white, except for some early reliefs in wood painted white with sharp accents of black. Plaster is a material which I have always particularly disliked because of the absence of tactile pleasure and light-carrying particles – a dead material excluding all the magical and sensuous qualities of the sculptural idea. Therefore, my delight in the poetic idea in Arp's sculptures, although they lacked these special qualities of material which I cannot do without in my work, came as a surprise to me, and the next day, as we travelled on the train to Avignon, I considered the question. I had never had any first-hand knowledge of the Dadaist movement, so that seeing Jean Arp's work for the first time freed me of many inhibitions and this helped me to see the figure in landscape with new eyes. I stood in the corridor almost all the way looking out on the superb Rhone valley and thinking of the way Arp had fused landscape with the human form in so extraordinary a manner. Perhaps in freeing himself from material demands his idea transcended all possible limitations. I began to imagine the earth rising and becoming human. I speculated as to how I was to find my own identification, as a human being and a sculptor, with the landscape around me.

It was my first visit to the South of France, and out of the three days at Avignon the most important time for me was spent at St. Rémy. It was Easter; and after a bus ride we walked up the hill and encountered at the top a sea of olive trees receding behind the ancient arch on the plateau, and human figures sitting, reclining, walking, and embracing at the foot of the arch, grouped in rhythmic relation to the far distant undulating hills and mountain rocks. There was the sound of dance music – and we discovered a gay café Robinson hidden by trees. I made several drawings. These were the last I ever made of actual landscape, because since then, as soon as I sit

down to draw the land or sea in front of me, I begin to draw ideas and forms for sculptures.

On the way back from Avignon after Easter we saw Picasso in his studio. I shall never forget the afternoon light streaming over roofs and chimney-pots through the window, on to a miraculous succession of large canvases which Picasso brought out to show us and from which emanated a blaze of energy in form and colour. It was a very small room, and the floor was covered with tubes of paint, pieces of paper, rags and piles of empty cigarette cartons, so that it was difficult to know where to stand. There was a unique tension between the power in the paintings and that in Picasso's eyes and hands. Ben Nicholson took some gaily-coloured and checked pencils and gave them to Picasso who rolled them across the table with a gesture which produced a new, vivid pattern of colour not inherent in the pencils but belonging to the artist.

I was at this time a member of the 7 & 5 Group in England, which I joined in 1930.[3] Before we left both Ben Nicholson and I joined the Abstraction-Création group in Paris. By 1934 the Unit One group was formed and exhibiting at the Mayor Gallery and had published the book *Unit One*.

3
constructive forms and poetic structure 1934–1939

On October 3rd, 1934 our triplets were born, Simon, Rachel, and Sarah, in a small basement flat very near our studios. It was a tremendously exciting event. We were only prepared for one child and the arrival of three babies by six o'clock in the morning meant considerable improvisation for the first few days. One of the things I remember best of that time was the profoundly moving quality of the affection that we felt for the three children who appeared so similar, and yet, from the earliest moment, showed such marked differences of personality.

It seemed as though it might be impossible to provide for such a family by the sale of abstract paintings and white reliefs, which Ben Nicholson was then doing, and by my sculptures; but the experience of the children seemed to intensify our sense of direction and purpose, and gave us both an even greater unity of idea and aim. Our influence on each other remained free and stimulating and is shown, I think, at its best in the coloured reliefs of Ben Nicholson's and in my sculptures with colour which were to come later.

The reliefs were, I believe, a most important phase of Ben Nicholson's work, contributing much to the understanding of colour and form generally; carved by a painter they were free of the hitherto accepted limitations of sculptured relief and their vitality sprang out of 'absolute' relationships of form and colour without resorting to any compromise with illusion or perspective and giving an impression of new and very great beauty. Each of us became, and still remains, the best critic of the other's work. This would not

have been possible had our influence on each other been less constructive or if either had been the more dominating; for constructive and creative criticism contains a high order of inspiration.

When I started carving again in November 1934, my work seemed to have changed direction although the only fresh influence had been the arrival of the children. The work was more formal and all traces of naturalism had disappeared, and for some years I was absorbed in the relationships in space, in size and texture and weight, as well as in the tensions between the forms. This formality initiated the exploration with which I have been preoccupied continuously since then, and in which I hope to discover some absolute essence in sculptural terms giving the quality of human relationships. This is written in 1952, and in front of me is a group in marble carved last year which consists of twelve separate forms each bearing a specific and absolute position in relation to the others. It is an extension of the same idea which started in November 1934, but extended gradually from within outwards; through the family group and its closely knit relationship out to the larger group related to architecture.

By 1935 the artists who had formed *Unit One* the year before had, quite naturally it seemed, split and joined the two new groups – Constructive on the one hand, and Surrealist on the other. For the next four years these expanding groups presented the main streams of activity in the visual and literary arts. The period during which Ben Nicholson had acted as a liaison with Paris had now ended and a new phase began. As a consequence of his friendships in Paris, Naum Gabo came over and decided to remain in England. Later Piet Mondrian came over and we found him a studio opposite our own.

Gropius, Moholy-Nagy, Breuer, Mendelsohn, had all come to live in London and suddenly England seemed alive and rich – the centre of an international movement in architecture and art. We all seemed to be carried on the crest of this robust and inspiring wave of imaginative and creative energy. We were not at that time prepared to admit that it was a movement in flight. But because of the danger of totalitarianism and impending war, all of us worked the harder to lay strong foundations for the future through an understanding of the true relationship between architecture, painting, and sculpture.

Early in 1935 the idea of publishing a book on Constructive Art was born during an evening's conversation in our studio between J.L. Martin, Ben Nicholson, Naum Gabo, Sadie Speight (Martin's wife), and myself.[4] Work began on it almost at once. The three men became co-editors, and the two wives became responsible for production and layout. The work involved in its preparation seemed prodigious coming on top of our ordinary day's work; but the co-operation between the five of us was most exciting. At the end of the year the book was published by Fabers under the title '*Circle*', *an International Survey of Constructive Art*.

Everywhere there seemed to be abundant energy, and hope, and a developing interest in the fusion of all the arts to some great purpose. But just when we felt the warmth and strength of this new understanding it eluded us. Even as late as 1938 we still hoped; but by then Gropius, Breuer, and Moholy-Nagy had left for the U.S.A. By 1940 Gabo was in Cornwall with us, and by 1941 Mondrian too had left for New York after his Hampstead studio had been damaged by the bombing.

I had seen Mondrian's studio in Paris where he had lived for nearly twenty-five years. When I first went there it made me gasp with surprise at its beauty – it seemed to be literally suspended over the main railway lines into Paris (Gare Montparnasse). Inside the studio everything gleamed with whiteness. The walls, furniture, easels, were all immaculate with white paint – except I remember, for a blue box and a red gramophone. Far up on the white walls were placed different sized rectangles of primary colours, red, yellow, and blue, all movable and all placed with conscious visual purpose, sometimes a blue next a yellow, sometimes two reds together. Mondrian's hospitality and exceptional charm of manner completed the feeling of being transported into a new world – yet somehow a world which accepted the noise and dirt of the railway outside.

Later he brought out his canvases and it was apparent at once that no photograph, no colour reproduction, could ever bring out any of the feeling of the real power of the paintings, or reveal anything even approaching the quality of the texture and sensed space, the glow of colour which one felt on seeing the actual paintings.

Mondrian built up the same atmosphere of space perfection in his studio in Hampstead, starting from an old grey room in a Victorian house and buying cheap unpainted furniture in Camden Town. Very soon the same intensity and clarity of whiteness glowed in his new surroundings; his thought seemed to radiate from every physical object which one could either touch or behold. New canvases appeared again – completed work and work in progress – with the same fierce impact that one had felt in Paris. I have never understood those who said that Mondrian's work closed the door to the development of abstract work. It seemed to me that the integrity and strength of passion in Mondrian's work was an example which should give everybody courage to go forward, following the thread of his own particular direction right to the end until what he has an urge to find has been discovered. One of the miracles of the human race is the infinitude of personal vision which can be unfolded by a simple devotion and undeviating courage. Mondrian showed how completely possible it was to find a personal equation, through courage and exceptional faith in life itself, and in the artist's intrinsic right to assume entire responsibility for the development of his art. No artists in our time have had such a powerful and *silent* influence as Mondrian and Brancusi. It is an influence which seems to stand quite apart – and it is the exact opposite in kind to the influence of Picasso which has reverberated through all quarters of the globe.

My own work went well. Carving became increasingly rhythmical and I was aware of the special pleasure which sculptors can have through carving, that of a complete unity of physical and mental rhythm. It seemed to be the most natural occupation in the world. It is perhaps strange that I should have become particularly aware of this at the moment when the forms themselves had become the absolute reverse of all that was arbitrary – when there had developed a deliberate conception of form and relationship.

In 1937 we had a short holiday in Varengeville, near Dieppe, staying with Alexander Calder and his family. Braque was working in his studio there, and Miró and his family who were staying with Paul Nelson, the architect, and his wife Francine, completed the party. I have always found people's hands an absorbing interest; watching their movement and gesture reveal their inner thoughts and purposes. I was fascinated by Miró's unique way of picking up pebbles on the beach and arranging them swiftly so that his gesture revealed a Miró painting in movement.

By early 1939 the Spanish War, Munich, and the ever-increasing threat of a European war not only absorbed most people's energy, but it seemed to extinguish for a while the interest which had been growing during the previous years. From late 1938 until war was declared it became increasingly difficult to sell a painting or a sculpture and make a bare living. At the most difficult moment of this period I did the maquette for the first sculpture with colour, and when I took the children to Cornwall five days before war was declared I took the maquette with me, also my hammer and a minimum of stone carving tools.

4
the war, Cornwall, and artist in landscape 1939–1946

When war was declared in September 1939 I was in Cornwall where good friends had offered hospitality to the children. Early in 1940 we managed to find a small house and for the next three years I ran a small nursery school. I was not able to carve at all; the only sculptures I carried out were some small plaster maquettes for the second 'sculpture with colour', and it was not until 1943, when we moved to another house, that I was able to carve this idea, and also the first idea for sculpture with colour of 1938, both in a larger and slightly different form in wood.

In the late evenings, and during the night I did innumerable drawings in gouache and pencil – all of them abstract, and all of them my own way of exploring the particular tensions and relationships of form and colour which were to occupy me in sculpture during the later years of the war.

At that time I was reading very extensively and I became concerned as to the true relationship of the artist and society. I remember expecting the major upheaval of war to change my outlook; but it seemed as though the worse the international scene became the more determined and passionate

became my desire to find a full expression of the ideas which had germinated before the war broke out, retaining freedom to do so whilst carrying out what was demanded of me as a human being. I do not think this preoccupation with abstract forms was escapism; I see it as a consolidation of faith in living values, and a completely logical way of expressing the intrinsic 'will to live' as opposed to the extrinsic disaster of the world war.

In St. Ives I was fortunate enough to have constant contact with artists and writers and craftsmen who lived there, Ben Nicholson my husband, Naum Gabo, Bernard Leach, Adrian Stokes, and there was a steady stream of visitors from London who came for a few days' rest, and who contributed in a great measure to the important exchange of ideas and stimulus to creative activity. Looking back it seems to have been a period of great preparation which was later to show in the work of younger painters and sculptors. Gabo made a profound effect during the six years he lived and worked here. His unusual powers of expression in discussion and the exceptional charm of his personality when talking of creative processes seemed to unleash a great energy in all who came near him. When he went to America everybody who knew him missed him. It is impossible to forget either the extraordinary beauty of his sculptures or the most rare warmth of his nature.

It was during this time that I gradually discovered the remarkable pagan landscape which lies between St. Ives, Penzance and Land's End; a landscape which still has a very deep effect on me, developing all my ideas about the relationship of the human figure in landscape – sculpture in landscape and the essential quality of light in relation to sculpture which induced a new way of piercing the forms to contain colour.

A new era seemed to begin for me when we moved into a larger house high on the cliff overlooking the grand sweep of the whole of St. Ives Bay from the Island to Godrevy lighthouse. There was a sudden release from what had seemed to be an almost unbearable diminution of space and now I had a studio workroom looking straight towards the horizon of the sea and enfolded (but with always the escape for the eye straight out to the Atlantic) by the arms of land to the left and the right of me. I have used this idea in *Pelagos* 1946.

The sea, a flat diminishing plane, held within itself the capacity to radiate an infinitude of blues, greys, greens, and even pinks of strange hues: the lighthouse and its strange rocky island was an eye; the Island of St. Ives an arm, a hand, a face. The rock formation of the great bay had a withinness of form which led my imagination straight to the country of West Penwith behind me – although the visual thrust was straight out to sea. The incoming and receding tides made strange and wonderful calligraphy on the pale granite sand which sparkled with felspar and mica. The rich mineral deposits of Cornwall were apparent on the very surface of things; quartz, amethyst, and topaz; tin and copper below in the old mine shafts, and geology and pre-history – a thousand facts induced a thousand fantasies of form and

purpose, structure and life, which had gone into the making of what I saw and what I was.

From the sculptor's point of view one can either be the spectator of the object or the object itself. For a few years I became the object. I was the figure in the landscape and every sculpture contained to a greater or lesser degree the ever-changing forms and contours embodying my own response to a given position in that landscape. What a different shape and 'being' one becomes lying on the sand with the sea almost above from when standing against the wind on a high sheer cliff with seabirds circling patterns below one; and again what a contrast between the form one feels within oneself sheltering near some great rocks or reclining in the sun on the grass-covered rocky shapes which make the double spiral of Pendour or Zennor Cove; this transmutation of essential unity with land and seascape, which derives from all the sensibilities, was for me a voyage of exploration. There is no landscape without the human figure: it is impossible for me to contemplate pre-history in the abstract. Without the relationship of man and his land the mental image becomes a nightmare. A sculpture might, and sculptures do, reside in emptiness; but nothing happens until the living human encounters the image. Then the magic occurs – the magic of scale and weight, form and texture, colour and movement, the encircling interplay and dance occurs between the object and the human sensibilities.

I used colour and strings in many of the carvings of this time. The colour in the concavities plunged me into the depth of water, caves, or shadows deeper than the carved concavities themselves. The strings were the tension I felt between myself and the sea, the wind or the hills. The barbaric and magical countryside of rocky hills, fertile valleys, and dynamic coastline of West Penwith has provided me with a background and a soil which compare in strength with those of my childhood in the West Riding. Moreover it has supplied me with one of my greatest needs for carving: a strong sunlight and a radiance from the sea which almost surrounds this spit of land, as well as a milder climate which enables me to carve out of doors nearly the whole year round.

5
rhythm and space 1946–1949

Abstract drawing has always been for me a particularly exciting adventure. First there is only one's mood; then the surface takes one's mood in colour and texture; then a line or curve which, made with a pencil on the hard surface of many coats of oil or gouache, has a particular kind of 'bite' rather like incising on slate; then one is lost in a new world of a thousand possibilities because the next line in association with the first will have a compulsion about it which will carry one forward into completely unknown territory. The conclusion will be reached only by an awareness of some special law of harmonics induced at the beginning with the second line added to the first.

Suddenly before one's eyes is a new form which, from the sculptor's point of view, free as it is from the problems of solid material, can be deepened or extended, twisted or flattened, tightened and hardened according to one's will, as one imbues it with its own special life. The whole process is opposite to that of drawing from life.

With the model before one, every known factor has to be understood, filtered and selected; and then, from these elements in the living object, one chooses those which seem to be structurally essential to the abstract equivalent, relevant to the composition and material in which one wishes to convey the idea. After my exhibition in 1946 at Lefevre the abstract drawings which I did led me into new territory; the forms took on a more human aspect – forms separated as standing or reclining elements, or linked and pulled together as groups. During the early part of 1947 I had been doing the drawings and maquettes for the Waterloo Bridge competition held by the London County Council and had sat on the bridge for many hours contemplating the architectural and sculptural scale of the site in relation to the thousands of people who passed over or under the bridge. The sculptures I designed for the four plinths were all reclining abstract forms and, to me, they looked slightly absurd as maquettes since every curved surface and every pierced hole had been thought out in relation to the scale of human beings. A surface or piercing the size of one's finger in no way expresses the sensation of a stone pierced so that one can climb through it, or carved so that one can imagine lying on it or being enclosed by it. This is a desperate problem for the sculptor in my opinion, and it is why I rarely do a maquette of any kind. If it is *right* in maquette form it would be utterly wrong when increased in size. The converse is also true – miniatures of large objects become merely toy-like.

I do not believe that one can ever alter the scale of form or transfer form from one medium to another. The scale dictates and creates its own forms, and the whole composition depends on the size of man himself and his eye level, his reach, the size of his hands, in fact, his whole physiological make-up.

I was therefore in a receptive mood when, in about the middle of 1947, a suggestion was made to me that I might watch an operation in a hospital. I expected that I should dislike it; but from the moment when I entered the operating theatre I became completely absorbed by two things: first, the extraordinary beauty of purpose and co-ordination between human beings all dedicated to the saving of life, and the way that unity of idea and purpose dictated a perfection of concentration, movement, and gesture, and secondly by the way this special grace (grace of mind and body) induced a spontaneous space composition, an articulated and animated kind of abstract sculpture very close to what I had been seeking in my own work.

We are all conditioned to seeing the nerveless kind of scurrying movement of modern life: dressed often in absurd clothes and with tense faces, blind to all but the necessity of working one's way through the crowds, we fight our

way through the days and weeks. When we need refreshment, most people seek the nourishment of graceful movement in watching football matches, the ballet, horse-racing, or Wimbledon. But our participation is at second or third hand; we forget, or we have no time in which to remember, that grace of living can only come out of some kind of training or dedication, and that to produce a culture we have to understand all the attributes of a proper co-ordination between hand and spirit in our daily life. A particularly beautiful example of the difference between physical and spiritual animation can be observed in a delicate operation on the human hand by a great surgeon. The anatomy of the unconscious hand exposed and manipulated by the conscious hand with the scalpel, expresses vividly the creative inspiration of superb co-ordination in contrast to the unconscious mechanism. The basic tenderness of the large and small form, or mother and child, proclaims a rhythm of composition which is in contrast to the slapping and pushing of tired mother and frustrated child through faults in our way of living and unresolved social conditions.

For two years I drew, not only in the operating theatres of hospitals, but from groups in my studio and groups observed around me. I studied all the changes and defects which occurred in the composition of human figures when there were faulty surroundings or muddled purpose. This led me to renewed study of anatomy and structure as well as the structure of integrated groups of two or more figures. I began to consider a group of separate figures as a single sculptural entity, and I started working on the idea of two or more figures as a unity, blended into one carved and rhythmic form. Many subsequent carvings were on this theme, for instance, *Bicentric Form* in the Tate Gallery. During 1949 I had some exciting conflicts with material. The sawn cube out of which I carved the *Cosdon Head* 1949 proved to be a singularly intractable metamorphic rock – the very nature of my tussle with it gave the whole carving a quality of some giant pebble worn by centuries of waves beating on it. The Himalayan rosewood (*Dyad* 1949) which I found through friends in a workshop in Devonshire had a kind of jungle-like ferocity and innate determination to go its own way. I enjoyed the daily struggle with its untamed dark spirit.

In the autumn of 1949 I acquired my present studio. It seemed a miracle indeed to find in the middle of a town a studio with workshops and yard and garden where nobody objected to the noise of hammering and where there was protection from cold winds so that I could carve out of doors nearly all the year round, and where there was proper space for all the multitudinous items of equipment needed for moving stone and carving it. The atmosphere was so ideal that I started a new carving the morning after I moved in – in spite of the difficulties of the move's involving six tons of tools and materials of all kinds.

6
artist in society 1949-1952

I went out to Venice in June 1950, when my work was shown at the 25th Biennale in the British Pavilion. The two weeks I spent there were a great stimulus to the idea on which I was working at that time. It was my first visit to Venice; and against the superb proportions of the buildings set in the expanded flatness of water, or confined, or rising out of ribboned canals where one is so aware of the magnitude of the sky, I watched new movements of people. The animation of light and shadow over earth colours of black, white, grey, and red in the architecture was so vital in relation to the proportions of mass and space that every human action against this setting seemed to be vested with a new importance. Whenever I could get away alone I walked and observed people in relation to the buildings. Every day I sat for a time in the Piazza San Marco, a miracle of man-made space, and wondered at the unique way in which one sensed within this opened space the closed-in space-volume of the interior of San Marco itself. One was aware of all the intricacies of height and breadth in planes and curvature. There seemed to be a dynamic interplay between the volume of mass and the volume of space which began decisively at this point and extended itself outwards even as far as Torcello. Before I left I was fortunate enough to watch from a balcony opposite San Marco the deeply moving ceremony of the procession of Corpus Christi round the Piazza.

But the most significant observation I made for my own work was that as soon as people, or groups of people, entered the Piazza they responded to the proportions of the architectural space. They walked differently, discovering their innate dignity. They grouped themselves in unconscious recognition of their importance in relation to each other as human beings. Apart from the Piazza, I noticed in Venice generally that there were particular movements of happiness springing from a mood among people which seemed to imbue them at once with greater swiftness and certainty of movement and gesture, and at the same time a greater relaxation.

All these events pertained to what are for me the dynamic properties of sculpture. If human beings respond so decisively to mood and environment, and also to space and proportion in architecture, then it is possible to, and imperative that we should, rediscover those perceptions in ourselves, so that architecture and sculpture can in the future evoke those definite responses in human beings which grew with Venice and still live to-day. Sculpture should act not only as a foil to architectural properties but the sculpture itself should provide a link between human scale and sensibility and the greater volumes of space and mass in architecture.

During the whole of my stay in Venice I was inspired not only by the architecture in relation to its natural setting and the people in relation to both, by the rhythmic relations of the use of colour in architecture and the painting

sensibilities which seemed to accentuate all movement – but also by the quality of sound. All the use of spaces and volumes accentuated and clarified sound so that the whole of Venice seemed to have a music of its own form. One felt this very keenly and with delight, because the absence of cars and buses brought renewed life to human relationships by means of sound. The water-borne sounds and bells stressed the opposition of vertical forms to the horizontal.

In the Festival Hall, opened in London in 1951, I feel that people respond in all these particular ways, just because the architecture itself was conceived so exactly in relation to human needs and sensibilities and to the purposes for which numbers of people gather together.

In making my roots in a small seaboard town I have felt compelled to meet the all-round problem of living in a comprehensible community, because I think that the discipline of my sculpture demands this sort of integration. The years I spent preoccupied with the landscape image in sculpture now form the apprenticeship to my present concern with an image in sculpture of the community as a unit in landscape. The two things which interest me most are the significance of human action, gesture, and movement, in the particular circumstances of our contemporary life, and the relation of these human actions to forms which are eternal in their significance.

In opposition to 'social realism' I believe that meanings in sculpture emerge more powerfully when they are carried through sculpture's own silent language; and that if the sculptor himself can find *personal* integration with his surroundings and his community his work will stand a greater chance of developing the poetry which is his free and affirmative contribution to society. I believe also very strongly that if the artist and his community are free in this way, the purpose and evocation of meaning in his work will be far more easily and clearly understandable in the long run.

In these very brief notes I seem to have omitted everything that goes to make up my usual working day. These things are immensely important to me; perhaps more important than the things about which I have written. My home and my children; listening to music, and thinking about its relation to the life of forms; the need for dancing as a recreation, and where dancing links with the actual physical rhythm of carving; the intense pleasure derived from tools and craftsmanship – all these things are daily expressions of the whole.

I have never understood why the word feminine is considered to be a compliment to one's sex if one is a woman, but has a derogatory meaning when applied to anything else. The feminine point of view is a complementary one to the masculine. Perhaps in the visual arts many women have been intimidated by the false idea of competing with the masculine. There is no question of competition. The woman's approach presents a different emphasis.

I think that women will contribute a great deal to this understanding through the visual arts, and perhaps especially in sculpture, for there is a

whole range of formal perception belonging to feminine experience. So many ideas spring from an inside response to form; for example, if I see a woman carrying a child in her arms it is not so much what I see that affects me, but what I feel within my own body. There is an immediate transference of sensation, a response within to the rhythm of weight, balance and tension of the large and small form making an interior organic whole. The transmutation of experience is, therefore, organically controlled and contains new emphasis of forms. It may be that the *sensation* of being a woman presents yet another facet of the sculptural idea. In some respects it is a form of 'being' rather than observing, which in sculpture should provide its own emotional and logical development of form.

B.H. 1952

1 3 August 1929.
2 See Chronology, 1932–3. The visit to France was in April 1933.
3 Hepworth first exhibited with the Seven and Five Society in February 1932.
4 *Circle* was conceived in 1936.

'Ideas and the Artist: An Interview with Barbara Hepworth',
Ideas of To-Day, London, November–December 1952, vol.2, no.4

Q. *How would you define the primal impulsion behind the creative artist? Does it originate in the individual, or does it come from something wider and more universal?*

A. The impulse certainly comes from outside. It is, I think, a life force. In the child it appears as a spontaneous response to life. It is inarticulate in one sense, in that the child doesn't know what he is doing; in innocence he just paints. What the artist has to go through in adolescence and early maturity is to try and find what is behind this urge, because otherwise he can become confused by all the influences at work. A writer asked me two or three years ago, 'When you work, are you God creating things, or are you trying to create God?' Of course, I said I was trying to create God, or good, or some image which one never achieves. There is always some falling short of the image, some imperfection; but one is carried forward to the next creative act by the force of the idea one is trying to express.

Q. *Would you say that the imperfection is because human limitations get in the way?*

A. Yes, it is certainly materialistic values which impede one's work. It is so easy to succumb to various pressures. One has to be receptive but instead of giving in and being a slave to all kinds of influences, one should digest them quietly and sift them, and then, I think, they come out as a new strength in

the work. The temptation to be diverted these days is very great, partly owing, I think, to the precarious position of the artist in our society. When children of two and a half start painting, they always begin with primitive shapes and symbols, and they gradually expand to the most joyous and personal interpretation of all their discoveries.

Q. *Would you say that the impulse in the child, though immature, is pure?*

A. Yes, in the sense that the forms and colours are a direct and imaginative response to the child's emotional situation and environment. One has to find that purity again when one grows up, but not as a primitive artist, not as a naïve. There are very few primitives left in our civilization. It is by understanding the validity of the creative expression in the child that you can free him from the suggestions of limitation which he will meet with in adolescence.

Q. *What is it that enables one to distinguish the true work of art from the counterfeit?*

A. Well, I can't think of anything but the vitality of the life force which emanates from it. That is the only way you can tell a copy from the original. But how to define the life force, well, you can only say, perhaps, that it is the animation of material matter to a state of spiritual significance.

In learning, I went through a perfectly academic training. I had a diploma and I had scholarships, and at the time I resisted it. But all that teaching of structure and form and discipline was good, because later one felt free to use it or discard it. At that time, if one made a copy from life, or painted a portrait that was 'so like' a person, people would say, 'You ought to be a portrait painter.' But that is quite the wrong approach, because one isn't seeking to imitate in that way. If you are a modeller, you can't just model a head and try to make it look like a person. You have to give it an entirely new life, so that it is the equivalent of the person in new terms. What you are really trying to do is to allow a process of transmutation, or translation.

And so gradually I learned that the direct approach to sculpture through carving was necessary to me, and that meant a very considerable change. All that I had learned had to be translated into terms of wood and stone. If you are a carver, the only way of selection is by allowing the idea and the material to fuse into a harmony, and you have got to allow them to form together their own spontaneous life and vitality. When you start knocking off the rough, for a little while it looks as though you are approaching your idea. And then it begins to have a very physical entity, where it assumes a new shape, something you had never thought of and that you didn't think it was capable of producing, and it suggests another idea to you, and you think you might follow that, but of course you can't – you have to banish that idea completely and go on until your image is clear, and it never is absolutely clear until your carving is finished.

I simply cannot believe that it is right to take a wood form and put it into plastic, or transfer a metal form into stone. If you are going to deal with a plastic material, you must understand what its structure is. Plastic which looks like cut glass is extremely distressing, because the temperature is wrong and the weight is wrong, and if you touch it you feel you have been cheated.

Q. *Is the tendency of the artist to-day to try more and more to break through the barriers of formal representation to a more liberated realm of ideas, where he is not confined to the view presented to him by his senses? For instance, Paul Klee says: 'He [the artist] does not attach such intense importance to natural form as do many realist critics, because, for him, these final forms are not the real stuff of the process of natural creation. For he places more value on the powers which do the forming than on the final forms themselves.'*

A. Your understanding of nature is to do with the senses. What you see, feel, hear, touch, reveals to you the beauty of the structure of life, and each person has to be aware of all this. Then when he is aware of it, he has to find out what lies behind it, what this structure is. If you see a wonderful tree, first there is the beauty of the tree, and the touch of its bark, and the feel of its leaves. Then there is the whole idea of the growth of the tree – its balance and life and structure and fibres. And the same with crystals, and all the things we observe, and anything which touches you. The human body, its wonderful capacity of taking stress, forever adapting itself towards the future, and the infinite variation of the human being are all quite astonishing, and yet underlying it all there is one simple law governing that apparently material structure. You have to take all that in through the senses, but it all has to be translated. Take, for instance, a flower. Instead of trying to paint a flower, I should want to paint something that had the equivalent, the glow, the shape, the beauty of the flower.

Q. *What you would really be depicting, then, would not be the actual flower of the moment but the indestructible qualities behind it?*

A. Yes, the intensity of expression, that particular light, and form, and colour, and freshness. You could study, for instance, the marvellous shape of an egg; its structure is a powerful and significant form. But if you were to take fifty eggs and look at them all, there wouldn't be two the same. You might become very interested in one of these eggs as an individual, or you might become deeply interested in the constant which lies behind this ever-varying structure which holds good in so many forms. In carving, perhaps the important thing is the underlying constant rather than the individual variation.

But the whole thing is a question of translation, and there is so much to be translated. You see, you don't work in a vacuum, you work in life, and everything you feel has to go through this process of being transformed. What applies to sculpture seems to me to apply to ordinary life. There may be some dreadful thing you have read about in the paper, or some difficulty

at home, or in your social life; each thing has to be resolved as far as one is able. Translation isn't only doing something in a moment of expression, it is a long-term attitude towards life, so that you are always selecting. You have to see that 'the powers that do the forming' are, as it were, the constant behind the structure.

Q. *Would you say that one of the constants behind the structure of a tree is growth?*

A. Yes, growth, also movement and balance. All these things interlock, and are principles which, when expressed aesthetically, do re-create this vitality. A good illustration is the Piazza San Marco in Venice, which I think is one of the most heavenly man-made spaces in the world. In the side streets, you get a whole lot of people moving and jostling, and then when they get into the Piazza, they move quite differently. They just can't jostle and shuffle across this superb space. It is as if they suddenly recognize and conform to the aesthetic values of space and proportion and architecture and dignity. It is in this way that architecture and sculpture will help to reshape cities and social life. I think you find the same thing in the Royal Festival Hall. People move well there through the changing levels and transparencies; everything is a joy to behold in form and purpose, and you can't help behaving differently – with an increased awareness.

Q. *It just shows, doesn't it, how every branch of progress, whether it is in art, architecture, or anything else, is all contributing to the same end?*

A. Yes it does indeed, and we can't have a real society until we have all given up some of our preconceived ideas in order to find our right place in the whole. There are many lost opportunities for integration. For instance, people are always arguing about whether architecture should be a setting for sculpture, or whether sculpture should be an ornament to architecture. But I feel that both should be regarded as separate but complementary entities in an active sense. You so often get people working in isolation. Ultimately we have got to come back to the fact that everything must flow together, each in its rightful place.

Q. *Is it the artist's responsibility to interpret his work? Why do many artists feel that their work must speak for itself, when so much good can be done by explanation? Is the fault always in the public where there is a failure to understand?*

A. I think quite a lot of good can be done by discussion. It helps to clarify thought and creates a greater energy and unity. Whenever an artist does write about his work, it reveals a great deal, but it is always a difficult problem for him, because he thinks in terms of form and colour, which are not easy to explain. It would be very difficult to explain in words the full content of a sculpture, for example, or of a musical composition; you can open the door, however, to a fuller understanding.

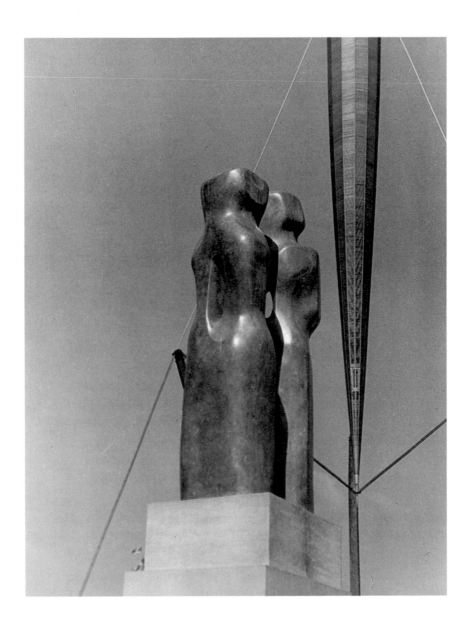

18. *Contrapuntal Forms* 1950–51, Irish blue limestone, BH 165,
on London's South Bank with the Skylon during the Festival of Britain, 1951.
Photograph: Anthony Panting

The real need is to have critics who are following the same path as the artists. I think the artist can often open the door quite well, but creative critics could open the door so much more. They should accompany the artists. There are creative critics, of course, and when they are creative they are trying through their criticisms to open the future, so that you feel immediately you want to do something beyond yourself and move towards an opening. What is so hard for the public is when you get a closed, destructive criticism, and that, I think, should be recognized as a wrong attitude of mind. The Festival of Britain really was a manifestation of extreme joy and beauty, and the public did respond, but it was attacked from the beginning by the idea that it was a silly thing to do, a waste of money, and so on. I think the Exhibition gave a tremendous sense of exhilaration, an entirely new attitude towards London.

The whole basis of our life is going through an extremely difficult crisis at the moment. We are obsessed by power, material belongings or lack of them, and war, and the whole acceleration of this century. There is on the one hand this great creative impulse to understand what life really is, and on the other hand there is this searching for power and possession because of fear. That fear is really what makes the destructive critic, whereas the life force is what is making a great movement in art at the moment. There has never been a richer period, and yet the artist is scarcely used by society because of this fundamental conflict. On the one hand, more and more people are realizing that this life force is the only thing which will save them. On the other hand, there is this attempt to extinguish the life force because it impedes material belief in power.

Q. *Then you feel that there is a great impetus growing in the public towards an appreciation of these issues?*

A. Yes. I suppose finally everyone will realize the difference between the two ways, and they will then speak, and you will get an answer from a nation, or an answer from the world, which will destroy the wrong attitude.

Q. *Should the interpretation of art, ideally speaking, make it available to everyone? And if so, is it not a consequence that every individual has within himself the potentiality of artistic self-expression?*

A. Ideally speaking, every person is an artist, but I think that the lesson to be learnt is in the way of life. Obviously you can't have a whole world doing sculpture. Every human activity has to be approached rather in the same manner. Artists are pioneers in the sense that they feel far ahead. They feel things perhaps before other people, and so their art forms are pointers or stresses. If things are going wrong, they will intuitively stress certain aspects of beauty which are needed. They have this particular capacity of co-ordinating the impressions that come from the senses.

Q. *Then the effect of the artist's work should be to fire everyone with the desire to be creative?*

A. Yes, everything should be creative. The way you approach a person, the way you speak to him, the way you place something on a table. There has to be a recognition of human rights and grace and dignity. The problem is to awaken the individual in each one.

Sculpture, for example, appeals to instincts that go far back into history. In all those vital periods of surging forward and reaching farther towards vitality, underlying all the special language of each period, there is an absolute unity which speaks to you through your eyes and your hands. This unity is expressed through sculpture, and it goes right back to the beginning of time. Nothing else speaks to you in these terms – it has to come through three dimensions; without them we have no position in the landscape. Sculpture speaks to people in the sense that it keeps them in a state of balance and poise. If there was no sculpture, our perceptions and awareness of architecture would diminish; we would become unrelated and scarcely know how to approach people, or shake them by the hand.

Q. *Is the work of the artist primarily for himself and his own satisfaction, or is it for the sake of mankind and for the purpose of raising mankind to a higher level? For example, Paul Klee says again: 'We have found parts, but not the whole. We still lack the ultimate power, for the people are not with us.'*[1]

A. I don't think an artist works with the idea of uplifting mankind. He works to satisfy his own integrity and vision by trying to reach it as nearly as he can. It is not a question of a great artist leading the way in a personal sense, but of a great character and a great tradition in which everyone takes part. That is what Paul Klee means, I think. There have been great artists in the last hundred years, but you can't speak about the period as a whole as having a great character. Until we are all willing to become integrated in a whole, we haven't found our complete expression. When we get to that point, the artist can become anonymous.

It isn't the power of personality that matters. I think a lot of bad work has been done by trying to be uplifting and to do good. The only thing that does any good is being as true as you possibly can be to your imagination and vision of the moment. Material success or failure may make you lose sight of what is really your own calligraphy, and then you are diverted, because you are no longer following a single thread – you are no longer following what is yourself. No man can do better than be true to himself.

Q. *If you are true to your own vision, then does it inevitably speak to others?*

A. Yes, inevitably, even if it only affects one person at first. And if you are really true to yourself, you will be led on to the next step. But if you are diverted for false reasons, it is very difficult to make the next step. You may have to go back to that stage again, until you get past it.

Q. *Throughout history there seems to be a tremendously close relationship between form, as enduring life, and stone. The Bible, for example, connects the ideal of manhood with the stone or rock, and the great sculptures of the human form are nearly always in stone. In your work as a sculptor, does stone, as a medium, have for you any deeply symbolic value?*

A. There is a symbolism, of course, in stone. Rock forms, the land we stand and move upon, clearly have a deep symbolism in history. Stone has many phases of movement and form, which express a permanent symbolism; it doesn't attempt to express many changing manifestations, and it has a stillness, in spite of its inner movement. You can give it tremendous movement within itself and inner power, but it has got a stillness and it is in a way timeless and constant.

Q. *In other words, it is a symbol in our sensuous experience which teaches the value of timelessness?*

A. Yes. The nervous energy which you can get in metal is very important too, but it is of quite a different kind. The whole point, whether you use stone or metal, is to give life, and no one medium is really greater than another. It is a different kind of movement you get in stone – a strong inner life. I love stone, but I should be very unhappy not to have wood as well, because it implies growth and resilience. With wood, you must conform to its structure and become one with that structure.

Q. *Does pure sculpture apply more to the realm of carving than of modelling? Is it true to say that carving involves the release of the perfect form already complete, whereas modelling involves building up the perfect form from a basis of nothing?*

A. I am a little nervous about that word 'perfect', because for many people it has such a limited, static sense, and they don't like to think of the artist trying to achieve perfection. There is an infinitude of images which are perfect, and it is not a question of finding a *perfect* shape, but of finding the right shape for a particular idea. What you are doing is to release the perfect image in an infinite number of varieties and ways.

In carving, you are really taking off everything that is not wanted, until the image is revealed; you set out to achieve the image you have in mind, and you have to know what you are going to do before you start. But with modelling, you start with nothing and you build up your vitality. Modelling is quite a different facet of art, which is nearer in a way to painting; and carving is, perhaps, near in some ways to composing music.

Q. *Would you agree that art in its deepest essence is the art of living? Or rather, is not the ultimate work of art to which all art is tending some such conception as the living perfection of man and his activities?*

A. I would prefer to say 'living integration' rather than 'living perfection'. First of all, individual man has to become integrated, integrated with the purpose of life. Then each man must become integrated in society. Finally, you must have the integration of man as a whole, when you get the rights of man acknowledged and each man is complete and himself.

This conception of perfection is capable of wider and wider expansion – there is no end to its manifestations. But dogma can wrap itself round the idea, so that it becomes debased. This happens with artists too, in their life and work. The one important thing is that you must always be receptive to growth and change, ready to follow along the way you are led by aesthetic intuition. Otherwise you say, 'This form has achieved what I am ever likely to do', and you try to emulate that, and the life has gone. The vital thing is not that one's work is great or important, or anything like that, but that when people see it, your energy and vitality should be passed back to them, so that the circle is complete. Each person who says, 'I have enjoyed tremendously those forms', completes a circle, and so the process of integration goes on.

Integration is one of the great needs to-day, and artists could do so much to help it on. Art is about the only language which nations can speak together and they don't quarrel. And yet in times of stress and war, the tiny grant which the State provides to maintain the visual arts is the first to go. If we would only let artists and writers and musicians feel more certain of their place in society, we could unleash a much greater force in them, which would benefit the whole. This universal language of the artist – so little in material terms is required to keep it alive, and yet a tremendous effort is made to quench it. I do not think the fullest powers of the artist can be freed until the link is made with society, until the need is recognized on both sides. When that is recognized there will be a more vital and affirmative culture – a creative act on the part of the whole.

1 From *Paul Klee on Modern Art*, with an introduction by Herbert Read, London 1948, p.55. The earlier quotation from Klee is also taken from this translation of a lecture he gave in 1924.

Statement by Hepworth in the exhibition catalogue *International Sculpture Competition: The Unknown Political Prisoner: International Exhibition of Grand Prize Winner and other Prize-Winning Entries and Runners-up*, Tate Gallery, London, 14 March–30 April 1953

Barbara Hepworth
Sculptor's Description of Model

The figure of the 'Prisoner' and the two supporting figures of 'Truth' and 'Knowledge' are intended to rise from ground level without plinth or base. They are conceived as figures 12 feet high carved in two shades of hard limestone or granite.

The figure of the 'Prisoner' would be carved in a <u>lighter</u> stone than the two supporting figures.

An inscribed stone would be set at the foot of the 'Prisoner' within the area of ground, either road or field, indicated by the base area of the maquette.

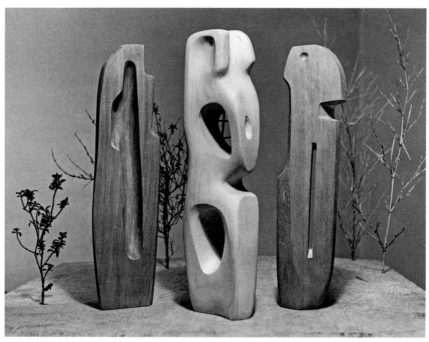

19. *Maquette for The Unknown Political Prisoner* 1952, three forms in wood, BH 186
(two forms in Tate; one, on the left here, in a private collection). Photograph: Studio St Ives

Letter from Hepworth on the St Ives Festival to the editor,
***The St Ives Times*, St Ives, 9 October 1953'**

FESTIVAL'S SPIRITUAL MEANING OBSCURED

Dear Sir, – As one of the founders of the St Ives Festival of Music and the Arts, I should like to reply to Miss Ballance's letter of October 2.

Since the festival ended, there has been so much discussion on the material gains and losses that I feel the spiritual meaning of the festival has become obscured.

The festival was originally conceived as an act of praise. For centuries man has tried to offer the best that he could give to God, and by joining in this act of dedication with his fellow men he has replenished his faith in the true values of life and work. In this century of great wars and political strife, men and women have endeavoured, through such festivals, to reach a better understanding with their fellow beings. Art is a universal language – music has the power to unite us and transport our spirit.

In an age when radio, television and cinema give light entertainment almost every night of the week, it is obvious that faith and devotion on the part of the **whole** community is needed to overcome the material difficulties of an annual festival in which visitors and residents can share in the rarest achievements of mankind.

Some of the hardest criticism has come from those who were unable either to help in the first festival or to be present at the events during the Festival Week itself. We needed both their ideas and their help.

Deficits can be met and overcome with the aid of more workers and greater faith.

The first Festival was a 'project' – an idea which should be seized upon and allowed to grow. It was also a tribute to the beauty of St Ives.

Yours faithfully,

BARBARA HEPWORTH

Trewyn Studio,

St Ives Oct. 3. 1953.

1 The St Ives Festival took place in June 1953. Founded by Hepworth and her friends the composers Priaulx Rainier and Michael Tippett, its courageous programme included music, drama and the visual arts. Its financial results were disappointing, however, and despite Hepworth's strong desire for it to be established as an annual festival, it was not repeated.

Lecture to surgeons in Exeter, untitled typescript with handwritten additions, c.1953

Ladies and Gentlemen

I must ask you to be patient with my deficiencies as a speaker – I have never spoken in public before and would not have attempted to speak about 'the artist's view of surgery' but for the fact that to refuse seemed ungracious when I, myself, owe so much to the kindness and generosity and help on the part of many surgeons and doctors who made my studies in the operating theatre a possibility.

The experience I had began as a result of a chance remark by a surgeon, that I should be very interested in watching what went on in a hospital theatre. My first reaction was one of horror and indeed I was so ill-informed that it seemed to me a grim idea that I, as an artist, should find anything beautiful in watching surgery; but the idea seemed a <u>challenge</u>, and eventually, with some reluctance (and, by the way, detailed provision for a speedy exit if

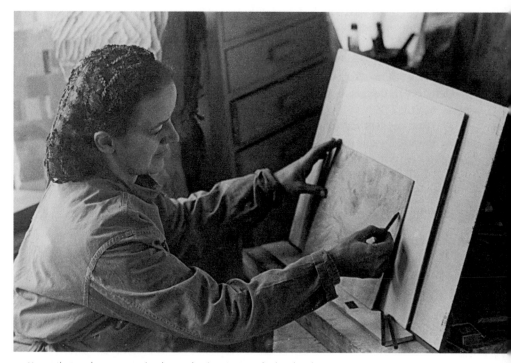

20. Hepworth at work on an operating theatre drawing, *Quartet I (Arthroplasty)*, Chy-an-Kerris, January 1948

necessary!) I entered an operating theatre to watch, for the first time, a reconstruction of a hip.

From the very first moment I was entirely enthralled by the classic beauty of what I saw there; classic in the sense that architecture and function were perfectly blended and purity of idea and grace of execution were in complete harmony.

For three years I was fortunate in being able to work in many operating theatres here in the West Country and in London – at the London Hospital, the Royal National Orthopaedic Hospital and at the London Clinic. Throughout this time I was being enriched as an artist by the experience of watching these various surgeons at work, not only by the visual impact but also by the mental (or shall I say spiritual) meaning of a group of people working harmoniously for a given purpose. It ratified, moreover, my previous ideas as a sculptor, of the basic principles of the abstract composition, rhythm, poise, and equilibrium which is inherent in human activity when the mind wholly governs the body for the fulfilment of an unselfish end.

I have produced the dreaded word 'abstract' very early on, because, as you know, I am an abstract artist by repute and it seems necessary to explain something of my approach to art before I show you the photographs of the paintings and drawings I made as a result of watching surgery.

There is, it seems to me, a very close affinity between the work and approach both of physicians and surgeons, and painters and sculptors.

In both professions we have a vocation and we cannot escape the consequences of it. The medical profession, as a whole, seeks to restore and to maintain the beauty and grace of the human mind and body; and, it seems to me, whatever illness a doctor sees before him, he never loses sight of the ideal, or state of perfection, of the human mind and body and spirit towards which he is working.

The artist, in his sphere, seeks to make concrete ideas of beauty which are spiritually affirmative, and which, if he succeeds, become a link in the long chain of human endeavour which enriches man's vitality and understanding, helping him to surmount his difficulties and gain a deeper respect for life.

The abstract artist is one who is predominantly interested in the basic principles and underlying structures of things, rather than in the particular scene or figure before him; and it was from this viewpoint that I was so deeply affected by what I saw in the operating theatre.

We are all used to deriving aesthetic pleasure from the ballet or from winter sports, from watching orchestras playing or the Olympic Games. Occasionally, all too rarely, I fear, we are stirred by the beautiful movement of men working in the fields, or by a young mother, for instance, handling her child with a primitive certainty and joyfulness.

But the rare beauty of <u>co-ordinated</u> and <u>harmonious</u> <u>unrehearsed</u> movement which takes place inside the framework of the ritual in the operating theatre is very rarely seen. Perhaps not one of you has ever been in the position, as I was, to regard it objectively and to speculate as to its meaning from the artist's point of view.

I was, I think, fortunate in being a sculptor – for a sculptor is trained to consider the <u>architecture of the human figure</u> and the outward meaning of movement; and his work makes him especially aware of the <u>inner meaning of gesture</u> and <u>expression</u>. He is trained to observe the relationship between the human figure and the space around the figure, and how the human mind reacts to <u>space and function in architecture,</u> and to observe the harmonious relationship of the human body with the designs of the hand such as instruments and tools. These are basic principles in the conception [of] sculpture.

(I shall have more to say about the hand later as it has a very special significance.) The surgeon, by his training and experience, can be the perfect designer of both the instruments he uses and the architecture he needs in his theatre, which will give him the maximum harmony for his work, and allow the greatest perception (or apprehension) of the living tissue under his fingers.

The modern operating theatre can, therefore, present a perfect example of <u>architecture for a given purpose</u> – a perfect space and setting in which figures move and work at a focal point. With all the form and colour designed aesthetically and functionally, enabling the group within this space to work in harmony together with sincerity, beauty, grace and tenderness, always aware of the unseen person, always aware of the ideal towards which they are working.

You will see, in the pictures which I am going to show you, how strongly this feeling came across to me – how it <u>formed</u> the composition of the figures and was portrayed by the eyes, the hands, and the inclination of the heads.

Of course there were a few less perfect moments: a surgeon or theatre sister slightly out of temper meant ripples of flustered movement on the outer perimeter – disturbing the entire composition momentarily. But then the ritual and training asserted itself and the whole rhythmical, unrehearsed and harmonious flow of movement went on again.

This I think helps to prove my original point – that in the operating theatre where one can observe the highest intention and purpose, one can <u>see</u>, consequently, the most perfectly attuned movements between a group of human beings.

The importance of architecture cannot be overstressed as a setting for human endeavour – There was one particularly old and ugly theatre where I was never able to get a single good drawing – it was too small for its purpose, and, finally my own reactions got the better of me and to my eternal shame

I knocked something over! I shall never forget my loathing for the hideous old gutters in the floor which were my undoing. But from the best designed and up-to-date theatres I got the maximum of inspiration and my compositions flowed with the same ease that one had encountered in the theatre itself.

In some recent architectural papers I have seen photographs of new hospital buildings and, in particular, new operating theatres here in Europe and in America which reveal the marvellous developments taking place in this consideration for form and space in relation to human activity. The influence of the medical profession can be very great on the future shape of architecture in the wider sense – influencing the health and happiness of people generally.

From all these experiences and from the paintings and drawings that I made, I learned how better to observe the world around me, and I was strengthened in my desire to work harder than before for an understanding of these values which so enhance life by their grace and goodness.

The artist is often absurdly portrayed by novelists; he is often wrongly accused of working in an 'ivory tower'. The truth is that he is an 'Observer' – he has to work alone, observing and feeling life around him so that he can allow a transmutation of his feelings to take place before he can make his ideas concrete in his chosen medium. It is his 'idea' which has to be revealed and this transposition must take place for his idea to become 'alive' and be a work of art.

Sometimes the forms that emerge are in advance of his time and cause great antagonism. Stravinsky's Rite of Spring when it was performed in Paris 30 years ago caused a riot and the composer had to be smuggled out of the hall. Now the work has become accepted everywhere and we find nothing strange in it. Cubism was regarded with horror during the First World War and now the great paintings of that time are in every big museum in the world.

I have read in the local papers recently that some forms of modern art have been denounced as 'degenerate, destructive and decadent – Teddy Boy stuff'. This is simply untrue – as untrue as if I denounced surgery as butchery. The form of beauty may be strange to us but if we lend our minds willingly to accustom ourselves to its strangeness, as a new experience, its message will reach us, and we shall be enriched by the infinite variety that beauty can take in its reinforcement of life.

I have tried to give you, in a few words, a general idea, not only of what I saw before me in the operating theatre, but, also, of my train of thought, because what I saw and what I thought had to become fused together in carrying out the paintings and drawings.

I realised of course, that it would be impossible to paint a composition after watching certain kinds of surgery. Any element of catastrophe would be

impossible for me. The paintings I am showing you are all of reconstructive work. Then there are certain operations which inspired me as an artist but which made a rather disturbing picture for the spectator – I remember drawing the magnificent hands of a surgeon doing a tonsillectomy. The whole scene was dramatic in the extreme but it was not a painting I could complete. It was a perfect example of what was seen by the artist dominating and excluding what he thought, so that a work of art did not evolve. It became too pictorial.

Having explained a little about the way I thought, and the significance the act of surgery had for me and its relation not only to its setting but also to its intention, I will show you my photographs which will, I hope, explain my ideas better than my words.[1]

Study of Heads and Hands
I was only allowed a small notebook and pen or pencil. I had to train myself to note only the most important things and to memorise the entire structure of the group which was always changing as the operation proceeded. It was from notes such as these that I made my paintings when I returned to the studio. During one operation I sometimes made 40 or 50 brief notes of this kind.

Surgeons and Hands
It was difficult at first to grasp the very intricate relationship of hands and instruments. Surgeons and theatre sisters were very kind in explaining afterwards any difficulty I encountered.

Concourse 2
From these notes I made paintings such as this one. They are all in oil, some of them quite large, and I used the colour, not in a realistic way, but in order to stress the meaning of form and light as I had seen it.

Concourse I
The arthroplasty I watched here gave an intentness to the grouping and was, as an operation, one of the best examples of the arrangement of a large group. The length of the operation gave a sense of repose which dominated the activity.

Scalpel
This one I called Scalpel. Not that the title is so important; but it induces the idea of the unseen person and the harmonious consideration which exists between the surgeons and theatre sister which I tried to portray.

[c.1953]

Prelude

This speaks for itself – The deep absorption in unselfish 'dedication' of work which impressed me very deeply.

Reconstruction

You will recognise here another 'arthroplasty' – In order to draw attention to the anaesthetist and the theatre sister I have used my licence to overemphasise forms (or what you may feel is distortion in the shoulders) so that the eye moves towards the members of the group instead of sticking in the cavity of the hip – away from the literary detail of hammer and chisel, to the active participants grouped around.

Procession

Here began a deeper preoccupation on my part with the eyes, and inclination of the heads, which reveal so much of what is going on although the object of their vision is not seen.

This is the kind of objectivity I spoke of earlier which an artist in the operating theatre is fortunate to experience in so far as he is not involved in what is actually taking place.

Trapezium

This one, called Trapezium, shows the same idea.

Concentration of hands

Again a rhythmic concentration of hands with the guardian of the unseen patient in the lower half of the painting.

Radial

Here in Radial is an even more concentrated focus of surgeons, not only in relation to their own hands, but to the work in progress, where delicacy of touch was especially apparent to the artist.

Median

And here the human hand and arm (which was being operated upon) begins to appear in the picture in this one called Median.

As I became more accustomed to the various operations I began to realise how profoundly important from an artist's point of view the expression of the human hand is. Not only is it the most revealing and expressive part of the human body – it is also the visible extension of the brain and feeling generally. In watching an operation there is simply no end to the revelations of thought and idea conveyed by the contemplation of these hands at work. And I will now show you a selection of paintings.

First – <u>Prevision</u>
This title explains my idea – the hands in relation to what is to follow – in the
operation about to take place.
I have simplified everything to throw the head and hands into prominence.

<u>The Hands</u>
Next this row of hands – a very moving moment (for me) when a
group of surgeons stood together, after discussion, before commencing
the operation.
Here to the left you see my much loved character – the theatre sister.
In her quiet stance and very tender hands I wanted to convey the whole
background of incredibly <u>intelligent</u> and devoted work which is vested
in her occupation and profession.

<u>Study of Surgeons' Hands</u>
Here are the hands related to the instruments – but the heads are very
nearly visible, I think you will agree!!

<u>Surgeon Moulding Plaster</u>
I watched many times the moulding of plaster jackets – it was very near
to my own profession and the swift shaping fascinated me.

<u>The Child's Hand</u>
This subject is, I think, one of my favourite ones. The exquisite small
child's hand – insensible and inanimate – relating itself to the very large,
but incredibly perceiving, mature hands at work on restoration is, I think,
a wonderful subject. In this picture and in the one that follows it, I wanted
to convey my feelings about the amazing structure of the inanimate hand
and arm –

<u>The Hands and Arm</u> which is the title of this painting – the arm, the
tendons of which can be manipulated whilst the spirit and mind of the
owner are temporarily absent – and the <u>living</u>, <u>seeing</u> and <u>highly intelligent</u>
hands of the surgeon which are carrying out the will and knowledge of his
brain – supported by the desire of his spirit to heal and <u>create</u>.
The colour I used in this painting was a deep blue and gold – supporting
the faintly translucent colour of the inanimate arm.

<u>Hands Operating</u>
This is quite a long painting done on a ground of rich ultramarine blue to
heighten the intense light on the <u>Hands Operating</u>. As you will see, it was a
subject which was the outcome of, and (I think), really shows the results of
months of work watching surgery.

Theatre Sister
Now to revert to the Theatre Sister.
A. Here are three studies of the drapery of a freshly donned gown and the attentive stillness of the theatre sister waiting for the surgeon. – This is a drawing in chalk and pencil.
B. This is another in oil paint and pencil on a green and blue ground.
C. And another in red conté chalk.

Conclusion
I am showing this one chiefly for the quiet figure of the theatre sister on the left. The painting is called 'Conclusion' – the operation nearly over. I wanted to convey in the theatre sister the 'continuously alert helper' behind the surgeon – I tried of course to convey my ideas of it rather than the people in particular – but portraiture has crept in and in a few of the ones to follow.

The Surgeon
You will see more of portraiture – Sir Reginald Watson-Jones, Mr. Capener and the late Mr. Garnett Passe – and certain specialised moments in the theatre. Here, you will recognise Sir Reginald. By the piercing form and movement I have tried to convey the special character – and individual force Again in this one: –

Tibia Graft
You will recognise the same figure.

Arthrodesis
In this one 'Arthrodesis' the thing which interested me was the sculptural shape made in space by this arrangement of the central figure and the three supporting surgeons – almost a shell like form.

Smith Peterson Pin
An operation which gave me intense pleasure was the 'Smith Peterson Pin' – the title of the two which follow. It appealed to me as a sculptor rather specially. This is a colour reproduction from my monograph – I am only too sad that all the others are black and white photos, because without the colour, some of the meaning is lost.

Smith Peterson Pin 2
This one was in dark sepia and ivory colour.
In this operation I was more aware of the figure of the patient – the whole thing had a feeling of magic about it!

Spiral
The fascinating movement made by hands – and the complicated movements made by the needle and thread – spiral in its essential movement – impressed a spiral form on the composition. It was very difficult for me, at first, to master it. It seemed to me a most subtle movement.

Skiagram
This was an exciting glimpse of three surgeons studying the X-rays – their faces illuminated and their united attention giving them a similarity of appearance.

H-Graft
A subject very near to a sculptor's heart and its precision much admired by me! This is a very poor photograph of the painting, unfortunately, but it gives the attentive focus of the three surgeons' eyes.[2]

Trio
I put this in to show the sculptural form of composition these figures made for me. These forms, when diagnosed, relate to my carving.

Fenestration of the Ear A
Now for the last four photographs of some paintings I did of the late Mr. Garnett Passe – showing the phases of fenestration of the ear.
You can imagine how impressed a sculptor would be by the precision and delicacy of this particular operation!
B. The long concentration, the minuteness of the work and the weight of the equipment, and the power of control behind the work, produced a very different kind of composition.
C. I was allowed to look through the microscope once!
D. The immobile figure of the assistant came to have a special meaning for me towards the end – but in this operation the movements were all known between a small highly specialised team. Before I end I would like to re-emphasise my first and main point that for me, as an artist, the privilege of watching surgery meant not only a period of very important study – but it was also an inspiration in complete harmony with what I feel to be the constructive approach to Art as a whole.

I did bring spare photographs if any of you would care to look again (the small prints for epidiascope obliterate some of the detail) and I should be glad to answer any questions.

1 The images used to accompany the lecture are reproduced in *Barbara Hepworth: The Hospital Drawings*, London 2012.
2 Ben Nicholson added 'of the painting' to the typescript.

[c.1953]

Perhaps what one wants to say is formed in childhood & the rest of one's life is spent in trying to say it? I know that all I felt during the early years of my life in Yorkshire is dynamic & constant in my life to-day. The West Riding of Yorkshire is a producer county — a land of grim & wonderful contrasts where men & women seemed to me, as a child, very tender & exceedingly strong in their belief in life. It is a county of quite extra-ordinary natural beauty & grandeur; & the contrast of this natural order with the unnatural disorder of the towns, the slag heaps, the dirt & ugliness made my respect & love for men & women all the greater. For the dignity & kindliness of colliers, mill hands, steel workers — all the people who made up that great industrial area gave me a lasting belief in the unity of man with nature — the nature of hills & dales beyond the towns. It is upon this unity that our continued existence depends.

Italy gave me quite another impression for it opened for me the wonderful realm of light — light which transforms & reveals, which intensifies the subtleties of form & contour & colour — & which imparts a richness & gaiety into the living material of stone & marble — bringing life & grace into what was, perhaps a too northern conception ~~~~. What I want to express always relates back to childhood but in finding a way to say it, Italy gave me the greatest lesson of all — for there I felt the continuity of aesthetic sensibility & was humbled by the richness of her heritage.

Here in Cornwall I have a background which links with Yorkshire in the natural shape of stone structure & fertility, & it links with Italy because of the intensity of light & colour. Here I can carve out of doors all the year round — a background for which I am grateful — for I have always

21. Manuscript of the opening text in Hepworth's 1954
Whitechapel catalogue, Tate Archive

Texts by Hepworth in the catalogue *Barbara Hepworth:*
A Retrospective Exhibition of Carvings and Drawings from 1927 to 1954,
Whitechapel Art Gallery, London, April–June 1954[1]

SECTION I 1927–1931

Perhaps what one wants to say is formed in childhood and the rest of one's life is spent in trying to say it. I know that all I felt during the early years of my life in Yorkshire is dynamic and constant in my life today. The West Riding of Yorkshire is a producer country – a land of grim and wonderful contrasts where men and women seemed to me, as a child, very tender and exceedingly strong in their belief in life. It is a country of quite extraordinary natural beauty and grandeur: and the contrast of this natural order with the unnatural disorder of the towns, the slag heaps, the dirt and ugliness, made my respect and love for men and women all the greater. For the dignity and kindliness of colliers, mill hands, steel workers – all the people who made up that great industrial area gave me a lasting belief in the unity of man with nature – the nature of hills and dales beyond the towns.

It is upon this unity that our continued existence depends.

Italy gave me quite another impression, for it opened for me the wonderful realm of light – light which transforms and reveals, which intensifies the subtleties of form and contour and colour – and which imparts a richness and gaiety into the living material of stone and marble – bringing life and grace into what was, perhaps, a too northern conception. What I want to express always relates back to childhood but in finding a way to say it, Italy gave me the greatest lesson of all – for there I felt the continuity of aesthetic sensibility and was humbled by the richness of her heritage.[2]

Here in Cornwall I have a background which links with Yorkshire in the natural shape of stone structure and fertility, and it links with Italy because of the intensity of light and colour. Here I can carve out of doors all the year round – a background for which I am grateful – for I have always been preoccupied with man's position in landscape and his relation to the structure of nature.

In sculpture there must be a complete realisation of the structure and quality of the stone or wood which is being carved. But I do not think that this alone supplies the life and vitality of sculpture. I believe that the understanding of the material and the meaning of the form being carved must be in perfect equilibrium. There are fundamental shapes which speak at all times and periods in the language of sculpture.

It is difficult to describe in words the meaning of forms because it is precisely this emotion which is conveyed by sculpture alone. Our sense of touch is a fundamental sensibility which comes into action at birth – our stereognostic sense – the ability to feel weight and form and assess its

significance. The forms which have had special meaning for me since childhood have been the standing form (which is the translation of my feeling towards the human being standing in landscape); the two forms (which is the tender relationship of one living thing beside another); and the closed form, such as the oval, spherical or pierced form (sometimes incorporating colour) which translates for me the association and meaning of gesture in landscape; in the repose of say a mother and child, or the feeling of the embrace of living things, either in nature or in the human spirit. In all these shapes the translation of what one feels about man and nature must be conveyed by the sculptor in terms of mass, inner tension and rhythm, scale in relation to our human size and the quality of surface which speaks through our hands as well as eyes.

I think that the necessary equilibrium between the material I carve and the form I want to make will always dictate an abstract interpretation in my sculpture – for there are essential stone shapes and essential wood shapes which are impossible for me to disregard. All my feeling has to be translated

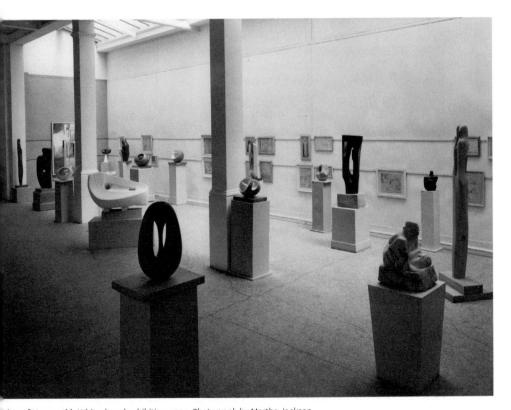

View of Hepworth's Whitechapel exhibition, 1954. Photograph by Martha Jackson

into this basic framework, for sculpture is the creation of a *real object* which relates to our human body and spirit as well as our visual appreciation of form and colour content. Therefore I am convinced that a sculptor must search with passionate intensity for the underlying principle of the organisation of mass and tension – the meaning of gesture and the structure of rhythm.

In my search for these values I like to work both realistically and abstractly. In my drawing and painting I turn from one to the other as a necessity or impulse and not because of preconceived design of action. When drawing what I see I am usually most conscious of the underlying principle of abstract form in human beings and their relationship one to the other. In making my abstract drawings I am most often aware of those human values which dominate the living structure and meaning of abstract forms.

Sculpture is the fusion of these two attitudes and I like to be free as to the degree of abstraction and realism in carving.

The dominant feeling will always be the love of humanity and nature; and the love of sculpture for itself. 1951

[. . .]

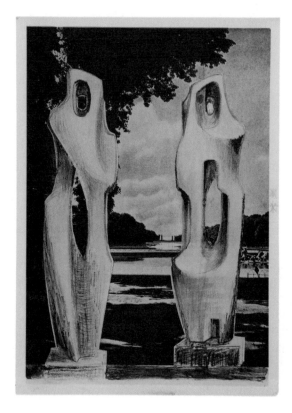

23. *Monolith (Empyrean)* 1953, Blue corrib limestone, BH 190. Photograph of a preliminary sketch montaged onto a reproduction of the gardens of the Palace of Versailles, annotated with Hepworth's asterisks marking eye level, April 1953. Photograph: Studio St Ives

24. (right) *Monolith (Empyrean)* in the garden of Trewyn Studio, St Ives, February 1954. Photograph: Studio St Ives

25. (far right) *Monolith (Empyrean)* on loan to the London County Council on the terrace outside the Royal Festival Hall, c.1954. Photograph: Photo Studios Ltd

MONOLITH (empyrean) should stand elevated in the landscape.[3] The rising forms spring from the bridged, pierced hollow which could be the bridge between the body and the mind seeking comprehension.

At this moment man seems to be a muted image, inarticulate in his environment and straining towards the understanding and realisation of outer space. Rivers and sea carve away their shapes in our planet; sun and frost, ice and heat mould our surfaces. We have deep roots; but our growth above the surface is towards an uncertain light, containing great sadness although the power to seek the light is our motivation.

Those who fly discard the earth for a while and find a poetry and vision in this freedom. The monolith is a monument to those who seek their freedom in the upper air even though it involves fire and falling earthwards.

PASTORALE:[4] Landscape directs its own images. A new form has its own life – the counterpart of man's awareness of his history and inheritance.

When we give ourselves to the summer landscape and generously surrender to the delights of abundant nature we are rewarded by a sense of freedom from care. The earth is warm and seems to yield to us; the grasses become intimate – each blade a source of sound; a single flower perceived against the sky when one's head is on the earth becomes a total world, and all the sounds of nature are transformed into a polyphony of colour and

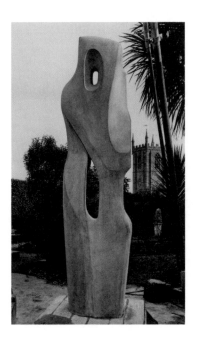
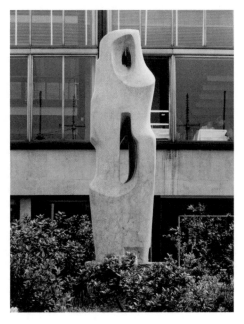

form. When this freedom quickens the spirit, and the body is supported for a while in the pastoral scene, every perception blends with those activating natural forces from which originate all forms in sculpture.

The artist needs, not only a landscape but also a society. He needs, not only a spectator but also a response from society. This is where the artist can meet his greatest danger for his need can sometimes make him seek conscious forms in either music, literature or the visual arts to gain his response. This is not a true answer because a conscious effort inevitably fails society as much as it fails the artist. All the artist can seek to do is to acknowledge his need of society and his debt to it within himself, to allow his compassion to grow: and at the same time fulfill his obligations as a human being and then have complete faith in the unconscious but logical evolution within himself of new forms which will hold the content of his imagination. These forms will evoke a response because they will be the forms which society needs. The forms will be affirmative and rich in direct ratio to contemporary vitality.

It is often stated that women's work is best when it accepts the limitation of their sex and is most feminine; but that by being feminine it has never scaled the upper reaches of achievement in art and presumably never will. This belief in the inevitable inferiority of woman's art presupposes a competitive element between the sexes. I do not believe that women are in competition with men. I believe that they have a sensibility, a perception and a contribution to make which is complementary to the masculine and which completes the total experience of life. If this is accepted, instead of feeling cheated because a woman is not a man, it becomes possible to enrich one's experience by the contemplation of a bivalent expression of idea.
February 1954

1 Extracts from *Unit 1* and *Circle*, from Hepworth's 1951 broadcast to the USA and from her contributions to the 1952 Lund Humphries monograph were also included. These have been omitted here.
2 This paragraph is largely derived from the 1952 monograph.
3 *Monolith (Empyrean)* (Blue corrib limestone, 1953) was conceived as a memorial to Hepworth's son Paul Skeaping and his navigator, who had been killed on active service with the RAF in Thailand in February 1953, and whom Hepworth would also commemorate in the painting *Two Figures (Heroes)* (Tate, 1954). She had hoped that the sculpture would be included in the London County Council's 1954 Open Air Sculpture Exhibition (correspondence with the Clerk of the LCC, London Metropolitan Archives). A preliminary sketch, made by Hepworth in April 1953 for the LCC while the sculpture was in progress, shows two aspects of it montaged onto a photograph of the gardens of the Palace of Versailles and the Apollo Fountain. This untraced sketch is known from a photograph taken for Hepworth in April 1953 (fig.23); the two forms seen in the sketch also correspond to the front and back of the completed sculpture, one of whose possible titles was then *Two Figures* (see fig.24).
 Typescripts of Hepworth's text are in her papers (Tate Archive). An early version continued after 'falling earthwards': 'to the feet to those who cannot share in their aspiration'.
 Following the closure of her Whitechapel exhibition at which the sculpture was first exhibited, Hepworth lent *Monolith* to the London County Council to be sited on the South Bank, on the terrace outside the Royal Festival Hall (fig.25). In 1959 the sculpture was acquired from Hepworth by the LCC and in 1961 it was moved from the South Bank to the grounds of Kenwood House, where it remains today.
4 *Pastorale*, 1953, Seravezza marble, BH 192.

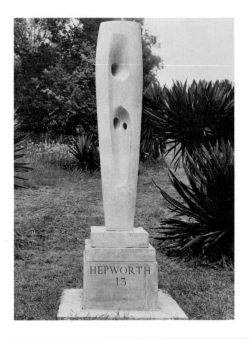

26. *Image* 1951–2,
Hoptonwood stone, ʙʜ 173,
at the London County Council
open air sculpture exhibition,
Holland Park, 1954

Text on the sculpture *Image* (1951–2, Hoptonwood stone, ʙʜ 173, fig.26) in the exhibition catalogue *Sculpture in the Open Air: London County Council Third International Exhibition of Sculpture*, Holland Park, London, May–September 1954

All landscape demands a figure. When a sculptor is the spectator he is aware that every landscape evokes a special image.

In creating this image the artist tries to find a synthesis of his own experience and the quality of the landscape. In this way the forms and piercings, the weight and poise of the sculpture also become evocative – a fusion of human experience and myth.

'Epidaurus', written in Greece in August 1954, unpublished manuscript (Dunluce notebook)[1]

Epidaurus – the greatest man-made concavity I have seen
Great in its perfection & power of form. I moved about getting a sense of position
stage actor spectator – climbed eventually to the furthest oblique high position / oblique? Perhaps the sculpture's essential view? I was alone. Above the wind was sighing across the upper circumference, within the great hollow form total silence – Kitto spoke from the arena – quietly – supremely the absolute essence of the words & voice.[2] This was <u>hearing</u> in its true sense below the vast concavity was arrested & held first by the horizontal with its verticals

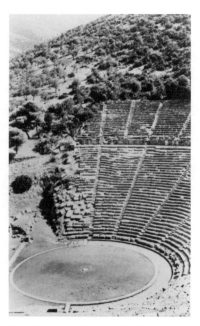

27. Cover of Dunluce notebook by Ben Nicholson, Christmas 1940, Tate Archive

28. Postcard of the Theatre at Epidaurus from Hepworth's collection

& then by the human figure – a figure without a face but a supreme voice like the voice of God in the Bible. The Greek <u>mask</u> alas only in imagination – there was to be a performance that night but we were whisked away the boat could not alter its timings.

I'm being antisocial – I can't help it – friends dear friends I try to escape all contact & proper human obligations. First off the boat alone, first on the site alone, escaping the lecture the arranged plan. I try to behave I can't I won't. I have waited 30 yrs to see Greece[.] How can I be in a state of perception, walk these paths hear with my eyes & feel with my ears & think with hands with 200 1954 English figures round me. The proper corrective exists already, everywhere the taxis which brought us have their radios on. I am in this 20th Century but this is Greece & in these few days I must know & find & hold all these essentials. Alas I know too little of history no dates & few facts would be nice to know – but not here! The quality of touch through feet hands cheek, the rhythm of movement, the temperature of marble, the worn path leading to somewhere & the space, volume rhythm weight & substance of sculpture temple or palace have a meaning which I must find & hold in these brief hours and silent exultant pleasure. I must be antisocial – Each morning at dawn we now arrive at some new island

1 Written in a decorated notebook made by Ben Nicholson and given to Hepworth at Christmas 1940. Nicholson inscribed it with the name of the house they were then living in, Dunluce, St Ives.
2 The historian of Greece, H.D.F. Kitto. Among his books was *The Greeks* (1951, Penguin Books), which Hepworth owned in the 1957 edition.

'Greek Diary: 1954–1964' in J.P. Hodin, *European Critic: Essays by Various Hands Contributed in Honour of his Sixtieth Birthday*, edited by Water Kern, London 1965[1]

I dedicate these notes to Paul Hodin with love and every good wish on his sixtieth birthday.

He has always understood what the visit to Greece meant to me a whole decade ago, and these notes written round the edge of my sketch-book in 1954 are a tribute to his perception, and an appreciation of his great contribution to the art and aesthetic of our century.

26.10.64.

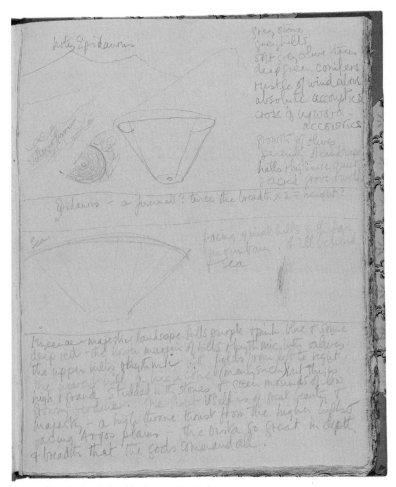

29. Page from the Greek Sketchbook, 1954, Tate Archive

COLOURS
Indigo sea which when light reflects from cliffs, becomes
pure cerulean.
Th[eir] indian red and pink hills – monastral purple mountains
at sunset which intensifies the greens to the wildest
vitality.

The Acropolis – the spaces between the columns – the depth
of flutings to touch – the breadth, weight and volume –
the magnificence of a single marble bole up-ended.
The passionate warm colour of the marble and all-pervading
philosophic proportion and space.

25.8.54.

NAUPLION – a serene and lovely port.

EPIDAURUS[2]
Olive, hill and figures
and the quality of sound.
Grey stone[s]
grey hills
Soft grey olive trees – deep green conifers – rustle of
the wind above.
Absolute acoustics
Cross and upwards acoustics
Growth of olives
Serenity of landscape
Sacred grove and well.

Epidaurus – a funnel? twice the breadth x 2 = height?

Facing quiet hills with far mountain
Hill behind [and] sea.

MYCENAE – rhythmic movement of mountains.
The Royal Tombs – a vast ellipse (pit) of stones on stones.

Majestic landscape, hills purple and pink, blue and some deep red –
the lower margin of hills rhythmic with olives; the upper hills
rhythmic with folds from left to right.

The nearest hill a high cone (many such) but this is high and
grand. Studded with stones and green mounds of low growing
verdure.

30. Pages from the Greek Sketchbook, 1954, Tate Archive

The site itself is of great beauty and majesty – a high throne thrust from the higher hills and facing Argos Plains – the vista so great in depth and breadth that the gods command all.

The view back through the Lion's Gate – the grandeur of the Royal Tomb looking towards the mountains with Argos on the left – the Treasury of Atreus and its noble proportion – the beehive within – the great curved supporting stone and the use of the triangle.
Only sign of growth, tobacco and olives – the corn gathered in April.

All the landscape forms of Greece tend to elevate the human figure – column and Koré are inevitable.

26.8.54.

CRETE
A similar landscape on approach, but more joyous in detail – Knossos (with plumbago in flower spilling over stone and marble – the deepest of deep blue convolvulus – Morning Glory?)

Knossos and its intimate proportion – its sturdy gay pillars and colour. The heavenly stone – grey striped marble –

grey stone sedimentary – sparkling quartz and the luminosity
of blocks of white mica.

Too hot to prowl like a cat above the shadowy rooms below,
where cool stone and human-sized baths and great urns abound.

But in the *museum* the gaiety of forms is paramount – an art
of non-aggression and even non-philosophical. The first room
had two magnificent cases of Cycladic figures –

first figure torso[s] in black terracotta bull's head

The Neolithic case had some wonderful figures, many very tiny –
many showing the first forms of figures [in] B.M.

two little pebbles flattened in front to create the female form.

early terracotta (Cretan)
with hands on stomach
and breasts sprouting.

<div align="right">27.8.54.</div>

RHODES
Bougainvilia in showers
Old town very strange
Three lovely windmills on the harbour.

<div align="right">28.8.54.</div>

PATMOS
a beautiful gay port.

a sublime summit upon
which the monastery towers
above the islands and water.

Rode up on a donkey – an incredible ascent revealing an unbelievable
panorama of indigo sea and deeply sculptured islands – Turkey
lying far on the horizon in mist – purple and brown with little
crowns of cloud round the summits.
Within the monastery the brilliance of white-washed architecture
(enclosed) and reaching skywards, with small cells and apertures,
filled with flowering plants of brilliance and the black-clothed
black long-haired and bearded monks with strangely feminine
countenances standing in every alcove was indeed a unique
experience. Coming down by foot (the people gayer and more
friendly than I'd seen) we called at the cave of St John
the Divine. Again all was white-washed – including the tiles
on top of the dome covering the cave.

COS

Authentic harbour – after Rhodes the authenticity (and identity
persisting in spite of invasion) was a joy. Small boats and
craft in a large semi-circular harbour edged with citrous trees
and eucalyptus. We walked towards the gardens where the tree,
a great plane of gigantic girth, is reported to have given shade
to Hippocrates. From there we went by bus (2 km?) through
lovely pastoral country – (Theocritus) to the Asclepeion – a
site too much restored by the Italians – but the immense three
tiers of the immense architectural space, approached by heavenly
trees at the base, lead to a view at the summit of very great
beauty. The country was idyllic – the people gay – (even under
a stone's shade in the Asclepeion two small boys in bleached
purple shifts – one naked but for his shift, gambolled with
gentle smiles).
Under the box-like cottages, with their sun protection of wattles,
the people were eating – a young calf, a goat and one sheep tethered
nearby under the shade of a citrous tree.

When returning to the habour we sat in the port's square – in
the centre of which were four fine olive trees round a delicious
simple fountain painted in white and prussian blue.

<div align="right">29.8.54.</div>

31. Page from the Greek
Sketchbook, 1954, Tate Archive

DELOS

Ascended Kynthos alone, the cave of Apollo – half-way magnificent and majestic. A pool with fine fig trees nearby full of giant (sacred?) toads – leaping and barking. Also green frogs.

Went on alone up the last steep ascent but the wind was angry – ferocious. I fell, my hair was nearly whisked off my head – my clothes nearly torn off me. I bowed to the will of the gods and descended.

Saw a magnificent Koros – tall, fierce and passionate bigger than life size – in the Museum. A heavenly work – the back and buttocks in relation to the hip and waist – an inspiration. I thought the fragment of leg and calf (attached below the knee) was falsely attributed. Fine Minoan ivories – especially the warrior with double shield.

Delos was perturbed – an angry wind – making it difficult to return to Miaoulis.

A flower of Santorin Island or Phira the town.[3]

The indescribable beauty of Santorin and the height, breadth and depth and colour of Phira on the peak of the crater's lip is not possible to take in from any phtotograph.

At dawn we arrived at the base of Santorin tied to the buoy in the water filling the deep crater – the quite incredible white bright light on Phira – 1200 ft. up in the air at the top of the crisscross mule track was almost visionary. Behind us lay the erupting and menacing little island of Quinica.

I went up alone on a very docile and friendly donkey. The people at the top were gay welcoming and enchanting. To look out over the sea to Asia Minor and Turkey with all the intervening islands was breathtaking – not a word could describe the sense of space, air and colour – or describe the 'lightness' of this celestial view of earth and heaven.

Sunny terraced fertile slopes of vineyards.

The colours of the volcanic rocks and pumice beyond belief – the whiteness 'whiter than white'.

Six lovely Archaic 7th Century sculptures. Parts of Kore and Koros. Fine marble and great scale.

Phira museum – wonderful early (2) white square figures Archaic and Cycladic.

Poros – famous for its lemon groves and the great mountain of the 'Sleeping Woman'.

We passed Hydra – unable to land for the NE gale. All the people, guns and flags were ready – birthplace of Miaoulis.

Poros – 'Sleeping Woman'
name of huge mountain. The tone of the pink tip of highest peak the same as the tone of the sky.

Hills of Aegina

<div align="right">31.8.54</div>

<div align="right">*October 1964*</div>

DELPHI

Perhaps I did not write in my notebook about Delphi because it meant so much to me. On a fair and glorious morning I managed to escape some 400 people and ascend the hill alone and in silence.

I also managed to descend alone. All very antisocial; but fantastically important to my work.

The forms, the mountains, the valleys – the colour and silence, were such a part of my life that even now, a whole decade later, I can scarcely speak of the experience. It is deeply part of my work.

32. Photograph of Hepworth at Delphi, August 1954

Standing alone in the stadium, alone below Olympus, I felt at ease both physically and spiritually.

This experience of being part of Mount Olympus, part of the plain of Itea and totally alone, did perhaps justify my existence.

To describe the day would dissipate the visual memory. Instead I hold it secretly to sustain me.

1 Hepworth's Greek Sketchbook of 1954 (figs 29–31 and endpapers) was the source of this Diary, contributed for Hodin's festschrift at his request. It was important to Hepworth that the text should be set out typographically as a poem, as it had been in the Sketchbook (letters to Ruth Zollschan, the Secretary for the festschrift, 26 and 29 October 1964, TGA 965/2/17/52). The Sketchbook incorporates drawings (largely in pencil and many drawn on coloured washes) alongside the writings. The published version of the text has been used here, with its additional piece on Delphi at the end. Several amendments have been made, indicated in square brackets, following the original text.

2 Cf. the text 'Epidaurus', written in the Dunluce notebook during the Greek voyage in August 1954 (see pp.99–100).

3 Between the pages of the Sketchbook are pressed flowers, leaves and plants.

'Barbara Hepworth asks, "Have you read . . .?" *The Story of an African Farm*, by Olive Schreiner', *News Chronicle*, London, 1 December 1955

I first read *The Story of an African Farm* in my early thirties, and the book moved me very deeply by its unusual beauty. I was amazed that this novel, written between 1875 and 1879, should seem so contemporary in form and spirit.

For, with humility and tenderness, Olive Schreiner describes the ever-changing adjustment between the factual world and the inner world which has to find integration if the personality, or soul, is to continue its growth.

The personality may be her own, but, nevertheless, by use of poetic imagery Olive Schreiner describes something we all share.

When she wrote this novel, Olive Schreiner was very young and almost alone in a sparsely populated region of Africa and yet by the simple and vivid observation of the landscape around her, she evokes the magical beauty of all Nature; and by her extraordinary perception of human gesture in relation to the exterior world she is able to describe the delicate balance between *seeing and feeling* and *doing and thinking* which maintains our growth.

Out of the microscosm she paints for us our common experience. 'The flat plain has been to us a monotonous red. We look at it, and every handful of sand starts into life.'

'Towards an <u>Open</u> Architecture', response to a UNESCO questionnaire on contemporary relationships between painting, sculpture and architecture, 1955, unpublished manuscript[1]

Jerome Mellquist
Hôtel Paris-Dinard
29, rue Cassette
Paris (VI), FRANCE

Questionnaire

LES RAPPORTS CONTEMPORAINS ENTRE LA PEINTURE,
LA SCULPTURE ET L'ARCHITECTURE

UNESCO
'Cahiers d'Histoires Mondiales'

INTERNATIONAL COMMISSION FOR A HISTORY OF THE SCIENTIFIC
AND CULTURAL HISTORY OF MANKIND

1. Quels furent, dans l'immédiat après-guerre (1920), les rapports entre la peinture, la sculpture et l'architecture?

 What was the relationship between ptg, sculpture & architecture immediately after the war (1920)?

2. Doit-on considérer l'effort fait alors vers la simplicité et le dépouillement comme une réaction contre l'art appliqué du commencement du siècle? Si non, quel sens lui donner?

 Should one consider the effort made towards simplicity & 'dépouillement' as a reaction against the applied art of the beginning of this century? If not, then what explanation would you give?

3. Quand se situe, selon vous, la fin de la période des murs blancs et des espaces vides qui avait éliminé la peinture et la sculpture de l'architecture?

 At what point, according to you, will the period of white walls & empty spaces which has eliminated painting & sculpture from architecture come to an end?

4. Où en est l'architecture d'aujourd'hui quant à la collaboration entre ces trois arts?

 Where is architecture today so far as collaboration between the three arts is concerned?

Towards an <u>Open</u> Architecture

1. From what I remember of my student days beginning in 1920 we were already discussing the possibilities of a new architecture & we worked with a conviction that the revolt against the destructive results of an inferior architecture decorated by pretentious sculptures & murals would be enough in itself to lead inevitably to the smooth evolution of a new culture. We had no conception then that collaboration between architects & artists would be so difficult to achieve nor that the reason for the revolt would in due course lead architecture to turn its back on much of the best of contemporary art & thereby deprive itself of what should be the normal poetry of living. The new forms of painting & sculpture were not understood & the few instances where they were accepted by architects the sculpture was applied in the old indulgent way against which the actual forms of the sculpture were in full revolt. It was not until the early 1930's that a desire for understanding & collaboration began to show signs of manifesting itself & this was
more fully awakened by the arrival in England of many pioneers from the Continent in both architecture & the arts. The discussions & hopes for the future brought about a new sense of shared 'vision' which gave a sense of equilibrium & strength. This hope for the future was short lived owing to the imminence of war.

2. I think only a part of 'the effort made towards simplicity & "dépouillement"' was due to reaction against ~~the pretensions~~ of applied art, & for this part we were all responsible, artist & architects alike. But for the other part ~~I feel~~ that the architects were <u>alone</u> responsible because I feel they had a complete misunderstanding of the basic functions of the arts & their relation to & share in a living architecture.

 In this sense the applied art of the early part of the century can not be held responsible. The real responsibility lay in the general materialistic outlook which had slowly disintegrated society & sapped its creativeness & its organic wholeness.

 Sculpture for instance is not a mere adornment to an architecture.
 It exists as a totally separate & vitally necessary experience. It should never be a decoration – if it <u>is</u>, it isn't sculpture.
 At that time, sensing this awkward reality, it was easier for the architects to steal colour from the painters & forms from the sculptors which they used to fill all the gaps which this new simplicity presented.
 The result was a <u>closed</u> architecture. A filled box which, with its incorporated colour & furniture & streamlined decoration tended, not only to inhibit all <u>development</u> of collaboration with the artists – but to smother the human inhabitant with a 'fait accompli' which denied him pleasure in, or access to, the aesthetic delight & nourishment of a growing culture.

3. I consider at this moment there is a discernible break with this almost
 obsessional interest in a closed unit, & we are moving towards an <u>open</u>
 architecture. This is true in particular of the youngest generation of
 architects who, not being inhibited by the mistakes of the 1920's &
 1930's, & shaken into more active thinking by the threat to civilization
 itself, are now developing a more 'humanist' & romantic conception
 of life. But I would not agree with the phrasing in this question no 3 of
 'empty spaces'. In my opinion there have not been any 'empty spaces'!
 Space is an active, & tangibly appreciated, dynamic – it is a reality asking
 for the relationship of the human figure or sculpture to perpetuate its
 dynamic. What we have had, & suffered from, have been blank spaces &
 empty surfaces. So ill conceived as spatial reality that even when colour
 or sculpture have been superimposed they have still remained blank
 surfaces, a spiritual vacuum which has slowed down our evolution. Form
 & space play upon each other & neither functions without the perfection
 of the other – they are active elements expressing vigour of action &
 vigour of response.
 Without space, in its true & active meaning, there can be no appreciation
 of sculpture & of its meaning – and sculpture (which is, perhaps, only
 fully appreciated by a mere handful of people) is a dynamic experience
 which is unobtainable from any other source in life.

4. We are again on the threshold of an understanding. Now is the moment
 for us all to collaborate in an open architecture which will lead to the
 imaginative siting of sculpture and the inspired & free inset of painting
 which will provoke a response in the beholder & animate our society.
 Catering for the material well being of people is simply not enough.
 People do not become affirmative by material comforts alone. There
 has been, on the part of architects, too timid a realisation of the true
 nature of the collaboration needed to free the imagination & allow the
 growth of social integration.

 When one considers the wealth of new materials, the freedom which
 modern engineering structure gives to form & space & the exciting,
 imaginative potential of these forces, it is a poor register of our vitality
 that such conservative use has been made of these materials & media
 of our time. It would be wrong however to blame only the architect. All
 of us, architects, engineers, planners, painters, sculptors & designers
 have lived through a tremendous period of discovery, of experiment & of
 revolution. Each one of us must shoulder his share of the responsibility
 for the lack of conviction which prevents a real state of activity taking
 place. We have the architects & we have the artists; but we have not had
 the conviction to work together towards a common end & now is the
 moment for a tremendous affirmative action.
 I do not myself believe that the solution will be in the sculptors &
 painters becoming absorbed by the architect & into the architecture,

thereby producing a new artist, a conglomerate of, & a growth out of, all three. I believe on the contrary that once we all recognise the spiritual & the aesthetic basic needs of human beings generally, we will recognise the specific part we must each play in the whole pattern. In this way the artist will come to understand architecture, the architect to understand painting & sculpture – each will then rise above his personal, & lonely, concept, and a new style will emerge & release our energies towards imaginative forms which will satisfy the needs of our society.

An architecture which seeks to satisfy human beings by adding colour & some form without incorporating the sculptor & painter does, in my opinion, literally strangle the perceptions of human beings, the very perceptions which make it possible to have an architecture worthy of the name. Human beings, in spite of all our science & all our knowledge, still remain much the same throughout the centuries in their needs, their hopes, fears & aspirations – and it is these same human elements we must satisfy by the new forms we have to evolve in our time.

It is not possible to force a pattern of living on to a people with any good result. The pattern which must evolve must spring from within & be the sum total of all our specialised endeavours, pooled, shared, & digested until the nourishment obtained gives us the strength & vitality to seize on the image which will make us a living spontaneous people, spiritually affirmative & aesthetically aware of the principles of life.

Paintings & sculptures as such may change their form entirely. But painting & sculpture as activities will always remain. They are dynamic activities of living. In the artist they reach the ultimate form in unconsciously registering the balancing forces required by his time & society for spiritual growth – this activates the non-artist to exercise his sensibilities towards creative living – in selecting, choosing, arranging, changing his environment; in his home, his dress, his work & his leisure so that he exists in a state of grace.

When we recognise our interdependence more fully I think we will achieve the open forms which will not only permit each man & woman to live freely & exercise his rights as a free man, but will also permit the fullest flowering of the artist's imagination towards an exuberant & vital poetry of expression which will be praise of living instead of a protest. We must seize this moment, for only the most generous & comprehensive actions in all fields can save our civilisation trembling on the brink of its own extermination.

1 The English translations of the French questions are in Ben Nicholson's hand (Hepworth's French was limited). Mellquist (1905–1963) was an American art historian and critic who worked for UNESCO in the 1950s. Nicholson's own response to the questionnaire is in the Tate Archive (TGA 8717/3/1/10 and 29). The questionnaire was part of an International Commission to produce a wildly ambitious history of human culture, an idea that was initiated at UNESCO in the later 1940s by Julian Huxley. See Christopher E.M. Pearson, *Designing UNESCO: Art, Architecture and International Politics at Mid-Century*, Farnham, Surrey, and Burlington, VT, 2010, pp.48–9, 65.

[1955]

Letter to *The Times* on the Hydrogen Bomb, 24 January 1956, unpublished typescripts[1]

Jan 24th 1956

To the Editor of *The Times*

Sir – The recent letters concerning the Hydrogen Bomb have given a sense of renewed courage – for, in the face of recent pronouncements in the Press, the absence of letters has seemed to indicate a moral apathy concerning a subject which must occupy the deepest recesses of all our minds. In my opinion, neither reason nor expediency can ever supply the total answer. Only a courageous moral decision can provide the necessary affirmative action which will allow our civilisation to grow and progress towards a beneficent culture.

To make, to test and to uphold the manufacture of the Hydrogen Bomb is against the growth of the spirit and moral sensibility of man, as well as against the growth of <u>grace</u> and all the Arts which affirm both man's love of life as well as his love for his neighbour.

To refuse at this point to assist any further with the development of the Hydrogen Bomb would not only (as the Bishop of Exeter pointed out) be a moral challenge to all men, but it would also force us to put constructive actions in the place of destructive actions. A negative state of mind is a destructive state of mind. A vacuum never exists – to refuse to be destructive forces us to supply a constructive answer.

To forswear the Hydrogen Bomb means filling the vacuum with deliberate and constructive action. This would lead to a deeper respect for life. To remain inert in this matter, or to argue over expediency, is to disbelieve in the power of good, and the moral courage generated by affirmative action. The Bishops of Chichester and Exeter have given us a lead. Our daily prayer should be that all of us face, as individuals, the situation and test our spiritual courage by relying on the power of good.

We have brought ourselves to this penultimate plight. Not to act now is spiritual suicide.

Yours faithfully,

BH
St Ives C

1 Cf. the September 1961 statement drawn up by Hepworth (pp.149–51).

Statement in *Témoignages pour la Sculpture Abstraite: Arp, Bloc, Descombin, Gilioli, Hepworth, Jacobsen, Lardera, Schnabel, Schöffer, Lippold, de Rivera, David Smith*, with a text by Pierre Guéguen, Paris 1956.[1] Typescript of English original in Tate Archive

Contemporary abstract art is affirmative and young – it is 'forward' looking – and such a natural and universal language that it is difficult to imagine anything other than a strong unfolding in the future. The abstract of our time contains the seed of true understanding which could exist between country and country, between man and man. The forms and colours (new to the world) stand firm in the face of the threat of world suicide.

This art is young and affirmative – offering freedom of expression and universal understanding to all men.

1 Hepworth's published text reads: 'L'art abstrait contemporain est affirmatif et jeune. Il regard "en avant", et c'est un langage si naturel et universel qu'il est difficile d'imaginer autre chose que son puissant développement dans l'avenir. L'art abstrait de notre temps contient le germe de la vraie comprehension qui pourrait exister de pays à pays et d'homme à homme. Les formes et les couleurs inédites font face fermement à la menace d'un suicide universel.'

Text on the sculpture *Curved Form (Trevalgan)* (1956, bronze, BH 213) in the exhibition catalogue *Sculpture 1850–1950*, organised by the London County Council, Holland Park, London, May–September 1957[1]

Curved Form (Trevalgan)

This 'Curved Form' was conceived standing on the hill called Trevalgan between St Ives and Zennor where the land of Cornwall ends and the cliffs divide as they touch the sea facing west.
At this point, facing the setting sun across the Atlantic, where sky and sea blend with hills and rocks, the forms seem to enfold the watcher and lift him towards the sky.

Dec 1956

1 The LCC invited artists to submit 'short accounts of how their pieces came to be devised, the salient themes and so on' for the exhibition catalogue (7 December 1956, LCC Parks [Special Entertainments] Committee, London Metropolitan Archives). Hepworth sent her text in manuscript with a letter to the Clerk of the LCC on 12 January 1957 (LMA). Another manuscript (carbon copy) is in her papers (reproduced in *A Pictorial Autobiography*, p.75).

33. *Curved Form (Trevalgan)*, BH 213, at the London County Council exhibition, Holland Park, 1957. Photograph: Ronald A. Chapman

34. Installation photograph showing *Hollow Form (Penwith)* BH 202 (foreground) in the exhibition *Barbara Hepworth, Ben Nicholson* at the Hatton Gallery, Newcastle, November–December 1956

Poem in the exhibition catalogue *Statements: A Review of British Abstract Art in 1956*, Institute of Contemporary Arts, London, January–February 1957[1]

You are I and I am the landscape.
I am <u>hollow form</u> and the form is time.
Penwith is all of us; it has shape and smell and sound.
The history envelops us;
the shape flows
enfolding time.

Who touches the soil and who smells the wood? Who lies
on crest or sits in hollow?
Who is the form?
And what is Penwith?
And why does man need a cave?

The birds smell the music
and foxes sing in flight.
The grasses taste the water and
the fragrance dances in the sun.

Within the hollow palm of this physical world
we touch our primitive image.
We contemplate our roots.

<div align="center">Jan 2nd 1957</div>

1 Hepworth exhibited *Hollow Form (Penwith)* 1955–6, Lagoswood, BH 202 (fig.34).

Text on the sculpture *Image* (1951–2, Hoptonwood stone, BH 173, fig.26) in the exhibition catalogue *Contemporary British Sculpture*, An Open Air Exhibition arranged by the Arts Council of Great Britain, at Leamington Spa, Shrewsbury Festival and Cardiff, May–August 1958

When I visited Greece and the islands of the Aegean I was greatly moved by the extraordinary power of the <u>vertical</u> in a landscape which was surrounded by the curved horizon of the sea. In the similar clear brilliant light of West Penwith – this last twenty miles of England thrusting out into the Atlantic, and enclosed by sea on three sides – the vertical power of a human figure is

similarly accentuated. In this pure light the solitary human figure, standing on hill or cliff, sand or rock, becomes a strong column, a thrust out of the land, as strong as the rock itself and powerfully rooted; but the impression overall is one of growth and expansion, a rising form which reaches outwards and upwards, an image, or symbol of the span of time. This is my own reaction to the effect of light and space on a figure seen in West Penwith in Cornwall.

Contribution to 'Why Cornwall?', *Monitor*, BBC TV, broadcast 14 September 1958[1]

I came, actually, accidentally, that is, I came for a holiday and I stayed, but as soon as I got here I began to realise very very swiftly why it was there had been artists working here for 75, 80 years. There are so many qualities here which I think are very strong and dynamic and very English and yet unenglish, cosmopolitan and alive qualities in so far as the community functions as a community and one can understand it and that seems to me to be a very important part of an artist's life.[2]

(Alternative recording, not broadcast)

Living here for 20 years has given me real insight as to why the artists have loved living and working here in St Ives for about 80 years or even longer.

Surrounded by sea on three sides, as we are in West Penwith, the wind is always changing, the weather forming, as the wind across the Atlantic meets the land, and the important thing every morning is to assess the day's weather and think about the light. People often think that light is a kind of a chocolate, beautiful and precious thing which one can enjoy. But it's not really that at all: it's a very hard master and teacher. So often one is satisfied with forms and textures on a grey day, and then when the full sun and clear brilliance – which we have very often here – when it arrives and you look at the forms, they don't seem strong enough or pure or strong and tight enough and one has to work to intensify and release the forms.

I have found this particularly interesting because, learning carving as I did out in Italy, I began very early to consider the forms in relation to the sun. Coming from the grey – what seemed to me very grey – light of Yorkshire, it was a revelation working in the Mediterranean as a student. And here, in St Ives, I appreciate every moment of the brilliance and clarity for the forms, for the space that one wants to make, within the forms and through the forms.

And again here, in West Penwith, there is a great similarity with the light and quality which I appreciated when I was out in Greece and in the Aegean. One thing struck me very forcibly when I was there, and that was the emphasis of the human figure in the landscape, or related to the sea. And here I have found so often that that very same emphasis – the human figure standing out on the rocks – assumes a great vertical proportion of direct importance historically and humanly, or, as one might well be the figure oneself, recumbent in the landscape or walking over the forms of the hills, one begins to contemplate the human form in relation to sculpture, which perhaps sounds odd, coming from one who, as I do, carves chiefly abstract forms. But the inspiration always comes either from the artist in the landscape, feeling it, becoming it, or the spectator observing the figure in the landscape. And these qualities, I think, are of profound importance to the sculptor.

1 Other contributors to the programme included Bernard Leach, Peter Lanyon, Bryan Wynter and W.S. Graham.
2 Typescript in Tate Archive.

Unpublished text on new developments in art and society, 1958, manuscript and typescripts

During the last fifty years an international 'language' has been forged in the realm of aesthetics. The new forms in painting and sculpture are capable, in my opinion, of infinite development and extension for the artist because they are the result of man's increasing awareness of the fundamental truths concerning the universe which are being discovered with the greatest rapidity during this century.

If the new forms appear strange it is because an entirely new concept of life is being revealed in which the artist, no less than the scientist or philosopher, is playing a part; and the greatest problem for the artist to-day is, I feel, to find a way to keep absolute integrity in his work whilst at the same time learning to accept his full responsibility in society.

At this very moment we face the most momentous decisions in the history of man. We have invented the means to destroy this planet and have forced ourselves to face a total issue. It is now, therefore, that we must decide to abandon forever the old concept of power, war and destruction, and to accept in its place the real vision of constructive harmony between all men. This decision will require of us an absolute dedication to allow a peaceful world to develop.

The major opportunity for the artist is, I believe, to 'declare' himself and act in society with the fullest responsibility whilst maintaining his aesthetic integrity.

The creative act should always be an <u>affirmation</u> of life, and the art of the 20th century is an affirmation of this pulse of growth and vitality in all the new manifestations of science and thought of our time, and I believe that we are on the threshold of a great extension of the creative idea in the arts; but in order to achieve this new freedom, the artist must abandon not only the 'ivory tower' but also resist every temptation to reach 'down' to the public. The apparent time-lag between the conception of an idea and the general understanding of it is always bridged when there is a complete integrity of idea. Art is not an escape from reality either for the artist or the public – nor can it be anything other than its own nature. The nature of art is <u>absolute</u> within itself; but it depends upon all other structures in society as much as it nourishes all other structures in life.

Interview by Margaret Tims, 'A Sculptor's Philosophy: A PN profile of Barbara Hepworth', *Peace News*, **London, 16 January 1959**

The sculptor's philosophy can never be adequately expressed in words: it must be experienced through the body of the work. But the sculptor, like other human beings, has ideas about the social significance of art, about man in the universe, and about peace and war, that can usefully be discussed in a wider context.

Barbara Hepworth, as a leading contemporary sculptor who is also an avowed pacifist, is particularly concerned with these relationships. The philosophical process, as she describes it, goes something like this: Creative work is the manifestation of faith in life, as faith in life is the end-product of creative work. Through the patient sifting of forms, the basic principles of life and growth are discovered. From the discovery of these basic principles comes the conclusion that pacifism is integral to the future of human existence.

Women and H-bombs

In discussing her work, however, she stresses that the creative impulse cannot be rationalised, and it would be misleading to try. It can only be said that the 'idea' of a composition grows out of the form; or, put another way, the form gives life to the idea that has hitherto been latent.

It was thus that she came to declare her pacifism, which she feels has always been latent but which has only comparatively recently emerged. In the pure sense, her work is its own declaration. But now, she says, 'time is so short that one must declare oneself outside one's work'.

A sponsor of the Campaign for Nuclear Disarmament, she is passionately opposed to nuclear weapons as the ultimate, evil consequence of 2,000 years

of deviation from Christian principles. Her own conviction is not specifically Christian, although it springs from a basically religious reverence for the whole structure of life.

She is concerned here not only as an artist but as a mother. The son of her first marriage, to John Skeaping, was killed in the RAF; from her second marriage, to Ben Nicholson, triplets were born. 'How can any woman support the manufacture or testing of the H-bomb?' she asks. 'It can only be that they are not yet fully emancipated and still cling to traditional ways of thinking.'

Art as a corrective

Unlike some lesser artists, Barbara Hepworth has never been content merely to reflect the prevailing moods and tensions. At all cost she has maintained an affirmation of living values. And the cost, one may suppose, has been great: no less than the assimilation of a world in chaos and its re-creation in meaningful forms. This is not, she insists, 'idealism', but the deepest kind of realism, since the natural processes of man and his environment are quite different from the artificially-imposed social forces of destruction.

To express the truth about human nature demands whole-hearted concentration and absolute integrity from the artist. And when this truth is represented in visible and tangible forms it must inevitably bring a right reaction from the people to whom it is shown.

It is therefore an important function of art, she believes, to act as a corrective to propaganda. It is a measuring-rod by which people can train themselves not to be bamboozled. Without art there can be no standard of values.

Materialism

Perhaps for this reason the State has been a parsimonious patron of the arts. Many local authorities are unwilling to spend even the authorised portion of the rates on works of art. What have we to show for this century, the most exciting in history, she asks. Only the mis-spending of astronomical sums that could have raised basic standards everywhere, which in turn would generate a great revival of culture.

The obsession with material possessions, which present Western policy encourages, she regards as utterly immoral. 'It is a bone thrown to the dog to stop him wanting the real thing and lull him into going on in the same wrong way.'

But Barbara Hepworth is too positive an artist to be a pessimist. After all, she observes, it isn't natural to commit suicide. At a time of change, the world is as full of hope as of despair. The change may well come by the personal decision of the individual to reaffirm a faith in life.

Personal and abstract

The last twelve months have shown a great increase in general awareness, and the ideal of world community has become the common aspiration of humanity. This trend towards internationalism cannot be reversed in the modern world: for the first time in history the universal language of art has been made a reality.

It is because she speaks a universal language that Barbara Hepworth uses 'abstract' forms. This does not mean that they are impersonal. On the contrary, she suggests that the personal calligraphy of the artist is stronger, because his vision is freed from conventional representational concepts, in abstract work. It is a direct fusion of the personal with the universal.

'Through these forms,' she says, 'we can express all the valid human emotions: there is no limit to the variety of forms and no barrier to understanding.' The resources of modern science have also contributed to this medium: she can draw on materials, of metal, wood and stone, from Aberdeen to Africa. Her current work is a bronze composition for a new building in London.[1]

35. Hepworth's Labour Party membership card for 1960

Artist as citizen

Although the impulse of the artist has nothing to do with creed or country or politics, Barbara Hepworth feels it her responsibility as a citizen to support the forces working against destruction. She joined the Labour Party at the time of Suez. She is a member of the Peace Pledge Union, and an enthusiastic reader of *Peace News*, which she regards as unique in its creative response to current issues.[2]

To have preserved the essential humanity within the universal structure is perhaps the special contribution of Barbara Hepworth to modern art and thought. At the heart of every abstraction, she reminds us, there lurks a human being. We can ignore it only at our peril.

1 *Meridian, Sculpture for State House* 1958–9.
2 *Peace News*, edited by Hugh Brock, was the official organ of the Peace Pledge Union, and campaigned for nuclear disarmament and non-violent direct action.

Note on hands, April 1959, unpublished manuscript and typescript, sent to Cornel Lucas in connection with his photographs of Hepworth's hands (fig.36)

In the normal way it is generally accepted that the right hand, in a right-handed person, is the most valuable of the two hands. In the case of a carver this is not really true – for in the main, the right hand for the sculptor, is the 'motor' hand – holding the hammer which drives the chisel in the left hand. The left hand acts as the thinking and feeling hand and it is the left hand which is trained to detect every contact between thought and material – whether it be the structure of the material being used in all its infinite organic variations or the development of the form to be revealed as the sculptor works. The left hand, it seems to me, develops an enormous sensitivity which co-ordinates the stereognostic perceptions of both hands. As a right-handed person, I find it easier to draw with my left hand than to carve with the chisel transferred to my right hand.

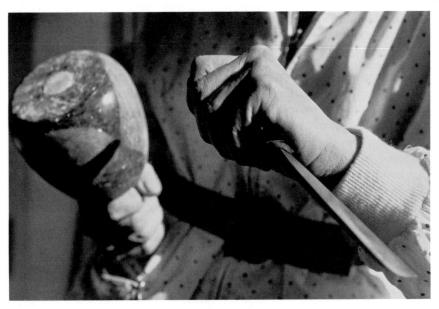

36. Photograph of Hepworth's hands, 1959. Photograph: Cornel Lucas

37. Manuscript draft for Trewyn Gardens *Sculpture Exhibition* catalogue, 1959, Tate Archive

Landscape demands a figure —
it directs its own image.
The lonely clearing or the empty
incline, the hollow or plain or
summit compel the solitary
spectator to loosen his imagin-
ation. The upright stone takes
charge of the sensibilities —
— Sunlight or moonlight shape
the growing contours & pierce
the stone with luminosity.
So men substantiate their
awareness.
The next encounter precipitates
perception & through the formal
image men take charge once
more of their inheritance.

Text on the figure in the landscape in the exhibition catalogue
Sculpture Exhibition, Trewyn Gardens, St Ives, 1–6 June 1959[1]

Landscape always demands a figure and directs its own images. The lonely clearing or the empty incline, the hollow, the plain or summit compel the artist, the solitary spectator, to loosen his imagination. Perhaps the upright stone takes charge of the sensibilities and becomes the standing figure – the inhabitant; then the sunlight shapes the growing contours and pierces the stone to give it luminosity.

A new form has its own life – an image in landscape – the counterpart of man's awareness of his history and inheritance. The next encounter, the stone encircled by the family group, completes the cycle.

BH 9/5/59

1 Hepworth exhibited *Forms in Movement (Pavan)* (1956, concrete, BH 211) and a cast of *Torso II (Torcello)* (1958, bronze, BH 234) in this exhibition, held in the public gardens adjacent to her Trewyn Studio. The text relates back to a manuscript and typescript dated 2 November 1953 (Tate Archive).

Statement in the exhibition catalogue *Moments of Vision*, with an introduction by Herbert Read, Rome-New York Art Foundation, Rome, July–November 1959[1]

If I claimed in the past a spiritual or metaphysical intention, then I was too proud. This does not alter my belief that if we have the wits to be quiet and 'intake', then those qualities flow in. I do believe it and in all those works of art which move me most I find this special sense of timeless praising and affirmative creation. It is perhaps the difference between thinking one is a god or believing that one should reflect God. It is so terribly easy to be a god reflecting power, despair or one's own personality; or even the excitements of knowledge and skill [in] forms, and drama, and newness. Then suddenly, either in unconscious acknowledgment of life or in the silent tribulation of overcoming despair, one lets in the divine force and there is the work, inevitably complete, timeless and unalterable.

1 Herbert Read invited Hepworth to participate in this exhibition of 'contemporary artists who have expressed a metaphysical or spritual intention' (letter from Read to Hepworth, 26 May 1959, TGA 20132/1/167). Her reply of 30 May contains the statement printed in the catalogue, which she prefaced with the words: 'I feel chastened by your letter.' (Read Archive, McPherson Library, University of Victoria, British Columbia). She exhibited a cast of *Torso II (Torcello)* 1958, bronze, BH 234, and *Wood and Strings (Solitary Figure)* 1952, elm and strings, BH 178, in the show.

Text on the nature of art, 19 June 1959, typescripts[1]

I think the very nature of art is affirmative and that in being so it reflects the laws and evolution of the universe – both in the power and rhythm of growth and structure as well as in the infinitude of ideas which reveal themselves when one is in accord with the cosmos and the personality is free to develop.

The artist works because he must! But he learns by the disciplines of his imagination the difference between creating as though he were a god – and learning to <u>reflect</u> God or the universal laws of evolution. Through moments of ecstasy, or great despair, when all thoughts of self are lost, a work seems to evolve which has not only the vivid uniqueness of a new creation, but also the seeming effortlessness and unalterable simplicity of a true idea relating to the universe.

In our present time, so governed by fear of destruction, the artist senses more and more the energies and impulses which give life and are the affirmation of life and perhaps by learning more and letting the microcosm reflect the macrocosm, a new way of life can be found which will allow the human spirit to develop and surmount fear.

1 This was later used in the *Pictorial Autobiography* (p.24), with slight amendments.

'Two Conversations with Barbara Hepworth: Art and Life; The Ethos of Sculpture', August 1959, in J.P. Hodin, *Barbara Hepworth*, London 1961[1]

[. . .] Many years later, in her maturity, she realized that there was an inner link between her youthful Yorkshire experiences and the most exquisite artistic sensation of her life – Greece. She once said to me: 'I remember standing on Patmos and thinking – with that incredible stretch of sea and islands before me – how intensely a figure rising in the distance expressed that perfect elevation of the human spirit which in a way is conveyed by a powerful sculptured form. I felt that the Greek idea had something of the will, the power, the ruggedness we need; that the human spirit could overcome all the problems which beset this industrial age; that it could, as did the Greeks through art, philosophy and poetry, point a clear way to a solution and give it form through a sense of grace and rhythm – I use the word grace in the Greek sense of its meaning. The Greeks lived a virile life. They ate simply, they worked hard, they dealt with the forces of nature, but they reached the standard of a philosophical and poetical culture which I feel sculpture can particularly express.'

Art and Life

Barbara Hepworth said to me (Conversation of the 18th of August 1959):
'Art at the moment is thrilling. The work of the artist today springs from innate impulses towards life, towards growth – impulses whose rhythms and structures have to do with the power and insistence of life. That is how I feel it: Life will always insist on begetting life. By upholding this faith in life we strengthen those who are flagging and becoming cynical because they fear for their lives. They fear for the continuity of life. This continuity contains a tremendous and impelling force. In autumn all the dynamics are laid for spring. That is why autumn is such a magnificent season. Spring is the manifestation of all that is laid down in the autumn. The artist who understands this is feeling his way to an understanding of the structures underlying these impulses. I believe that this is true not only for the artist but for the scientist and the healer as well. Researches have been made into what lies behind the power of healing (in all spheres). People try to understand what is the meaning of the continuity in life. In sculpture in particular this notion opens up an entirely new field. This is the true way, the way which I feel is showing itself in the younger generation. There is not the same tendency towards the academic as in our youth. That is past. But there is another danger. If a young person sees only the form but does not see the structure behind and underlying the form, then he may get lost. Because you are left with concrete forms without meaning. In the past, when sculpture was based on the human figure, we knew this structure well. But today we are concerned with structures in an infinitely wider sense, in a universal sense. Our thoughts can either lead us to life and continuity or they may lead us to the way of the biologist applying radiation on mice: the way to annihilation. That is why it is so important that we find our complete sense of continuity backwards and forwards in this new world of forms and values. I see the present development in art as something opposed to any materialistic, anti-human or mechanistic direction of mind.'

The Ethos of Sculpture

Barbara Hepworth said to me (Conversation of the 28th of August 1959):
'I do not think sculpture can come alive in architecture at all unless it is recognized as a value in its own right. Sculpture is not primarily an embellishment. It gives the human dimension, it gives that added perception which only sculpture can give. In order to get the right relationship sculptor and architect both have to clarify their ideas from this specific point of view. The architect will have to make up his mind to provide valid space for the sculpture and he can only do this if he understands the meaning of sculpture in terms of its human content and appeal. And the sculptor has to rediscover for himself that, given valid space, his trained perception should react to it and produce what is required. The Gothic age found an instinctive relation-ship; we have to jump this hurdle, for we have reached a stage of intellectual

awareness where we are not quite sure what instinct is. But contemporary sculpture has proved to me that ordinary people react exactly as one would always hope they would when they are in the presence of sculpture organically placed, that is, without a sense of inferiority. Sculpture makes people act in a certain way; they move in a certain manner. Their gestures and their reaction to a sculpture are extremely expressive and this is the point – if the architect and the sculptor know how to seize upon it – where one might achieve a vital development in the architect's as well as in the sculptor's work in relation to human needs.

What is the meaning of sculpture? Today when we are all conscious of the expanding universe, the forms experienced by the sculptor should express not only this consciousness but should, I feel, emphasize also the possibilities of new developments of the human spirit, so that it can affirm and continue life in its highest form. The story is still the same as that of the Gothic or any other culture. I mean – it does not matter what philosophy or which religion is involved; the point is that we must be aware of this extension of our knowledge of the universe and must utilize it in the service of the continuity of the human spirit. And as we are speaking of sculpture, let us remember that sculpture affects the human mind through the senses of sight and touch.

Sculpture communicates an immediate sense of life – you can feel the pulse of it. It is perceived, above all, by the sense of touch which is our earliest sensation; and touch gives us a sense of living contact and security. Hence the vital power of sculpture. Again, the freedom of the spectator in viewing it without inferiority or frustration imparts that sense of vitality which is an essential element of continuity. Only sculpture can do this in this particular context. The sense of vitality, the sense of security, and the sense of continuity are essential to wellbeing. That has nothing to do with the question of perfection, or harmony, or purity, or escapism. It lies far deeper; it is the primitive instinct which allows man to live fully with all his perceptions active and alert, and in the calm acceptance of the balance of life and death. In its insistence on elementary values, sculpture is perhaps more important today than ever before because life's continuity is threatened and this has given us a sense of unbalance.

In sculpture we have a complete orientation of body and mind. And sculpture is so important in relation to architecture because it reveals the individual's relation to the architecture.

What has happened in architecture since the Thirties? As the result of economic pressures and a sense of impermanence the architect has been forced to try and supply all the needs in his architecture himself – an impossible undertaking. If the architect does not acknowledge the particular elements of the other arts, even though they may be only at an experimental stage, there will be no space to fill with a sculpture, no walls to cover with paintings. Experimenting by trial and error has always been the sign of good

mental health. The people who live with an architecture so starved will not develop their perceptions because it is like being mutilated.

Nowadays there is nothing done which conveys the feeling of praise. We have no time for praise. And yet, without this feeling of inner wealth that can afford to praise we are injuring ourselves and each other.

It depends very much on the architect to change this state of affairs. We have forgotten that it is more important to put up something which does justice to our time – and all times have produced buildings in which the architects and the artists co-operated to express their particular relationship to creation – than to prepare ourselves for mass extermination. There have never been so many architects, sculptors and painters as now and there has never been less to show for it. What we really suffer from is spiritual malnutrition.'

1 'I am really pleased to know that this re-telling of your story gave you inner satisfaction and reassurance,' Hodin replied to a letter from Hepworth following these conversations, which were part of the preparations for a new book on her work, published in 1961 (letter of 6 September 1959, TGA 21032/1/93/2).

Text on the sculpture _Torso I_ (_Ulysses_) (1958, bronze, BH 233, fig.38) in the catalogue to the exhibition _Sculpture in the Open Air_, organised by the London County Council, Battersea Park, London, May–September 1960[1]

The form of _Torso_ (_Ulysses_) was inspired by the eager stance of a figure poised between sea and sky – a rhythm of form which has its roots in earth but reaches outwards towards the unknown experiences of the future. The thought underlying this form is, for me, the delicate balance the spirit of man maintains between his knowledge and the laws of the universe.

1 Typescript dated 3 October 1959 sent with a letter from Hepworth to the Clerk of the London County Council, W.O. Hart, of 5 October (London Metropolitan Archives, GLC/DG/AE/ROL/1/89). A short paragraph on the sculpture had been requested, as in previous years (see pp.99 and 114).

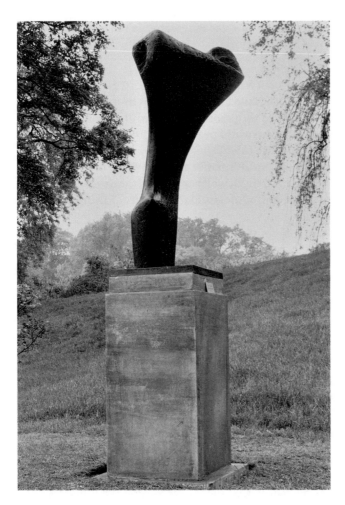

38. *Torso I (Ulysses)*
1958, bronze, BH 233,
at the London County
Council *Sculpture in
the Open Air* exhibition,
Battersea Park, 1960

**Text sent to John Russell, December 1959, unpublished manuscript
and typescript**

Throughout the 20th century the world has been rich in artists and an
international language has been established; but we have little to show
because there is, as yet, no culture. The pulse would grow strong if in 1960
the great positive move towards world peace could be made. This act of
faith is what everyone is waiting for. A sculptor, for instance, can only reach
full strength when commissioned to work at full strength; so it is with
society and international relationships. I hope that 1960 will see the
growth of a new vitality.

Text of 22 December 1959 on the new decade, unpublished manuscript and typescript

I find the thought of entering a new decade almost too disturbing to write about because I feel that we have failed to live <u>positively</u> as a society during the last decade. We have reached the point of waiting with a weak pulse for the essential move to establish world peace. There are individuals; and there is an international language established in the world of art; but art depends for its full strength on an affirmative society. What I most hope for in 1960 is a quick gathering of strength which will allow the development in all the arts and give the people of the world the security of living and working for posterity.

22/12/59

Text on working practice, c.1959, unpublished typescript[1]

'Carved direct' since 1920.
Used clay only until 1928 on <u>rare occasions</u> for bronze.
No bronzes until 1956 when experiments in sheet metal, rod, brass and copper led to enjoyment of metal forms. Started working straight into the plaster for bronze.

Wood, stone and marble constitute the main work since 1956.

The excitement of organic material with its highly vivid and sensuous quality of growth and structure – leading to tactile qualities as well as highly individual qualities of each living structure, exerts the greatest influence.

But in the latest bronzes am aiming at getting, not only the qualities of molten metal and the poignancy of fire but also a tactile expression by contrast of part-carved and part-plastic technique in the plaster.
Still adhere to the <u>truth to material</u> concept.
Never make maquettes unless absolutely forced to do so – as prefer to work into the 'direct scale' and am firmly convinced that change in size demands great alterations in form. A scale model is very unsatisfactory.

<u>Rarely</u> satisfied with a bronze cast unless have had the opportunity to work the surface myself.

In drawing, like to work from life in order to find essences of structure and movement – and alternate this with drawing (using colour) as an exploration of form and space; – starting with nothing and working line of colour leads to new forms and become alive.

<u>Re colour</u>
Have used colour in concavities since 1938 in order to vary sense of depth
and space. This has rarely been remarked upon – which pleases me as it
seems to have been accepted naturally as part of the form.

1 Context untraced.

Text on women's art, c. late 1950s, unpublished manuscript and typescripts[1]

It is often stated that women's work is best when it accepts the limitations
of their sex and is most feminine; but that by being feminine it has never
scaled the upper reaches of achievement in art and presumably never
will. This belief in the inevitable inferiority of woman's art presupposes a
competitive element between the sexes. I do not believe that women are in
competition with men. I believe that they have a sensibility, a perception and
a contribution to make which is complementary to the masculine and which
completes the total experience of life. If this is accepted, instead of feeling
cheated because a woman is not a man, it becomes possible to enrich one's
experience by the contemplation of a bivalent expression of idea.

I suggest that men – and women too – should be on the lookout for these
developing ideas in every sphere which are the attribute and expression of the
feminine viewpoint. In so doing they will help forward a new equilibrium in
our society – in the home, in politics and in statesmanship.

1 This text was a reaction to press reviews of an exhibition of women's art (untraced), which is referred
to in one of the typescript variants of the piece. Among Hepworth's papers is a manuscript of the
text in Margaret Gardiner's hand, suggesting that they may have worked on it together.

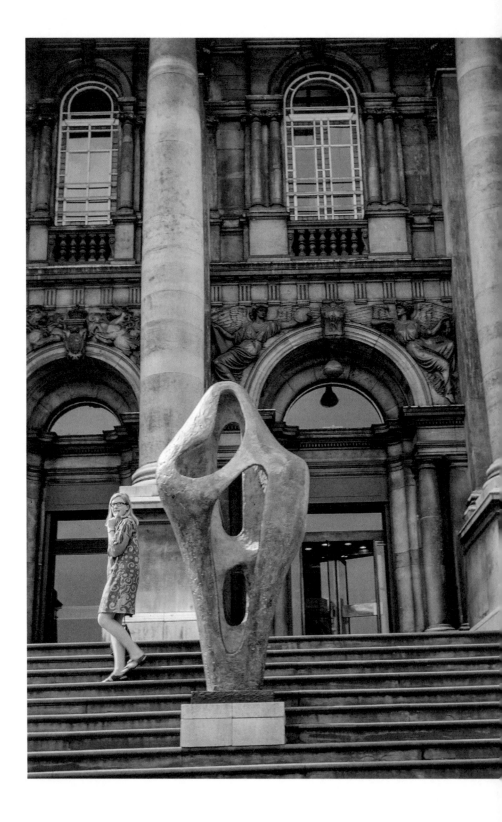

1960s

Edouard Roditi, 'Barbara Hepworth' (interview), in *Dialogues on Art*, London 1960

E.R.: *What are the advantages, in your opinion, of working in the open air?*

HEPWORTH: Light and space are the sculptor's materials as much as wood or stone. In a closed studio, you cannot have the variety of light and shadow that you find in the open air, where even the colours of the shadows change. I feel that I can relate my work more easily, in the open air, to the climate and the landscape, whereas the light and the space of a closed studio are always more or less the same, and more or less artificial.

E.R.: *In almost every explanation of your work that I have read, I find that the word landscape occurs, obviously used with a very special meaning. Certainly, when you refer to the relationship of one of your works to a landscape, you are not thinking of a view such as one finds in a painting by Constable or by Turner.*

HEPWORTH: Certainly not. I think of landscape in a far broader sense. I extend its meaning to include an idea of the whole universe.

E.R.: *The landscape of one of your works might thus be interpreted as its ecology, I mean its relationship to nature.*

HEPWORTH: Yes, I suppose that would be a correct interpretation of what I mean by landscape.

E.R.: *But the relationship of a sculpture, as a man-made object, to its natural surroundings might be based either on harmony or contrast.*

HEPWORTH: That would depend on the artist's response to a specific landscape. A sculpture, as I conceive it, is for a specific landscape. My own awareness of the structure of the landscape, I mean the individual forms too that contribute towards its general quality, provides me with a kind of stimulus. Suddenly, an image emerges clearly in my mind, the idea of an object that illustrates the nature or quality of my response. This object, once I have created it as a sculpture, may harmonize with the landscape that inspired it, in that its form suggests those that I observed in nature. On the other hand, the form of the sculpture may also contrast with the forms of the landscape. But, whatever the formal quality of this relationship, the sculpture remains, in my mind, so closely associated with the landscape to which I originally responded that I often try to perpetuate this relationship in the title that I choose for the work.

E.R.: *Do you mean that you give your works specific titles like those that landscape-painters choose? I mean like the titles of paintings of Constable or Whistler?*

HEPWORTH: Not exactly, since I'm always thinking of landscape in a broader and less specific sense. For instance, one of my sculptures is entitled *Pelagos*, meaning 'the sea'. Well, from my studio, I could see the whole bay of St Ives, and my response to this view was that of a primitive who observes the curves of coast and horizon and experiences, as he faces the ocean, a sense of containment and security rather than of the dangers of an endless expanse of waters. So *Pelagos* represents not so much what I saw as what I felt.

E.R.: *Do you believe that it is possible to explain or justify in words such an individual response to a landscape?*

HEPWORTH: No such explanation would be entirely satisfactory. It would always fail to convince some individual spectator. But the individual also remains free to repudiate my particular response and to affirm his own different response to the same landscape. Still, the violence of such an individual's repudiation of my response may also serve its purpose in clarifying his own response. The important thing is that there should be a genuine response, whether to my own work or to the landscape that originally suggested it to me. . . .

E.R.: *So you admit that different artists may conceive different forms as responses to one and the same landscape?*

HEPWORTH: Certainly, and each different form, each different response, is valid as a kind of testimony. My own testimony represents the sum total of my own life and experience, in that particular moment, as a response to that particular experience.

E.R.: *In terms of Platonic philosophy, your works should thus be defined as imitations of something that occurs in your own mind rather than of nature as it is or as it might ideally be.*

HEPWORTH: Yes – an imitation of my own past and present and of my own creative vitality as I experience them in one particular instant of my emotional and imaginative life.

E.R.: *Would you say that you set out to impose upon your material a very clearly conceived form, or that you allow your material, as you work on it, to suggest to you the final form of the sculpture?*

HEPWORTH: I must always have a clear image of the form of a work before I begin. Otherwise there is no impulse to create. The kind of sculpture that I indulge in is hard work, and I would always hesitate to start doodling with a mass of wood or stone as if I were waiting for the form to develop out of the work. Still, the preconceived form is always connected with a material. I think of it as stone, or as bronze, or as wood, and I then carry out the project accordingly, imposing my own will on the material. The size of the sculpture is also important, in my first clear image of what I want to do. I can see the

material that I want to work on, and also the exact relationship of the object to its surroundings, I mean its scale. I hate to think of any of my works being reproduced in a smaller format.

E.R.: *You mean as a kind of pocket edition reproduced in ceramic and tucked away on the shelf of a book-case, in front of a row of cookery-books?*

HEPWORTH: Yes – that might well be one of my nightmares.

E.R.: *But doesn't the material, as you work on it, ever suggest to you any modification of your original image?*

HEPWORTH: Of course it does, and that is the great temptation. Half-way through any work, one is often tempted to go off on a tangent. But then one knows that there can be no end to such temptations, such abandonments of one's plan. Once you have yielded, you will be tempted to yield again and again as you progress on a single job. Finally, you would only produce something hybrid, so I always resist these temptations and try to impose my will on the material, allowing myself only, as I work, to clarify the original image. At the same time, one must be entirely sensitive to the structure of the material that one is handling. One must yield to it in tiny details of execution, perhaps the handling of the surface or grain, and one must master it as a whole.

E.R.: *It sounds rather like the art of mastering a thoroughbred horse.*

HEPWORTH: I've never ridden a horse, but I can well imagine that this is a good simile.

E.R.: *As I look around your studio and see all these samples of your work, I feel that you have an awareness of what I would call the different epidermis of bronze, stone or wood. Your bronzes, for instance, have a rougher surface that is peculiar to them, whereas your stone and wood sculptures achieve as smooth a 'skin' as the grain of the material can allow.*

HEPWORTH: It requires an extra effort, some additional strength, to discover the wonderfully individual quality of each material. In the case of bronze, this problem of the finish is particularly subtle as the model which I send to the foundry is of an entirely different material. I have to visualize it, as I work on it, as if it were bronze, and this means disregarding completely its own material qualities. That is why I find it necessary to work with a foundry that has an artistic understanding of the quality of finish and of colour that I want to obtain in the bronze. I enjoy working for instance with Susse Frères, the great Paris foundry. They are artists and masters and I can always trust them to interpret my ideas. Look at the colour, for instance, of that bronze, which came back from Paris only recently.[1] The blue-grey quality of the shadows, on the interior surfaces, is exactly what I wanted, though I had never seen it

before in any bronze. It turned out exactly as I had visualized it when I was still working on the plaster model.

E.R.: *This awareness of the specific qualities of various materials is what strikes me as lacking in most nineteenth-century sculpture.*

HEPWORTH: Many sculptors then tended to misuse clay, wax or plaster. In handling something that is soft and yields, they would forget too easily that their model was to be reproduced in stone. Generally, it was another man, a craftsman rather than an artist, who carried out in marble the model that the sculptor had entrusted to him.

E.R.: *The French poet Léon-Paul Fargue once referred to this kind of art as 'noodles camouflaged to look like steel'. I suppose that is why so many marble figures of that period look as if they had been squirted out of a toothpaste tube, then hastily and quite easily licked into shape and allowed to cool off and harden.*

HEPWORTH: That sounds rather revolting to me. But so many of these human figures of the nineteenth century are like petrified humanity, as if they had been injected with a chemical that immediately transformed living flesh into bronze or stone.

E.R.: *The Greeks were already aware of the dangers of this kind of naturalism. Medusa, the gorgon, could turn human beings to stone by merely looking at them, and the legend horrified the ancient Greeks.*

HEPWORTH: Well, I share their horror of a living being that has been overcome by a kind of *rigor mortis*. I feel that a work of art should always reflect to some extent the peculiar kind of effort that its material imposed on the artist.

E.R.: *May I interrupt you here to say how much I am enjoying the aptness and articulate quality of everything that you have said to me about your art? I've had the occasion of interviewing, in recent months, quite a number of artists, whether in English, French, Italian or German. Some of them, I found, were quite inarticulate, except in their own medium. Others, when they spoke, were almost too articulate, so that I felt that they often failed to express, in their particular medium, all that they claimed, as they spoke, to have set out to achieve. In your case, I find that your verbal explanations apply very aptly to your actual sculpture.*

HEPWORTH: It is important for an artist never to talk about his ideas until he has made them concrete as works of art. In explaining what one intends to do, one always wastes or loses some of the energy or force that is required to achieve the work of art. I suppose I am able to explain only those works which I have already completed. I don't think I would ever want to talk about an image or an idea that is still in my mind, or that I haven't yet made fully concrete.

E.R.: *Brancusi was never very eloquent about his own sculpture.*

HEPWORTH: No. I visited him twice in Paris, in his studio, before the war. It was wonderful. He simply pulled the dust-sheet off each sculpture in turn, and there it was, something that needed no explanation because it was already as much a part of the visible world as a rock or a tree.

E.R.: *For Brancusi, the act of creation was something as simple and as self-explanatory as the act of procreation among animals. But he could also be articulate whenever he discussed the work of another artist. I happened to meet him shortly before he died, when I called one afternoon on a young American painter who lives in Paris and occupies a studio next door to Brancusi's. That day, I didn't recognize Brancusi at once as I hadn't seen him for over twenty years. My American friend, Reginald Pollack, is a figurative painter who has settled in France in order to study the techniques of the great French post-impressionists and Fauvists, from Bonnard to Dufy – which is scarcely the kind of art that one generally associates with the name of Brancusi. Well, here was Brancusi, carefully analysing his young neighbour's recent works and giving him very specific advice on how to solve certain problems of colour and texture that Pollack was still trying to solve.*

HEPWORTH: That doesn't surprise me at all. There was an essential humility in Brancusi. He knew very well what he wanted to achieve, but this did not exclude the other aims which other artists might set themselves. Within the scope of his own field of creation, he could achieve the perfection of form that he sought. At the same time, he was aware of other types of expression which other artists might achieve.

E.R.: *I seem to detect a great affinity between your own work and that of a few Continental sculptors, I mean Brancusi and Arp. But I also feel that your work, like that of Henry Moore, has contributed very decisively towards establishing the notion of a specifically English school of contemporary sculpture. I would even say that England and Italy are now the only two European countries that have a national style of contemporary sculpture.*

HEPWORTH: It is safe for you, an American to make this kind of remark. On my lips, it might sound almost too chauvinistic, though there may be some truth in it.

E.R.: *Until 1939, English artists tended, I feel, to follow almost too closely the directives of the School of Paris. When they were cut off from Paris by the war, they became aware of their own power and of their own potential style.*

HEPWORTH: It is an awareness that we developed as a group rather than as individuals. After the First World War, we became conscious of all the values of our civilization that we were called upon to defend. We then realized that sculpture, as a stone-cutter's art, had been widely and successfully practised five centuries ago in England.

E.R.: *I suppose you are referring to the masters who carved such figures as those that one sees on the façade of Exeter cathedral.*

HEPWORTH: Yes. But this stone-cutter's art had been abandoned and forgotten. In the 'twenties, we began to seek a return to the fundamentals of our art. We recoiled at last from the kind of reproduction of a reproduction which had satisfied the sculptors of the Victorian era. Epstein, Eric Gill and Gaudier-Brzeska had cleared the decks for the sculptors of our generation, I mean Henry Moore, myself and others. We then rediscovered the principles of Anglo-Norman sculpture too. I remember how, during the war, a bombing once led to the accidental unearthing of a carved Anglo-Norman capital in which the artificial colouring of the stone had somehow been preserved. I was able to see how the cavities of the reliefs had once been coloured with a bright terracotta red, and this was exactly the kind of effect that I too had been seeking from 1938 onwards, in some of my own works. What I had considered an innovation thus turned out to be a lost tradition in English sculpture.

E.R.: *Of course, there had also been at one time a specifically French school of modern sculpture, from Carpeaux, Degas and Renoir in the generation of the Impressionists, to Rodin, then Bourdelle, Maillol and Despiau in our own age. But the great sculptors of the School of Paris, in recent years, have generally been foreigners, I mean Brancusi and Modigliani, Lipchitz, Zadkine and Arp, who had been active in German artistic movements before his native Alsace, in 1919, became again a French province.*

HEPWORTH: The English sculptors of my generation still owe a great debt to these artists of the School of Paris. They have taught us the basic principles of form in its relationship to the surrounding space. But we also had to solve a problem of our own. I mean that we had to deal, in our relations with the English public, with that very English characteristic of always seeking a literary explanation for every work of art. In France, the Impressionists had solved that problem decades earlier. But we had to remind England that a sculpture need not be a monument to the dead, or a reminder of a great work of Michelangelo. On the contrary, a sculpture should be enjoyed for its own intrinsic qualities.

E.R.: *That had already been the basic doctrine of Oscar Wilde's campaign against the 'anecdotage' of Victorian art. But Oscar Wilde had been so eloquent in his praise of French art that most English artists, from 1890 until 1940, looked to France for their directives.*

HEPWORTH: In 1940, we were then cut off from France and suddenly realized that everything that we really needed, for the time being, was available here. In sculpture, painting, architecture and music, everything that we stood for, that we had to defend in the war, was here. We realized that contemporary

English art and music could indeed be as rich and varied as contemporary English literature. It was up to us to forge ahead and prove it.

E.R.: *I think you, in particular, have proved it very eloquently.*

HEPWORTH: I sometimes feel now that we are beginning to be threatened by a certain chauvinism. People would love to return to the comfortably insular or English ways of thinking. Now we have to combat this danger. We must avoid contributing towards the establishment of a new kind of specifically English academism.

E.R.: *So you feel that you are now committed to defending the kind of non-figurative art which is considered most controversial.*

HEPWORTH: No, not necessarily. I have not always been a non-figurative artist, and I may very well, one day, feel the urge to return to a more recognizably figurative style of art. Besides, we are already having to cope – I mean those British artists who have long been pioneers of abstract art – with a kind of placid academic recognition that is at times quite disconcerting.

E.R.: *When did you first begin creating abstract forms?*

HEPWORTH: Around 1931, I began to experiment in a kind of organic abstraction, reducing the forms of the natural world to abstractions. Then, in 1934, I created my first entirely non-figurative works. But it was in 1931 that I began to burrow into the mass of sculptured form, to pierce it and make it hollow so as to let light and air into forms and figures.

E.R.: *Is there any connection between this idea of an inner surface, I mean of a hollow mass that is penetrated by light, and the concave-convex ambiguity of certain Cubist paintings – it's actually a kind of optical punning – where objects that are convex in real life are depicted as concave, or vice versa?*

HEPWORTH: No, I don't think there is any such play, in my work, with the ambiguities of optical impressions. I think this development, in my sculpture, was a response to an organic sensual impulse. I believe that the dynamic quality of the surfaces of a sculpture can be increased by devices which give one the impression that a form has been created by forces operating from within its own mass as well as from outside. I have never seen things, even inadvertently, in reverse, though I have often observed that some other artists tend to suggest that they have seen in relief what is actually hollowed out, or vice versa. In my own work, the piercing of mass is a response to my desire to liberate mass without departing from it.

E.R.: *This is indeed a curiosity of the senses rather than of the intellect. It suggests a desire, on your part, to explore the inside of a mass with your finger-tips rather than with your mind. But the Cubists were more intellectual, as artists, than sensual; besides, they invented and tested most of their devices, even those that suggest sculptural effects, in paintings rather than in sculptures.*

[1960]

HEPWORTH: Still, there is an element of intellectualism in my sculpture too. I feel that sculpture is always, to some extent, an intellectual game, though the sculptor generally obeys sensuous impulses. The sculptor sets out to appeal to all the senses of the spectator, in fact to his whole body, not merely to his sight and his sense of touch.

E.R.: *In most Cubist sculpture, I seem to miss, above all, this appeal to the spectator's sense of touch, except when the Cubist sculptor sets out to fool the spectator by offering him a convex form where one expects a concave one.*

HEPWORTH: But there is a certain amount of fooling of this kind in all art. You are perhaps right when you suggest that the Cubists refrained from appealing to our sense of touch, except perhaps when they set out to deceive us. But my own sculpture also sets out, at times, to deceive the spectator. I thus try to suggest, in my forms, a kind of stereoscopic quality, but without necessarily allowing the spectator to touch these forms. The piercing of masses, by allowing light to enter the form, gives the spectator a stereoscopic impression of the interior surfaces of this mass too. I set out to convey a sense of being contained by a form as well as of containing it, I mean of being held within it as well as of holding it, in fact of being a part of this form as well as of contemplating it as an object. It is as if I were both the creator of the form conceived and at the same time the form itself, and I deliberately set out to convey this ambiguity to the spectator, who must feel, as I did, that he is part of this sculpture, in its relationship to space or landscape.

E.R.: *This would indeed be the ideal of communication between artist and spectator. But it requires a kind of contemplative approach to the work of art, on the part of the spectator, that has become almost impossibe in our over-crowded world where one often feels that there is already standing room only. In the Museum of Modern Art in New York, for instance, the modern sculptures are so crowded that one can sometimes see a detail of a César through a hollow in a Henry Moore. I found that very disturbing, like a vision of skulls and bones piled up promiscuously in a charnel house.*

HEPWORTH: To me it sounds quite macabre. Besides, it is contrary to the basic idea that underlies most sculpture ever since that of ancient Greece. A human figure, set in the daylight and in a landscape, should give us there the scale of everything. If you wish to suggest a deity that dominates nature, a colossal figure will do the trick. But if you crowd together, in a single space, a lot of figures conceived on different scales, you deprive them all of their aesthetic purpose and reduce them to the status of 'ancient remains', I mean of objects of interest to an antiquarian. In the case of modern sculpture too, this overcrowding in galleries and museums deprives each work of its intended relationship to space, I mean of its ideal landscape. Once, when I was in Greece, I became intensely aware of the relationship that a single human figure might bear to a whole vast landscape. It was on Patmos, and

I was coming down a mountain-side when I saw a single black-robed Greek Orthodox priest standing beneath me in a snow-white courtyard, with the blue sea beyond and, on the curved horizon, the shores of other islands. This single human figure then seemed to me to give the scale of the whole universe, and this is exactly what a sculpture should suggest in its relationship to its surroundings: it should seem to be the centre of a globe, compelling the whole world around it to rotate, as it were, like a system of planets around a central sun. That is why each sculpture should be contemplated by itself.

E.R.: *But the public generally gets to know sculptures only in a crowd, in exhibitions or museums, or else in photographs. Even the best photograph, I feel, betrays a sculpture, depriving it of its proper format and of its own quality of surface. A photograph reduces polished brass or polished marble to mere outlines, robbing them of their content, their mass, their density or weight. Museums might thus be said to have become concentration-camps for works of art, and art-books be compared to rogues' galleries in which each individual work is stripped, in a reproduction, of most of the qualities that should compel our admiration. But here we are beginning to discuss problems of economics or sociology – I mean the problems that arise in our age if one wants to bring art to the attention of the public, especially when the public approaches art as a Sunday crowd in an already crowded museum.*

HEPWORTH: Yes, that would take us too far, though I am sure we could still talk about enough problems to fill a whole book.

1 Probably one of the series of three *Torso* bronzes of 1958 (see fig.38, BH 233).

Contribution to the film *Barbara Hepworth* directed by John Read, BBC TV, 1961[1]

All my early memories are of forms and shapes and textures. I remember moving through the landscape with my father in his car, and the hills were sculptures; the roads defined the forms. There was the sensation of moving physically over the fullness of a moor, and through the hollows and slopes of peaks and dales, feeling, seeing, touching, through the mind, the eye and the hand. The touch and texture of things – sculpture, rock, myself and the landscape. This sensation has never left me. I, the sculptor, <u>am</u> the landscape.

It took a long time for me to find my own personal way of making sculpture, a long time to discover the purest forms which would exactly evoke my own sensations, and to visualise images which would express the timelessness of

primitive forces which I felt and the constant urges towards survival and growth which I knew to be fundamental, both to the human being and to the landscape in which we stand.

I have always loved the joy of carving and the rhythm of movement that grows in the sculpture itself, just as I like dancing or skating. I like the relaxation of sound and movement. When I am carving, or when I am listening to someone else carving, I know what is happening not by what I see, but by what I hear. The tools a sculptor uses become his friends and they become intensely personal to one – the most precious extensions of one's sight and touch. The right hand is the motor in carving and the left hand is the thinking, feeling hand – feeling the use of the gouge, chisel, the adze, the point – all these tools have their special uses and the left hand senses the organic structure of the material, as it feels its way about the form.

Many people select a stone or a pebble to carry for the day. The weight and form and texture felt in our hands relates us to the past and gives us a sense of universal force. The beautifully shaped stone washed up by the sea is a symbol of continuity, a silent image of our desire for survival, peace and security.

It may be that the sensation of being a woman presents another emphasis in art and particularly in terms of sculpture, for there is a whole range of perception belonging to feminine experience. So many ideas spring from an inside response to form. A nut in its shell, or a child in the womb, or the structures of growth in shells and crystals, the hidden energy and rhythms of wood and stone, and the pure and gentle quality of reflected light on the surfaces of natural material which produces sensations of vitality, security and calm.

When I am making a drawing, I like to begin with a board which I have prepared with a definite texture and tone. I like to rub and scrape the surfaces as I might handle the surface of a sculpture. The surface takes my mood in colour and texture, then a line or a curve made on it has a bite rather like cutting into a slate. Then one gets lost in a world of space and creation with a thousand possibilities because the next line one draws in association with the one before will have a compulsion about it which will carry one forward into unknown territory. The conclusion will be reached by a sense of balance. Suddenly, before one's eyes, is a new form which, from a sculptor's point of view, can be deepened or extended, twisted, tightened, hardened, flattened, according to one's will, as one brings to it one's own special life. And in this kind of non-realistic art, the artist is free to follow his imagination and to create precisely to his will. What one does springs from a profound response to life itself.[2]

Notes relating to Hepworth's contribution to John Read's film, unpublished manuscript and typescript (fig.39)[3]

All my early memories are of forms & shapes & textures.
Moving through & over the West Riding landscape with my father in his car the hills were sculptures; the roads defined the form.
Above all, there was the sensation of moving physically over the contours of fullnesses & concavities, through hollows & over peaks – feeling, touching, seeing, through mind & hand & eye.
This sensation has never left me.
I, the sculptor, <u>am</u> the landscape. I am the form & I am the hollow, the thrust & the contour.
Feelings about ideas & people & the world all about us struggles inside me to find the evocative symbol affirming these early & secure sensations – the feeling of the magic of man in a landscape, whether it be pastoral or a miner, squatting in the rectangle of his door, or the 'Single form' of a mill-girl moving against the wind with her shawl wrapped round her head and body.

But I needed light. In the Mediterranean there was sun & light & warmth.

I like the sea – the movement, the sound & the way it shapes the rocks, & throws towards us the pebbles & leaves the sign of its rhythms on the sand.

Here in Cornwall I have found a strong landscape & strong people – as in the West Riding; but with the added stability of climate which enables me to work out of doors for much of the time. Here as in Yorkshire the figure plays a dynamic part in the landscape. On the lonely hills or on the rocks by the coast a human figure has the vitality & the poignancy of all man's struggles in this universe.

Many people select a stone or pebble to carry for the day. The weight & form & texture do, through our hands, relate us to the past & give a sense of universal force.

It took a long time to find my personal calligraphy – the pure forms which would evoke my own sensations – & to find the image which would express the timelessness of primitive forces which incorporate the basic urges towards survival & growth as well as the austerity of the disciplines involved.

I have always thrived on the physical joy of carving & the rhythm of movement in the actual work itself.

I like dancing, skating, the delineation of form in movement – by watching I feel the meaning of gravity & the radius of movement.

I like the relaxation of co-ordinated sound & movement. The tools the sculptor uses are his friends. The material is a new adventure of organic force.

All my early memories are of forms & shapes
& textures

Moving through & over the West Riding Land-
scape with my father in his car the
hills were sculptures; the roads defined
the form.

Above all, there was the sensation of
moving physically over the contours
of fullnesses & concavities, through
hollows & & over peaks — feeling,
touching, seeing, through mind & hand & eye

This sensation has never left me..

I, the sculptor, am the landscape. I
am the form & I am the hollow,
the thrust & the contour.

Feelings about ideas & people & the
world all about (us) struggles inside
(me) to find the evocative symbol

39. Page in notebook relating to *Barbara Hepworth* film, Tate Archive

I like incising my prepared boards with the pencil & cutting into the marble
or wood. I like the rubbing down of the shaped forms & the patina they get
with handling.

I cannot begin a work until it is suddenly clear in my mind – seen from all
the way round as a complete form – a complete physical experience – & the
outward symbol of what I have been feeling.

Then I am so absorbed by the act of making it concrete maintaining the clear image that I never know what the sculpture means, or what it is called, until it is <u>finished</u>.

Since 1938 I have liked using colour in concavities – it gives another dimension –

Since 1931 I have needed to pierce the forms to let in the light & to feel the depth.

Light is always changing. The sun moves, & every hour, as well as every day, is a different experience.

Once by chance I wakened & walked in the garden in the full strange light of a waning moon from the east. It was a piercing light giving new meanings to forms in the silence.
Shortly afterwards this strange illumination faded & the light of dawn came. Although it was from the east, every form & texture took on a different aspect as the sounds of life began once more.

For me sculpture is the reassurance of the quality of things both <u>felt</u> & seen.

It reaffirms the nature of our physical orientation, & reaffirms our vitality. The essence of the materials is a symbol of continuity – and the figure in a landscape, the silent image, or the standing stone is a sign of our desire for survival & security.

1 Filming took place in St Ives in November 1960 and April 1961. The first part of Hepworth's contribution was later adapted for the *Pictorial Autobiography*. Another section was taken from her text for the Whitechapel catalogue of 1952 describing the forms which have special meaning for her (omitted here). Other sections look back to her texts in the 1952 Lund Humphries monograph.
2 Cf. her words on abstract drawing in the 1952 monograph, pp.68–9 above.
3 Hepworth sent a copy of these notes to John Read in February 1961 (see their correspondence, BBC Written Archives). She invited him to choose what he wanted for the film and she would use the remainder for other things. In her papers there is also a typescript containing additional material she recorded for the programme.

Quotations on *Meridian* in J.P. Hodin, 'Artist and Architect: Recent Monumental Works Produced in England', *Quadrum: Revue Internationale d'Art Moderne*, Brussels, 1961, no.10[1]

Hepworth on *Meridian*, *Sculpture for State House* (1958–9, unique bronze, BH 250, fig.40)

It is part of my conviction as a sculptor to treat both the maquette and the scale model as complete works – a 'changing development of an idea' in different sizes. With the full-scale model, more than three times my own height, I altered the disposition of the uprising curves in order to get what

40. *Meridian* at State House, London, March 1960. Photograph: David Farrell

pleased me from the perspective of ground level, and by using steamed timbers 17 ft. high to create the thrust of the curves from ground level I was able to hold them under tensions which was my original idea of a rhythm and thrust in relation to the site.

Although a sculptor may say that the ideal situation for a sculpture is one which gives sky and landscape, there is a basic and fundamental relationship of a human being to a sculpture, and the stimulus of this idea can create a force which can carry one over certain limitations of sculpture within city life.

1 Hodin and Herbert Read represented Great Britain on the International Editorial Committee of the review *Quadrum*.

Tribute to Dag Hammarskjöld on his death, September 1961, unpublished manuscript

I was privileged to meet Mr Hammarskjöld when I visited the United Nations Headquarters late in 1959 & I would like to add my tribute to his memory.[1] As an artist I was deeply & lastingly moved by the sense of extraordinary integration of perception & purpose. He was a man of immense compassion & courage, a visionary who integrated the 'rights of man' with an aesthetic comprehension of the creativity of man. Both in his presence & within the Secretariat there was a reality created of what life <u>should</u> be – the love for mankind which embraces all the arts of which man is capable brought into a state of active work for the preservation of peace & creative endeavour.

To me this was a unique experience – a glimpse of what life could be &, indeed, must be, if life is to continue at all.

Mr Hammarskjöld fought for this ideal & died for it. But the ideal conception of peace & creative activity did not die with him. With immense courage & selflessness he demonstrated what is, in fact the only way of life – & I feel that his tragic death at this moment lays upon us a most solemn charge to follow his example & approach the immediate world problems in an entirely new way – that is – with the same faith & compassion & the same understanding of aesthetic values & their rightness & validity. The sum total of each person's endeavour in this respect could achieve what Mr Dag Hammarskjöld both understood & demonstrated.

1 They had first met in London in April 1958.

Speech at the opening of the new Penwith Gallery, St Ives, introducing its president, Herbert Read, 23 September 1961, unpublished typescripts[1]

Mr Mayor, Ladies and Gentlemen,

It is with very sincere and deep pleasure that I introduce to you to-night our President – Sir Herbert Read.

A great poet and a great philosopher, he is a man of exceptional vision and courage whose creative power has interpreted the visual arts in such a vital way that his name is known throughout the world to-day.

In all his writings there has been a consistent aesthetic principle which, when fully understood, could help to establish a new way of life in this troubled world and lead mankind towards peace.

Herbert Read has, both by his own visionary powers and by his immense faith in the creative powers of man, done more than anyone of our time to bring about an understanding of the meaning of art and the force of the imagination.

Our debt to him is immense.

I should like to add, out of my personal experience, that his life has been a completely dedicated one and I remember with gratitude how, thirty years ago when the world seemed very hostile to the few of us working in England, his understanding and his faith sustained us.

Herbert Read gave the Penwith Society the backing of his name twelve years ago. This building is, in some measure, a justification of his faith. He has come here to-night in spite of world-wide demands on him.

I am sure that Herbert Read's address will give us, through his unique understanding, a sense of direction and will reveal something of what is eternal in the ways of the imagination.

1 Read had been president since the formation of the Penwith Society of Arts in 1949 by Hepworth, Nicholson, Bernard Leach, Peter Lanyon and others. In his opening speech, Read described the new gallery in Back Road West as 'one of the most beautiful places for the exhibition of art I have ever seen' (reported in the *St Ives Times and Echo*, 29 September 1961).

Statement on nuclear weapons, 29 September 1961, quoted in *The Sunday Times*, London, 1 October 1961, and *The Times*, London, 2 October 1961. Manuscript and typescripts

The statement was written by Hepworth in consultation with John Bratby, Benjamin Britten, Herbert Read and Graham Sutherland, and signed by 59 artists, musicians and writers [1]

STATEMENT:

We feel that the time has come to protest against the immorality of present power politics.

Culture means the affirmation of life. There can be no true culture while we make stock-piles of nuclear weapons – they are the negation of life.

It is said that the bones of our children and grandchildren will be contaminated by dirty tests. But all our minds are already contaminated by the present situation.

We, the undersigned, believe that hope and good for the human race can only come out of doing what is right. Expediency, fear and hatred have already left their mark on our children and will leave it on their children.

*We feel that the
time has come
to protest against
the immorality
of present power
politics.
Culture means
the affirmation
of life. There
cannot be any
culture whilst
we make stock-
piles of nuclear
weapons.
It is said that*

*the bones of our
children + grand-
children will be
contaminated by
dirty tests.
But all our
minds are already
contaminated
by the present
situation.
We, the under-
signed believe
that good for the
human race can
only come out of
doing what is right.
Expediency fear +
hatred has already*

We call upon our Government to take some initiative to break through
the present deadlock and we ask all Governments, in the name of all the Arts
to halt the contamination of man's spiritual growth.

B H

1 The full statement is printed here from the papers in the Tate Archive. The Campaign for Nuclear
Disarmament sent the protest to the prime minister and the American, Soviet and French ambassadors
in London. The signatories also included Henry Moore, John Piper, Patrick Heron, Peter Lanyon,
C. Day-Lewis, J.B. Priestley, Iris Murdoch and Michael Tippett.
 Hepworth asked Dore Ashton to circulate the statement to colleagues in America and Ashton
obtained the signatures of Joseph Cornell, Philip Guston, Elaine de Kooning, Robert Motherwell,
Harold Rosenberg, David Smith and others (undated letter to Hepworth, c. December 1961, TGA).

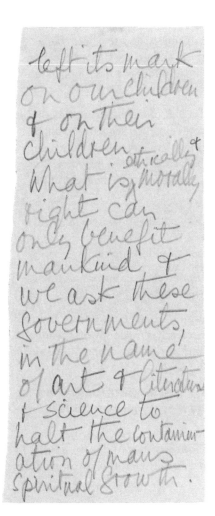

left its mark on our children & on their children. What is morally & ethically right can only benefit mankind & we ask these governments, in the name of art & literature & science to halt the contamination of mans spiritual growth.

**'The Sculptor Speaks', recorded talk for the British Council,
8 December 1961**[1]

MERIDIAN

Meridian (fig.40)

In 1958 I was asked whether I would do a large bronze for State House in
Holborn. I met the architect and we studied the plans and elevations –

I felt very interested. This was a chance to work on a big scale and the
largest commission I had so far been offered for a sculpture in bronze.

After our discussion the architect took me to the site where the building was already nearly half-way up. I could see the approach to the place for the sculpture from the road under the first floor of the tall section of the building.

In spite of the giant cranes above, the roar of machinery and pounding of cement crushers – I was able to appreciate the scale of the open space in relation to the whole building. I had a very immediate, and strong, feeling about the scale of a human being moving across this space and into the doors which you can see here on the right of my bronze sculpture *Meridian*.

The curved wall behind the bronze was already indicated. I carried back with me to Cornwall that evening a very vivid impression of the site and a nearly-formed idea of what I would like to do.

I have always felt that I could never undertake a commission unless I had an immediate <u>formal impact</u> when first seeing the site.

With this commission I felt no hesitation whatsoever. By next morning I saw the sculpture in my mind quite clearly. I made my first maquette, and from this, began the armature for the working model ⅓ the size required.

I felt very prepared to carry out a large bronze which would have a rhythm of thrusts and curves as I had been working on this idea for some time previously –

The problem was to develop a technique which would allow a full spontaneity of expression when carrying out the full scale model from which the bronze was cast.

I wanted to keep all the freshness and excitement when making the plaster a full fifteen feet high – so I made the 'working' model very freely – to look harmonious at a scale of only five feet. Then I felt sure that I would retain the excitement of developing the idea on a massive scale.

I used long seventeen foot timbers, steamed so that they could be curved and then clamped together – giving an immediate sense of perspective and scale.
I was able to adjust the arcs quite freely and was then ready to lash the curves into solids by using laths – rather like boat building. This not only gave sufficient strength to bear the great weight of plaster which was eventually to be carried overhead – it also allowed me to build the joints ready for cutting up the model into nine sections ready for the foundry.

The next stage was winding the forms with hessian soaked in Plaster of Paris – and on this I built up the surfaces with a very large spatula. I had in mind, all the time, the living quality of metal – the polished edges – the darkness of the hollows.

Also, I had to bear in mind, the many views of the sculpture from the hundreds of windows in the building – from the top floor to ground level – as well as the <u>distant</u> views from the main road and the <u>close</u> approach when entering the doors with the bronze towering above.

<u>The human scale was all important</u> in the evolution of this sculpture placed in this court where it had to be both intimate and commanding at the same time.

ENVIRONMENT

Garden

It took nearly thirty years to reach the point where I felt free to work in metal.

I am basically and primarily a carver and the properties of stone and wood and marble have obsessed me all my life.

Trewyn

This feeling for material and conviction about 'truth to material' is <u>not</u> in my case a matter of just letting material inspire me – on the contrary, the completed image occupies my mind first – fully formed as a stone form, or wood form, or marble form, in my mind – before I start the sculpture.

Carving yard

The actual living organic properties of material – and the firm hard resistance in carving them – aids my articulation. It allows me to say what I want to say about human life in relation to the universe – in forms which I feel to be valid – at all times – to human experience and tactile perception.

Palais

Trewyn

In the late twenties I realised that only by a long process of sifting and selecting my mental images could I say more forcibly what I wanted to say,

<u>and</u>, at the same time, give the forms an increased 'life' in the organic materials which I was carving.

Torso (fossil marble)

In 1927 this marble torso depended on some human representation for its vigour though already there was an awareness of the hand moving up the sculpture in a more formal relationship.

Two Forms, 1937

By 1937 this idea of human essence had grown into these two marble forms in which – for me – the qualities of human relationship and tenderness are more forcibly expressed.

The extraneous literary references have gone – and a full glow of the properties of light and crystal structure of marble has been realised.

Torso (ivory wood)

In the torso in ivory wood of 1929 the vertical rhythm of the fundamental growth of wood is present – with the quality of warm, surface vitality which is inherent in all hard woods –

Single form (sycamore)[2]

– but I much prefer this image of 1937 called *Single form* because I feel it has a greater <u>presence</u> – I, myself, felt free by then to impress on the nature of the wood my mental image of human presence in its essence.

Pierced form (alabaster, 1931)

The first pierced form which I carved in 1931, in alabaster, let light into the interior of the sculpture by hollowing out below the breast so that the eye travelled both through and round the form.

IDEAS

Pierced hemisphere, 1937

Gradually by 1937 in – for instance, *Pierced hemisphere* in marble, the hollowing out and the use of light had allowed me an important continuity of surface in the carving. This gave a greater sensation and articulation to both hand and eye – <u>the material and the idea were unified</u>.

Large and small form, 1934

The large and small form of 1934 was visually still a recumbent mother and child – with the small form belonging to the large form but visually attached –

Nesting stones, 1937

– but by 1937 in *Nesting stones* the oval 'mother form' contains the marble 'small form' within the concavity – and in being able to lift it out, and feel its quality as marble form in the hand, I was entirely free to evoke sensations of aliveness and maternity.

Wave

When in 1943 I made a wood sculpture with colour and strings called *Wave* I drew on carvings which I had made in the late thirties before the war. They contained both colour in the interior and strings which were used to create transparent tensions.

The strings, which I had used first to emphasise tensions, now began to cast, as it were, transparent curvatures against the colour of the concavities. The forms they developed stressed the three dimensional torsion of the sculpture.

In these sculptures the theme had changed and during the war years the philosophic content necessarily grew as I became preoccupied with the making of forms which would more and more express an affirmation of life – and the spirit of man as a figure in landscape. [When war broke out in 1939 I had moved with my young family from London to St Ives in Cornwall, where I still live.]

Landscape sculpture

It was the first time I had ever lived and worked in the country and by the sea. The grandeur of the horizon – and the strong pagan land-scape of Cornwall gave me a more strongly developed pre-occupation with the formal rhythm which would convey my response to this environment.

Cornwall as landscape is both as strong as my native Yorkshire and as beautiful as Greece, which I did not see until a whole decade later.

Pelagos

The forms of these sculptures are the forms of my thoughts and also my bodily sensations being related to the universe at a time when all life and freedom was threatened by the course of world war.

This wood sculpture called *Pelagos* was not only the land and seascape around me – but it is also a personal affirmation of faith – using the material of living wood – with colour and strings – and even the sense of sound – as an eternal image.

The outer surfaces are smooth unpolished wood – the interior surface is highly finished and painted pale blue with dark strings which seem to change the actual physical dimensions of the curves.

STONE

Biolith

In always remaining constant to my conviction about truth to material I have found a greater freedom for myself – freedom to develop my own responses to my surroundings and to stress the sensation of those experiences. Stone forms are for me rounded and weathered or split and sharp. They are responsive to light and air – to the sun and shadow and to rain and weathering – but they always keep their innate stony structure as they stand outside related to the landscape –

Hieroglyph

Sculpture is not a decoration to architecture. It has a life of its own – affecting the human mind through the senses of sight and touch. The

architect must create a valid space for sculpture so that it becomes organically part of our spiritual perception as well as our three dimensional life. To do less is to destroy sculpture and admit to an impoverished architecture.

Image

Themes recur – the relationship between two forms – the oval – the group – or the vertical form, which, for me, has the presence of the human standing form – acting sentinel, or guardian, in all weathers and in all qualities of light – but stone forms are not wood forms. –

WOOD

Churinga (Spanish mahogany)

In *Churinga*, made from Spanish mahogany – the warmth of the wood – the glow of colour and the intrinsically tactile qualities of living timber, allowed me to express the idea of ritual image containing the soul, or of the outer figure containing the inner figure –
One can see the essential difference that material makes to the choice of form and meaning.

Two Figures (Menhirs) 1954

These *Two Figures Menhirs* of 1954 are just two presences bound together by their nature in eternal relationship. – the painted concavities are an integral part of their character.
Ever since the late 1930's I have often used colour within forms and concavities to create another dimension of light and depth which would give a contrapuntal emphasis as in *Figure (Requiem)*.

Figure (Requiem)

This effect of the outer surfaces and quality being in counterpoint with the inner heart is intrinsic to the material – in this case walnut. I have always been fascinated by the relationship of inner and outer form.
The relationship of a nut in its shell – or of a child in the womb – or the amazingly different qualities of say the inner and outer surfaces of shells or of crystals. They seem to me significant of an important aspect of life and an aspect which will reveal itself more clearly as time goes on and we extend our understanding of the universe in space.

Head (Elegy)

In *Head (Elegy)* I wanted to stress the contrast between inner and outer surfaces. The stringing of the pierced curves and hollows in direct opposition to the concavities emphasises the warm tactile surfaces of the exterior form.

Curved form (Delphi)

In *Curved form (Delphi)* the continuity of inner and outer movement has a different kind of contrast by the use of a change of texture. The cutting and gouging and painting of the interior can only be done in one mood.

The rhythm of the cutting is so sensitive and subconscious that it can express the slightest variation of bodily or physical response from day to day – as does one's handwriting. To achieve a whole rhythm I lock myself up for the day – and, if I can't achieve it – then I wait for another and more auspicious day.

Toledo

I do not like drama in sculpture. To me drama has its fulfilment in time and space – not in being arrested in concrete material. I want to achieve a 'presence' in my sculptures of such a kind that they remain true and valid in all moods. The sense of humanity and compassion, perhaps one could call it the religious apprehension, seems far more important in giving a sculpture this special <u>countenance</u> which can remain eternal.

MARBLE

Marble Group [*Group I (Concourse)*]

The quality of marble is one of radiance – the Italian serravezza gives off a light from its component crystals. These crystals are so sensitive in their structure that the marble really changes its colour under different people's hands. The relationship of figures in groups occupied my mind for several years – especially in relation to space and architecture. There – I observed – that all human beings seem to reflect an acknowledgement of space and form by their movements and their poise and gesture.

Pastorale (marble)

All gestures – and the meaning of movement – are of interest to me. Why people poise themselves on cliff or hillside or why they instinctively assume a particularly sculptural reclining posture when they rest in some hollow place where they can gaze out over sea or sky. Their thoughts in landscape are always expressed <u>outwardly</u> and the eternal grace of feeling part of the world around us is expressed by human vitality.

Head (Icon)

Very often <u>I</u> am the figure in landscape, and my own reaction to environment takes shape as a new form – a new sculpture. This is really the concrete evidence of what I was feeling in a given situation, and I always hope that the chain of events is completed by the

spectator – who – both visually and tactilely is drawn to move round the carving or put out his hand to touch it.

Image II

In all these marble carvings there is – for me – a constant element – the nature of the material which is both exact and sensuous.
The warmth of light within it is in contrast to its intrinsic coolness even in the hottest sun.
The changing subtlety of shadows on marble enables me to express an exact image of the feeling of contemplation. It would be impossible for me to imagine these forms turned into wood or metal.
This sculpture *Image* and the group of small marble figures would have no meaning for me if they were cast into another medium and lost the interplay of light.

METAL

Galliard

Metal has an entirely different kind of structure and, as I have said, it took me nearly thirty years to find a way of using it. I needed to understand it in order to be stimulated by it.
I came to enjoy its very exciting properties, experimenting with sheet metal. I bent and twisted the sheets under tension until I found out the nature of its construction and forced it to express what I wanted by its nature and not against its nature.
I worked entirely by instinct – cutting, shaping and rubbing the metal into what I wanted until the final moment of bending and twisting the whole thing. Either it worked, or all was lost. There was no possible retreat.

Orpheus

I found the most intense pleasure in this new adventure in material – and revelled in the lightness of poise and delicacy of forms which seemed nearer to the flight of birds and their form in flight rather than to more gravity-bound rocks and humans.

Curlew

Out of all these forms I suddenly found a way of using bronze – I had always hated clay and never previously liked any bronze casts of forms modelled in clay.

Trevalgan

But now I felt free to enjoy the making of the armature. I could blend it with my carving technique – by building up the plaster of Paris and then cutting it down as though carving.
Finally as in *Curved form (Trevalgan)* by treating the plaster as if it was

oil paint, with large flat spatulae, I built surfaces which I could then
cut down when hard.

This method gave me the same feeling of personal surfaces as when
I prepare the boards on which I draw and paint.

This sculpture *Trevalgan* was a form inspired by being at the top of
a hill overlooking the Atlantic where I felt the infinitude of space
surrounding me.

Galatea

This torso *Galatea* also sprang out of the sense of mobility gained by
the use of bronze.

In these forms I felt the inner movement as something resisting outer
friction. We all feel this when our movement is subjected to outer forces
– such as wind or water movement – as when emerging from the sea in
a heavy tide, when waves encompass our limbs.

Porthmeor

I found a new freedom of forms – almost defying gravity – and a new
rhythm of forms which enabled me to express even the <u>sound</u> of the
Atlantic, with one's own body becoming a part of the sea's action –

Archaean

As in this figure, where I felt the sensation of molten metal filling
every crevice until a symbol was shaped that embraced – as well as
defied – the sea and land.

It is perhaps a lonely figure. But it can stand firm because the forms
rise and expand to allow the large apertures.

These two related piercings allow the passage of wind and water.
A symbol to me of man's strength and frailty.

Curved form with inner form (Anima)

Even the 'maternal' two forms took new shape as it became bronze.
When I touch this bronze two forms it still conveys the tension of the
oval forms – the sense of inner and outer forms – although it is in
metal and a different organic structure.

Thea

Inevitably this led me to carving and incising bronze – grinding the
metal to a precise form which deleted the strangeness (to me) of
the method of casting sculptures. I find the personal sympathy of
the hand all important to the life of small sculptures.

Chûn

These highly finished rubbed and polished surfaces grew into being
as I realised that bronze was – like the hardwoods and marbles – a
<u>malleable</u> material, as well as a fiery one. It is capable of responding to
touch as well as heat. These sculptures are monolithic in form although

they are small. Their heaviness seems to accentuate the subtleties of the reflections on the surfaces.

Small hieroglyph

The small hieroglyph is rather like a very weighty bird in the hand. But whether a sculpture is six inches or fifteen feet high it always relates to our own human scale – either by our hands – or our arms, or our total height and sight when we are compelled to walk round the forms to know them –

Figure for landscape

as in this bronze – 'a figure for landscape' – nine feet high, which I made in 1960.
It combines not only the inner and outer form – which I have spoken about – but it is also a compelling cave within which one can stand.
In an open landscape this figure would be maternal. Near to – it becomes a refuge.

Icon

Before concluding I would like to re-iterate my feelings about material – I have often been called puritanical or cold or geometric – but it is the significance of human and spiritual responses to life around us which obsesses me at all times.

Hollow form (Churinga III)

It is the actual presence created by the tenderness of a dark hard wood such as this carving in lignum which reassures me. The fact that it is such a fierce wood – of such fine grain – enables one to develop the compassion and tenderness in contrast to its innate strength.

Nyanga

I need the almost human pleading of a figure like *Nyanga* where external drama is absent – and inner pleading arises out of unity of form and material.
I try to eliminate all external drama as it always tires and bores me later.

Icon II

I like to create a serene countenance such as *Icon II* in marble. By working instinctively – I react to life around me – either in the immediate sense of being related to a community –

Bryher

– or, in the <u>long term</u> sense, of being aware of the implications of our century. The urgent need is to build our lives on strong foundations.

Large oval (Delos) with self

I try to make sculptures which will affirm and re-affirm the magic of the <u>will to life</u> and the miracle of rebirth and continuity in the universe.

clay - plaster - carving

wood stone marble alabaster

vertical rounded intrinsic
& branching light
 & movement

 translucent
fresh + instant rounded & tactile
 or split &
or carvable weathered

 temperature
metal + its properties tactile

 coolness
 warmth
 coldness
sheet under tension sharpness
 silkiness
 roughness
 patinated
relaxed rhythms
of curves fire, running metal

 molten - passionate
 arrested movement
carved metal
 inducement of sound & resonance
 or the deliberation of hand ground
 metal shaped & refined to
 give the quality

42. Page of notes from sketchbook related to British Council lecture, 1961, Tate Archive

Self with stoneblock

The physical and sensuous joy in carving all these materials is a way of giving praise – and, as a woman, I can only say that it is an act of faith and an urge which is as inevitable as being feminine.

1 Edited by Alan Bowness. Images used in the talk are indicated in red (BH catalogue numbers for these are given in the Index). The recording is in the Tate Archive and British Library Sound Archive; a transcript and film-strip are also in the Tate Archive, as are typescripts and a manuscript draft in a sketchbook (see fig.42). There are some small variations between the typescripts and the recording.
2 The image on the film-strip is of a photograph Hepworth took of the holly wood *Single Form* (1937–8, BH 102) at Herbert Read's house in Buckinghamshire, overlooking the garden.

'Artist's notes on technique' (1962) in Michael Shepherd, *Barbara Hepworth*, London 1963[1]

I am primarily a carver and therefore do not start my work until the idea is absolutely clear in my mind. I use drawing and painting for the exploration of forms and depths which lead finally to the idea of a new sculpture.

I rarely make a maquette. They are essential when working for an architect or a commission; but I always find that a good maquette, in the sense of being accurate, is an unpleasing object; whereas an exciting small sculpture is necessarily very different from the ultimate large one – but more stimulating.

My ideas from the beginning are conceived for a particular material, either wood, stone, marble or bronze and the intense pleasure, to me, is in relating oneself to the 'life' in the particular material.

I have used bronze and other metals only in the last seven or eight years, and when working for bronze I build an armature and work direct in plaster of Paris which I prefer to clay, as it is possible to cut it and get a surface nearer to my personal sense of form. Certain forms, I find, re-occur during one's lifetime and I have found some considerable pleasure in re-interpreting forms originally carved, and which in bronze, by greater attenuation, can give a new aspect to certain themes.

I think power tools are very limited in their use. The mechanical drill is a great help in boring a hole towards which one can carve freely without breaking one's carving tools. The carborundum wheel also has its uses for certain inaccessible forms; but I regard them as strictly utilitarian and dislike very much any mechanical kind of surface, as I think the hand-work reveals the quality of thought right down to the final stages.

The range in size of my work varies between what can be held in the hand, up to blocks of stone weighing four tons or more. I like to move from one material to another and find every block of stone or marble, and every piece

[1961-2]

of carving timber, different in its quality of life and its demand on one's appreciation of it.

I always envisage 'perfect settings' for sculpture and they are, of course, mostly envisaged *outside* and related to the landscape. Whenever I drive through the countryside and up the hills, I imagine forms placed in situations of natural beauty and I wish more could be done about the permanent siting of sculptures in strange and lonely places.

I prefer my work to be shown outside. I think sculpture grows in the open light and with the movement of the sun its aspect is always changing; and with space and the sky above, it can expand and breathe. Wood sculptures, of course, are not happy out of doors; but they have other properties more tactile and intimate which relate to an indoor life.

I feel that direct carving is a fundamental part of the development of man and his attitude to the future. The drawbacks of the present, which perhaps discourage the younger carvers, are the difficulties of cost, transport, the rigours of climate round the world, and the expense of dealing with heavy weights. I should like to see much done to offset this and some encouragement of a natural and affirmative art.

I always have at least two assistants; they are either highly-skilled craftsmen, who appreciate the nature of sculpture, and who work in close collaboration with me, and who are able to work very closely in relation to the logic of my own particular form; or pupil assistants whom I enjoy teaching what I know. I am convinced that the full understanding of one person's working methods should release the individuality within a younger artist – providing the essential lesson is accepted – that of taking every idea to its ultimate conclusion with all the sincerity and passion of which one is capable.

A sculptor's studio is always a turmoil – a mixture of new ideas being thrown up in three dimensions – of sculptures arriving or departing to exhibitions – of sculptures prostrate on the ground and requiring bases and pins to set them up – or blocks of stone and wood standing about and begging for work to proceed on them when the sun comes out.

I love the demands that such activities make on one and find that the workshop atmosphere is of prime importance to the liberation of the imagination.

Barbara Hepworth, 1962

1 Hepworth was responding to questions on her working methods posed by Michael Shepherd in a letter to her of 20 January 1962, for example, 'Do you plan settings for the works, or envisage perfect settings?' (TGA 20132/1/192). Her text was written in 1962 but the book did not come out until the following year.

Texts on *Curved Reclining Form (Rosewall)* (1960–2, Nebrasina stone, BH 291), 3 November 1962, unpublished manuscripts and typescripts[1]

Rosewall is a composition of forms which came into my mind when I was on Rosewall Hill itself, outside St Ives. High up, surrounded by ancient stones, granite rocks worn by time and weather, looking out over the Atlantic with the sound and smell of the sea. There is always a sense of peace and of exhilaration at one and the same time.

On this particular day when I walked to the top, a fusion of ideas took place – for *Reclining form (Rosewall)* is also myself as I gazed out upon this superb scene. The sculpture is gazing outwards also and gives emphasis to the forms which are evocative of the moment and the action of the elements in the shaping of land and coast.

[Alternative text]

Rosewall is a hill outside St Ives, crowned by an outcrop of granite rocks worn by time and weather and from the summit of this ancient site one can gaze out upon a most noble land and sea-scape. The sound of the Atlantic,

43. *Curved Reclining Form (Rosewall)* 1960–2, Nebrasina stone, BH 291, on show in Hepworth's exhibition at the Whitechapel Art Gallery, 1962. Photograph: John Webb

the exhilaration of air, and wind and water, and the fragrance of gorse and grasses combine to give one a sense of timeless serenity.

My sculpture *Reclining form (Rosewall)* was conceived at the top of this hill and is a fusion of ideas – a composition of forms which express, for me, both the inward and outward perceptions in a new image. The stone is myself, gazing outward as countless thousands of people must have done during centuries in this place. The stone itself gazes out in awareness. But the forms are the forms of a fusion of all the elements giving, I hope, a sense of repose as well as being evocative of the exhilaration of man in his landscape.

1 The sculpture was acquired by the General Post Office in 1963 to be sited outside the new building in Chesterfield, Derbyshire, housing its Accountant General's Department. Hepworth wrote these short texts at the request of Sir Kenneth Anderson of the GPO.

'Statement about the meaning of Chûn for Professor Allan Edwards', 11 March 1963, typescript[1]

In Cornish this word was originally Chy Goom which means in Cornish 'House on the moor'.

In 1283 there was a written reference to this place name as Chiwoen. By 1623 the word had become Chiwone, later in 1760 Borlase referred to it for the first time as Chûn.[2]

There are two Chûns. 1. Chûn Quoit erected about 2000 B.C. and 2. Chûn Castle which dates from the year 0. Both these places are a magnificent inspiration to a sculptor both in form and in placing in the landscape, and where the only sound is that of a lark in the summer. I used these words therefore to name the sculptures which had come to myself when alone in these particular places. I have always been interested in the relationship of the human being to his landscape and the universe.

I hope very much that this will give you some reasonable explanation of the use of the word Chûn.

1 Professor of English at the University of Western Australia.
2 William Borlase, the father of Cornish archaeology, author of *Observations on the Antiquities, Historical and Monumental, of the County of Cornwall*, 1754; revised 1769.

44. *Single Form (Chûn Quoit)* 1961, bronze, BH 311,
photographed by Studio St Ives in June 1963 overlooking St Ives Bay

Statement to Inquiry on proposed mine development at Carnelloe, near Zennor, 18 March 1963, unpublished typescript and manuscript[1]

I believe that Zennor and its coastline are unique in this country. To countless thousands who visit there every year it represents an experience which gives spiritual solace and renewed courage in a materialistic world.

Man has never been able to create a landscape. I feel, therefore, that we have a duty to posterity to ensure that we do not despoil places of rare beauty and quiet solitude.

To do so for any reason whatsoever would be a confession of total failure on the part of our generation, and a crime, on our part, if we do not preserve for our children what we ourselves have been bequeathed.

That is, a place to visit where we can feel at one with God and the universe.

A place of quite rare and unique beauty.

1 A campaign was led by the National Trust against the re-opening of the long-abandoned tin mine at Carnelloe, between St Ives and Land's End, in 1960–3. The issue aroused passionate feelings on either side, with Hepworth, Nicholson and Patrick Heron among those opposing re-opening, and Peter Lanyon arguing that it would bring economic benefits to the county and that beauty could be man-made as well as natural.

J.P. Hodin, 'Barbara Hepworth and the Mediterranean Spirit', *Marmo*, Milan, December 1964, no.3. Quotations from Hepworth of June 1963

> Poets that lasting
> marble seek
> Must carve in Latin
> or in Greek
>
> *Edmund Waller*

We were sitting in the garden of Barbara Hepworth's 'Trewyn' Studio in St Ives. It was a late afternoon in the summer, the sky was blue, the bells of the nearby church sounded clear in the warm air. When the sound died down one could hear from afar the mighty roar of the waves which the flood threw against the sharp Cornish granite cliffs.[1] The tops of the buildings and of the high trees here and there glowed up in the warm light of the setting sun. Under palm trees and flowering shrubs, between roses and gladioli some work of this outstanding English sculptor stood in the open. Nowhere in England has the spirit of the Mediterranean embodied itself so generously as here in this most Western strip of Cornwall, and nowhere in England is

there an artist now at work who has expressed himself so perfectly in the medium of the classical style and its most beloved material – marble. It is true Barbara Hepworth has carved many a sculpture in tropical hardwood – blackwood, lignum vitae, ivorywood – in Spanish mahogany or in stone from near and far, she has even lately embarked on handling bronze but some of her most fascinating works are in marble and the artist herself, looking dreamily and relaxed at an unfinished sculpture after the day's hard work, said on that same afternoon when I remarked that we might be sitting somewhere in Greece or in Southern Italy, at Corinth or near Cuma where Aeneas landed on his flight from Troy – so unmistakably classical was the marble, the light and the sound of the South: 'Yes, and how right to start with the marble, to continue with light and to finish up with the sound of the whole, its music. Do you know that I love marble specially because of its radiance in the light, its hardness, precision and response to the sun? All this I learned to appreciate in Italy when I was a young student, and to have found this spot in Cornwall where nature corresponds so genuinely to my concept of style and my whole feeling has for years been a deep source of joy and satisfaction to me. To be quite correct; one of my earliest efforts, when a student in Chelsea, was to carve marble. The work got lost when I went abroad. But it was in Italy that I discovered truly the qualities of marble in its natural setting.'[2]

And Barbara Hepworth, who was born in the coal-mining county of Yorkshire with its dark aspects of the industrial revolution and who, even as a young girl made a vow to bring beauty into that hell created by industrialism, to convey to her hard-working countrymen the meaning of harmony, of the dignity of man and of *bellezza*, found the pure sound of her soul when travelling in Italy and learning the difficult craft of sculpture. [. . .]

Barbara Hepworth explored the whole of Tuscany, Romanesque architecture in landscape and sunlight; Masaccio; Michelangelo; Cimabue; Giotto; Assisi; Siena, and Perugia. In the Etruscan works she discovered a freedom in the use of form and a vitality of expression which stirred her deeply. And then followed Rome, one of the cradles of our European culture, the strong seat of Western tradition even now, and in many ways its climax. Only in years later, in 1954 did Barbara Hepworth discover for herself Greece, the origin of all these achievements, the spirit of the classic style, its seed and its triumph. Again her love for the Mediterranean flared up as it only can in the nostalgic heart of a Northerner and like steps to this temple of clarity, science and beauty which she worshipped, led her works, this time named in Greek: Corinthos, Delos, Delphi, Anthos, Coré, Mykonos. The shadows grew longer, the twilight dipped the garden in blue. We still spoke about the Mediterranean around which every idea, concept and form, art, myth and religion, philosophy and science of Europe was born, without which we could not exist even for an instant. The Mediterranean radiates even now the strength and the spell of human imagination and vision which are the rare fruit of the human heart

[1963]

quickened by the sun within it, and the mind and soul of Europe are thus still alive after five thousand years and more.

Barbara Hepworth has experienced both: the presence and the past of the Mediterranean. She belonged to the generation of artists who believed that only in direct carving, in the work hewn directly into the material by the artist's own hand, would the decadence in European sculpture which had lasted for almost 300 years come to an end and a new style would dawn. In the 1930's carving in hard materials was a 'must'. In Florence[3] Barbara Hepworth studied the traditional technique of marble carving with the Italian master-carver Ardini. The atmosphere in his workshop was stimulating for her. She watched him working on blocks of some twenty tons. She listened to the sound of the steel tool as it struck the stone, and to the master-carver's words: 'Marble can only be carved with tenderness . . .' [. . .]

Barbara Hepworth made a soft movement with her hand – she wished thus to remark on the quality of the light around us or, maybe, on the harmony of inner and outer forms in her work, their interaction or both: light and sculpture, as a symbol of life and spirit in their relationship. And so it was: the landscape looked at us through the wide openings in some of her wood and stone sculptures, the holes were like eyes mirroring the horizon, the foliage and the sky.

The sculptures and drawings of Barbara Hepworth are too well known for us to enter here into a chronological description of her work, its unfolding and its stylistic development. Her personal contact with the world of vision of Ben Nicholson, of Brancusi, of Arp and Picasso, of Gabo, of Mondrian, of Calder and Miró was a strong stimulus. But complete and individual, like a flower of its own, her art has evolved into that perfection and mastership which make her one of the most esteemed sculptors of our time, an artist of inner integrity and consequence, a human being with high ethical and artistic aims and a will-power and mind strong enough to live in accordance with them and to impress them on her work as a message to our time.
For is there not a message in harmony, beauty, and the strength in restraint for a time which is torn between superficial success and despair, nihilism and brutality?

Marble has become the body and the symbol of classical qualities in Barbara Hepworth's work. The luminous marble of Carrara and Seravezza especially, for which she has a particular feeling. She has carved grey and black marble, of course, and Greek Parian marble as well as others, 'but I think,' she said, 'I like carving Italian marble best. Marble is indeed a noble material, it has a most exceptional sensitivity and delicacy as well as a tremendous strength. I like best some of my work in marble. Among them: *Doves*, 1927; *Pierced Hemisphere*, 1937; *Two Forms*, 1937; *Pastorale*, 1953; and then *Talisman*, *Head (Icon)*, *Mykonos*, *Talisman II*, *Image II*, *Icon II* as well as *Totem*. I wish I had carried out my *Three Forms* – project for the *Unknown*

Political Prisoner (a competition of 1953) in marble. I hewed *Monolith (Empyrean)* and *Contrapuntal Forms* in grey marble from Galway, but what I would have preferred then was to have worked in the Mediterranean countries. Alas! . . .

'You may realize, that I have carved white marble as much as I possibly could, but in this dark, dirty and cold country it has not been very easy to place these works. In Cornwall they are very happy out of doors – you can see – even all the winter through, as they can be in Italy. The clean air and brilliant sun makes it possible for me to site them easily.

'Contemporary artists working in marble please me just as much as the Greeks of the Archaic period, or the early Italian masters, providing they feel for the special quality of its luminosity and severity. I think one either feels for marble or one does not.'

We repeat, Barbara Hepworth is a true classical artist. Where in the sculptures of our day can be found that crystal-like realization of the ideal of early Greek art, in which joy, clarity and beauty are united, where the acceptance of the 'now and here' dominates, not a dissatisfaction with existence, a longing for a yet unformed future or a regret for the transitoriness of things which is always combined with the glorification of the past – in one word Romanticism, and estrangement from the world. This realization of the ideal of early classical Greece was not conceived by Barbara Hepworth in a neo-classical spirit, as an imitation of the old, not as a synthesis of the Archaic and the new, as we can experience it in the work of a Manzù, a Marini, a Greco or a Heiliger – the archaic quality in their work is less of Greek inspiration, more understood in the spirit of the Etruscans or of Rome and of the Renaissance into which an influence from the Far East has entered; with Marini it is China, with Greco Japan and India – but through the creation of a new world of forms whereby the spirit of our age is fertilized by a creative penetration into the Greek tradition, a lightning-like understanding of its spiritual meaning, as we have realized it now, even in the realm of science. For the modern scientist has a new regard for the findings and the attitudes of the old Greek philosophers and scientists (Schrödinger, Heisenberg and others). This direction towards a style which reached its climax in the 5th century B.C. was, in Barbara Hepworth's work and life, not a decision but the discovery of an affinity, a spiritual fate more than a conquest.

I realized this when contemplating once one of her most distinguished works called *Pastorale*. Carved in the white and translucent marble of Seravezza this piece of sculpture breathes like a living being in the gentle light and peace of the Kröller-Müller Museum in Otterlo; in a light which seems to penetrate the vibrating skin of the stone, in the peace which allows our thoughts to embrace this pure manifestation of the Greek spirit with empathy and love. Here I understood what an outstanding achievement it was, this acceptance and re-creation of science and art in the Greek sense. It was to me as if Barbara Hepworth had uttered the memorable words of

the great forerunner of modern sculpture – Auguste Rodin, who once said: 'The Greeks were truly scientists, their art is pure geometry. Beauty in which the Greeks believed was an order discovered by reason; it was directed only to the intelligence of the highly educated; it despised the poor and lowly souls. It had no loving sympathy for the good-will of modest creatures and ignored what we can find in every human heart, a reflection of the heavenly light. It was tyrannical against every one unable to think in a proud and superior manner . . . It suffered only the perfection of form . . . Never was the Art of Sculpture so glorious and radiant as then. No artist will ever surpass Phidias. For progress may exist in the world but not in art.'

Barbara Hepworth has never doubted what an artist should do in barbaric times 'who still believes in the Greeks and the Romans', as Ingres did. Her conviction is rather that the proud and divine Greek attitude towards beauty may have a beneficent influence on the common man, she believes in the ethical, the educational power of art. Beauty enobles. May she be right, for never has a time needed such a wisdom more urgently than ours.

'What is the meaning of art, of sculpture in our time?' she suddenly asked. And she replied in these words – 'Today when we are all conscious of the expanding universe, the forms experienced by the sculptor should express not only this consciousness but should, I feel, emphasize also the possibilities of new developments of the human spirit, so that it can affirm and continue life in its highest form. The story is still the same as that of the Greek or of any other culture. I mean – it does not matter what philosophy or which religion is involved; the point is that we must be aware of this extension of our knowledge of the universe and must utilize it in the service of the continuity of the human spirit.'

With these words I took leave of her, knowing that same night, maybe, a new materialization of beauty would rise out of her mind in the small hours of the morning, like Pallas once emerged from her father's head, the head of the creator, and the all-embracing father.

1 An imaginative conceit.
2 Although Hepworth's words in this article are presented as spoken in the garden at Trewyn Studio, they were in part based on her written responses to Hodin's questions in a letter to him of 18 June 1963 (copy in TGA 20132/1/93/4). She wrote there: 'I hope you can put them into shape and embroider them'. As well as quoting from her letter, Hodin also paraphrased some of her responses. The article is printed in full, apart from quotations from Hepworth's texts in the 1952 Lund Humphries monograph. Hepworth wrote of the subject of Italian marble as 'one which has always been so near to my heart'. (Letter to Hodin of 3 May 1963, TGA 965/2/17/52.)
3 Rome.

Text on *Winged Figure* (1961–3, aluminium, BH 315), 4 July 1963, unpublished typescript[1]

The whole project of the Winged Figure for Oxford Street, on the wall of the new John Lewis building, was for me extremely interesting and enjoyable.

It was such a challenge to create the right sort of sculpture for this unusual position and to make the forms rise above the immense hurly-burly of Oxford Street as well as to make the concept remain calm over and above the immense stream of traffic.

I wanted to capture the greatest variety of light and shadow, from morning sun, afternoon reflected light and night floodlighting, so that visually the sculpture never remained static. The use of the apertures and stainless steel rods enabled me to get a constant 'variation' of the 'Winged Figure' by ever changing light and shade.

The slant of this great wall, tipped slightly towards Oxford Street and Marble Arch was a great help to me. It allowed my imagination to develop freely my idea of the forms of air, wind, sea and space of Cornwall (where I live) and let this sculpture alight in Oxford Street where it still looks free enough to fly straight up to Marble Arch and home again!

Throughout my work on this project I was deeply grateful for the help I was given by the John Lewis Partnership and by the architect Mr. Uren, of Slater & Uren. They gave me a free hand, and great encouragement, even to the design of the supporting base lines and helped me most generously over every technical and other problem.

I only had one (last minute) problem. I placed the form very precisely in relation to the position of a road centre existing lamp-standard. When the work went up, I found a new, recently placed, lamp-post on the pavement in front of the sculpture! The Marylebone Borough Council most graciously moved this lamp-standard very soon afterwards so that it no longer interferes with the long views of the sculpture.

1 Hepworth sent this text to Paul Hodin with a covering letter of 4 July 1963 (TGA 965/2/17/52/7). The publication for which it was intended is not known.

45. *Winged Figure* 1961-3, aluminium, BH 315, newly installed on the John Lewis building, Oxford Street, London, April 1963. Photograph: Anthony Panting

'Barbara Hepworth' in Warren Forma, *5 British Sculptors (Work and Talk)*, New York 1964. Interview/statement recorded in St Ives in July 1963'

I was born in Wakefield, in the West Riding, which is about eight miles from Leeds, and all my earliest memories are of this tremendously industrial area where people seemed to get up [to work] at 5 A.M. and kept on till they had supper late at night. And the most powerful impression, I think, apart from the very fine natures of Yorkshire people, was the amazing difference between the industrial devastation, where everything was so dark and so black the light never seemed to percolate at all, and the exquisite country far outside in the dales of Yorkshire, which I was able to enjoy with my father (when I was not at school), who took me in his car. And the country – the unspoiled country there – was so magnificently shaped that the roads became, as it were, contours over a sculpture. And these great conflicting ideas of what man can do and the way darkness affects a man spiritually and what could be perceived in the countryside, in the unspoiled way, really, I think, shaped my whole life.

I came to Cornwall about twenty-two years ago – no, more than that, I think; just before the war. My triplet children were about four years old, and we'd been asked to come down here to stay with a friend to give them a holiday, and we were offered shelter to keep the children here when war broke out, which it did [with]in a couple of weeks. Before I came, I thought it was rather a fearful idea to come so far away to an artists' colony; and, very strangely, a foreword to one of my exhibitions in 1937 [had] likened many of my works to many of the Cornish stones and cromlechs and dolmens, which I'd never seen, as I'd never been here. And I didn't want to come, but I found after a while that it was quite impossible to leave here. I am still completely in love with the place. No day is ever the same, and it is [as] near to my Yorkshire background because of the history of Cornwall of tin mining and the strength of the countryside, the ravages in places of the industrial exploitations in the past, and the whole strength which lies behind the landscape; and I think, also, a great similarity between the people – the Cornish people are far-travelled, tremendously hardy miners, sailors, and engineers – so [that] I felt immediately spiritually at home. It has strengthened my work, in the sense that I have an additional magnificent gift living here, which I never had in Yorkshire, and that is light and warmth and quietness and the ability to use this in my carving out of doors, which, of course, would be impossible in the north of England.

In approaching a commissioned sculpture, I very much like to begin from the position that a new form, a new idea springs into one's mind. If it doesn't, I never really want to carry out the commission. It must be an

instant reaction to the light and place. [With all] the free works which I do for myself, I always imagine the sort of setting I would like to see them in, because I firmly believe that sculpture and forms generally grow in magnitude out in the open with space and distance and hills, so that the natural setting is the most tremendously inspiring one to me. And when I go out in the country here in Cornwall, motoring over the hills, I stop, and more often than not I make drawings, not of what I'm looking at, but what springs into my mind as a form which I would love to make for such a landscape. Therefore, the works I do are a mixture of an ideal situation in shape and spontaneity reacting to landscape and a feeling of evoking how I feel, myself bodily, in relation to this landscape [, evoking a response in the beholder to the position of man spiritually, mentally, in his landscape and relating to the universe.]

To follow through from that, I think it would be true to say that it is perfectly possible to be on a lonely hill, considering man's philosophic development and relation to life, and create a work which could transport the whole of this environment of the world in its absolute beauty, unspoiled beauty, and place it, say, in the middle of Piccadilly and create the exact evocation of idea so that everything becomes quite stilled and controls the impetus, which I think we suffer from, of rushing and confusion, and create an exact response. I do believe, in abstract work, that it is possible for sculptors to create forms which, for instance, make man consider space, or travelling in space, or moving 'round the world as we now do, and produce this in the middle of the biggest hurly-burly but still make it completely valid. That is, I don't wish to make a work fit for Piccadilly, but I would like to make what I most truly feel and put it in Piccadilly and say, 'Here is something of myself, of Cornwall, of sky, sea, space', and let it tell in that environment.

This large stone here, which is about three tons in weight, I carved last year out in the open, here in the garden, and it's now going to a very beautiful permanent site where it will be on a plinth in the water.[2] It is a recumbent form with great caves, and I'm hoping that the reflections of the water and the whole setting will bring out the feeling of stone. It's an Italian limestone, which I'm now carving another piece of – this tall vertical.[3] I so love carving. It seems to me the most rhythmical and marvelous way of working on live and sensuous material because, even if one has two pieces of the same stone, they have another nature. Every piece of wood and every piece of stone has its own particular live quality of growth, crystal structure, and one becomes utterly absorbed and blended rhythmically within the cutting of this. I think of all the activities it is the most rhythmical; the left hand, as it were, does all the thinking, holding the chisel, and the right is merely a motor, and one gets a very easy rhythm which allows one's thought[s] completely free rein as one tries to make the forms and contours which will express oneself. And this

really goes on right to the end where the very final work – the finest rubbing and hand polishing – will reveal the state of mind of the artist and what he is trying to express.

Being a carver, I do have a complete conception in my mind of the form I'm making before I start carving or, indeed, making any work. It is, I suppose, simply a faculty one happens to be born with – being able to see mentally all around the form before one begins. And I do find that if, for instance, architects ask for a maquette for a given position, that is one of the most difficult things, because my whole idea is to make a small maquette which will live as a small sculpture but leave myself completely free and, indeed, I always have to stipulate this, that when I work on a bigger scale that it will change because scale is all important. Man is only up to six foot high, and our whole vision changes according to height [and breadth] and depth, and it is a physical reaction which tells on all our spiritual perceptions. Therefore, I would prefer to make a maquette which looks terribly nice as a small sculpture and is exciting to me, and then act quite freely when I do much bigger work – to change and expand and alter wherever I feel the physical and spiritual necessity.

I like to have a lot of my work somewhere near me, and the garden is a beautiful place to have it in, because often I go out in different light[s] – even in moonlight, in the middle of the night, or at sunrise – because the changing light reveals so much with sculpture. It takes on an entirely new presence, and one can learn and be stimulated the whole time. If I'm deep in work on a particular new piece, I am, of course, entirely dedicated to that one, and until I've firmly established my thoughts on the material, I don't really pay much attention to anything else. But then, I quite often have two or three things going, because I love to work regularly; and I have, say, a large work which is quite clearly defined, which I can work in fine weather, or indoors I can have a great piece of wood which I'm developing or that has to be polished or the fine work done. And I particularly love to have things related in a friendly and near way to human beings, so that they can be touched. The patina of people's hands is a wonderful thing on sculpture, and I really believe that through touching they can be deeply expressive to people. In fact, one or two letters I've had in the past years have been from people who were blind, and who did through their hands really get the idea that I had been trying to express.

1 The book and associated LP record and cassette accompanied the film 5 *British Sculptors Work and Talk* made by the American documentary filmmaker Warren Forma and released in 1964 (the film was an edited version of the publication and LP). Variations on the LP are indicated in square brackets.
2 *Curved Reclining Form (Rosewall)* 1960-2, Nebrasina stone, BH 291, Chesterfield, Derbyshire. See pp.164–5 and fig.43.
3 *Pierced Vertical Form* 1960-4, Nebrasina stone, BH 295.

Tribute to Herbert Read on his 70th birthday, January 1964, unpublished manuscript and typescripts[1]

It would be impossible to imagine the last 35 years without Herbert Read. Since the end of the first world war he has been not only an inspiration to 'a way of life' but also a friend and a unique companion to our generation of artists because he understood the wholeness of life by an understanding of all its individual parts as manifested in the creative activity of our time.

This most rare capacity to co-ordinate all the facets of poetry and art has made him an international figure of tremendous importance as we all realise – we have all been inspired by his philosophic thought and the incomparable beauty of his style in prose; but basically he is a poet and a poet who will be appreciated more and more as the years pass.

In a limited way, I have often thought that Herbert Read should be allowed to wander quietly in his own garden and within this peace, write more poetry.

46. Hepworth and Herbert Read at the opening of the Penwith Gallery Summer Exhibition, St Ives, 1 July 1964, in the new sculpture court, with a cast of the bronze *Figure (Archaean)*, 1959. Photograph: Lee Sheldrake/ Penwith Photo Press

But more recently I have understood that by meeting the demands that the world has made upon him, he has been nourished and not deprived, and has reached, in both poetry and thought, a transcendental quality of perception.

Over twenty years ago, when Herbert Read was staying with us, my youngest daughter then eight years old, asked me 'what it was that made Herbert so good'. This question I have never forgotten because 'goodness' in its true sense is <u>wholeness</u>: and Herbert Read as a poet and Herbert Read as a man, with a rare compassionate understanding, has given to our generation more than anybody else. His integrity and vision remain as fresh and unspoiled to-day in 1964 as in 1929 – I pay homage to him, and with great love acknowledge my debt to him.

1 J.P. Hodin requested in January 1964 that Hepworth 'write down what Read meant for your generation' for a tribute he had been asked to write on the occasion of Herbert Read's 7oth birthday for *The British Journal of Aesthetics* (letter of 20 January 1964, TGA 20132/1/93/6). In the event only short pieces by Hodin and Adrian Stokes appeared there in July 1964.

Quotations from Hepworth in J.P. Hodin, 'Quand les artistes parlent du sacré', *XXe siècle*, Paris, December 1964, vol.XXVI, no.24 (new series)[1]

All true works of art are an act of praise. Out of inert substance a new inevitable idea is born which is of itself an apprehension of the force of life. It is an acknowledgement of the external power which enables man to create in an infinitude of ways visions which all share. A perception of the holiness of life and the universe. Reverence for procreation and the whole vital generating power of life in our universe has endowed the human spirit with the gift of an affirmative creation in art. This will persist as long as human life continues. The image is the mystery and the mystery lies within the image.

The sculpture within the hands can be as moving as the head of an infant. To look within a painting can be an experience equal to the unfathomable beauty in human eyes. The force is unseen and unknown; but it is the universal principle which speaks to men at all times.

1 A response to Hodin's request that Hepworth should send 'a poetic statement for me:- 10–20 lines' on the 'persistence of "holiness" in art' for an essay he was writing on the subject (letter from Hodin to Hepworth, 20 January 1964, TGA 20132/1/93/6). Hodin also quoted from his conversations with Picasso, Braque, Brancusi, Miró, Moore and others. Hepworth wrote her tribute to Herbert Read (pp.177–8) at the same time.

Tribute to Michael Tippett, January 1964, in *Michael Tippett: A Symposium on his 6oth Birthday*, edited by Ian Kemp, London 1965

I first got to know Michael Tippett well in 1952 when we were all working on the idea of the St Ives Festival of Music which took place in June 1953. During this time I grew to appreciate the fine discipline and the philosophically inspired faith which makes him the artist he is. As a composer, and as a man, he has taken a stand (and stood firm) in a belief, as I understand it, that life has its own innate laws, and he has demonstrated, as an act of faith, this trust in the human spirit and conception of a pure idea in both his music and his ideas on music.

It was in 1954 that Michael approached me about the sets for *The Midsummer Marriage*. We discussed it, sitting in my garden; and for the next months I had the opportunity of seeing him at work and of appreciating more and more his remarkable powers of disciplined and yet inspired co-operation. Even under dire provocation he was always serene, non-aggressive and gentle. His quiet presence, even in a turmoil, always had the effect of resolving the problem. Ten years have passed and yet the memory of his presence has never faded.

At the time I thought that *The Midsummer Marriage* contained a new idea for opera: a concept which I felt could open the doors for a formal concept of opera in the future. Ten years later I still think the same way about it.

47. Photograph of Tippett and Hepworth with one of her designs for *The Midsummer Marriage*, 14 January 1955. Photograph: Alpha General/Press Association Images

If this opera suffered a defeat, it was a worldly defeat – and only of consequence in so far as it set back the natural development in this field by perhaps twenty years. I do feel, however, that Michael Tippett is the person best equipped to develop this more abstract idea of opera and to explore what it might mean to our culture today. I have often tried to imagine this development and I believe it could only be done by absolutely refuting compromise. I feel that with severe discipline and a totally abstract (or a totally romantic) presentation this opera has a most meaningful life of its own. It was a great experience to be present during its rehearsal and presentation.

I think *The Midsummer Marriage* asked, in both its allegorical meaning and its symbolism, for a new discipline; also for a new tradition, perhaps related to the formality of Greek theatre or of the Mystery Plays. This demand should, I feel, be developed and fulfilled. On traditional lines, the unwieldy passion of the chorus could be an asset. But in unconventional presentations, musically, the chorus is needed only as voice, and, both musically and in *mass*, should be as disciplined as part of an orchestra and not dramatically produced in the traditional sense.

The English find a romantic idea easier to accept; but I still have an absolute faith in the classical development even in opera (that most difficult

48. The first production of Michael Tippett's *The Midsummer Marriage* with sets and costumes by Hepworth, Royal Opera House, London, 1955. Photograph: Houston Rogers

[1964]

of all the arts), and I believe that just round the corner, as Michael Tippett saw, the composer can find a new form which will in the future be full of meaning for our society.

But as I see it, it means a new discipline. It means a new emphasis on movement and the meaning of gesture; a new emphasis on the use of light and of darkness, and on colour and form so that the music and the composer's 'idea' can speak without dilution.

As a composer, Michael Tippett has great fields of creativity now open to him; but as an individual with rare poetic and lyrical insight, both qualities which are as much rooted in our past as the great romantic tradition, I think he is specially endowed with the creative perception which would enable the development of this idea, in sound, form and colour, to become a new part of our heritage.

On his sixtieth birthday I send Michael my deepest appreciation of his music, as well as my gratitude for his friendship; and I wish him the best of health and happiness so that during many long years of work to come, he can reach out further into the world of music so peculiarly his own and give to all of us the joy of sharing in his expanding vision of music and philosophy.

Speech made at the unveiling of the United Nations *Single Form* on 11 June 1964, published in *The Unveiling of* Single Form *by Barbara Hepworth, Gift of Jacob Blaustein after a Wish of Dag Hammarskjöld*, New York, United Nations, 1964

It is very difficult for me to speak, because I can only communicate through my sculpture, but I would like to offer these few words.

Dag Hammarskjöld spoke to me often about the evolution of the *Single Form* in relation to compassion, and to courage and to our creativity. When I heard of his death, and sharing grief with countless thousands of people, my only thought was to carry out his wishes.

Dag Hammarskjöld had a pure and exact perception of aesthetic principles, as exact as it was over ethical and moral principles. I believe they were, to him, one and the same thing, and he asked of each one of us the best we could give.

The United Nations is our conscience. If it succeeds it is our success. If it fails it is our failure. Throughout my work on the *Single Form* I have kept in mind Dag Hammarskjöld's ideas of human and aesthetic ideology and I have tried to perfect a symbol that would reflect the nobility of his life, and at the same time give us a motive and symbol of both continuity and solidarity for the future.

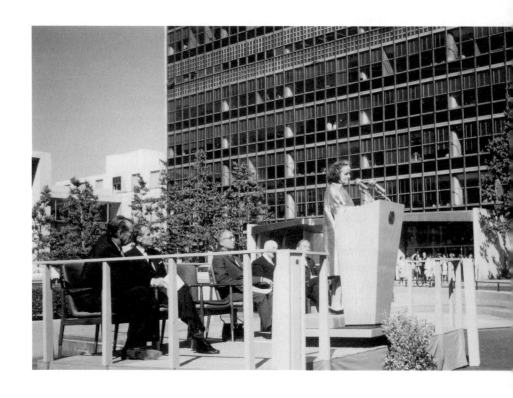

49. Hepworth speaking at the unveiling of *Single Form* 1961–4, unique bronze, at the United Nations, 11 June 1964

50. *Single Form* in situ at the United Nations, c. December 1964. Photograph: Warren Forma

**Tribute to Peter Lanyon, *St Ives Times and Echo*, St Ives,
4 September 1964[1]**

He was a great painter, a painter of international stature and a very unique
artist, therefore his death is a terrible loss to British painting and to
contemporary painting in the world. He was a unique spirit – a spirit that
was perhaps airborne. I don't suppose he knew how much we all thought
of him, but we did love and admire him tremendously.

1 Hepworth's words were quoted in this news report on Lanyon's death aged 46 on 31 August following
a gliding accident.

**Notes for Paul Hodin, 1 February 1965, unpublished manuscript
and typescript**

1. *Torso* 1929 ivory wood Private collection

 For the first time I felt free of all my training as a sculptor – free to make
 any form in any <u>mood</u> and in any material.

 Somebody came and bought this sculpture and I have never heard of
 it nor seen it since.[1] But I will always remember the delight I felt in this
 new found freedom and the physical exhilaration of the ivory wood and
 the knowledge that within my hands new forms and life were growing.

2. *Pelagos* 1946 wood with colour and strings The Tate Gallery

 'Fusion with landscape' – In this sculpture I felt that I and my landscape
 and seascape were as one. I felt sure at this moment that early primitive
 images were entirely active and of significance in the year of 1946. My
 ideas and my working body became fused into one simple image and
 my perceptions unified in both time and situation.

3. *Pierced form* 1963–4 Pentelicon marble The Tate Gallery

 I have always felt that sculpture must come out of the whole mind and
 body – a bringing forth of evocative forms from far back in life. Forms
 that impel loving hands and have a sense of magic.

 In this sculpture I felt that of all my many marble carvings it is the
 strongest and yet the most tender in feeling. I cannot describe the
 sensation of the joy of completing it. I know it provokes hostility in
 many people; but I also know that hostility means people have been
 moved and they resent being moved by simple images.

Another work of Art

I do not think I have been deeply affected by any single work of art –
but I have been conditioned and activated by great early periods of art –
particularly paleolithic, neolithic, cycladic art, archaic Greek, primitive
periods of all times. I have been moved more by the mood and climate
of a period – rather than by personal achievement. I do not like drama
in sculpture, nor human pretensions of sophistication or versatility.

Even a fragment of an early period will move me deeply – I admire and
wonder at the beauty and extent of man's creativity especially in this
20th century. But I am profoundly moved by the simple magic of the
unconscious forms which arrest our attention in field or forest or by
moon or sunlight. The image which impels us to make a movement
towards affirmative life. I have always felt that sculpture was a sense of
touch with reality – a holding of hands in the face of life and death –
a balance. It should be anonymous.

1 Whitworth Art Gallery, Manchester (gift of Dr A.E. Anderson, 1934).

**Short note on *Sphere with Inner Form* (1963, bronze, BH 333) included
in *Contemporary British Sculpture* (open-air Arts Council touring
exhibition), written for the *Northampton Chronicle & Echo*, 14 June 1965[1]**

Every form, whether it be square, circle or oval, or organic, has its inner
form as well as its outer form. Both are dynamically related and within this
relationship there is always the centre, or the foetus, or the eye, or the heart
where one can feel the pulsation of life.

This, to me, is what sculpture is about – to release the inner force and to
poise a new energy which will make one's own body and spirit react to our
life and the universe.

1 Abington Park, Northampton, was the third venue for the Arts Council's open-air sculpture
 exhibition of 1965. The *Chronicle & Echo* wrote to Hepworth to request a commentary of 50 to
 100 words on her work in the exhibition, a cast of *Sphere with Inner Form*. Her typescript,
 dated 8 June 1965, is in the Tate Archive.

51. *Sphere with Inner Form*
1963, bronze, BH 333.
Photograph: Studio St Ives,
early 1965

'The Artist on his Work – 4: "Sculpture – An Act of Praise"' in *The Christian Science Monitor* (London edition), 13 July 1965, vol.57, no.192[1]

It is sometimes said that contemporary art is too impersonal; is lacking in warmth. It is also accused of being insincere. But to me abstract art is the most passionate and affirmative form of art there has been for centuries. In any movement there is always an academic group who are insincere because they are not quite at grips with the meaning of art. But surely this cannot be said of the men and women who have been prepared to be without money or status to fulfill what to them is an expansion of human experience? Many of us had to wait a long time to achieve recognition or what the world calls success.

However, during the past thirty years there has been an extraordinary development in the understanding of contemporary art. This is the result, partly of our own persistence, of our own faith, partly of the faith of others which enabled us to continue. More and more the man in the street has the chance to see contemporary art. In such places as Battersea Park in London,

in the Tate Gallery and in International Exhibitions, he has been able to enjoy sculpture in the open. He has begun to realize that sculpture can be a thing of joy, not just a memorial on a plinth, or a memorial to the dead.

In the main I find my own inspiration comes from man's recognition of the universe. I have watched people a great deal. We all use phrases such as 'being in touch', or 'out of touch'. When people come into my studio in Cornwall – those, that is, who are not so steeped in tradition that they can no longer 'look' – it delights me to hear such people say: 'May I touch?' and having touched: 'I don't understand it, but it does make me think of so and so.' They are always right. We are in touch because they have picked up the evocation of an idea I had wanted to communicate.

In the sculpture entitled *Wave*, for instance, people have recognized the curve of the Cornish breakers, the music of the wind passing through the strings. *Curved Stone with Yellow* conjures up the sense of being curled up in the shelter of sunlit cliffs. To many the bronze sculpture *Meridian*, which stands outside the State House in Holborn, London, expresses the impetus of growth. This sculpture stands fifteen feet high.

Much has been done in recent years through radio to bring modern music to the people. The many groups who have built up collections of painting and sculpture and are taking them round the schools, are promoting the most lively interest among children, are drawing penetrating comments. There is a world of difference between seeing an original and seeing a color reproduction.

I always wanted to be a sculptor. As a child I motored with my father all over the West Riding of Yorkshire. To my eyes every landscape became a sculpture. I had to be a sculptor because I had to use my hands to make an image. I rather think that seeing an image mentally before one begins is a special faculty. As a musician conceives his composition from end to end in space and time, so a sculptor sees in his mind the finished work, all the way round, before he begins it.

My Yorkshire background was tremendously vital. The paradox of the rather grim industrial towns springing out of the magnificent beauty of the West Riding made one think philosophically about the relationship of man to his environment, of the dignity and beauty of the human spirit which can transcend a drab environment and harsh economic conditions. To me a basic purpose of sculpture is to express the importance of man and his fundamental unity with nature. Gesture, movement, rhythm, whether in human behavior or in nature, are of vital importance.

When at seventeen I was fortunate enough to win a scholarship to the Leeds School of Art I did not find myself in harmony with the school's traditional methods of tuition, but I did accept discipline because I had to keep my scholarship. Nor was the year spent there wasted. I learned a tremendous amount about movement, anatomy and structure, even though I did not put the knowledge to traditional use.

At the Royal School of Art in London, to which my next scholarship took me just after the war, there was a tremendously vital movement. In addition to people like myself, almost straight from school, there were fully formed students back from the war on army grants. Several of these proved to be major artists, among them Henry Moore. We made quite a group who really helped and sustained one another. We had a clear idea of our goal. But I do not think we were in any way aggressive.

A Traveling Scholarship to Italy was enormously important. Neither in Yorkshire nor in London had I really appreciated the relationship of light, of moon or sun, to forms. In the strong Italian light the subtleties of form, color and contour were intensified. I spent my entire year looking at and studying painting, architecture and sculpture in relation to light. I also studied the traditional ways of carving marble, a stone not native to England. Once more I was in disgrace. Instead of coming back with traditional works, I did not produce a single piece. But that year of looking (not making) has remained a constant inspiration.

Much later, in 1954, I went to Greece. There was no money to go earlier. Greece more than fulfilled my greatest hopes. There I found the extraordinary light which I had discovered in Cornwall. I also found the philosophical relationship between man and his landscape, an understanding and harmony, a maintenance of the spirit which gives power to form. Form as an affirmative image is really the tactile as well as the visual, concrete, embodiment of man's poise in relation to the universe.

In 1930 I turned away from realism because I was a carver and believed in 'direct' carving, that is in working straight into the block. When I found that I could thus carve freely, make forms which expressed my feelings, but which bore no relation to anything but my own ideas about life itself, I realized that the whole conception and harmony of the idea was of paramount importance. When in 1931 I pierced my first piece, I remember the great joy it gave me to find the depth and resulting expansion of the form and of the light entering it. I had achieved a complete sense of freedom for my own calligraphy.

In a foreword to the catalog for an exhibition of my work in 1937, Professor J.D. Bernal likened some of my sculptures to the ancient stones and cromlechs of Cornwall. But at that time I had not been to Cornwall. When, just before the war, I came here to live, the Cornish landscape linked up so many of my earlier convictions that it fused for me my childhood in Yorkshire with the inspiration of the light and philosophies of Italy and Greece. In the sculpture *Three Forms (Winter Rocks)*, the stones are reminiscent of the groups of stone scattered about the moors, or a group of figures on the beaches.[2] *Group I (Concourse)*, carved in marble, imagines the movement of a group of people communicating with one another in a state of stability and understanding.[3]

To me one of the most exciting things about present-day sculpture is the expansion of the sculptural idea in the entirely visionary conceptions, in the

use of many different materials. In addition to stone, bronze and wood, sculptors now work in cement, slate, copper, steel, glass and even plastics. Just as the Italian Primitives, by their perceptive use of the very colors one now experiences on a jet flight, expressed their ideas of heavenly beauty, so I feel that contemporary sculptors are unconsciously realizing the affirmative images which our present society needs if it is to come to grips with the extraordinary developments in science and in space; if it is to meet the uneasy sense that we may not be able to hold our own.

It seems to me that the post-war difficulties which architects have had to meet (the current sense of danger) have produced in them, and in some artists, a trend toward a short-term policy, a pessimistic outlook. But I do feel that this can be overcome. The issue may well depend on the attitudes we adopt. Are we going to be rich, rich that is in ideas, or are we going to be obsessed by the fear of being poor materially? In the expression of ideas there is no limitation. I believe most strongly that any sculpture made now should be valid in its form and ideas a thousand years hence. A sculpture should be an act of praise, an enduring expression of the divine spirit.

1 Based on an interview on 17 May 1965 with Marjorie Bruce-Milne from *The Christian Science Monitor*, who provided Hepworth with a transcript for her comments and alterations. See their correspondence, together with the list of questions Bruce-Milne sent to Hepworth, on which the interview was based (TGA 965/2/17/16).
2 1965, slate, BH 374.
3 1951, Seravezza marble, BH 171.

Robert Hughes, 'About Nothing Except Love: Visiting Barbara Hepworth in Cornwall', *The Bulletin*, Sydney, 19 March 1966[1]

From Robert Hughes in London

At Land's End, England suddenly stops. The earth of Cornwall plunges away, in seamed granite cliffs, to the Atlantic. In winter it is a menacing sea, dully grey, streaked with white and turquoise, grunting and sucking at the black rocks which project from it.

The light is very pure. It bounces from all angles off the sea and is reflected by the sky: it seems to be washed clean by the great Atlantic winds, and one can see for miles. Seen in the fading light, a pair of mines on the ridge of a distant hill have the mythical look of ancient beasts poised for battle.

But then, this is an ancient landscape. On the moors, one walks in the presence of archetypes. The landscape is so bare, so structural, so moulded and carved and rippled by wind and water, that all its elements are explicit: fined down to their essential rhythms. The rocks above Zennor and St Ives are exposed like the granite spine of a buried animal, and the wind has cut

[1965-6]

them into sculptural shapes: some of them, eroded to one point of balance, can have their 10 or 50 tons set rocking by the pressure of a hand.

'It's like a Hepworth,' I said to a painter who lives in St Ives, Patrick Heron, who represented England at the São Paulo Biennale. We were looking at such a rock, carved by friction into a long moonlike curve and pierced with holes. 'It's better,' said Heron. 'It's original.' I did not agree. I had just spent a couple of days with Barbara Hepworth in her studio in St Ives.

Hepworth's studio is tucked behind a long, very high stone wall. The stones she carves, the limestone, Hopton Wood stone, black slate and translucent blocks of marble, get hoisted over this wall by a crane: visitors go in through a low, blue, wooden door. The first impression, on entering, is of cool, absolute precision, black and white: a circular white dining-table with black leather swivel chairs, white walls, a collage by an Italian artist named Valenti (three heavy overlapping black shapes on a white ground): and two corpulent cats, one black with white spots, the other white with a black tail, each with a bell round its neck to warn the birds.

'We had a silent spring here last year,' Barbara Hepworth told me later. 'A frightening experience: one hardly heard a single bird, not even an owl hooting at night. Have you read Rachel Carson's book?' I had. 'I'm doing what I can to induce the birds to come back to my garden, so the cats must be belled.' Like everything else in the studio, the cats have an infallible sense of placement, gliding between the slate groups and strung bronze forms like sailors in rigging.

In *Private View*, Bryan Robertson described Barbara Hepworth as 'an amiable Captain Ahab'. It was not my first impression: but one was prepared for something like it. The image suggests a wrinkled, exultant giant of the sea, driving the harpoon into the white whale (or the chisel into the white Carrara) with a rhetorical yell. In fact, the initial surprise of meeting Barbara Hepworth – banal as it sounds – is how small she is, and how self-contained. Not a gesture or a movement, not a flick of an eye-brow, is wasted. How could this diminuitive woman, 62 years old, with skin and flesh laid over bones as delicate as a seagull's, have modelled and carved a body of work five times the size of Michelangelo's, in equally resistant materials and on as big a scale?

'I am constantly plagued by this little-woman attitude,' she remarked to me. 'There is a deep prejudice against women in art. Many people – most people still, I imagine – think that women should not involve themselves in the act of creation except on its more trivial fringes. They still think of sculpture as a male occupation: because, I suppose, they have a misconception of what sculpture involves. There is this cliché, you see, a sculptor is a muscular brute bashing at an inert lump of stone, but sculpture is not rape. No good form is hacked. Stone never surrenders to force. One must seek out the latent form within the stone and then it need only be touched with the chisel, so –' a quick tap of the edge of the hand, in air – 'and the form will appear. I am the

last sculptor alive who knows how to carve marble. The others treat the stone as if it were cold. Tomb monuments. They attack it and crush the crystals. But it is such a live stone that it can only retaliate by going dead. Its being can only be released by love.'

She learnt to carve marble as a student in Italy. There she studied Etruscan, Romanesque and Early Renaissance sculpture (especially the carvings of Niccolo Pisano). But she instinctively recoiled from the High Renaissance: most of all, from Michelangelo. 'I detest the rhetorical, and Michelangelo, like Rodin, is a rhetorical sculptor. I do not believe that he had a very articulate sense of sculptural form.' And in this context, the transcendently important moment of Barbara Hepworth's life came when, in 1954, she visited Greece for the first time.

'I remember standing on Patras,'[2] Barbara Hepworth said later, 'and thinking – with that incredible stretch of sea and islands before me – how intensely a figure rising in the distance expressed that perfect elevation of the human spirit which in a way is conveyed by powerful sculptured form. I felt that the Greek idea had something of the will, the power, the ruggedness we need...'

The whole content of Barbara Hepworth's work is its sensuality. These smooth, exquisitely shaped carvings, with their hollows and caves, their polished or vibrantly textured surfaces, their surging contours, don't merely invite the touch of one's hands: they demand it.

'I was never so delighted,' Barbara Hepworth told me, 'as when my sculptures came back from a retrospective at the Whitechapel Gallery. They were black with handprints, from people touching and feeling them – and black in all the right places. The hand goes instinctively to the form. I think it's a terrible mistake to treat sculpture as if it were simply a thing to be looked at.'

We talked for a while about the practical difficulties of sculpture. 'It's a most costly profession,' said Hepworth, picking up a chisel. 'This has a tungsten bit. Every time it breaks, it costs three pounds. I suppose my expenses start at £200 a week, with the assistants I employ. And then there are those embarrassing gifts. For instance, a kind maharajah sent me, not long ago, a present of some very beautiful wood from India, most exotic. The unfortunate thing was that it cost me about £300 to get the load from Plymouth to here. Come outside, I want to show you my sheep.'

Puzzled, and vaguely remembering that Barbara Hepworth had, in poorer days, supported herself by market gardening (but merinos in St Ives?), I followed her into the studio yard. It was piled with new blocks of Carrara, virgin white. 'They are like sheep, aren't they?' she said, running her hand over one. 'One reason why I live in St Ives is that I can carve out-of-doors, all the year round. That would be unthinkable in London. It gets so cold that one's hands stick to the chisel. I must work in the open air. One feels a continuity with the landscape.'

The garden around Barbara Hepworth's studio yard is full of sculpture. Great bronzes, ten feet high, rise serenely among the trees. Generally, the sight of many sculptures crowded into a small space has a depressing effect on me. Every form generates its own space around it, and these spaces and scales can clash, producing an effect like bodies heaped in a mortuary. Not so in Hepworth's garden. Each sculpture, large or small, has a marvellous continuity of scale and space with its neighbor. As one walks among the sculptures in this garden, or among the 50 or so more which inhabit the St Ives Palais de Danse across the road, which Hepworth recently bought for a store-house, one becomes aware of the urgent pressure of landscape. Each shape is an epigram of some landscape experience, in Cornwall or Greece.

'Nearly all my sculpture is related to landscape,' Barbara Hepworth said, confirming my impression. 'In fact, as you will have seen, the sculptures sometimes have quite specific titles – *Sea Form, Porthmeor* and so on. They are about this world.' Another precise gesture, the hand arching to take in the curve of the Atlantic and the curve of the moors behind. 'I see this as the aim of art: to create an ideal structure which is sensual, too. To give sensual coherence a philosophic form. And that can only be achieved through love. In the end, my sculpture is about nothing except love.'

1 Hughes also reviewed Hepworth's exhibition at Gimpel Fils on 29 May in *The Sunday Times*.
2 Patmos (see Roditi interview, pp.141–2).

'A Sculptor's Landscape', *Barbara Hepworth: Drawings from a Sculptor's Landscape*, with an introduction by Alan Bowness, London 1966[1]

I cannot write anything about landscape without writing about the human figure and human spirit inhabiting the landscape. For me, the whole art of sculpture is the fusion of these two elements – the balance of sensation and evocation of man in this universe. At an early age I began to observe the movements and behaviour of people, to study their posture and gestures and anticipate what was about to happen. Were people around me ill, or cross, or anxious? Why did the people in the asylum opposite shuffle along when they had green grass and trees, whereas we were so gay just playing on the paving-stones outside?

I think I must have been obsessive and secretive and obstinate from birth, and a difficult child to live with. I remember my first day at school and the fantastic sensuous joy of the smell of the paints I was given and the brilliance of the colours I used, and the terrible scene that ensued when the class ended, the paints were taken away and I screamed and screamed.

Then at the age of seven there was a lecture with slides on Egyptian sculpture given by the headmistress, who later became one of my greatest

friends and helpers, and my mind was completely focused. This was the world I understood, and I must get to know more! So I read everything I could: I made models, did portraits in clay and plaster of my sisters, I rejected all the pictures around me and tried to find the contacts that would enable me to go orientated in the world that meant reality to me. More and more I observed the granite sets, the steep hills of industrial Yorkshire, the scurrying of mill girls in their shawls huddled against the cold and wind – the lonely figure against a street gas-lamp, the squatting miner outside his door, and the gleaming 'withinness' of his sparkling ugly house.

Then came the great day when I was allowed to go with my father on his rounds of roads and bridges, in the course of his duties as civil engineer. I became a sort of bird soaring over the landscape. My father would mention very quietly the stresses and strains of roads and bridges and we would then continue to float through the landscape in our private thoughts. It was an early and very high car, which enabled us to see over hedges. At the furious pace of about 25 miles per hour, and being very careful not to disturb the horses and drivers of their carts, we roamed through the dales and valleys and up the moors, and through the Pennines. From the deep indigo and black and scarlets of the industrial heart we sailed through unimaginable beauty of unspoiled countryside. The position of man in relation to this country, and the horror of the approaching slump and then the First World War, absorbed all my thoughts. The exploitation of man, the image of human dignity in spite of these horrors, obsessed me. I would imagine stone 'images' rising out of the ground, which would pinpoint the spiritual triumph of man and at the same time give the sensuous, evocative, and biologically necessary fetish for survival.

My father was an exceptional person. In all the years I knew and treasured his friendship I never once heard him be angry or say an unkind word. He never intruded on my thoughts and he was very silent, and so we travelled, in quiet harmony, through the industrial heart of the West Riding and through the superb country. These photographs which I have taken of Yorkshire were chosen nostalgically. [figs 52, 53, 54] The textures, the form and the sense of movement all belong to my sculptor's world, where you (the reader) and I the sculptor become one, and here we create an image that combines all our unspoken perceptions of infinite continuity of life and the physical apprehension of time and space.

At an early stage I became troubled about the 'graven image', but I decided that it was sin only when the image sought to elevate the pretensions of man instead of man praising God and his universe. Every work in sculpture is, and must be, an act of praise and an awareness of man in his landscape. It is either a figure I see, or a sensation I have, whether in Yorkshire, Cornwall or Greece, or the Mediterranean.

In spite of being such a silent and obstinate child, I must have been surrounded by real love and understanding. At home I was allowed to make

52, 53, 54. Photographs of the Yorkshire landscape commissioned by Hepworth and taken in October 1964, reproduced in *Drawings from a Sculptor's Landscape*: (clockwise from left) near Keighley; Cow and Calf Rocks above Ilkley; Haworth. Photographs: Lee Sheldrake/Penwith Photo Press

an awful mess. At school I was allowed to paint and draw whenever I was free to do so. A strange kind of obstinacy made me do studies of my white mice, newts, and frogs, which never got me a prize, but made me highly critical. At a fairly early age I got hold of Thompson's book on Anatomy and studied it furiously. The wonderful structure of the human frame is an architecture of highest proportion, and all sensitivity to landscape is in one's ability to feel within one's body: to feel with a primitive humility a response to life and location, a response to form, texture and rhythm, and a response to the magic of light, both sun and moon everchanging. A great gift my parents gave me and my sisters and brother was the annual trip to Robin Hood's Bay. Here we stayed in a house on rock rising out of the beach. I had an attic room and would get up at dawn to go painting all by myself and undisturbed in a world of fantastic beauty. The rocky scars, the boats, sea and cliffs inspired me continuously. Artists lived in Robin Hood's Bay and I was able to go and sniff the smell of paint and canvas and explore this wonderful free world of changing light and tide and colour. These holidays must have started early in

my life because the only prize I got at school was for a collection of seaweeds gathered from the pools at the age of seven. But here I painted and studied the structure of natural forces, and noticed the importance of a figure standing far out on the rocks.

I began to co-ordinate the human figure and landscape.

Many years later I moved into this Cornish landscape, where the superb light and colour emphasize the importance of man in landscape. Again many years, and I managed to get to Greece, where the same extraordinary thing happened. In that supreme light the importance of a human being in the landscape became predominant.

I have been in St Ives over a quarter of a century. Never, in the time, have I seen two days alike. Here I have found the same bones and roots and scars and tissues as in Yorkshire; but in addition there is light and warmth, and a sense of gaiety of movement that has left our great cities. Here I can slowly travel to a near-by hill and, with larks singing above and the distant sound of sea and wind and voices carrying from far-away farms, a distant figure is a monument, whilst I myself am cradled in the anatomy of landscape.

I rarely draw what I see – I draw what I feel in my body. Sculpture is a three-dimensional projection of primitive feeling: touch, texture, size and scale, hardness and warmth, evocation and compulsion to move, live, and love. Landscape is strong – it has bones and flesh and skin and hair. It has age and history and a principle behind its evolution.

I detest arbitrary form like an indented pillow or a misshapen potato. In all natural forces there is an underlying principle of growth and form, endlessly adjusting and purifying itself. Only when man intervenes, as in open-cast mining, does the landscape become as shapeless and ugly as an old pillow.

Whenever I am embraced by land and seascape I draw ideas for new sculptures: new forms to touch and walk round, new people to embrace, with an exactitude of form that those without sight can hold and realize. For me it is the same as the touch of a child in health, not in sickness. The feel of a loved person who is strong and fierce and not tired and bowed down. This is not an aesthetic doctrine, nor is it a mystical idea. It is essentially practical and passionate, and it is my whole life, as expressed in stone, marble, wood and bronze.

In Greece the inspiration was fantastic. I ran up the hills like a hare, with my notebook, to get there first and have the total impact of solitude. I made many drawings for new sculptures called Delphi, Delos, Mycenae, Epidauros, and Santorin. These forms were my experience there. After my solitude I waited for the 199 people I had left behind and watched their movements and responses on entering the architecture in the superb location of mountain, hill and plain. This was very anti-social, I admit; but I had waited thirty years to get to Greece.

To get up early and be the first to climb up to Santorin, to find my place at the top of the theatre of Epidauros, surrounded by the sighing wind above,

and warmed by the worn marble – with the heavenly sound of the human voice coming from below and the whole vast and glorious shape below me – was the embodiment of the sculptor's landscape. Timeless and in space, pure in conception and like a rock to hold on to, these forms in Greece have been a constant source of inspiration – Patmos in particular, where the curve of the horizon was omnipotent and the islands rose up from the water like flowers in the sun. A sculptor's landscape embraces all things that grow and live and are articulate in principle: the shape of the buds already formed in autumn, the thrust and fury of spring growth, the adjustment of trees and rocks and human beings to the fierceness of winter – all these belong to the sculptor's world, as well as the supreme perception of man, woman and child of this expanding universe. It is within our bodies to feel and to be, and in making a sculpture we do, in fact, make a talisman that enables us to enter our architecture and look at our painting as fully posed human beings. Every movement we make has its meaning. And I have seen, as I have else-where written, people enter the Piazza San Marco in Venice with an entirely different physical bearing, reacting to the space and proportion around them, and I have seen wonderful teams in operating theatres work together with instinctive grace and harmony of movement, making a spontaneous composition of the highest order.

I usually get dancers as models and ask them to move about, to limber up, to relax and to move and move until I know them all the way round. I become the model and the drawing becomes me. But always it is the structure and spirit which is the inspiration.

I have included a photograph of St Ives taken for me from the air. [fig.55] For twenty-five years, walking through these streets, I have felt through my feet the geological shape of the place. The aerial view proved to me my point; it is through our senses that form, colour and meaning are given to everything we make and do. I wrote about St Ives many years ago: 'The sea, a flat diminishing plane, held within itself the capacity to radiate an infinitude of blues, greys, greens and even pinks of strange hues, the lighthouse and its strange rocky island was the eye: the Island of St Ives an arm, a hand, a face. The rock formation of the great bay had a withinness of form which led my imagination straight to the country of West Penwith behind me – although the visual thrust was straight out to sea. The incoming and receding tides made strange and wonderful calligraphy on the pale granite sand which sparkled with felspar and mica. The rich mineral deposits of Cornwall were apparent on the very surface of things; quartz, amethyst, and topaz; tin and copper below in the old mineshafts; geology and prehistory – a thousand facts induced a thousand fantasies of form and purpose, structure and life, which had gone into the making of what I saw and what I was.'[2] I also wrote to Sir Herbert Read (*The Meaning of Art*): 'Working realistically replenishes one's *love* for life, humanity and the earth' (Here I would now add 'the universe').[3]

55. Aerial view of St Ives with Hepworth's studio in the centre foreground. Photograph commissioned by Hepworth from Aerofilms in summer 1963, reproduced in *Drawings from a Sculptor's Landscape*

Working abstractly seems to release one's personality and sharpen the perception so that in the observation of life it is the wholeness, or inner intention, that moves one so profoundly: the components fall into place, the detail is significant of unity.

When I start drawing and painting abstract forms I am really exploring new forms, hollows, and tensions which will lead me where I need to go. Planes and curves are the pure rhythm of stance and energy. The pierced hole allows bodily entry and re-entry. The spiral takes hold of one's hand and arm. A fullness can be a breast, or a head or a shoulder. A hollow can be the taut hollow in the thigh. Strings can twist one from the front to the back, and colour establish the mood of place and time. Out of all these components I search for new associations of form and hollow and space, and a new tautness and awareness for the growth of new sculptures.

Sculpture is to me an affirmative statement of our will to live: whether it be small, to rest in the hand; or larger, to be embraced; or larger still, to force us to move around it and establish our rhythm of life. Sculpture is, in the twentieth century, a wide field of experience, with many facets of symbol and

[1966]

material and individual calligraphy. But in all these varied and exciting extensions of our experience we always come back to the fact that we are human beings of such and such a size, biologically the same as primitive man, and that it is through drawing and observing, or observing and drawing, that we equate our bodies with our landscape. A sculptor's landscape is one of ever-changing space and light where forms reveal themselves in new aspects as the sun rises and sets, and the moon comes up. It is a primitive world; but a world of infinite subtle meaning. Nothing we ever touch and feel, or see and love, is ever lost to us. From birth to old age it is retained like the warmth of rocks, the coolness of grass and the everflow of the sea.

St Ives, April 1966

1 One typescript draft for this essay has corrections in the hand of Hepworth's friend, the literary scholar Frank Halliday (Tate Archive).
2 1952 monograph, pp.67–8.
3 See p.43.

Edwin Mullins, 'Hepworth at Home', *The Daily Telegraph Supplement* (Weekend Telegraph), London, 20 May 1966[1]

'Carving is to me a necessary approach: in fact, a biological necessity, as it is concerned with aspects of living from which we cannot afford to be deprived. I regard the present era of flight and projection into space as a tremendous expansion of our sensibilities, and space sculpture and kinetic forms are an expression of it; but in order to appreciate this fully I think that we must affirm some ancient stability – a stability which is inherent in land and rocks and trees, inherent in our capacity to stand and move and feel.'

'In opposition to "social realism", I believe that meanings in sculpture emerge more powerfully when they are carried through sculpture's own silent language.'

'In sculpture there is a whole range of formal perception belonging to feminine experience. So many ideas spring from an inside response to form. It may be that the sensation of being a woman presents yet another facet of the sculptural idea.'

[. . .]

Barbara Hepworth has lived 26 years in St Ives. And for the last 16 of these she has had the small two-floor corner house next to the 'tropical' garden, that opens straight on to an alley as steep as a ski-jump.

'I'd been looking for a studio like this for ten years. I couldn't believe it when I saw it. In the middle of the town, and yet I could hammer away and no one could hear me.' And gradually she spread her wings over the place, until today Trewyn Studio must be as ideally equipped to meet an artist's every need as any in the world. The way she has systematically adjusted her surroundings to suit her – like a writer who sees to it that every possible reference book is within reach – is a key to the apparently effortless output of work, which increases year by year.

Barbara Hepworth is precise and self-disciplined in all she does, a generous hostess and an excellent cook. She is also the mother of grown-up triplets (her ex-husband is the painter Ben Nicholson), and her slender hands you expect to see play minuets but not chisel teak. She is diminutive, moves as though weighing nothing at all, looks fragile as a moth, and clearly is exceptionally strong. One feels her to be incapable of wasting anything – energy or time.

'First thing in the morning I see which way the wind is blowing.' Then she decides where she will work – carve marble out in the garden, or wood indoors. Or work on a plaster for bronze across the road, or write. 'I arrange it so that I always have alternatives.' Because of the extraordinary mildness of the climate down here she can carve out of doors all the year round if she wants to, 'and that's tremendously important to me'.

Indeed, in the background as we were talking – and it was still winter – I could hear the tapping of hammers, where one of Dame Barbara's assistants worked on a marble block in the garden. 'I have three assistants now. They're not artists. Two are trained mechanics, and one is a fine wood-carver' (whose father, Morton Nance, held the distinction of having compiled the one and only Cornish Dictionary).

'I have trained them so that I can now say, "This hole has to be started". Carvings I have always planned straight through in my mind at the very beginning, so that the result is inevitable.' It seemed amazing to a mere writer that just from observing the outside of a piece of stone or wood anyone should be able to calculate precisely what would happen if you bored inside at this or that place. The quiet reply to my query was typically assured: 'One does have a certain instinct for carving after 40 years.'

Barbara Hepworth is without question the most accomplished carver alive today. She adores materials; likes to work *with* them rather than bend them to her will. Bronze, black slate, white marble, Swedish green marble, Carrara marble, serravezza marble, alabaster, Roman stone, teak, elm, walnut, Guarea wood: her work of the past few years is made from all these. Enter Trewyn Studio and the eye is caught immediately by the carefully arranged clutter of small sculptures – wood, slate, marble, polished or rough bronze – all subtly relating and lit against a rough white wall.

'I've just ordered nine new pieces of marble,' she said excitedly, 'and I'm busy dreaming about them.' But moving heavy materials in from the steep

road – let alone huge sculptures out! – is quite an operation, involving 'scores of jolly men who all have to have tea made'.

'It's sad, but marble has become very scarce in England. They split it up into thin sheets for veneer facing, and get a good deal more for it that way. White marble I love especially. When I lived in Italy in the 1920s I went to the carving places in Rome and picked up what I could.' It was during those years, after leaving the Royal College, that she was told by an Italian master carver that 'marble changes colour under different people's hands'. This fascinated her.

'Wood one has to hunt for, too. It's not easy to get properly seasoned wood. What I do is to write to timber-merchants and ask them what they've got. I get it in when I can, and keep a lot in store here.'

She has seen to it that there is always space. Besides the outdoor and indoor studios, a little higher up the garden there is a large conservatory in the process of being transformed into a place for writing (she is highly articulate about her work), although at the moment it houses cacti. Then there is the studio-flat overlooking Porthmeor Beach and the sea, where she draws and paints. And there's the Palais.

This was literally the town Palais de Danse. It stands diagonally opposite Trewyn Studio, and Barbara Hepworth has had it five years. The cut-glass mirrors are still there; so is the bar, and the proscenium-arch stage. There is also a giant mirror still in position at the end of the room, which doubles the apparent length of the dance floor.

It's an enormous place even without the mirror. It is here that she made the Hammarskjöld Memorial, now outside the UN Building in New York. The first room upstairs is where plasters are prepared for bronze-casting. Scrapers, files, rasps and brushes were all immaculately laid out on the work-bench as if for inspection. On the walls hung sheets of wire mesh for building armatures to support the plaster, which lay on the floor in large sacks labelled 'Surgical and Dental Plaster'.

The main room of the Palais is an ever-changing private museum, and here when I was there stood most of the work for the present exhibition, open for two months at her London gallery, Gimpel Fils. Textures and materials again caught the eye; rounded wood forms hollowed out and coloured white or blue, waiting to be polished or strung like fine musical instruments. There was matt stone and sleek black slate; starved-looking white forms in plaster; bronze shapes taut as sinews, and green marble smoothed round and heavy.

All pieces that can withstand the elements are arranged not in the Palais but in the 'tropical' garden. Sculptures come and go as buyers call and remove a piece, or a travelling exhibition returns them home; but on this occasion the garden comfortably stocked 40, which worked out as roughly one sculpture per tree or shrub. The garden looked to have grown them both.

Twenty-six years in a small town at the end of England is a long time. Why Cornwall, and St Ives in particular, I asked her? 'It gives me what I need,' Barbara Hepworth reflected. 'I'm a North Country-woman. I was born at Wakefield and brought up in Yorkshire. I was profoundly influenced by Yorkshire. My father used to drive me all over the Dales.

'But what was lacking in Yorkshire I only discovered when I went to Italy, and that was *light*. In my work I've always used light a great deal. I test everything I do by sunlight, and by moonlight, and in rain and greyness. This place is like Yorkshire *and* the Mediterranean, and I need them both.' And she talked of the urban devastation and mining areas round Redruth and Camborne that remind her of her native county. She talked of the 'pagan hills' between St Ives and Land's End; and most of all the sea, and the colours that radiate from it – blues, greys, greens, pinks – and of the effects of the ultra-violet rays on the light in Cornwall.

'You see, the weather here forms from Land's End. It's forever changing. The light can change three or four times a day. I've never seen it look twice the same.' And she spoke of the landscape round her, and of its importance in her sculpture: tides, wind, cliffs, caves. 'Any rock or sea movement, but particularly when I see human beings related to it. Everything's a matter of our own physical orientation: the question is, what are we, and how? If you saw a figure poised on a rock in Greece, it would be a monument.'

Barbara Hepworth's art echoes not only her experience of landscape, but of man's relation to it. 'In my dreams I see people rising out of the rush of the tides.' The black upright forms of her sculptures are like rocks smoothed by the sea, but they are also like humans grouped in some relationship to one another.

In her imagination, the carving of a stone by a sculptor's hand is intimately associated with the hollowing of a cliff by the waves and with the hollows and cavities of a human body. She is herself a part of each sculpture she carves. 'I have to feel my sculpture in my whole body.' All her work contains this passionate blending of imagery, marking a search for symbols which will affirm what she feels to be the fundamental unity of man and nature.

1 Edwin Mullins, born 1933, art critic, writer and broadcaster. The article was published as Hepworth's latest exhibition opened at Gimpel Fils in London.

'The Sun and Moon', June 1966, unpublished manuscript and typescript text on the *Sun and Moon* sculptures of 1966

During the quarter of a century I have observed both the Sun and the Moon rise over the water, and set over the water, in ever varying aspects.

To climb a hill on this small thrust of land allows the artist to observe the changing light and form between the rising and setting, and the total relationship with sea and land.

'*Single form (Sun and Moon)*' suggests the reflections in both rock and land forms.[1]

'*Sun and Moon with six strings*' is really a wave form embracing the two sources of light.[2] The strings express the tension between the light and the waves. [fig.56]

The gold gives the quality of radiance and expresses my deep interest in a new sense of poetry in our scientific age.

St Ives
June 1966

1 *Single Form (Sun and Moon)*, gold, BH 418, and the related work of the same title, BH 431, polished bronze (edition of 3 + 0), both 1966.
2 *Sun and Moon* 1966, gold with gold strings, BH 417.

56. *Sun and Moon* 1966, gold with gold strings, BH 417

Contribution to 'Mondrian in London: Reminiscences of Mondrian', *Studio International*, London, December 1966, vol.172, no.884

We knew, of course, by photographs, the works of Mondrian. We asked if we might see him on one of our visits to Paris in the early 1930's.

In London it had been said that the works of Piet Mondrian were the 'end of painting'. I trembled at the thought of meeting him and seeing the paintings and the environment.

We arrived, and the door opened and there was a man with twinkling eyes and kindness in mouth and expression. Also an extraordinary grace of movement, and grace and manner of welcome.

We entered, and I, as a sculptor, was entranced by his grace and delicacy of welcome. He served us tea on a white table with red and blue boxes containing a few biscuits. I looked up at the great studio and began to take in the force and power of this astonishing creative glow of colour and form.

It is now over thirty years ago, and yet the impact of that studio and the magnificent paintings he showed us last forever in my mind.

He showed us paintings with the utmost grace and gentleness – also with a humility which made our love for him instant and everlasting.

When we left Mondrian's studio we sat down outside a café, and over another cup of tea we discussed the experience and said that this was not the end of anything – it was the *beginning* of something. If every artist could truly, and with dedication, pull the string with which he was born – to the end – then a new concept could evolve.

Each of us has, within, his own calligraphy; but it is only by pursuing what is our true identity that we can expand and develop the world of form, colour and experience.

In those days we were very poor. To sell something for £40 was a great occasion.

We kept in touch with Mondrian; but alas, I have none of the letters.[1] When things worsened in Paris, Ben Nicholson helped him to come to England and found him a studio. It was a dreary room overlooking ours, but in a week Piet Mondrian had turned it into his Montparnasse Studio. He got cheap furniture from Camden Town – painted it white, his wonderful squares of primary colours climbed up the walls. His paintings and canvases were all in evidence.

Once again I was struck by his most extraordinary grace and strength.

He often asked us to cross over to his studio and discuss the latest work. Again, this was done with the utmost grace of thought and movement.

I was a bit nervous about Piet coming over to my studio. I knew he preferred a less violent atmosphere for his own thoughts.

We had three studios – Ben's just under Mondrian's. Mine, just full of stone dust, and a third studio just full of children.

> Piet Mondrian Artist / great
> memories of a great painter
>
> We knew, of course, by photographs
> the work of Mondrian. We asked
> if we might see him on one of
> our visits to Paris in the early
> 1930's.
> In London it had been said that
> the works of Piet Mondrian were
> the "end of painting". I trembled
> at the thought of meeting him
> & seeing the paintings & the
> environment.
> We arrived & the door opened
> & there was a man with twinkling
> eyes & kindness in mouth &
> expression. Also an extraordinary
> grace of movement & grace &
> manner of welcome.
> We entered & I, as a sculptor, was
> entranced by his grace & delicacy

57. Manuscript of Mondrian memoir, 1966, Tate Archive

Nevertheless, Piet Mondrian became a pillar of strength. He, with utter equanimity, had tea with the triplets in the nursery studio. Three pairs of eyes stared at him and he treated them as grown-ups which filled them with surprise and wonder.

With Ben, of course, he was at complete ease.

When he came to my studio I pulled the curtains, as I had planted flowering shrubs in the tiny garden. But Mondrian seemed to like my carvings and patted them as though they were children or cats or dogs – which of course they were! And very soon all the curtains were drawn [back] – exposing the flowering shrubs and the plebeian plants.

But Mondrian seemed to love this family life and would relax and talk about painting and about 'jazz'. His intellect was superb.

My job was to work and rear the children. Ben Nicholson saw to it that Mondrian was not ill and that he had his baked potatoes and tomatoes and his paints.

Then came the imminence of war. All our scant earnings diminished, Mondrian's too.

We had been asked for a holiday by Adrian Stokes, to bring the children to St Ives. And, if war broke out to keep them there in safety. Obviously, a glass roofed studio was not safe.

We set off in deepest gloom in a second-hand car costing £17 (less than the fares by rail) and all the children, one hammer and chisel and some paints.

The last person we saw was Piet Mondrian in the street. We begged him to come too, or to follow us. We said we would find a studio for him. How could we look after him if we could not get back?

He said *No*. He kept on writing to us until the bombing started and he left for U.S.A.

I shall always remember his eyes and elegant figure in the street in Hampstead. The feeling that I should never see him again. The feeling that I should never again see his studio, or Ben's, or mine again.

And so it was. A saint in Hampstead. A much loved friend – a great artist, whom we missed so very much.

Once again I say that what he created was the beginning of something – an opening of the door to all of us.

1 Over 60 letters survive from Mondrian to Hepworth and Nicholson. The majority are in the Ben Nicholson Archive in the Tate Archive, and eight are in the Hepworth Archive there.

Catalogue note on *Rock Form (Porthcurno)* (1964, bronze, BH 363), March 1967, for *International Sculpture* exhibition, Pittencrieff Park, Dunfermline, April 1967; not published there (known from typescripts only)

22nd March 1967

PORTHCURNO

I think that, first of all, a sculpture should be rhythmical and in poise as a human being in good health. Secondly, I feel it should project all the tactile qualities of nature and nature's actions [in growth].

The light pouring through a hole, whether sun or moon: The texture of sea, sand or land: The colour of dawn or sunset; all put into the poise of the human response to our environment and the expanding universe.

[1966-7]

58. *Rock Form (Porthcurno)* 1964, bronze, BH 363, at the exhibition
Sculpture in the Open Air, Battersea Park, London, 1966

Conversation with Peggy Archer for *Woman's Hour* on the BBC's Home Service, 28 July 1967 (recording in British Library Sound Archive)[1]

ARCHER: *When did you first know you wanted to become a sculptor?*

HEPWORTH: Definitely by the age of seven, and probably before that. At the age of seven I saw this film on Egyptian sculpture at my school and it simply became a fixture in my mind.

ARCHER: *How did you know – did you have a feeling with your hands?*

HEPWORTH: Yes, the strange feeling that one could make anything and do anything and shape anything, and I suppose it's just the silly way one is born. I painted and made theatres and modelled my sisters and brother and made anything that I could make.

ARCHER: *Were your family artistically inclined?*

HEPWORTH: Not really. My father was an engineer, which interested me even at a very early age. But there were no artists in the family and it was difficult to find company but I spent every moment I had making things.

ARCHER: *Did your family encourage you?*

HEPWORTH: They were tolerant, extremely. I was rather confined to the cellar because of making such a mess in clay and plaster and everything else, but I was very helped at my school, where the headmistress had an extraordinary perception, I think, allowing me time off between exams to paint and carve in marble whenever I could. I was fed up, that was at the age of sixteen, and suddenly screwed up courage and went to her and said: 'How can I become a sculptor because I'm sure my family will never agree unless I can get a scholarship?' And she said you could sit for one tomorrow, and fixed it, and I got it.

ARCHER: *What was pushing you along all the time, what were you striving for?*

HEPWORTH: I was striving to make a thing which I could live with and hold and touch and which would have some sense of eternity in it. After all, I had seen sculptures, I'd been to Paris, I'd seen many things, in cathedrals, and it was entirely natural to me.

ARCHER: *Who were you influenced by most at that particular time, do you think?*

HEPWORTH: Well at that particular time I would say Brancusi and Mondrian for the same reasons – one was a sculptor, one was a painter, but the thing that so impressed me was that if you worked hard enough and pulled the one thread that you had yourself within you hard enough, that something would eventually happen, and they were two such superb and devoted artists, their whole environment and their work astonished me and I really tried to take my greatest lesson I think from both the visits to their studios.

ARCHER: *Were you influenced at all by outside events, what was happening in the world outside?*

HEPWORTH: That I've always been. It was, I suppose, inevitable, coming from the West Riding, that one could not disregard the sufferings and the ups and downs of people and the whole industrial difficulty and political difficulty. So that I have always been involved.

ARCHER: *Did you feel this involvement coming through to you in your day-to-day work?*

HEPWORTH: Yes because it seemed to me that the only way that we could live and determine to live and fight off the incipient terrors, was by making the most affirmative images possible, which is after all what sculpture is for. They are images to remind us of eternity and not ephemeral decorations.

ARCHER: *At what stage did you move on from doing traditional figures to doing the sort of work that you're doing today?*

HEPWORTH: It was a very natural evolution which was sharpened very much. It began I think quite early, about '27; it got more and more abstract as I carved because stone and wood are very demanding to get what I wanted to get. And I got nearer and nearer to the strength of the material. And then '31 I made the first piercing through and a hole completely through a sculpture so that you could see from back to front and when my children were born in '34 by that time it became entirely abstract in the sense of being not organic so much as an image of what I felt about people and things.

ARCHER: *Why don't you do any traditional work nowadays?*

HEPWORTH: I just don't feel like it. Who wants to look at somebody's face?

ARCHER: *You feel it would be going backwards do you?*

HEPWORTH: Not backwards. It's so easy to do, but it's not, in our age you see, in all the wonderful developments of our time, we have so many new experiences and sensations that we want to know all about these. And I have just finished a big work which is entirely abstract but I'm hoping it's got the feeling of the eternal in it and will link up with tradition.[2]

ARCHER: *But you're very small and I should imagine to get to work on some of your larger sculptures you'll need a ladder and all sorts of apparatus actually to reach them.*

HEPWORTH: People always say I'm small but then I've got less weight to carry around!

ARCHER: *Do you visualise your work completed before ever you start?*

HEPWORTH: Always. I think one goes around sort of brooding. And then suddenly it flashes into one's mind complete.

ARCHER: *And does it ever change on the way before it's finished?*

HEPWORTH: If it does it's usually a mistake and in a few odd cases I have destroyed things. If I think I can't live with them a thousand years hence then out they go. But mercifully it doesn't happen often!

1 Recorded at Trewyn Studio in April 1967.
2 Probably a reference to *Construction (Crucifixion)* 1966–7, bronze, BH 443.

'Barbara Hepworth, Sculptor', *Viewpoint*, BBC 1, broadcast 13 September 1967; quotations from Hepworth on *Oval Sculpture* (1943, plane wood with painted interior, BH 121 A) in *Radio Times*, London, 7 September 1967[1]

This *Oval Sculpture*, which I carved in 1943, is, I think, one of my most religious sculptures and people may wonder why I feel this. It was made at a time of very deep despair and trouble when one of my children was gravely ill and I thought and thought what I could do which was helpful or useful and decided the only thing I could do would be to make as affirmative a sculpture as I could and as perfect as possible as a gift no matter what happened, but it did help me enormously because I realised that eventually I would find a way of speaking within these terms in my own work about my own particular feeling and religion.

Artists are not gods – they are the servants of God.

1 This programme in the *Viewpoint* series survives in the BBC archive. It marked the completion of *Construction (Crucifixion)* (1966–7, bronze, BH 443). Hepworth's friend Moelwyn Merchant, who conducted the broadcast interview with her, was Canon of Salisbury Cathedral and Professor of English at Exeter University. He was instrumental in the controversial siting of a cast of *Crucifixion* at Salisbury Cathedral in 1969. He discussed the *Viewpoint* programme in his autobiography, *Fragments of a Life*, 1990.

Edwin Mullins, 'Scale and Monumentality: Notes and Conversations on the Recent Work of Barbara Hepworth', *Sculpture International*, Oxford, 1967, issue no.4

The point is that everything answers to a human scale, insists on a human orientation; and without this physical response – this sense of relationship – her work can't mean anything. The spectator has to relate himself to it, not look up at it agog (like Moore, whose work is always enlarging in the imagination), or squint down at it (like Giacometti, always diminishing). It is neither overbearing nor shrunken. She says 'the real sense of scale goes back to our bodies'. This is nothing to do with real size, but imagined size.

59. *Oval Sculpture* 1943, plane wood with painted interior, BH 121 A, Pier Arts Centre, Stromness

The hint of the dance is in so much of her work: sculpture raised on tiptoes. It is both elegiac and sensuous – a symbol of the human spirit uplifted, and provocative of a reaction. Analogies are with the tensions and litheness of the human body, not its bulk. It is on the alert rather than in repose.

She has recently completed a 'walk-through' sculpture. This piece emphasises her insistence that the whole body must be engaged in response to sculpture. 'This engagement helps to orientate us – give us an image of security and a sense of architecture.' On another occasion 'You can't look at sculpture if you don't move, experience it from all vantage-points, see how the light enters it and changes the emphasis.'

A reaction in the stomach; that each piece in a slate group was somehow a different facet of a person, and that the cavities might well be sea-caves but they were also wombs.

Am aware of no other sculptor whose work so demonstrates a consciousness of being a woman. (I have never felt it about Germaine Richier, for instance.)

She says 'Throwing up a big sculpture is something one can only experience within one's body and one's sight, and the more pliable one feels the more exciting it becomes . . . This extraordinary feeling of starting from a tiny base-line and swelling up and up to 20 ft gives one a sense of the gorgeous architecture of the human body, poised and expanding.'

Her work is also about a consciousness of human surroundings, and one's physical location, relevance and adjustment to them: i.e., it occurs to me, the Parthenon would *be* the same if I personally were a giant or an ant, but it would not *feel* the same. Its particular effect depends on my being man-sized. She talks of the problem she experienced finding the appropriate human scale for her memorial sculpture to Dag Hammarskjöld in front of the 36-floor United Nations building in New York.

'The heroic is death to me; it is beyond the comprehension of a human being. Something big demands one's bodily acceptance.'

A small object held in the hand can easily be imagined as large, but a large object can only appear small at a great distance. She is conscious of different categories of scale: what you hold, what you can put your arms round, what you have to walk round, what you can walk through. Everything has its appropriate scale. She never works from a maquette: 'you can't blow things up'.

'Two or three pieces together and you become involved in a relationship.' She talks of her reaction to the monolithic stone-circles at Avebury, and how a single monolith demands quite a different reaction from a group. She has always been concerned with this kind of relationship between people/objects: it goes back to *Doves* (1927), *Two Heads* (1932), *Mother and Child* (1933), *Two Forms* (1934), which is an ancestor of the smoothed rock groups of today, in marble or slate, and *Discs in Echelon* (1935).[1] She is always asking what that relationship is – like trying to express visually the relationship between three people seen talking on a pavement. [. . .]

Recently she has started to see things as being translated on to a great scale, without their losing a human reference and becoming heroic.

Because of the importance to her of scale, location and landscape are likewise important. 'I remember seeing Maillol's *Three Figures* in the first Battersea Park open-air sculpture show, and they looked marvellous. Then later I came across them in a dark passage of the Tate Gallery, and they just died.'[2]

Consider the scale and shape of rocks (or people) seen far out on Porthmeor Beach, compared to the same close-to. 'Three men fishing on a beach at dusk – they blend'. In the process what do they lose of their identity, what preserve, what gain?

She looks at sculpture by every light, day and night, in order to test it; and everything she carves rests on wheels so that she can accommodate it to each day's surprises. [. . .]

Her belief in the magnifying powers of Ultra-Violet light, which is particularly strong in this part of Cornwall. She describes how jackdaws in her garden at St Ives can look larger than ravens, and fishermen on the quay giants. This is linked with her love of Greece, where similar conditions of

light exist: 'In Greece I noticed the wonderful stance of men. I thought of Greek philosophy, of the majesty of Greek tragedy, and of a certain strength of the human mind which causes people to become bigger when you see them.' This made me think of a photograph of the beautiful *Torso I (Ulysses)* bronze raised up in silhouette against the sea. 'And Patmos – it was like an atlas laid out. You could see an infinitude of islands receding. It was like being an astronaut.'

'Those carvings of Presidents in the American mountains are mere *bulk*: nothing whatever to do with monumentality.' They are on a heroic scale, like the Pacific Ocean, but that has nothing to do with it. The Pacific doesn't necessarily look as impressively big as the Bay of Biscay. The monumental scale and the heroic scale are not the same. 'Think of the eloquence of cathedrals: however big, they are never heroic.' [. . .] She adds, 'today architecture is grandiose in scale, mean in concept.'

The interest in themes which demand to be measured not by rule but by the imagination: the monolith, the group of rocks in a vast theatre of space, also the Sun and Moon theme. Several of her recent works hint at this last ([BH 418] is a good example): the larger and the smaller form, positive and negative, heat and cold, and the fact that the two are immeasurably far apart but as far as we on earth are concerned bound together in a relationship. 'They both rise over the sea, always: it's a phenomenon of living here on this peninsula. And they chase each other.' And there are the other contacts important to her; the Moon's tides, the Sun's flowers. Power, growth, light, mystery, movement, form.

Size is always related to materials also. Something may be cast in bronze or aluminium up to virtually any size, but direct carving in wood has to be restricted to the width of a tree-trunk, and in marble by what can feasibly be cut and moved from Carrara to St Ives. These conditions take on the authority of imposing natural scales for each material. (Her assistant was doing the basic work on a two-metre walnut tree-trunk, hollowing it like a primitive canoe. She suggested the comparison.)[3]

1 BH 3; BH 38; BH 53; BH 61; BH 73 A.
2 *The Three Nymphs* 1930–8, lead edition, cast in Tate collection.
3 *River Form* 1965, American walnut, BH 401.

HEPWORTH: One of the first excitements I had, as we unpacked crates from abroad, was the marvellous condition of everything. The works I hadn't seen for twenty or thirty years had the most wonderful patina. They were loved, and I'd imagined that I would have to restore everything after so many years, instead of which they simply glowed, and as we stood them up one by one I began to remember the absolute mood when I made them, the feeling I had on working on the surface and suddenly making an eye or a mark or a hand, and the whole thing became not a past experience but almost a present experience, except that these works showed the signs of being handled for thirty years. And then I began to look around and I realised that, say, the *Infant* which I carved in 1929, which was of my first son, was really in the mood, a very young mood, of *Cantate Domino*. And then I realised that the figure of a girl of '28/'29[2] was a young version of *Coré* of 1955–6.

MULLINS: *And none of these things had occurred to you before?*

HEPWORTH: No, not at all. And the *Doves*, which again I think were '28/'29,[3] I suddenly realised, good gracious, these are the forms in echelon, that through my life I've done works of two forms related to each other in a kind of tender relationship and this was the beginning of searching for this kind of emotional impact of the two together. And quite suddenly I felt enormously at home and I looked round thinking that I might find a foreigner, something that I heartily disliked, that was out of the pattern and, mercifully, I didn't. I found that they all fitted together in a young and a middle age and an older age, period of experience, changing their outer format, but the kind of thing I wanted to express, the tenderness of a young girl, an infant, or praising, or two forms together, three forms, twelve forms, was consistent and that must have come from very early on because I don't remember in the '20s thinking of these – it was subconscious, perhaps, but they must have come from a much earlier age of experience when one is in childhood and one observes and is touched by some experience which goes deep down.

MULLINS: [. . .] *Are you very sensitive to public reaction?* [. . .]

HEPWORTH: Yes I think I am. I watch people and they do, in the main, react the way I want. But you see it's very interesting: I have a terrible passion for sculpture – I mean to hold a Cycladic or Neolithic work in my hands is an ecstasy. To see Etruscan work lit up, or Mexican work. To walk round a Henry Moore and to feel the thrust in space and to go round and round and round, or to be drawn into the withinness of a work by Phillip King – this is to me a true life and a lot of people I think still don't quite understand sculpture in

50. Tate Gallery retrospective, 1968

its entirety because from far off you may see a great oval which appears to be ovoid, poised, and you say there's an oval, but when you approach it, all the lines recede, the left and the right recede – you're conscious that it is an oval but you can't see it any more nor can you see where it's poised, and as you approach, you go within and inside are a new set of factors, this is within an oval, which you no longer see. And the withinness becomes a kind of passionate thing of how your body will explore this, what fantasy does it raise and you are enveloped in an oval which you no longer see, and people don't always realise there's no fixed point for a sculpture, there's no fixed point at which you can see it, there's no fixed point of light in which you can experience it, because it's ever-changing and it's a sensation which cannot be replaced by words or colour or anything else at all, and your view of approaching a sculpture is totally different from a view where you walk backwards.

[. . .] The scale is a thing which you physically experience and, if you see a tiny object on the floor and you pick it up, you've got an immediate scale, but if you have a big thing and you see it from far off and you approach it, the scale changes, you change, your walking, your stance should change and there isn't a fixed point any more beyond movement.

MULLINS: *Does this tie up with something that you've said to me before which is that the very intense ultra-violet light in St Ives where you live gives an appearance of scale very often far removed from the real scale of something?* [. . .]

HEPWORTH: I experience this not only in St Ives but when I went to Greece and went round the islands in the Aegean, in a very similar light, and on Patmos and Delos and Santorin I observed this extraordinary importance of a figure standing on a cliff edge, or a bird, or an animal, which suddenly became enormously important in the landscape, blended with it but had this extraordinary dignity. And as far as the human figure is concerned it gave it a feeling for me of the past, growth, of philosophy and spiritual power which has enabled man to encompass the past centuries. And the importance of the standing figure, keen against the wind or poised looking out, that he was the thought, not just a human figure which one might draw in one's studio from life, but somebody who was assessing his place in the universe, his place in the world, and was alive and keen, and this is a marvellous thing that happens here in St Ives.

[. . .] There's always a certain loss in an indoor exhibition where there's a fixed light because to start with nothing out-of-doors is ever in a fixed light, it's never the same two days running or even on the same day next year. It's always different and one is keenly aware of this and very much aware of the effect of moonlight or rain or cloud, anything you like. But with a fixed light there is a limitation and then I rather tend to fall back, of course, on touch and I would love, of course, in big exhibitions to change the lights every day and have them quite different next day, twist and turn them so that the visitor who comes back to have a look sees it differently. But nevertheless there is so much to be gained by awareness of touch, and you don't necessarily have to touch to know what a thing feels like because once your hands are alive and you have touched and you know what you're handling, as a child does, you can experience this through your eyes, you know the temperature, the silkiness, the roughness, the hardness, the warmth, you know everything and it becomes an experience which I think is vastly important and makes up for the loss of changing light.

MULLINS: *Do you think that classical sculpture had this thing about physical identity with the scale of an object, that you stress this very much in your own work? Do you feel it, for example, about classical architecture, about the Parthenon?*

HEPWORTH: The Parthenon, yes, but more of course the archaic period when the sense of form and intention and vitality was so much the greater and I think all early periods have got this complete identification with changing light, with touch, with stance, with rhythm and for me sculpture *is* a matter of rhythm.

MULLINS: *But these qualities went out of European sculpture, didn't they?*

HEPWORTH: Oh dear yes. And stayed out for about three hundred years. When we started to carve direct in the '20s, we had a background of total inertia and rather dreary things done from a point of view of material wealth, copies of copies of copies, which meant absolutely nothing. Sculpture wasn't a thing of joy, it was either a thing of money or a horrible thing of a memorial.

MULLINS: *So getting back to materials, which was very important to you in the '20s, was not only because it was important for a sculptor to establish a kind of feeling with the material he was working in, it was also to establish this kind of physical relationship with the finished product in a way that had been lost.*

HEPWORTH: Yes, a total physical identification with the making and the solving of the form and the rhythm that you wanted to express.

1 Recording in British Library Sound Archive. Mullins' questions have been edited; Hepworth's responses are given in full. She was delighted with the programme, writing to the producer Helen Rapp to request a typescript: 'I seem to have expressed some new ideas, which I would like to enlarge on sometime.' (Letter of 9 May, TGA 965/2/18/6.)
2 *Figure of a Woman* 1929–30 (Tate).
3 *Doves (Group)* 1927 (Manchester Art Gallery).

Contribution to 'Icons of the Sea – Recollections of Alfred Wallis', *The Listener*, London, 20 June 1968[1]

BARBARA HEPWORTH: Ben took me several times to see him. He was incredibly small and I think his eyes must have been grey-green. They were very serious eyes, but he had a twist to his mouth which denoted a high sense of humour, and he wore a cap and an apron covered in paint. When we called, his whole face lit up at the sight of Ben. He always asked us in and we stood there, just within the door, because there was nowhere to sit. It was such a tiny, tiny room and between us and Wallis lay this very big table and on the left was a rackety old easel with one painting on it, which we knew we must not look at until he wanted us to. And he and Ben would talk in a rather desultory way as one friend who's just bumped into another friend and knows he's on even ground. And this great table – Wallis on the far side and we two standing by the door – was spread out with all his boards, some he was working on, all his paints – tin after tin of the best ship's paint, which he believed in – and brushes, and in his right hand he held a brush; his left hand was on an enormous open Bible and to his further left was a teapot – perhaps a crust of bread, half a turnip, some sugar, and there he stood and he was the most serene and dignified person I've ever met. I never, of course, saw him in anger because with Ben he was so happy, but I can imagine that if anyone challenged his integrity, his dignity, his privacy, that he would flash out. He talked about his paintings and he produced them. He never actually addressed me until we

were about to depart. He then looked at me very directly and said: 'Mind you read your Bible every day and mind you see what company you keep.' Then towards the end he would draw Ben towards the painting on the easel and say: 'This is your painting.' We knew all the time that this had been built up towards this moment. And then, before his death, when Herbert Read was staying with us, Ben said: 'You take Herbert down to see Wallis.' When he opened the door, quite suddenly he began to talk and he spoke non-stop, I think for something like 40 minutes, in rather a sonorous voice, and we stood absolutely transfixed. He spoke of all his life, his friends, his troubles, his cousins, his enmities, the Bible, the course one must take in life. He mentioned the fact that a distant cousin had, alas, gone off to South Africa and had ended in a pauper's grave: and that he himself thought it was the most terrible thing that could happen to anybody. And he said that he had saved £20 long ago and had given it to a friend, and that the friend would hold it so that he would have a proper grave. And he referred to this over and over again. In August 1942 we heard that he had died. By the good offices of Adrian Stokes, who worked so hard for three days, we achieved, instead of a pauper's grave, a private grave. Many of us stood there seeing this tiny coffin lowered with, I must say, tears in our eyes. But also a certain happiness that it had been the way he really wanted it. Every time I saw him he said: 'These are for you to copy off of.' He knew his experience of walking round a harbour, going under a bridge, seeing the boats come in, was true information which what he called real artists could take off from, as he said. But of course he certainly didn't know how much we all learned and took off from him.[2]

1 An edited version of a broadcast on the BBC's Third Programme, *Alfred Wallis: A Portrait*, introduced by Edwin Mullins, in connection with the exhibition of Wallis' work at the Tate Gallery (first broadcast on 29 May 1968; recording in the British Library Sound Archive and Tate Archive). A few small amendments have been made here to *The Listener* text where Hepworth's words in the recording differ. Other contributors to the programme included Bernard Leach and Patrick Heron. Hepworth's contribution was recorded in St Ives in April at the same time as her 'Lively Arts' conversation with Mullins (see pp.212–15).
2 In the broadcast Hepworth said: 'But of course he maybe sensed but certainly he didn't know how much we all learned from him and took off from him by this magical sense of reality, colour and tone which he did so simply and so truthfully and which inspired all of us.'

**'In Memoriam Herbert Read, June 15th 1968',
unpublished manuscript and typescripts**[1]

Summer-sweet wild flowers
and soft gentle grasses
flank us to left and right

the wild roses hide in hedgerows

the road leads whitely
rich fertile fields spread
ahead and onwards
tended by strong hands
leading to upward moors

facing sun and moon

countenances give praise
as the air trembles
with larks-song

gently quiet the earth receives
the pure spirit
so proudly born of this good earth

the air moves quivers
with unshed tears from far and near
a rustle of awareness and gratitude

we recede as enfoldment
completes
a stab of loneliness pierces
as tears fall

but we are in trust

poet philosopher friend
to all humanity
a radiance spread so generously
quickens for all posterity

it is high summer
and a strong pulse
is felt as again
again the lark rises
giving praise

1 See the *Pictorial Autobiography*, p.115. Read died on 12 June 1968.

I always remember with considerable excitement my first acquaintance
with the painting of Frances Hodgkins. It must have been about 1929 or 1930
and I think at St George's Gallery in London.[2] The work had great strength
and purity and so individual that it was like discovering some new world.

I think I only met her twice because I was so tied up with the care of home
and children; but she came once to my studio and I was delighted by her wit
and gaiety and her quick appreciative feeling for sculpture.

I was in close touch with her painting throughout the thirties because of
the '7 & 5' exhibitions and the fact that we were under the wing of the same
gallery, the Lefevre Gallery.[3] The late Duncan Macdonald had so many of us
under his wing. His great gift was in sustaining the artists of that time and
completely believing in what they were doing, and to all of us who knew him,
our debt is immense, for in those times, which were so very difficult financially,
his constant care and faith meant so very much. We were sustained during
the thirties by the encouragement of a handful of people who seemed to
have complete faith in what we were doing, although we were not able to sell

61. Frances Hodgkins, *Wings over Water* 1930, oil paint on canvas, Tate

much, and for people like Frances Hodgkins, Ben Nicholson, myself and many others it was perhaps one of the happiest times, although it was so very difficult to make a living.

Frances Hodgkins seemed to me to have the most tremendous courage and dedication; but I often thought how very difficult it was to be so very much alone. We all loved her and the other artists in our group admired her work and appreciated it and I think it was the fact that the contemporary artists of that period understood each other's work and this understanding produced a very real revolution in both sculpture, painting and architecture by the very unity of our spirit and friendship.

1 For the BBC Third Programme broadcast, *Frances Hodgkins – Portrait of an Artist*, transmitted on 11 February 1970, in Hodgkins' centenary year. Hepworth's contribution was not broadcast. In Ben Nicholson's contribution to the programme he recalled that when he first met Hepworth, she had just seen an exhibition of Hodgkins' work and much admired it (this is the only recording of Nicholson's voice).
2 October 1930, 'Paintings and Water-Colours by Frances Hodgkins', St George's Gallery, London. Cf. p.61.
3 They showed alongside one another at the Seven and Five Society exhibitions of 1932 and 1933; Hepworth and Nicholson's joint exhibition at the Lefevre ran concurrently with Hodgkins' own in October–November 1933; and Hepworth's October 1937 Lefevre exhibition immediately preceded Hodgkins' own.

Comment on power tools in Arnold Whittick, 'Power for the Sculptor', *Stone Industries*, Slough, September–October 1969[1]

I have carved all my life and I positively detest power tools. The only one I use is a drill when I am piercing a stone (I used to use a hand drill; but now I have a power drill), as in this way I can avoid bruising the stone or breaking my point, and the actual piercing plays no part in the final work.

1 From a letter of 5 August 1969 replying to Whittick's request for a comment on her attitude to power tools (TGA 20132/1/226).

1970s

Edwin Mullins, 'Barbara Hepworth' in the exhibition catalogue
Barbara Hepworth Exhibition 1970, Hakone Open-Air Museum,
1 June–15 September 1970. Includes quotations by Hepworth from
letters to and conversations with Mullins, 1969–70[1]

'By working instinctively – I react to life around me – either in the
immediate sense of being related to a community – or, in the long term
sense, of being aware of the implications of our century.
The urgent need is to build our lives on strong foundations.
I try to make sculptures which will affirm and re-affirm the magic of the
will of life and the miracle of rebirth and continuity in the Universe.'

[. . .]

In the Preface which she wrote to the first large monograph on her
work, in 1952, Barbara Hepworth grouped her sculpture 'into the phases of
experience to which they belong'. This resulted in a division of her sculpture
into blocks of time, as follows: before 1930 – the excitement of discovering
the nature of carving; 1930–1934 – the poetry of the figure in landscape;
1934–1939 – constructive forms and poetic structure; 1939–1946 – Cornwall,
and the artist in landscape; 1946–1949 – rhythm and space; 1949–1952 – the
artist in society. Her work since 1952 she has recently grouped in a similar way:
until 1954 – the artist in society (continued); 1954–1959 – post-Greece, and the
ratification of her view of sculpture; since 1960 – removal of restrictions in
size, emergence of subconscious imagery, and a general fusion of ideas
and themes.[2] [. . .]
'In sculpture I am vertical. I always have been like that.' The single
standing form [. . .] has always been the archetypal Barbara Hepworth
image [. . .]
The early carvings done after her return [from Italy] already show a
tendency to simplify and depersonalise the forms of nature, and to echo the
bold distortions of archaic sculpture rather than the sophisticated naturalism
of Classical and Renaissance art. 'I wanted to be free to make shapes that
were uninhibited by what had been drummed into me: shapes that had a
sense of touch, and a presence, and which were a rejection of portraiture.
In Italy I was browned off by all those faces on memorial sculpture. Why
should I give a face an expression, and if so what expression?' [. . .]
And when, in the late-1940's, her sculpture began to be involved explicitly
with the human figure once more, it was with a new kind of sensitivity, born
of her involvement with landscape, her response to the enfolding shapes of
Cornish harbours and sea-caves, headlands and tides. 'I think landscape
had been a fruitful escape from the harshness of World War Two; but now
I wanted to go back to human tenderness.' [. . .]

'If I see a woman walking down the road pregnant, I feel pregnant.' [. . .]

In 1947 Barbara Hepworth made a series of drawings which were based on sketches done in an operating theatre. What struck her most forcibly was the rhythm and coordination that existed between numerous pairs of hands all moving with the utmost economy and harmony to a common purpose, as though guided by a single mind. Translated into sculptural terms, such an experience gave shape to the idea she had been nursing of bringing a large number of separate figures together into a single composition, in which each figure would occupy an indispensable formal role. She expanded this idea to me: 'You see, I've always wanted people to be aware of what they are physically; to acquire a sense of their being forms, each of which implies some sort of relationship and possesses a certain poise. Poise! That is most important. It's much more than merely being elegant [:] it's being able to feel the ground under your feet, to appreciate what you are in relation to the ground. This is not an optical sensation: it's a matter of physical relationship.' [. . .]

At the Wakefield Girls' High School, in Yorkshire, Barbara Hepworth took advantage of an enlightened attitude towards organised games to 'concentrate on dancing of all kinds'. [. . .] While she was a student at the Royal College of Art in London Barbara Hepworth would go and watch Diaghilev's dancers limbering up, and get herself invited behind the scenes. In 1947 she made a number of drawings based on the movements of dancers whom she had persuaded to perform in her studio. Altogether, dancing has been a passion which has given her innumerable insights into life far from the professional stage: 'if you see a fisherman wrestling with a rope or his nets in a high sea,' she has remarked, 'that is another and equally marvellous kind of dance'. [. . .]

'My sculpture has often seemed to me like offering a prayer at moments of great unhappiness. When there has been a threat to life – like the atomic bomb dropped on Hiroshima, or now the menace of pollution – my reaction has been to swallow despair, to make something that rises up, something that will win. In another age, a more peaceful age, I would not have felt the need to do this: in a cathedral-building age I would simply have carved cathedrals. But an artist responds to his times. The war, Hiroshima, pollution, all this supplies the moral climate in which my sculpture is produced, and the passionate thinking that lies behind it.' [. . .]

To have been working in an era of technological revolution has been, she insists, a privilege; and in particular to be living and working in the age of flight. 'Man's discovery of flight has radically altered the shape of our sculpture, just as it has altered our thinking.' [. . .]

'It was in 1937 that I began to be hungry for landscape. Monoliths were creeping into my work, and so were images of the sea; but it was all in the mind. Of course I knew the sea well from childhood holidays spent on the Yorkshire coast, and I had visited the prehistoric stone circles at Avebury and Stonehenge. But that was all. And when Ben and I came to live in Cornwall

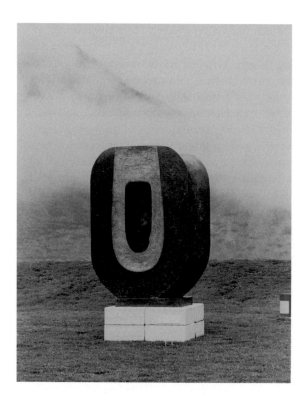

two years later I was amazed. There it all was . . . Cornwall brought my young days in Yorkshire back to me, made them more vivid. I had not expected to feel happy here, but I was enchanted: the bays, caves, promontories, the beaches, hills and rocks, the stones weathering.' [. . .]

[On her method of using strings in her sculptures] 'One knows the wind, one connects up spaces between objects, one measures out distance. Think of jumping from rock to rock: you have to calculate with your mind, also feel with your feet. I have always experienced a desire to pull together these tensions.' [. . .]

'Greece strengthened me: it was a confirmation, not a transformation. It made me understand a lot about the dignity of man and his own setting, and about the meaning of Greek philosophy.' [. . .]

[Of the recent bronze *Six forms (2 × 3)*], she describes how the angles at which the pieces are set, and the patterning on the bronze itself, were related to the experience of a boat-trip in the Scilly Isles, off the coast of Cornwall, and in particular 'the swirling motion of going round and round in the boat'. [. . .]

Lastly – and it seems appropriate to end this Introduction on a note personal to the artist – the geometrical elements present in her work, drawings as well as sculpture, have the effect of imposing a discipline, an orderliness, on

what Barbara Hepworth admits to be a tendency in her work towards lushness. She kept her distance from what she felt to be the rather life-denying influence of Gabo ('if I felt like a voluptuous curve I didn't want to be made to feel I was betraying the Constructivist cause'). On the other hand she has recognised the need for correction, for some rule of discipline and restraint which would ensure that the maximum richness might be obtained by the greatest simplicity of means. [. . .]

London, March, 1970

1 A version was used in the catalogue of Hepworth's exhibition at the City Art Gallery, Plymouth, which ran concurrently (16 June–16 August 1970).

2 In a letter of 15 February 1970, Mullins asked Hepworth to suggest how she would group her work since 1952 (TGA 20132/1/142).

Women and Men's Daughters: Portrait Studies by Zsuzsi Roboz, compiled and edited by William Wordsworth, London 1970[1]

I have always thought of my profession as an ordinary work-a-day job. I wanted to paint and make things and everyone said you can't, because you'll starve to death. Well we nearly did, but not quite. When the triplets arrived, I thought, working as we did abstractly, how on earth can we feed this family; but it was no good sitting and deliberating; the family undoubtedly became a spur.

An artist can never do anything worthwhile unless it is worked out in his head and this is a question of mood. I might wake up in the middle of the night with a complete sculpture in my head. Fine; but if it isn't, how do I start chopping a bit of stone about? It has to come as part of living or a part of dying or out of catastrophe – it has to be complete in my head.

Cornwall is a perfect place for working, perfect light, perfect everything. I wouldn't come back and work in London under any circumstances. I tried about 1946, but it didn't work out. Cornwall is much more attuned to sculpture and to movement; it's quieter, the sounds are beautiful and the people are beautiful. Everyone thinks it is glorious because you can sit on the beach; I honestly don't think I've sat on the beach for years. There is a marvellous artistic community life in St Ives, artists, writers, musicians; it suits us because we live at a tempo which fits our work. The tempo of a big city these days is very much against one. When I lived in Hampstead it was still a village. [It seems rather sad that these urban areas can no longer retain their original character.]

I'm interested in working in the abstract because it seems so much more eloquent. On occasions when I have been present, say, in an operating theatre, or at a ballet, or something similar which is directly concerned with

the human form, such experiences are a stimulant contributing to the next abstract. I know my anatomy, but it's very good to go back and study it because I know, at the end of it, a new abstract will eventually evolve. I love watching people, I watch them all the time, how they move, what they do, everything. I have not drawn any landscape for a long time, because when I go and look at them I get a new idea for a sculpture. So I draw the sculpture.

The places that have influenced my work? Well, Greece, Provence, Italy and more than anywhere else – Cornwall, because it's always changing. Yes, I'd love to do stage designs again, as I did for the Old Vic and the ballet, but I've got this dream of a new big sculpture – nine figures walking up a hill. [fig.65] It's an idea that has been boiling for years, now it's boiled and I'm starting. The figures will be bigger than life-size. Significance in the number of figures? Three times three! More stage designs would take time, six to eight months, and if I'm to complete my nine figures I'd better get on with it.

I must confess I've got rather tired of the practical side of sculpture exhibitions, the transportation and the displaying of the pieces. I think the only answer is to stop it. Now, let there be no misunderstanding, my galleries are absolutely marvellous. My exhibitions there are done with so much care and provide a beautiful show. I did, of course, enjoy my Tate show tremendously.

I am much happier to show my work in the garden of my studio in St Ives. I'm really serious about this; I like being at home.

I have found I have needed to be affirmative. It would never do for me to be pessimistic. Better to go to bed, chew it over and get up in a better mood. No, I must be affirmative, otherwise I cannot do good work.

People, I know, are always shouting about the young, who I think have been through a very hard time. The perpetual criticisms and preaching must be ghastly for them and so boring. But I do think we've given them a poser – politically and in other ways – which is a great shame. Now some of the young poets to-day are writing some very beautiful poetry. I feel that the young need friendship far more than guidance and help. Yes, friendship; that's something that all of us need.

We've got to use our wits over today's problems, otherwise we've had it. Pollution, pest control, conservation – all these things are of absolutely vital importance. I would think we have no more than about twenty years to cope with these and their related problems. You see, people are so stupid. They will say 'Oh dear, yes, yes', and promptly throw more muck in the river. I have seven grandchildren and I don't think they have a hope of a good life unless some immediate action is taken. We are repeatedly told it is urgent, the operative word is immediate. Here, in fact, is a really worthwhile job for the young, if they'd only 'cotton on' – forgive the Yorkshire phrase. If they would only say 'This world is ours and we are going to cope with these problems.'

1 Based on a conversation with William Wordsworth. Hepworth amended a draft of the text
 (typescript in Tate Archive, 8 June 1970, followed here).

**'Alan Bowness: Conversations with Barbara Hepworth', 1970,
published in *The Complete Sculpture of Barbara Hepworth, 1960–69,*
edited by Alan Bowness, London 1971[1]**

AB: *In the pages that follow, we have catalogued and illustrated all the sculptures
that you have made in the last ten years. Two things strike me at once: numerically,
there are almost as many since 1960 as there were in the preceding thirty-five years
– 227 works compared with 273 from 1925 to 1960. And secondly, I feel that the
range and scale of your sculpture has broadened considerably during the last
decade, as though you could at last do what you wanted to do, more or less free
from material considerations.*

BH: I think that what you say is true. This period did start with a feeling of
tremendous liberation, because I at last had space and money and time to
work on a much bigger scale. I had felt inhibited for a very long time over the
scale on which I could work. If you remember, I had, just before war broke
out, made a series of small plasters for monuments. Most of them have not
survived, but a few were reproduced in Herbert Read's early book on my work
(Lund Humphries, 1952). There was one sculpture that I did – it was called
Monumental stele (83)[2] – which was my first chance of doing something large.
It was over six feet tall, but was damaged and destroyed during the war.
I enjoyed making it so much.

AB: *Do you mean that throughout the 'forties and 'fifties you always wanted to
work on a much bigger scale?*

BH: Tremendously. These ideas lurked in my mind all through the war, and
afterwards, when it was still difficult to find the space in which to do the
work. It's so natural to work large – it fits one's body. This doesn't mean
that I don't like working small because I do. It's refreshing, like painting or
drawing, but I've always wanted to go to my arm's length and walk round
things, or climb up them. I kept on thinking of large works in a landscape:
this has always been a dream in my mind. And in the last ten years I've had
the space and time and money for materials, so I've been able to fulfil many
ideas that were around for a long, long time.

AB: *It was in 1958–9 that you were first able to make a really large sculpture –*
Meridian *(250), the sculpture for State House in High Holborn, London. This has
always seemed to me to be a key work not only because of its size, but also because
it is in bronze, and because it introduces new formal ideas into your sculpture.*

BH: It came after a period of doing both drawings and small sculptures of
growing forms and interweaving forms. These came about, quite naturally,
after I had started using bronze for the first time.

AB: *This introduction of new materials has widened the scope of your sculpture,
hasn't it? The variety of material is particularly characteristic of the last decade,*

so that your work now seems fairly evenly divided between bronze and stone
and wood – and between polished and patinated bronze surfaces, between slate
and marble, between light and dark woods.

BH: Yes, they are all materials that I like, but my working methods are some-
times not so different. My approach to bronze isn't a modeller's approach.
I like to create the armature of a bronze as if I'm building a boat, and then
putting the plaster on is like covering the bones with skin and muscles. But
I build it up so that I can cut it. I like to carve the hard plaster surface. Even
at the very last minute when it's finished I take a hatchet to it.

AB: *Do you make changes? Because there's clearly a basic difference between a*
carver and a modeller – a carver who has cut off a piece of stone or wood can't
put it back, but a modeller can. Are you tempted to do this?

BH: No. If I had to, I would feel I'd made an awful mess and destroy the thing.
I hate modelling. I always know from the beginning what a work is going to
look like.

AB: *There's no question then of working your way towards something that you can*
only vaguely envisage?

BH: Oh no, the idea of changing is terrible to me. I live with my material and
know it.

AB: *What happens when for example some blocks of stone arrive in the yard – do*
you have any immediate reaction towards their shapes? Do you think at once, oh,
that's what I want for this idea?

BH: Yes – I stalk round them as though they are a flock of sheep. I know every
one of them: what's inside the block. With a sculpture made of several parts
I know precisely where they all belong.

AB: *You've used some quite new materials in the last decade – slate for example,*
and the Irish and Swedish marbles. How did this come about?

BH: People bring me things, and I've gone exploring. I found out that if they
quarried very deeply in the slate quarry here at Delabole (in Cornwall) they
could get a reasonable thickness for me, and a very fine quality – much finer
than the top layers which are used industrially. So every time they come
across what they consider a sculptor's piece, they telephone me. The slates
from these deep beds are very beautiful. Some have quartz in them, and the
largest of all – the *Menhirs* now in the Tate (361) – has the most gorgeous
fossil of a fern.

AB: *What are the problems of carving slate? Is it like marble?*

BH: No, it demands quite another technique. You can easily split it, just as
you can bruise marble.

[1970]

AB: *Is it a challenge to have a new stone to carve?*

BH: I adore it. First of all I prowl as usual, and then I try a bit and work it, and bring it to a polish and consider it. There are certain things I don't like. I don't like anything too heavily marked, or mottled, and anything pink drives me mad, because it's so suggestive of human flesh or something. I've worked in Portland in the past, but it's not my favourite stone by any means. And I hate very soft stones, like Bath stone, because they don't have resistance.

AB: *I imagine there is a great difference in technique between stone and wood carving.*

BH: Yes there is. With wood, you are always considering the whole growth, which is vertical. You can carve accordingly, up and down, or across, and with quite a different set of tools. With stone you have to use your ears very sharply, listening how each hammer blow is going to take away the piece you want. If the sound is poor, you know you must move round, and if it's a bad sound, then you have to find out if there's a flaw anywhere. Marble in particular is very delicate, and you can bruise it, you can stun it, you can change its colour by being clumsy. I know how to carve it because I was very well taught in Italy.

AB: *Does it sadden you that so few sculptors are interested in carving today?*

BH: Yes it does.

AB: *What's the explanation of this? Is it so difficult?*

BH: No, it's not difficult. I think it's because sculptors don't think they've got the time. And you have to be very clear about your ideas. I suppose that in a way carving is close to writing music – in so far as the composer takes in his whole work from beginning to end before he begins to write it down. Once you start it has its complete logic – it's an inevitable procedure.

AB: *Do you find that you work in sequences? Does one work lead on to another?*

BH: All the time. I think every work has the germ of the next. The last piece of work you do is crucial. When I like it, I find I'm obsessed by a new idea in my head.

AB: *But you always seem to do a lot of work simultaneously – there are always half a dozen sculptures being made at the same time.*

BH: Ah yes, but any which are not complete are perfectly clear in my head. They have surmounted the hurdles which concern me, and I know the idea is coming as I want it to. I'm often dependent on the sheer mechanics of weather. If it's dark and pouring with rain, I go and finish something which I'm sure of. I probably wouldn't touch something I had only just nibbled at. But when the sun shines I'm out in the yard. I like to use the sun when I'm carving marble – it's difficult to work in mist.

AB: *How do you switch from one work to another, though? Is it partly a question of feeling like a change of medium?*

BH: Yes I think it is a question of mood. When I wake in the morning I like to see which way the wind is. Very much a question of mood. But you can't as with modelling do something in six hours. If you're on a large carving you can work all day and so far as you can see there's not much difference. But you know perfectly well that after a fortnight it will be all right.

AB: *It's no longer possible for you to stand carving all day, and this is where the men help. Exactly what role do they play?*

BH: They don't know what I'm doing. I don't give them an object and say copy that. I hardly ever make a model or a maquette, and if I do it's only to show an architect, and I always claim the right to change it. No – Dicon and Norman and George are my good friends and extra hands. I couldn't do so much work if I had to do all the carving from beginning to end, because it takes such a long time. I have a very definite way of showing them what they are to do. If I take a cut, two inches deep and ten inches long, and do this several times, they know that it has its own logic, like sea coming in over the sand. It might take them two days to join up my cuts, because the stone has to come off bit by bit. Or I might say, I want this piece to balance, and they bore holes and trim the marble below, and make the sculpture balance. And there are many other things that they can do for me. They have come to know, instinctively, what I'm aiming at, because we've worked together for so long. But all the really delicate stages are entirely my own.

AB: *How long have you had the present team? Isn't it nearly ten years?*

BH: Yes I think two have been with me for ten years, and one for eight. And they are all highly skilled in their various ways. Their intuition is splendid – I think because they're not artists themselves.

AB: *Do you now prefer not to have artists to help you?*

BH: Yes. I did in the past, but now I've given it up. I was keen to hand on this carving technique which is now so hard to acquire. I did hand it on, but of course in the most successful cases it turned out that they have never carved at all. I know they gained a lot of experience working on big sculptures of a size they couldn't then afford to make themselves, but all they really wanted was to find their own individuality. And I think they did, because they have ended up by using quite different materials in a very free way, which is very good. But then I got tired of teaching.

AB: *Did you think of yourself as a teacher?*

BH: I suppose I did. I was taught and I know how to teach. I was rather severe. People always want to carve a nose before they can make a piece of stone

stand up. I think all potential sculptors should read Thor Heyerdahl's book where he describes his attempts to make an Easter Island figure stand up.[3] He and his friends discovered within themselves a native instinct for moving a ten-ton stone. They didn't know how to do it, but between them the idea was reborn. It comes back to us after a thousand and more years.

AB: *I want to ask you now about particular sculptures, and am going to start again with* Meridian, *which, though it just falls outside the period of this book, is such a key work. How did this commission come about? Were you invited to make a large sculpture for a new and unfinished building?*

BH: Yes I was. The architect took me to see the building when only one storey was up. It was in the most terrific state, with jibs and cranes and tremendous activity. He showed me the spot, and explained how he wanted the curved wall behind. Well, mercifully, I did get an immediate idea. I thought the building needed some kind of growing form, and I went straight ahead. When I'd finished he was delighted.

AB: *Of course* Meridian *is closely related to earlier and smaller sculptures, but was this a case where you hadn't any preconceived idea before you saw the building?*

BH: Yes – if I don't get an idea when I see a site, then I can't touch it. Sometimes the limitations of sites are such that I can't see any solution.

AB: *The next large sculpture was a particularly difficult challenge –* Winged figure *(315) for the new John Lewis store in Oxford Street. I have always felt your first idea (306) would have been a more satisfactory solution to the problem of placing a sculpture on a flat wall, but no doubt it was too bold to be acceptable at the time. As it is, the support for the* Winged figure *seems rather heavy: I would like to see the form free at the bottom.*

BH: Well then it would have to have had greater thickness, and there would have been bolt holes that one could have seen from the side. I admit that it was awkward to fix. We cast it in aluminium, because of its comparative lightness: after all, it's a bird-like form, about to take off. The only thing that put me out was the lamp-post which was erected in front as soon as I'd got the sculpture up. But I was very grateful again for the opportunity of working on a big scale.

AB: Winged figure *was made at the time you were working on the United Nations sculpture, wasn't it? This commission has a rather complicated history which I think you should explain.*

BH: *Bryher II* (305) was really the beginning of the work. Dag Hammarskjöld wanted me to do a scheme for the new United Nations building in New York, so my mind dwelt on it, and we got as far as this. We talked about the nature of the site, and about the kind of shapes he liked. I also made *Chûn Quoit* (311)

and the small walnut carving, *Single form (September)* (312), with Dag in mind – we discussed our ideas together but hadn't reached any conclusion.

AB: *Why did you make this in wood?*

BH: It was such a beautiful piece of wood, and I knew Dag loved wood. He already had two carvings of mine in his collection, and maybe this would have ended up with them. Then, when I heard of his death, in a kind of despair, I made the ten-foot high *Single form (Memorial)* (314). This is the same theme as *September*, but the hole is moved over and now goes through the form. *Memorial* was made just to console myself, because I was so upset. I never dreamt that anything further would develop. While I was making it I realized that it ought to be bigger, because I wanted to expand from a very small base to a very wide top, and with a great swing to the form. Then to my surprise, I heard from U Thant, who wanted to know what Dag's thoughts had been and what I'd done. I sent the photographs, and he asked me to go out to New York to see him. He told me about the last walk he'd had with Dag around the pond, when Dag had said that I was developing an idea which he wanted very badly. Everything went forward from there.

AB: *What are the differences between the half-size* Memorial *and the final version of* Single form *(325)?*

BH: I had to alter the dimensions, because of the effects of perspective. When I went to New York I had a full-scale mock-up made of wood. The argument was, should it be seventeen feet or twenty-one feet high? – and when it was put up in wood for me to look at coming down the street, I knew it must be the larger size. The Memorial Library had by then been completed, so there was a question of scale, too. The proportions had to be changed, compared with *Memorial*. The base line could remain the same, but the swell at the top had to be half as thick again. I had to change the hole and make it more of a spiral and larger.

AB: *How did you know it would stand up? Did you have an engineer's opinion?*

BH: Oh no, it was instinctive. I suppose I've got a certain heritage from my father, hearing him talk about building bridges and wind resistance and the like. We put it together in the foundry and stood it up and when it balanced I was so excited . . . I just can't tell you how thrilled I was.

AB: *Why are there lines across the form in the final version?*

BH: *Memorial* – the smaller version – was cast in one piece, but that must be about the largest piece of bronze casting you can do. The final version was cast in seven pieces. When I knew that I would have to dissect it in order to cast it at all, I decided to use the divisions as an inherent part of the composition. I didn't want to cover up the joints. As it is you can see how all the pieces lock together and how each part balances the other.

AB: *The photographs of work in progress give one a good idea of the structure. Is the final cast built like the plaster version?*

BH: It's in metal of course, but it's similarly reinforced like a battleship, criss-crossed, to take all the strains. It was marvellous to make, and strangely easy. When I was working at the foundry on the surface there were about nine men inside. It looks quite slim now, when you're inside it really is like a battleship.

AB: *Are you satisfied with the architectural setting? For instance, I don't much like the design of the pond, and would prefer a simpler surround.*

BH: Well, the base had to meet many requirements and of course it's difficult when there's water in the pond one minute and none the next. But I don't think this matters particularly.

AB: *Though* Single form *would look enormous in most cities, it doesn't look large in New York. Do you feel that it's dwarfed by the skyscraper environment?*

BH: Not at all. It's the right scale for human beings to relate to. They've left behind enormous buildings, and now here's this vast façade of glass, but the sculpture is still on a human scale. A person walking round can encompass it as part of their life. And when you look down on it from the 38th floor, it's like an old friend standing there below. I don't believe in heroic sculpture – I want to get the human relationship right. When I'm working big, what concerns me most is first the perspective in relation to the height of man – for we don't change, whatever else does – and then the movement which has to take place if you're going to look at it, and finally I like to try to give an emphasis of quietude and draw out what I hope is some poetry.

AB: *One of the first ideas for* Single form *is the sculpture we've already mentioned which you call* Curved form (Bryher) *(299 and 305). Bryher is one of the Isles of Scilly, and I wanted to ask you about your use of titles.*

BH: They are always added later. When I've made something, I think: where did I get that idea from? And then I remember. *Bryher* is being in a boat, and sailing round Bryher, and the water, the island, the movement of course. If I experience something bodily like that, I often get an idea for a sculpture. *Bryher* is a relationship between the sea and the land. But I don't start with a title: I make a shape, and there may or may not be an association with it – but this comes afterwards.

AB: *You say that* Bryher *is about relationships between sea and land. It belongs with a whole sequence of landscape sculptures which have subtitles like* Trezion *(304),* Atlantic *(362),* Porthcurno *(363).*

BH: Yes, these are all sea forms and rock forms, related to Porthcurno on the Land's End coast with its queer caves pierced by the sea. They were experiences of people – the movement of people in and out is always a part of them.

They are bronze sculptures, and the material allows more openness of course. I was a comparative newcomer to bronze, so I used it extravagantly to see how far I could go. It has a presence, but it doesn't look at you in the way that a carving does. There is a stronger sense of participating in the form – you want to go in and out as you look at a sculpture like *Trezion* or *Porthcurno*. Maybe it's not big enough to do this, but you don't need to be physically entangled if you've got a pair of hands. If you feel something, you know what the experience is.

AB: *So you would like people to feel the apertures.*

BH: Yes I would.

AB: *Am I right in thinking that this idea led directly on to the* Walk through *(433), where you can actually pass through the sculpture?*

BH: Yes it did. I wanted to involve people, make them reach to the surfaces and the size, finding out which spiral goes which way, realizing the differences between the parts. But you can walk through these works, just by looking at the photographs. You can climb through the *Divided circle* (477) – you don't need to do it physically to experience it.

AB: *Sculptures like the* Walk through *are necessarily on a much bigger scale, and this makes them difficult to execute. The first idea of the* Walk through *(407) belongs with a whole group of projects made in 1966 (e.g. 409–13), all of which seem to invite execution on a monumental size. Why did you suddenly make all these? Was it to do with being seriously ill at the time?*

BH: Yes of course it was. It was the same in 1938. If war is imminent, or you're very ill or something's threatening, you want to put something down for big work while you can. I was in an absolute fever of ideas, without much hope of fulfilment. It's never easy for a sculptor to have enough money, enough space and enough material to do quickly what he wants to do. Maybe you have to wait. I could only make small works, but I wrote in my records, projects for monuments.

AB: *That was a title you had used in 1938. I think of the* Project for sculpture in a landscape *(115) and especially of the* Project (Monument to the Spanish War) *(111) [fig.63] which had five enormous plane wood forms.*

BH: That was very large, and unfortunately it was destroyed in the war. There were masses of these schemes, all of them meant to be huge, and none of them ever executed. Some of them have always been in my mind, and I think they're related to work I've done in the last decade. *Squares with two circles* (347) for example is a throwback to my frustrations of the 1930's. The *Monumental stele* (83) in the garden of the Mall studio was the first time I had been able to go up to six feet. It was damaged during the war by shrapnel and had to be destroyed. But it's haunted me ever since, and when I was able

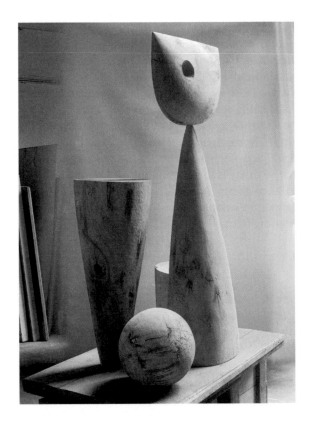

63. *Project (Monument to the Spanish War)* (unfinished) 1938–9, plane wood, BH 111 (destroyed in the Second World War). Photograph taken by Hepworth

to make *Squares with two circles* I kept thinking about it. The back view has the curve that was in the earlier work. I don't often express preferences about my own work, but I must admit it's a particular favourite of mine, perhaps because of the earlier connection.

AB: *Would you like to make some of the other 1966 projects on a larger scale – apart from the* Walk through *and the* Walk in *(473)?*

BH: Yes, I would – provided that I saw them. I'm particular about that.

AB: *Which would you choose first?*

BH: I think *Mykonos* (413), because the slant of the three circles is so important – they're all slanted, you know, with a suggestion of spirals. Everyone thinks my circles are just plonked down, but they're not. If you climbed through the circles of *Squares with two circles*, you'd soon find that out.

AB: *When you talk about climbing through the circles, it makes me think of the pierced stone of the* Men-an-tol. *Have these ancient Cornish standing stones had any influence on you? Do you regard such cult objects as sculpture?*

BH: It's curious, I had never seen them before I came to Cornwall in 1939 – Desmond Bernal talked about the *Men-an-tol* and about neolithic menhirs in his foreword to my 1937 show, but at that time I'd never heard of Cornwall, and knew nothing about dolmens and cromlechs and the like. All it did coming here was to ratify my ideas that when you make a sculpture you're making an image, a fetish, something which alters human behaviour or movement. Now I've come to love this landscape and don't want to leave it. Any stone standing in the hills here is a figure, but you have to go further than that. What figure? And which countenance? To resolve the image so that it has something affirmative to say is to my mind the only point. That has always been my creed. I like to dream of things rising from the ground – it would be marvellous to walk in the woods and suddenly come across such things. Or to meet a reclining form.

AB: *This is all very surrealist, Barbara.*

BH: Yes – and why not?

AB: *There seems to be an inevitable presence in all abstract sculptures of human dimensions. I think this is one of the reasons why the younger sculptors have tended to work on an enormous scale. If you have twenty-foot dimensions you can escape the suggestion of the human figure.*

BH: What you say is probably true, but I am always concerned with the human relationship.

AB: *When you make two-part forms, are they two-part forms from the beginning?*

BH: Yes.

AB: *Have you been tempted to add another to keep them company?*

BH: No, I don't think I've ever wanted that. I always have a very clear idea before I start of what the end result is going to be. It would be very confusing to make a complex entity and then add something. You must start with all the relationships from the beginning, otherwise it would alter their countenance entirely.

AB: *You don't sometimes start with a rough idea of what you want, and let the work lead you through?*

BH: No I don't. I have to fall in with the material I'm using, but I always know what I want from the beginning. Ideas are with one for a very long time. In Rome when I was 21 I found a beautiful piece of marble, and I thought, I must make something to go on top. Then we had to leave Rome, and I didn't have enough money to bring back the marble with me. All my life through I've wanted to put a form on a form on a form as an offering.

AB: *And this was to be the three-piece vertical sculpture that you made in 1967 (452)?*

BH: Yes it is. I spent more time on the lowest form than on anything else. Every cut was a personal mark.

AB: *It's strangely like the* Monument to the Spanish War *(111) – is there a connection?*

BH: Of course there is. With Viet-Nam people of my age are reliving the same thing. But there's now more passion about it.

AB: *What about the* Construction (Crucifixion) *(443)? – that was an unexpected development.*

BH: Look back at my drawings. I wanted to go free. I'd been experimenting with colour in relation to bronze, and I wanted to go free and hang up a circle. Why shouldn't I? It seems to upset people: I find it very serene and quiet.

AB: *Perhaps the associations in the title worry people. Did you see it as a crucifixion when you started making it?*

BH: Entirely. I had been very ill, and I wanted to do it – it had been boiling in my mind. I admit it's not easy to show – I hated it at the Tate – but here in the St Ives churchyard setting it looked marvellous.

AB: *Your use of colour in bronze is very unusual. I think for example of the blues in the hollows of* Two figures *(460).*

BH: That is very sharp and biting. It's an extension of the contrast I have often made between polished and patinated surfaces.

AB: *Why do you introduce painted colour into stone and wood carvings? This is something you've been doing for a very long time, yet hardly anyone has remarked upon it.*

BH: I can only think I've been successful in so far as it's seen as part of the form. But in a way my colour has been accepted, but never understood.

AB: *It's easy to understand why the apertures of the wood sculptures are so often coloured. But why did you paint those flat surfaces of the Swedish marble carvings (387, 389)?*

BH: It was a new material that I hadn't carved before. I don't usually like a patterned marble, and I didn't know how intense the markings would be until we began polishing the stone. They needed taming.

AB: *Did you plan to use paint from the beginning?*

BH: The flat surfaces were always going to be coloured, but I wasn't at first thinking in terms of black and white. I didn't appreciate that I would have to go right to black – it could have been blue. This is a case where one does have to work with the material.

AB: *You often make two or three closely related works – is there any special reason for this?*

BH: It's true that there are often different interpretations of an idea. If I have not been able to explore all the possibilities of the shape, I'll do another one and see what happens. The differences may be very subtle – it's rather like contemplating a basket of eggs: you never find two eggs of the same shape. The possibilities of the oval sculptures are so immense – one could spend the rest of one's life carving ovals or rhomboids or piercing circles.

AB: *But your latest work points to a diversification rather than a concentration, doesn't it?*

BH: Yes, I know, and I think I'm going to be led into using various opposing forms and materials. I so enjoyed making the *Pierced hemisphere with a cluster of stones* (481) – all the materials are such personal loves – white marble, slate, hopton wood, Irish marble. They seem to suit each other and they suit my present mood. And *Apolima* (493) juxtaposes the two forms in marble and slate.

AB: *The* Pierced hemisphere *is like that early bowl of plaster forms,* Forms in hollow *(71), which was lost during the war. Have you in the last ten years been quite deliberately reviving and resolving earlier ideas?*

BH: To some extent perhaps, though naturally, I hope I'm now more mature. I don't think anyone realizes how much the last ten years has been a fulfilment of my youth. Even breaking my leg in 1967 was a good thing because it made me extend my arms as far as I could. But going back also opens the door to brand new ideas. There is still so much to be done. Looking back, I ask myself why I didn't do more work, but you can't hurry things up. I find it easier now I'm more free to make forms and move them around. I don't feel so personally involved – I'm not exactly the sculpture in the landscape any more. I think of the works as objects which rise out of the land or the sea, mysteriously. You can't make a sculpture without it being a thing – a creature, a figure, a fetish. I called that marvellous piece of Irish black marble *Touchstone* (496), and that is what sculpture is about. It's something you experience through your senses, but it's also a life-giving, purposeful force.

AB: *Barbara, for you sculpture is a very physical process, and you often speak about the sensual pleasure involved in making it. I think you often find a way of using the different materials that will maximize this personal involvement. Can you describe your experience of carving a hole in a wooden sculpture, for example?*

BH: In the wood carvings the interior gouging is all done by hand, and no mallet. I can cut half an inch deep. It has to be rhythmical – one's whole mind and body must be focused on it, otherwise the carving just changes character and direction. If I'm interrupted I have to start all over again. The thing is to

get the flow of the lines all in one mood, then you can come out through the hole and join up where you want to.

AB: *Is the same kind of process involved in making the surfaces of a bronze like the big* Single form *(325)?*

BH: Yes, I built the bones first, and put on a lot of plaster with a spatula, and then began to carve the surface. I was very nervous at first, and aware of the height it went to and what you could see and what you could feel. And then as usual I began to cut it down, and the more I cut the better it was. I used axes, rakes, hatchets – different kinds in a different rhythm. You can see the axe marks where I wanted the extra vitality. I had to be in the mood to do the whole surface and get what I wanted.

AB: *Is there an element of chance in the surface?*

BH: None: I don't like chance. It is entirely deliberate.

AB: *What is it like carving a very hard material like slate? You can't shape that as much as you can a marble carving, can you?*

BH: No it's another technique. The material is precious, and you can't hit it with a hammer. You use a saw, and it's rather hard work. You can use a gouge and mallet if you're careful, but it's mostly filing. You can do some fine chiselling, but only with very light-weight tools. It's possible to feather slate: you bore holes and drive in wood wedges and wet the wood. As it expands, it splits. You do the same thing with marble. The marks on the side of *Two faces* (498) are the remains of feathering. We did that here in the studio. I usually obliterate all the marks, but this time it looked so natural, I stood the pieces of marble outside, side by side, and kept looking at the marks. To do it again deliberately might be most uninspiring and boring. I wouldn't like it.

AB: *When you talk about the practical problems you have spent your life tackling, it makes one appreciate how much the sculptor is involved in technology. At first your interest in science and technology seems unexpected, as if one didn't expect an artist to be involved in such matters. Then one remembers the interest distinguished scientists like Desmond Bernal and Solly Zuckerman and C.H. Waddington have always shown in your work. Do you think there is an affinity between modern science and modern sculpture?*

BH: Yes, I always have, right from the 'thirties.

AB: *And perhaps your vision is closer to that of the scientist than to that of a novelist for example?*

BH: Much closer. I'm not scientifically or mathematically educated, and I work by instinct – if I were to start measuring things I would make a fearful mess of it. But dividing a line, or making something stand up – I depend on instinct, that's the only thing I can trust.

AB: *And do you think that it's in this way that the scientist makes his discoveries?*

BH: Certainly, yes. I can remember J.D. Bernal looking at my work in the 'thirties. He always said, I can give you the mathematical equation for that carving, and then he'd say, oh no, you've broken the equation, you've broken the rule. So I would say where? He would point, and I'd say – but that is the eye of the piece. We were always very close.

AB: *Has your interest in science affected your work directly? I think for example of that wood carving you called* Telstar *(327) after the Post Office tracking satellites on Goonhilly Downs in the Lizard peninsula.*

BH: It so happened that I was invited to go on board the first one when it began to go round, and it was so magical and so strange.[4] I find such forms of our technology very exciting and inspiring. You might say that the *Four hemispheres* (483) equals the dishes at Goonhilly and the trackers of the sky. I would love to have been able to place them in the landscape. Though at the same time the *Four hemispheres* has nothing to do with Goonhilly: they're part-blind faces, looking in four directions. Technology may stimulate my intellect – I can feed upon it – but I am an emotional sculptor, only I have to have enough intellect and learning to carry out what I feel I must do.

AB: *Has the general broadening of your work in the last decade anything to do with this?*

BH: Yes I think we've all assimilated a great deal of scientific discovery – the sensation of space, as well as a new conception of the universe.

AB: *And you feel this has made a difference to you?*

BH: Very much.

AB: *So we might conclude by seeing your sculpture as having its roots in the very distant past, and its basic motivation in a very primitive impulse to make sculptural objects. Yet at the same time there is this intense awareness of the modern world which we inhabit, and the human response to that world and to its problems. The sculpture stands at the still centre, a classical demonstration of the eternal viability of art.*

BH: I feel this.

1 The conversations took place on 14 April, 2 and 4 September 1970. Hepworth approved the edited version made by Alan Bowness from the tape recordings. He wanted to keep the flavour of the spoken word as far as possible.

2 References to BH catalogue numbers in the text have been retained (in brackets).

3 *Aku-Aku: The Secret of Easter Island*, London 1958 (Hepworth owned a copy).

4 The visit in September 1963 was organised by Sir Kenneth Anderson of the GPO whom Hepworth had met through its acquisition of *Curved Reclining Form (Rosewall)* (see pp.164–5). In a letter to him she described the alabaster *Goonhilly September* (1963, BH 342), carved at the same time as *Pierced Hemisphere (Telstar)*, as 'the relationship between the scientific form and the primitive'. (Letter of 10 December 1963, Royal Mail files.)

Interview with Robert Sharpe at Trewyn Studio, St Ives, August 1971, for the Central Office of Information (COI). On the occasion of the gift of Hepworth's *Figure* (1964, bronze, B H 357 B, fig.64) by the British Government to the Kennedy Memorial Center, Washington D.C., in July 1971[1]

RS: *Dame Barbara, will you describe the work for me?*

BH: I call it *Figure* and indeed, in my mind, it is a figure. It has a presence, every figure has a presence. In fact, you can barely have any standing object which doesn't, except engineering-wise, which doesn't take one to the presence of the figure in landscape. This particular one is hollowed out and within it there is, in space, another figure and when the light goes through and reflects in shadows or lighting you have almost a presence of yet another figure behind it. So, whichever way you go round, you have the sense of there being the central presence but other presences.

RS: *Now,* Figure *is in bronze. Why did you choose this material. What were your feelings when you created it?*

BH: I tried various materials to start with to get my idea right and my first project was in wood, then I reworked it, ready for casting in bronze very specifically because I wanted to get colour inside, in the inner figure or the inner heart of the figure. So I used bronze so that it's golden outside and it's deep bluey-green within.

RS: *In the United Kingdom the name John F. Kennedy is, it's tremendously evocative, still. Now, the British government selected* Figure. *Do you feel that they chose wisely?*

BH: Yes, I think I do. It mattered very much to me when I heard that they had chosen this particular one. And I was also told that it might go in the concert hall, in the foyer of the concert hall and, again, this mattered a lot because it has a certain kinship with music and sound and is very evocative and one can hardly think of this tribute to John Kennedy without feeling very, very deeply about it.

RS: *What was it like for a young girl breaking into the masculine province of sculpture?*

BH: Well, I always wanted to be a sculptor, at least from the age of seven, and I must have been born with that kind of mind because I was always making things, modelling, cutting things and everyone thought this was extremely enchanting until they realized I was serious, then the trouble started because they, they, I mean the outer world said this is ridiculous you can't make a living and it's not a province for women. And I never believed a word of it because it's not just strength that makes sculpture; it's your idea and your sense of rhythm, just as in dancing or playing tennis, swimming or anything.

You're good at the job in so far as you appreciate what the principles are which are involved.

RS: *Did you encounter early setbacks?*

BH: Yes, disappointments, not setbacks because I was so intent on pursuing the idea that I had inside me that really nothing was a setback but there were disappointments when I got, at the beginning, I got left out of things.

RS: *Had you not become a sculptor, what would you have become?*

BH: I can't imagine not being a sculptor but I think I'd have been a surgeon.

RS: *Just one point, Dame Barbara, do you call yourself a sculptor or a sculptress?*

BH: Oh please! Sculptor. It's the name of the job, not the sex.

RS: *You didn't see yourself as being in the van of women's liberation in your day?*

BH: Well, I think maybe I was fairly advanced at that time, in my thoughts, but then I'd been very fortunate in my parents who were very far-thinking, far-reaching in their ideas on education altogether and I look back now in wonder.

RS: *Would you have arrived at your present style if you had not studied the naturalistic manner?*

BH: No, I think my training was extremely useful. I threw overboard anything I didn't want but everything I was taught – anatomy and perspective, drawing from life, modelling from life, going through exams has all stood me in tremendously good stead. I thoroughly enjoyed it. I wouldn't have had it otherwise.

RS: *Is there such a thing as a national, say, a national British style? And, if there is, where do you see your place in it?*

BH: I think that certainly the British sculptors of the last forty years have made a tremendous contribution, well, in fact it began, of course at the beginning of the sixties and it's a very valid style, perhaps because we did have three hundred years ago a sort of sensibility, nationally, and then it faded out completely and it all became merely repetitive stuff for – for just the money value. There was nothing desperately interesting in the world of sculpture, you know, to kindle.

RS: *And your place in English sculpture?*

BH: Well, I was one of the group of the twenties/thirties who absolutely broke new ground by saying 'if we're going to be sculptors, we cut stone, ourselves, direct'.

RS: *Can you identify the points, the places at which your work changed?*

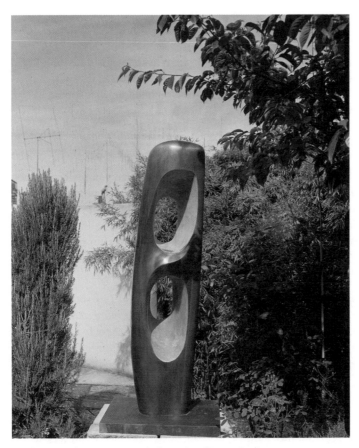

64. *Figure* 1964, bronze, BH 357 B, in the garden of Trewyn Studio.
Photograph: Studio St Ives, June 1965

BH: About 1931, I remember very clearly a feeling that I had got completely free of having to copy any form, either a form I'd been taught or form I had observed and I realized that I could carve new forms which only I could think up because they came in my head, as a sort of experience of everything else; and then again, in about '34/'35, after I'd had my triplet children I realised that I was as free as air, to make entirely new forms; the more I believed in them the more exciting they became to me and to the few people who supported us in those days.

RS: *Do you see yet another form emerging?*

BH: I just had a new phase the last year. It's not so much new as a fulfilment on a big scale of an idea which has cropped up all my life, and that is a group of figures – and I call them *Nine Figures on a Hill* and they could be placed working up from *Ancestors* through to the *Ultimate Form* and I've finished them now.[2] The only thing I haven't got is a hill.

RS: *You are credited with introducing the pierced form into sculpture. What are your comments on that?*

BH: I remember very clearly piercing a form '30/'31 and my absolute delight and astonishment at the effect this had of enabling one to see through and round, and the new forms it made.³ I think this did become widespread as an approach, this piercing, later on.

RS: *I believe it's true that you don't work from a model normally but wouldn't it perhaps be safer, say, when you're working on a large ten ton block of stone?*

BH: No, it wouldn't be safer because I've always believed that you really cannot blow up a small thing and make it big because the *only* thing that matters about scale is that you judge its scale right from the beginning; if you're going to do a large thing, I like to work it in relation to the size I am, walking round it. If I do a maquette, which I do, from time to time, it's usually done after I've dreamed up the big one and, of course, a maquette to look right has to be nice small; if it's nice small it would look absolutely awful big.

RS: *On that thing I think I probably belong to the I-know-what-I-like brigade but it has seemed to me that some of your works, particularly the more rounded ones, if they were miniaturized, say to the point where I could hold them in my hand, they would have a very pleasing, tactile quality. Would this be fair or is this an impertinence?*

BH: I think that's fair but I do, I do many small works for the hands and such tactile pleasure as people get out of big ones would not be enhanced in any way by making a little one of it because if you made a little one, the tactile quality would be reduced into a different scale altogether, so it would be a new sculpture. You can't diminish and you can't blow up.

RS: *That's fair. How many works have you destroyed because you haven't been satisfied with them?*

BH: I should think over my lifetime about twenty. I lost a few during the war. They got damaged. So I lost about forty works, but I deliberately destroyed twenty.

RS: *How important to you was your arrival in Cornwall?*

BH: Well, it proved to me incredibly important. I didn't really want to come. And it was a very great delight when I was able to travel round the countryside and appreciate the marvellous landscape and seascape because being town-bred although I knew the Yorkshire countryside. This has become so much a part of me now I couldn't possibly live anywhere else.

RS: *I once saw a newspaper article which said that you were in love with Cornish granite. Now, when I look at a piece of unhewn stone all I see is a lump of rock. What do you see?*

BH: Well, I am in love with Cornish granite in so far as wherever it appears, in cromlechs or walls or buildings, I think it's astonishingly beautiful. I'd have to live another lifetime to learn how to carve it because it's quite another technique, and it has one drawback for a sculptor is that you really have to wear a mask all the time.

RS: *When you carve a piece of wood you could claim that you are doing something unnatural to it, but supposing that piece of wood then cracks, it's probably very distressing to the owner but how do you feel about it?*

BH: I don't really mind the cracks in wood. Naturally, if one was carving out a vessel to escape from a desert island it would be unfortunate if it cracked too soon.

RS: *Very unfortunate.*

BH: But the real enemy of wood is, of course, central heating because wood is very, very organic, very sensitive to moisture; it'll even change if there is a rainstorm coming up and change in the heat, change wherever you put it and you can't expect wood to be like perspex. Even perspex will bend and misbehave itself in bad temperatures, bad position.

RS: *So, for yourself you're not over-disturbed by the thought, once you've created it.*

BH: No, I'm not, I'm not, no.

RS: *What is your favourite material?*

BH: I love all the organic materials. I go from marble to stone, to wood, to slate and back again with the greatest joy, the whole time. And, it took me a long time to really get to love bronze. I didn't begin until about '56 because I didn't, I've never liked modelling, that is handling clay, but then in '56 I found a way of using very, very hard plaster on sort of armature of bones and it was hard enough for me to take a hammer and chisel to, and then I began to enjoy it and began thinking in terms of the molten metal flowing into this form and the texture.

RS: *Do you have a favourite work?*

BH: There are some favourites, yes. Throughout the years from '29; '29 I did a carving I called *Infant*; '46 I did a carving which is in the Tate now called *Pelagos*; one of my favourites, if you can call . . . – such a silly word to use, isn't it – one in which one's whole heart went and, I think, successfully was the memorial to Dag Hammarskjöld. Now, I have many new works since then, many new quite large marbles which I like very much.

RS: *Is there something formulating in your mind at this moment which years hence people will look at and say 'this is the essence of Barbara Hepworth'?*

BH: Oh, I very much hope there is something formulating; one would be finished otherwise. No, I could go on carving for 2000 years and never get tired or ever reach the end of ideas that I have. The thing is that sculpture takes a long time and therefore one has to live a very disciplined life, in the sense that I don't do anything in the middle of a job which I know will disturb it; such as going to the cinema or anything silly like that. I prefer to listen to music and go back to work.

RS: *So, one could take any one of those pieces during 2000 years and say 'this is Barbara Hepworth'?*

BH: I think you'd know them.

RS: *Ah, Dame Barbara, your hands – you are a carver and yet your hands are strong but they're still very feminine hands; and yet some sculptors, their hands, they become rigid bunches of bananas. Why is that?*

BH: Well, I learned very early, very early on that one has to train one's body and correct one's body all the time in order to do any job properly – whether it's dancing or carving or playing tennis or anything of that sort. And, I have therefore always taken a great deal of trouble over keeping flexibility and making sure that I don't get rigid, anywhere, because it's the end if you do.

RS: *Looking around this conservatory it's just a conservatory, the flower pots are simple flower pots and the chairs are just chairs. Does this mean that you're solely bound up in sculpture? Could you, for example, design a building?*

BH: I could . . . Do you mean a building for sculpture?

RS: *No, just a building.*

BH: Oh, I could design a building: I probably couldn't live in it though – unless it was a complete mess because my work, it's changing all the time, one's always bringing in tons of blocks of stuff; I've got six and a half tons of white marble waiting for me in the docks now – which has to be got in and put somewhere. There's not much point in bothering, as long as the chair is reasonably tolerable to look at. It's not meant to be pretty in any sense of the word. I like it very much when I go. I like the garden too. Well, that looks wild too, doesn't it? A little bit wild.

RS: *Slightly wild.*

BH: Well, things grow, don't they?

RS: *Dame Barbara, I think that's my cue to let you get back to your marble.*

1 Recording in the British Library Sound Archive.
2 Hepworth's original title, *Nine Figures on a Hill*, for the monumental nine-part bronze of 1970–1, *The Family of Man*. (see fig.65)
3 *Pierced Form*, pink alabaster, 1932 (destroyed in the Second World War). (see fig.3)

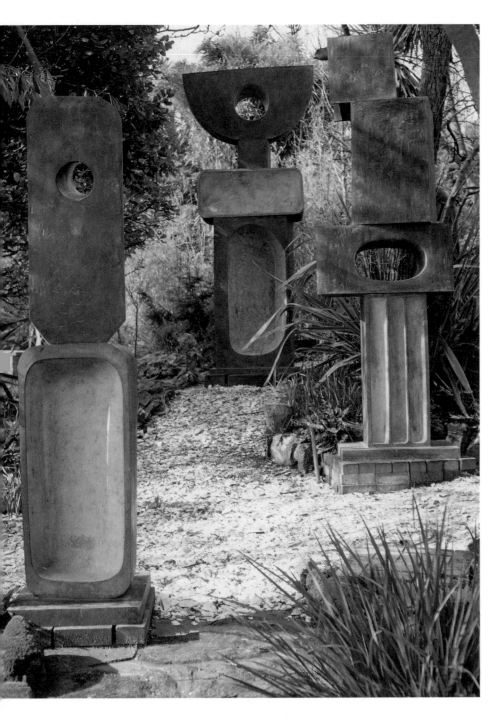

5. Three figures (*Youth*, *Ultimate Form* and *Bridegroom*) from *The Family of Man* 1970–1, bronze, BH 513, in the garden of Trewyn Studio, March 1971

Edwin Mullins, 'Barbara Hepworth's "Family"', Daily Telegraph Magazine, London, 7 April 1972, quotations from Hepworth[1]

In her seventieth year Dame Barbara Hepworth has fulfilled an ambition cherished for more than a quarter of a century. She has completed a series of monumental standing figures on the theme of *The Family of Man*. [fig.65]

The figures are in bronze, and rather over life-size. With the exception of a totem-figure, or 'fetish' as she refers to it, the Family breaks down into pairs: two ancestors, two parents, a bride and bridegroom, a youth and a young girl; nine in all. The totem is called merely *Ultimate Form*. Its role is to represent man's power and potential, the spirit that keeps him alive and looking forward. 'It is not a god but something in ourselves,' the artist explains. 'Something I have observed by working with people.' And she illustrates what she means with a typical dance-like gesture, arms extended upwards and outwards.

It was in 1947 that she first conceived this idea of the *Family*, and she has been waiting since for the right moment, and enough money in the bank, to carry it out. Even before 1939 there had been stirrings of a desire to make sculpture in which individual figures could be related together to form a group. She actually made such a piece at the time of the Spanish Civil War, but it was destroyed during the Second World War. [fig.63] From photographs one can see a marked family relationship between the principal figure in that prototype and the *Ultimate Form*. When this group first took shape in her mind after the Second World War she saw the figures, for reasons she cannot fully understand nor explain, rising out of the sea.

This rather impractical vision soon evaporated, and the *Family* came later to be associated in her mind with a stretch of Cornish hillside, and it is in such a setting that she still prefers to envisage them. Barbara Hepworth has lived in Cornwall since 1939.

They are in no sense portraits, though she would claim the figures have character and characteristics. The sculptor rejected the European tradition of naturalistic portraiture during her early days as a student. She recalls how in Italy during the Twenties she became depressed and bored by the ranks of memorial sculpture she found wherever she went.

Her aim in making sculpture is as always to evoke what she describes as an 'ancient response'. This is a physical response by the onlooker, a sensation he experiences within his body and which he expresses through his own movements around the sculpture, and in particular through actually touching it. During her retrospective exhibition at the Tate Gallery in 1968 she insisted, to the consternation of well-trained gallery officials, that spectators be permitted to stroke her work.[2] And since she is a Trustee of the Tate she got her way. One large bronze was specifically designed to be walked through. She has also deliberately carved a piece to be enjoyed by the blind.

This 'ancient response' – she is adamant – is only possible where sculptural forms are not specifically human. 'Everyone likes to run their hands over stone, but you can't go and pat legs and buttocks and breasts,' she says firmly; and her observation is borne out by the distance at which many of us have felt compelled to respond to even so sensual [a] carving as Rodin's *The Kiss* in the Tate Gallery. One is distanced by its very lifelikeness. Today Rodin is firmly back in favour for a host of reasons that might not have been obvious to his admirers half a century ago. But Barbara Hepworth belongs to the first generation bold enough to topple him from his throne as the monarch of a long tradition of sculptural sterility (whatever his individual gifts). About the deadness of that tradition she sticks to her guns. 'We had to get rid of so much bunk, sculpture that was untouchable, that was not related to our history.'

By 'history' she means our immediate past – world wars, the Bomb, space-flights, her own youth during the Depression in Yorkshire – and she means, besides, something deeper in time, a mystical association of man with landscape, which she feels to be specially strong in the region of England where she lives, West Cornwall, with its Stone Age villages and its innumerable quoits and cromlechs scattered over the moors. 'I can't go up a hill and see a cromlech and not want to pat it, or pick some flowers and put them on it: it's very ancient this feeling, and very pagan.'

In maintaining contact with this deeper sense of history, the sculptor's role as carver and modeller of natural materials is particularly poignant to her. It is a role she feels to be analogous to the very forces that brought the world and human life into being. It is a profoundly spiritual role, and it is this awareness of the spiritual content of art that draws her to themes like *The Family of Man*.

The two ancestors in the group are each about nine feet tall. Typically these combine echoes of her own childhood and family experience with a more general response to pre-history and man's primitive awe and need of forefathers. On the one hand she speaks of the impossibility of standing on the Cornish hills without being made powerfully aware of one's forebears; they had to get to the hilltops to survive, she explains; later, men went down into the pits to die.

On the other hand she talks of her great-great-grandmother, whom she can just remember. 'To me she was on a throne. She was rather like Queen Victoria. I was always being presented to her.' It is through a sense of family, she maintains, that one tries to establish some kind of sense out of the world we live in: some kind of sense and some kind of hope. A sense of who and what you are, of what you owe to your great-grandfather, to your newborn, where your debts lie, what your future may be.

Barbara Hepworth was 15 when the First World War ended, and she remembers being severely punished because she would not wave her hat in the air like the rest of them. She couldn't, she says, for the thought of all those dead.

Then came the Twenties and the Depression. Out of her bedroom window she watched the slagheaps cease to glow one by one as the coalmines closed down. She saw millgirls out of work, and more and more people getting along without enough food and clothing. Though her father was one of the more fortunate ones with a good job and a car – he was County Surveyor of the West Riding – she was one of four children and there was never any money to spare.

These times moulded her character and her will. It was during these years that she became conscious of how strong the spirit of man could be; how vital was the unity of a family. Significantly, the Father figure in the *Family* group is only a few inches shorter than the two ancestors. She feels in close sympathy with Cornwall because it has much the same social history as her native Yorkshire: the same pattern of early industrial exploitation, of consequent slump and unemployment – the dead mines, the dead villages. There is a community spirit which she recognises here. 'I know,' she adds movingly, 'how people live who lose half their year in darkness.'

Her experiences of the 20th century have made Barbara Hepworth a natural radical, just as they have infused her work as a sculptor with the quality of stoical optimism. 'Sculpture is to me an affirmative statement of our will to live,' she has written in what could stand as her personal Credo. She was brought up, she points out, at a time when in spite of the wars and poverty and unemployment there remained a widely held confidence among thinking men that man's creative self would triumph over his destructive self, and that we would reach in our lifetime a state of equilibrium with our fellow men and with our environment. And she cites such lifelong friends as the late Sir Herbert Read, and physicist Professor J.D. Bernal.

She needs no blueprint for survival to remind her that things have scarcely worked out that way, and that neither have they worked out that way for herself. Though she is successful, her personal life has been far from easy, at moments tragic. Her health broke down too. She has had to fight to survive. 'I felt deeply depressed about the world last year,' she confesses. 'It was a bad time. So I had to do something to act.' It was time to realise her *Family of Man*. 'In sculpture there's still an affirmation. I was never so happy as when making these.'

Barbara Hepworth's work has the precision which derives from a belief that emotions are most eloquently expressed with the least waste. Critics who persist in finding her work rigid and cold tend, in my experience, to be describing themselves.

1 An exhibition of Hepworth's work opened the following week at Marlborough Fine Art, London, at which *The Family of Man* was shown in full for the first time.
2 Norman Reid, Director of the Tate Gallery, clarified the gallery's policy of allowing visitors to the exhibition to touch the bronzes but not the carvings in a letter to *The Times* of 20 April 1968.

Tribute to Desmond Bernal, 1972, typescript[1]

I remember Desmond Bernal with deep love as one of the most creative and the most extraordinary men of this (or any) century. He was, of course, unique as a scientist but I comment here on his quite extraordinary insight into the visual world as a whole and particularly of the sculptor and painter.

During the four decades that I knew him and cherished his friendship, he was the most inspiring person ever to come into my workshop as he had the amazing capacity for comprehending in an instant the nature (and even the formula) of every sculpture, and hours were spent in exciting discussion and drawing, and even drawings of the inter-relation of artist and scientist within the nature of the universe.

Des always inspired, encouraged and cross-fertilized. His genius sustained us from the first time I met him to the last.

He was a wonderful and generous man as well as a unique genius and I am so happy and grateful to have been close to him for so many years.

1 The distinguised physicist J.D. Bernal (1901–1971) wrote the introduction to Hepworth's 1937 Lefevre Gallery exhibition. Hepworth's tribute was displayed in the exhibition on Bernal's life and work held in London in December 1972. An extract from it was published in the J.D. Bernal Peace Library brochure, 1973.

Cindy Nemser, 'Conversation with Barbara Hepworth', *Feminist Art Journal*, Brooklyn, Spring 1973, vol.2, no.2[1]

Barbara Hepworth has been an engaged artist for over fifty years. Lack of funds, two husbands, four children (triplets among them), a major world war, a son's tragic death have not prevented her from producing a massive and highly distinguished body of sculpture. Though, by her own testimony, family came first, none of her obligations or commitments ever forced her to put aside her lifelong work. For many years, her sculptures, drawings and lithographs have been known and revered throughout the world. Still at the height of her powers in her 69th year, Dame Barbara Hepworth is living proof of women's ability to achieve greatness in the fine arts, no matter what the odds.

CN: *You were married for 33 years and had four children. I find it astonishing that you could have done so much having such a large family to take care of and having so many financial difficulties.*

BH: I found it was a great inspiration to me. I loved the family and everything to do with them. I loved the environment and the cooking. I used to cook and go in my studio. I had to have methods of working. If I was in the middle of a work and the oven burned or the children called for me, I used to make an

arrangement with music, records or poetry, so that when I went back to the studio, I picked up where I left off. I enjoyed it, you see; it was part of me.

CN: *Well, I know for myself I find it very hard to work if I have my little daughter around. I usually get someone to watch her. Did your husband help? He was an artist too.*

BH: I had two husbands. Did they help me? Well, of course, because they were fond of children. But we lived a life of work and the children were brought up in it, in the middle of the dust and the dirt and the paint and everything. They were just part of it. But it is taxing if the children fall ill. That becomes a strain. I found the only way to resolve it in my mind was that it had to come out in the form of a new work. All my thoughts about the strain of the illness, all anxiety – this I think did discipline me in a way in which I'm deeply grateful for.

CN: *So it was in a sense overcoming an obstacle or a painful moment which made you strive in a different or almost harder way?*

BH: Well I found that there was no point in giving in to anxiety and concern about illness. One had to retire and think about it and become affirmative inside oneself and then wait – and if one waited, good work came out of it – if one got into a terrible state – then bad work would come out of it.

CN: *I can understand that. If you get too overwrought it's almost as if you can't do anything. If you resolve it and somehow calm yourself and accept, things begin to flow again. I feel there's a great balance and harmony in your work. Looking at it I feel that there's a great deal of the spiritual in it too. I was looking at the lithographs you did recently. There's so much space in them and the forms are enveloped in this space. One feels it's a cosmic vision.*

BH: Well, I have to work that way. I have to dedicate myself. Do you understand? I don't feel conflict in myself because if I do my work doesn't go well. If there's conflict I have to sit down or go to sleep to solve it. And the only way to solve the whole problem is to produce really affirmative work which can only come – I can't make it come. I can't conjure it up. I can only go to sleep and hope it happens.

CN: *You mean one can't work under terrible tensions.*

BH: You have to digest it and if you digest you can contribute. This is where women are very good because they have great fortitude and on that they should draw. If they have the fortitude to raise families and go through life supporting this and that, surely they have the fortitude to use their blinking heads. I never had much patience with women who said – Well, I can't work this week or next week or the week after, but maybe I'll work in six months' time or maybe in a year's time. I found one had to do some work every day even at midnight because either you're professional or you're not.

CN: *I know exactly what you mean. Coming down here on the train we met a woman who asked me what I did. I said, 'I'm an art critic', and she said, 'Oh I used to paint but then I got married and I haven't painted for 30 years and I suppose it's too late but I had all my family and children.' I always feel sorry for people who don't do what they want or need to do.*

BH: Well you need to know what to do and discipline yourself. I mean my home came first but my work was there always.

CN: *But don't you think it would have been easier for you if it hadn't been that way?*

BH: No. No, I was made that way – to incorporate family, children and everything. I hadn't much patience with women artists trying to be women artists. At no point do I wish to be in conflict with any man or masculine thought. It doesn't enter my consciousness. I think art is anonymous. It's not competitive with men. It's a complementary contribution. I've said that and I do believe it, that one does contribute to art and that's nothing to do with being male or female.

CN: *But I noticed that when Adrian Stokes was writing about your art he said something about its being feminine.*

BH: It's inevitably feminine because it's my experience.

CN: *True, but then we have to get into the problem of what the word feminine means.*

BH: We do, yes, because I don't think a good work of art can just be said to be feminine or masculine and I'm sure men would be very annoyed if they were called masculine.

CN: *Well, some would and some wouldn't. I think there was a big cult of the masculine at one point.*

BH: But art's either good or it isn't.

CN: *True, but in our society masculine has always been the higher good and feminine the lower.*

BH: But that's a stupid thing because the scales are out of balance. I mean as far as I'm concerned in my work and in my life, the scales are in balance.

CN: *Ultimately, we know that's true but still I noticed that Stokes also used the word 'complaisant' in reference to your work. That's a word that's also very often often applied to women's art. I did an article where I put together a whole collection of words I call stereotypes which are often used to describe women's work. I think these categorizations are nonsense and I'm out to break down those stereotypes.*

BH: Well, that is marvelous. It has to be done but you have to back up 200 years to George Eliot. Come to think of it I noticed from time to time that people look me up and down and say, 'Oh we thought you'd be a very large, hefty woman.' This irritates me vastly. The same way when I've been teaching, I've found opposition to my teaching because I said it's not the strength which does it, it's a rhythm. You don't need huge muscles, great strength, in fact, if you have that and misuse it, you're going to damage the material. It's absurd. It's a rhythmical flow of an idea whichever sex you are.

CN: *Linda Nochlin wrote a piece called 'Why There Are No Great Women Artists', and I think that's a terrible title for an article about women artists because I don't think it's true at all.*

BH: But it isn't true. Looking back women dancers and entertainers, singers, actresses have been accepted because they were entertaining. It's been hard for women architects, engineers, lawyers, sculptors and so on to be left free, but I never accepted this point of view – never.

CN: *Right from the beginning of your career, you've done what you wanted to do?*

BH: Yes.

CN: *I read that you went to Florence on a scholarship and spent the time looking and didn't come back with any concrete work. I thought that was marvelous to have the nerve – the courage to have done that.*

BH: Oh, I was in terrible trouble because the committee of men said they would never again give a scholarship to a woman. But if I'd done a lot of work and got married, they would have said the same.

CN: *Oh, they assumed it was because you got married you didn't do any work.*

BH: Well, they put two and two together – 'Women are hopeless.'

CN: *It was amazing that they gave you the scholarship in the first place.*

BH: Well, I was a bit of a fighter. Yes, it was really amazing looking back, nevertheless, I've never been disturbed by this.

CN: *What about the whole community of men artists that come in the 1930's, Mondrian, Gabo?*

BH: They were marvelous. They were all my friends.

CN: *And did they treat you like an equal?*

BH: Absolutely. They did. You see it was the English who are terribly patriarchical in this country.

CN: *What about the English men artists, were they the same? Patriarchical too?*

BH: [silence]

CN: *It's for posterity. The truth has to out.*

BH: I'll say yes.

CN: *Didn't you work with the men on a magazine called* The Circle?

BH: It's been reprinted and it's now referred to as a classic. Well it is. But that was done by Ben Nicholson, Sir Leslie Martin, Gabo and Leslie Martin's wife Sadie Speight and me. We were sitting round the fire and we said, 'Why shouldn't we do a book?' And so we started and now it's a classic and referred to as such. But we worked on it equally.

CN: *Yet, I noticed they didn't put you down as an editor.*

BH: There was no acknowledgment to the two women who did the dirty work.

CN: *I noticed that right off.*

BH: We did the layout, we did the corrections, proofing, everything.

CN: *And the research and helped to write it too?*

BH: Of course.

CN: *Well, that's the sort of thing I'm trying to pick up on.*

BH: Well, men don't like being beholden to women. I quite like being beholden to men. I've no resentment. In fact I wouldn't be happy if I couldn't respect my husband or my men friends. I acknowledge that.

CN: *The point is that women really don't want to destroy men. We just want them to treat us with the same respect that we have given to them.*

BH: Precisely. I'd hoped I would live long enough to see a balance maintained without any friction because I can't see any point in it.

CN: *I think people who are oppressed have to assert themselves. Nobody is going to do it for them.*

BH: Yes, there's a difference which I think is silly between being a female entertainer, dancer or singer, looking beautiful, and being a barrister or a sculptor. I don't find my forms menacing. I do them to please myself.

CN: *Have people said that your forms have a certain menacing quality in them? Or an uneasiness?*

BH: Well, either they're not menacing which is bad or they say they are and either way it's supposed to be slightly belittling. I don't care that the forms are stronger than they are.

CN: *In the United States there was the minimal art movement and there was a reaction against Henry Moore's sculpture. There was a feeling that his work was too romantic, not austere enough. Your work seemed to me much more contemporary.*

BH: I'm younger than Henry and I'm more in touch with the young people. I'm lucky. I have seven grandchildren and I watch them with great interest. I find there is still a tendency to give preference to the boys and that is rather heartbreaking because my father did not do that, so he was a damned sight more enlightened than people are now.

CN: *Well, he was an extraordinary man I suppose?*

BH: He was a very gentle, thoughtful person. He said my daughters will have the same freedom and the same everything as my son.

CN: *Was that unusual for that time?*

BH: It's a terribly long time ago. Sixty years ago. But he was true to it.

CN: *He was an engineer, wasn't he?*

BH: Yes. I learned a great deal from him. I inherited this aptitude, let's say, for form and construction largely through his gentleness. He didn't teach me; he just took me and I absorbed it. But he backed me up through thick and thin. I left home at sixteen.

CN: *You also had a head mistress, Miss McCroben, at your school who was devoted to you, didn't you? She gave you support and encouragement and recognized your talent.*

BH: She was marvelous. She was a very enlightened woman and much more enlightened than you find now. The only thing that worries me now, of course I shouldn't worry, life goes like that doesn't it? but if the poor girls are going to be hemmed in and obviously preference for the male to be prolonged – I think it's a very sad thing. Honestly, looking round at my friends' grandchildren and at my own grandchildren I find that the girls are extraordinarily intelligent.

CN: *Yes. And now women are getting together to channel their intelligence and energy and creativity into a direction which will make it easier for them to gain recognition.*

BH: I'm actually not sure whether it should be channeled by women getting together or taking the whole picture.

CN: *That's a matter of a transitory stage. We have to do it at this point. Hopefully there'll be a point where women will be accepted just as people. After all, you haven't had a retrospective in the United States. I think it's a shame that they don't know your work in my country as well as they should.*

BH: It will come one day.

CN: *In our earlier discussion you mentioned certain works you did after periods of anxiety. Can you remember any of them specifically? Pieces that came out of any particular tensions?*

BH: There's an oval sculpture of 1943. [fig.59] I was in despair because my youngest daughter, one of the triplets, had osteomyelitis. In those days the war was on and you couldn't get anything. She was ill for four years. I thought the only thing I can do to help this awful situation, because we never knew if it would worsen, is to make some beautiful object. Something so clear as I can make it as a kind of present for her. It's happened again and again. When my son died, he was killed, it's the only way I can go on.

CN: *It's as if you as an artist instead of keeping in your anxiety and grief – letting it fester – you let it out and use it. And out of something bad comes something beautiful.*

BH: I have to.

CN: *It's like a rebirth.*

BH: Yes. And I'm quite sure I owe a lot to my upbringing, my parents, my background that was hard working but pretty emancipated in its thought. It was a fairly cruel background, industrial stagnation, poverty, but books and music came first and hard work.

CN: *Were there artists in your family?*

BH: No, no artists in my family but they loved life and music and literature.

CN: *It seems as if everything fell into place for you. You seemed to have gone to the right places to meet the people who were right for you.*

BH: I hope I've matured in my work. I had to wait many years to do my recent sculptures, *The Family of Man*, because I had to have money and space and time.

CN: *You always wanted to work big didn't you?*

BH: Yes. I worked big in '38, '39, but then the war came and then of course things were quite difficult.

CN: *How large are the largest of* The Family of Man *sculptures?*

BH: Up to 11 feet.

CN: *They look beautiful on this hillside where you've photographed them. They make me think of prehistoric stone structures, placed on top of that hill as if by some giant hand. It makes one think of Stonehenge.*

BH: Maybe I helped to make Stonehenge. I don't know.

CN: *Are they welded together?*

BH: Each piece is placed on top of the other.

CN: *There is a certain sense of the minimal in them, in the contemporary sense of the word. And yet I never think of your work as minimal.*

BH: I don't know what it means. Can you tell me?

CN: *People who did that kind of art were interested in simplifying almost to the very bone all the objects that they made. They produced almost basic geometric forms and then placed the whole perceptual response on the viewer. The viewer has to bring so much to the sculpture that he or she has to get very involved with it. It's a kind of perceptual give and take.*

BH: You wouldn't call Rothko minimal would you? He's all embracing.

CN: *The minimalists took off from Barnett Newman. His very simple stark kind of image. In fact before he died Rothko had rather gone out of fashion.*

BH: I'm a great admirer of Newman's.

CN: *Yet most of the work the minimalists have done is very geometric. There's an emphasis on the geometric, on the intellectual. I think that's why theirs was such a violent reaction to Henry Moore. His work was so organic, so humanistic. It was too threatening. Yet I don't think that would ever bother you. Your work is very organic, too.*

BH: It's meant to be. I'm organic myself.

CN: *In your writings you've mentioned being very concerned with how people relate to your sculpture in an environmental way. You too wanted them to almost get into it, to react to it on a physical level.*

BH: I've always felt this. You can't make a sculpture, in my opinion, without involving your body. You move and you feel and you breathe and you touch. The spectator is the same. His body is involved too. If it's a sculpture he has to first of all sense gravity. He's got two feet. Then he must walk and move and use his eyes and this is a great involvement. Then if a form goes in like that – what are those holes for? One is physically involved and this is sculpture. It's not architecture. It's rhythm and dance and everything. It's to do with swimming and movement and air and sea and all our well being. Look at all the phrases that we use 'being on his toes', 'bowed with grief'. All those phrases to denote the human body in relation to its environment. In sculpture the main thing is to stand on your toes and become aware to the fingertips. You know it bores me to think people come in and say, 'We'd thought you'd be a large woman', I mean it's so stupid. I did my largest works when I broke my leg. I was so hopping mad to have broken my leg, I found every means I could to surmount that improbable disaster.

CN: *You seem to react to obstacles very well. They become a challenge, something to work against.*

BH: Yes, but that's a part of the involvement. Touch, and poise, wind and water, everything. Sculpture is involved in the body living in the spirit or the spirit living in the body, whichever way you like to put it.

CN: *Do you think, for the most part, people understand what your sculpture is all about?*

BH: The comforting thing is that many people do. The ones who find it difficult are the ones who've decided that women artists are no damn good anyway and they stiffen up as soon as they see a work. So they don't communicate because they can't move. Their bodies are stiff. They don't go round; they can't touch.

CN: *What do you think of Anthony Caro's work?*

BH: I think all these new young sculptors are – he's not all that young though – taking a stand against abominable architecture since the war and I think rightly so. But again I feel it's not enough to be against something. You have to do something that will damn well replace it. Where do you put these sculptures? I mean if they don't work with architecture or culture what do these sculptors do with their work and what do we do with our heritage?

CN: *There's been a great deal of anti-art being done now, out of Duchamp, as if artists want to tear everything down but they have nothing to put up in its place.*

BH: I like to think that time is timeless and I wouldn't want to make a work which wouldn't last for more than ten years – nor a work that wouldn't go anywhere. It would make me terribly mad. Mind you, I have to wait to find a place for my work. It doesn't happen all that easily, but it does happen. It slips in somewhere. Before the war the architects were very much one with the sculptors, painters, everybody. We thought alike. Then the war was over and there was the economic unit. It was so ugly. Then the architects gave up coming to look at sculpture and painting.

CN: *There has been a tremendous alienation between architects and artists?*

BH: Tremendous, terrible.

CN: *Then have you gotten many commissions like the one for the United Nations plaza where you actually knew where the sculpture will be placed?*

BH: If an architect says, 'Will you do a sculpture for here?' and I get an immediate reaction, I say 'yes'. If I don't and I stay blank, I say, 'no'. Simple.

CN: *The sculpture has to be right for the setting that it's going to be placed in? But very often the pieces are placed afterward?*

BH: So far so good. I've got a new one they will unveil next month in Cheltenham which is 30 feet long. It's the longest I've done and I enjoyed it very much but I've had to wait two years for the architects. It's called *Theme and Variations*. It's kind of a musical piece.

CN: *It's beautiful in St Ives. I guess you always wanted to stay here once you got settled in.*

BH: I couldn't get away.

CN: *Don't you miss the big city? Or the art life?*

BH: I tried to run two studios, one in London, one here. But whenever I was in London I wanted a piece of rock that was here. I couldn't work it. I think where you live as a sculptor is a very practical matter. You want space and light, materials, simple living and everything. But one can't get it in London anymore. It doesn't exist.

CN: *In New York everybody has lofts. They live in them and they're in the downtown section of Manhattan.*

BH: But a sculptor can't live in a loft. How do they get the stuff up?

CN: *A lot of people have their work fabricated now. They work from mock-ups or maquettes.*

BH: Well, I never liked maquettes much. I like to work to the size that I must. I like making small works but they are to be handled and they're different.

CN: *Yours is basically a public art isn't it? It's trying to reach out and be part of a total environment.*

BH: Absolutely. I have been asked to do a work for various things – commissions to do with things like life boats and wild life and all kinds of things. I love this because I am part of this life. I can't be unpolitically minded. I'm very involved.

CN: *In what way? You don't actually participate in political movements?*

BH: I don't march.

CN: *You feel you can express your involvements through your work?*

BH: Yes.

CN: *How do you do this specifically?*

BH: Well, I'm involved in everything I read just as I was in the 30's during the Spanish War, and Franco and everything. And after all there's not a great deal of difference between the *Monument to the Spanish War*, a group of things one on top of the other, that I lost and the *Family of Man*.[2] I mean I've always been involved. I was involved in industry in my home town. I was involved in the distress and the strikes, everything. I wasn't marching but I was involved in my work.

CN: *There's been a great deal of discussion about how an artist can become involved in a political way in the sense of doing something about problems that exist and how the work can say something about it. Some people say the work has to be a direct political expression which can be read by people to have any political impact.*

BH: If that was true people wouldn't ask me to help with my work would they?

CN: *Well evidently they feel that it's a very positive statement and that something that's strong and beautiful gives courage to people.*

BH: If you wake up in the morning you have to have something strong and affirmative to start the day on. I don't mean you have to have a sculpture but you have to have your eyes open, your body aware and receptive.

CN: *Recently I saw your lithographs at the Marlborough gallery in New York. I thought they were beautiful.*

BH: Oh, I've done three lots. I'm just embarking on the fourth.

CN: *I think the lithographs are a wonderful way of reaching people who could not afford to own one of your sculptures.*

BH: Yes and I thoroughly enjoy it. I've always drawn as my exploration of forms and space, for what could *be* in a vague sort of way. I've never drawn a sculpture – though five years later you could say, 'oh my goodness, that's related to that.'

CN: *I also remember you saying that no work of yours is an accident. Do you mean by that that your work isn't a chance thing – that there's nothing whatever automatic about it?*

BH: Oh no, there isn't, though, by the way, that is quite a useful contribution. But if you're looking after a sick child or a sick husband you use your intuition or sharp response to a set of conditions and this is simple providing one knows oneself. I would just hate it if I did things heedlessly. I would hate them so, I would set fire to the whole studio. I really would.

CN: *I think very often one has to work very hard, do lots of research and lots of thinking, and then when you start to work, it's all there waiting to come out – to flow out of you.*

BH: It is. There's a beautiful book written by Stravinsky, *The Poetics of Music*. It's so beautiful because of the whole early description of the flow of the beginning and procedure to the end. You only have to change a word or two and it becomes form.

CN: *I think all creative work is very similar but it's such a mystery at the same time. How do things really happen? What is the catalyst?*

BH: Well, I think one of the mysteries is how the human mind can hear a piece of music, a symphony from the beginning to the end, before beginning, or see a sculpture finished all the way round when it doesn't exist. Now these faculties are the sort of faculties which are needed in sciences, maths and medicine and all kinds of things but if one has them, one has to learn to use them. You have to learn how to play the piano, don't you?

cn: *Actually, what's happened in some of the recent art is that artists are trying to teach people how the process of creation evolves. How to see is the idea behind minimal art. There are modern composers who just make sounds. They just make noise as if they are trying to get people to understand that this is the process – this is the thing that has to go on. I think it's not enough for an artist to do. You have to get beyond the process.*

bh: Well there are various aptitudes. I think carving or building or construction is perhaps nearer to composing music and some painting and modeling and so on is much nearer to a more fluid interpretation, to film. But you can't start with a block and say, 'Now it's going to dictate to me.' You dictate to it.

cn: *But there's an interaction at the same time, isn't there?*

bh: Oh yes, of course.

cn: *And you have said that you follow the stone. It speaks to you.*

bh: Oh yes, of course, but you can't put anything back.

cn: *It's a high risk business you're in.*

bh: I enjoy that.

cn: *But still it's very scary. The thought of making one false move and then ruining it.*

bh: I'm not afraid you see. I know how to carve. No credit to me. I was just born like that.

1 The tape-recorded interview on which this was based was conducted in St Ives in August 1972.
 Nemser included a different, longer introductory text when the interview was reprinted in
 Art Talk: Conversations with 12 Women Artists, New York 1975.
2 Figs 63, 65.

[1973]

SELECTIONS FROM INTERVIEWS WITH JOURNALISTS AND WRITERS

Diary item by John Carpenter on Hepworth's Lefevre Gallery exhibition, *Evening News (Night Special edition)*, London, 2 October 1952

[Hepworth] told me that she wants to have a new 'family': A large group of life-size figures permanently placed on a hillside near her home at St Ives, Cornwall.

Abstract sculpture, she said, is 'emotionally exhausting work'.

Interview in *The Bradford Telegraph and Argus*, Bradford, 19 October 1960

'Would I advise a girl who thinks that she has talent to become a sculptor? Either the girl is an artist, and has it in her, or she is not. It isn't an easy life, but if she has talent, it will come out somehow.'

We were sitting in the comfortable studio at St Ives, Cornwall, of the Wakefield-born sculptor, Barbara Hepworth, discussing the world of the artist and the work and world of the sculptor in particular. (Miss Hepworth objects to the term 'sculptress', and who can blame her? One wouldn't think of a woman whose profession is engineering as an 'engineeress'!) [. . .]

'I didn't pick my work,' she said. 'I was born like this. I went to a lecture on Egyptian art when I was seven, and I knew from then on what I wanted to do. I was, of course, lucky. My parents had advanced ideas for those days, and they encouraged me.

'It is not as hard now as it was then. Many people had the idea that my work – I am not here speaking personally but as a woman – was a waste of time. Women, they said, got married. They wouldn't realise that marriage, far from being a bar, could be a help. But this made it difficult to get people to take one seriously.

'One must sacrifice a lot to be a sculptor, but one doesn't lose by looking after children – that is if one accepts this as part of one's enriching experience and uses it to its best advantage and do not, as so many women, try to reject it.

'I normally use a 4 lb. hammer and chisels. One lets the hammer do the work as much as possible. Even so, one has to be fit to be a sculptor, for it can be very laborious.

'It is in some ways like competing in the Olympics! One has to keep in training, develop a working rhythm, and maintain that rhythm.

'One must also have regular working hours, in my case from eight to six. Otherwise one tends to say to oneself "Isn't it a nice day" – and out one goes!

This will not do at all. One must exert discipline, for it is on the nice days that one should be working. This applies especially to me, for I prefer working out of doors, and have so organised my life that I can do much of my work in the garden.

'Of course one doesn't work all the time, either physically or mentally. One needs to switch off and vegetate occasionally, and St Ives is a marvellous place for doing this.' [. . .]

'You could almost say that I am obsessed with form, and that's why I am a sculptor and not a painter. It is surprising that more women have not been sculptors. Surely the tactile senses are more developed in women? This, after all, is part of our nature.

'Which leads me on to relations between the sexes. I believe that they should be complementary, not equal. That this doesn't command general acceptance is not just the fault of men, but of women also. Women hitherto did not seem to realise that they had to come to terms with their sex. The more a woman you are, the richer can be your ideas in your profession.

'Let us take one obvious example. A man sees a woman carrying a child, and carves what he sees.

'If I did the same thing it would be different, for I should feel it, and could get what you might call an inside sensation. There are many other fields of sensation which no man can explore as well as a woman.

'I am working now on sculptures for a show in London next year. I always like to work on more than one thing at a time, preferably in different materials with different textures. I never work in synthetic materials or use welding as do so many other sculptors. I think the woman's field is one of natural stones and woods.

'I am also working (in my mind) on two blocks of stone which haven't arrived yet; one of two tons, one of three. One hopes the result will do what one wants it to do without words being needed, which after all is what sculpture is about.'

Interview by Sally Vincent, 'Woman to Woman: Barbara Hepworth', *Daily Express*, London, 3 October 1961

[. . .] 'I've made a list of my convictions to help you.'

She took up a piece of paper and read from the bold, black letters she had made.

'I am a pacifist and an ardent supporter of the United Nations. And of nuclear disarmament. I am against capital punishment and I support the Treason Trial Fund of South Africa.'

The dark glasses turned twinklingly in my direction. 'I thought we might as well get that straight at the start,' she concluded.

It would, of course, have been impossible for Barbara Hepworth not to have been all of these things. What she does and what she is, she explained early on, were inseparable. And she is a woman who works in hard materials. As a sculptor she bites into stone, marble, and the hardest of woods, and loves the life she finds in them. She is a carver; she works for longer hours each day than a labourer; her tools are chisels and gouges and mallets.

It is not surprising, perhaps, that as a woman she has found the world as recalcitrant as the materials she works with. And it makes her militancy a gentle and wonderful thing when she is prepared to hack at the wrong she sees in the world with as much faith and optimism as she feels when she takes a chisel to a huge block of granite. In this bitter age, a person who believes he or she can actually do something to save the world is regarded as a crank or a figure of fun. Barbara Hepworth is such a person, but listening to her ideas I could find nothing funny or cranky: in fact, I almost thought the world could be saved.

'When I was a child, half a century ago, I was filled with the joy of life. I could wake up in the morning and know how good it was to live. But I also knew that when I died it was not the end of life itself. The world would go on being wonderful without me. This balance between life and death is now lost. The world is threatened and human beings have no security any more. We must restore the balance and give people back their security. Otherwise we will disintegrate.'

Barbara Hepworth believes that people can integrate through culture. And as she believes it sincerely she has her reason to work.

'I work to affirm. To do something positive, to underline what is affirmative. I want to emphasise, in the affirmative, all the elements of human beings which are vital and able to give praise for life. In my activity of trying to work I attempt to eliminate all that is pessimistic, and to communicate to others the optimism I feel inside myself. There is now the possibility of a total world, brought together by the universal language of art.'

This kind of remark, made by someone who has spent her life within the secrets of the most abstract of all abstract art, is wont to receive a somewhat cynical response. But Barbara Hepworth was plausible.

'Because of the danger we all face, there is a heightened awareness of things that matter. Of poetry, art and music. These are the things which will be instrumental in saving us. When the last war broke out I was surprised by the way these things suddenly mattered so much more to people. That is why, at this threatening time, it is so vital to continue this kind of work. You have got to believe in the extraordinary beauty which is outside yourself, because that is what will make you fight to preserve it. This is the time to change our way of thinking, which has become somewhat obsolete in the past few years. I am only a link in a chain, but at least I hope I am a solid link, not a cracked one.'

Another one of Barbara Hepworth's key phrases is 'we must protest', followed closely by a sort of women-can-save-the-world idea. But for the first time in my life these sentiments, voiced by a woman, were not irritating. Instead, I found them strangely moving.

'We have got to relearn optimism. If we, as women, behave in an affirmative way, we can implement this optimism. We must seek something definite to do. There has got to be a mass intention to preserve life, and it is up to women to act in a concerted way, because it is their job, their nature, to preserve life. It is time that we all stopped behaving like hypnotised hens. Our minds have been affected by this terrible brainwashing we've been getting, and we must protest against it; we must not allow ourselves to be contaminated by destructiveness.'

I asked, simply, how women could protest. In a practical way. Barbara Hepworth was momentarily lost. I began to feel that, for her, the abstract protest was enough. If enough people felt enough protest in their hearts this would be enough for the mass intention that was needed. But Barbara Hepworth struggled.

'Oh,' she said, 'just protest. Protest against the fear, enmity, and punishment that is going on around us. Write to politicians, ring up the B.B.C. – write to Mr. Kennedy if you like. But just keep on and on saying "We will not have it, we will not have it."'

'But women,' I suggested, 'are not like that. They *submit*.'

'We've got to get over that,' she replied. 'Women must learn that to express their feelings does not make them suffragettes. They must realise that they can no longer keep quiet and submit in order to keep the peace in a man's world. They must understand that they are there to complement men, not to compete with them. We don't want a matriarchy, God forbid, just a balance. And women are our only hope now – the only people who can help because they are intrinsically opposed to destroying life.'

All this she delivered in her reasoned, vicar's wife tones. And afterwards, like a middle-aged Englishwoman showing her rose garden, she led me to the ballroom she uses as a studio, where about 40 of her sculptures (all three and four times her own size) rose from the parquet. Barbara Hepworth politely did not believe me, but I do not think I appreciate sculpture. I like the graceful shapes of carved wood and stone. I even get quite excited about texture. But I see no message. But that ballroom, with all those strange, looming, rather loveable shapes, was like a new world. A very *brave* new world.

[. . .] [Hepworth] insists that the making of a better, more peaceful world is not exclusively a task for the politicians. 'Women everywhere should really think this thing out in order to protect their own children and future generations. I was lucky enough to be born at a time when you grew up believing that this wonderful life of ours went on for ever. But how can a child, today, open the door and look at the world with a spirit of real happiness? We've taken away the sense of security.'

[Hepworth] considers that the abolition of the Bomb is an important first step towards real peace, and a happier mental climate. She is a sponsor of C.N.D., but does not support Bertrand Russell and the Committee of 100. She disapproves of civil disobedience on more than legal grounds. 'Such actions provoke violence in others.'

[. . .] Looking at the arts today, she thinks that there is a greater spirit of tolerance. 'Women were once the odd men out, but people now understand that they can be as good as men. The fact is, they're different. The women's approach in the arts, in anything in fact, presents a quite different emphasis. Women are not competitors, they are complementary to the masculine point of view.' [. . .]

It was in 1939 that Barbara Hepworth first came to Cornwall. [. . .] 'I couldn't live anywhere else now. I love the sea, the geography and the history of the place.

'Every artist relies on light . . . and there's a radiant light here. I've only experienced equal brilliance in Greece and certain parts of the Mediterranean. I particularly appreciate the softer climate, which enables me to work out of doors, away from the stonedust and the articial light.' Furthermore, she values the local people. 'The artist needs a responsive community, and here in West Penwith we have just that. The artists have become absorbed into the scene.' On this matter of relationship with the people living in St Ives, and the surrounding district, Barbara laments the decline in Show Days. 'Opening your doors on open days in St Ives was a very good thing. The people who came, nearly all of them locals, gave me so much. I was amply rewarded. I am sure that the old practice must be restored.'

The life of a sculptor, in Barbara Hepworth's estimation, is largely a matter of self-discipline. 'I usually do an eight-hour-day. Personally I find the longer you work, the better you work.' You may, on occasion, have to concentrate on one thing for three months. For that reason alone, I dislike being in London; there one gets caught up, so quickly and easily, in a mass of events.' Of her actual work she says, 'I don't want people to think of these forms as cold abstractions. They are, to me, warm and sensuous.' She stresses too, that the

sculptor's satisfaction is physical as well as mental. 'People think being a sculptor is terribly hard work . . . I suppose it can be, but you know really it's a matter of rhythm.'

On the subject of the arts today, Barbara Hepworth believes that the artists are more united than is often imagined. 'For all the quarrels about different styles and different personalities, we are, at heart, all at peace with one another.' In fact she is quite convinced that East and West can come closer together through the arts. 'We've learnt so much from the East, and they've learnt so much from us. Through the development of art, we've formed an international language. Nothing, of course, is static in the arts, especially nowadays, when there are changes everywhere. New shapes in sculpture, new forms in art, new sounds in music, new experiences in the universe. How can we remain static?'

One of the last remarks she made to me at the close of a most stimulating meeting, stimulating both on account of the compelling nature of her work, and the sparkling flow of her conversation, was this. 'We must get over our inhibitions, but who can be happy when we spread so much fear in the world?' [. . .]

1 A variant quotation in *The Guardian* piece Michael Williams wrote based on the same interview reads: 'I find the longer I work, the better I work . . . one gets more sub-conscious about it . . . and often during those last moments of the day the great decisions are made.' (17 April 1963; see excerpt below.)

Related article by Michael Williams, 'Barbara Hepworth Talks to Michael Williams', *The Guardian*, London, 17 April 1963

[. . .]

'The artist needs a responsive community and here, in West Penwith, we have just that. The artists have become absorbed into the scene. The Cornish, I think, are an altogether sophisticated race; they've travelled as sailors, they've worked abroad as miners . . . they're very attuned to the universe.'

She sees close parallels between this south-westerly peninsula and her own native West Riding. 'The landscape in both places possesses a tremendous power. Both places show the same type of scars in industrial development. The people, too, have a good deal in common. They are as open as their landscapes. They have an innate sense of craft. They know how to put a stone in a wall instinctively; it fits just right – and at the first attempt.'

Recalling her beginnings in sculpture: 'I've been unable to think in any other way. I've always been thinking of shapes. This is my language. I was born with the ability to conceive my ideas in form . . . it's a gift. I started tremendously early – at the age of seven – I still recall the immense pleasure of being allowed to make things.'

'Were you the first artist in your family?'

'Yes, though my father was an engineer and he had [a] feeling for the creative part of one's personality. Initially, I was very lucky in having an understanding headmistress who allowed me to sit for the county minor scholarship to go to Leeds School of Art. When I got it my parents were reassured: they then knew I had some sort of aptitude.'

Throughout the course of her career Barbara Hepworth has worked in various media – wood, reinforced concrete, bronze, brass, and aluminium are only some of them. 'I love them all, but most of all I adore stone-carving. You have the idea first and each idea demands its own medium. "I must find a piece of wood eight feet high," and so on. I like a lot of material lying around . . . not that the shape means anything.

'I suppose in every phase there's a particular piece of work that gives special satisfaction. You feel with some things that you have managed to transcend material issues, that you have created a thing which looks as though it has grown itself. You've transcended human personality. You begin to think that you didn't make it at all.

'Some things, I am sorry to see go. When I feel like this about a work, and see it again in a new situation, I become rather frightened. I know it'll be all right, but I've left it. It has its own personality . . . I'm outside it now.'

Barbara Hepworth's attitude to tools underlines her sense of vocation – yet she has no hesitation about employing modern instruments.

'I am entirely happy about using modern devices, provided we think of them as means to knowledge and not as means to financial gain. I don't want too many tools, but the sensitive ones are so precious that I can't bear to think of them being touched by anybody else. I see a sensitive tool as an extension of my hand.'

In the past – as a pioneer in her field – Barbara Hepworth has had to contend with a good deal of criticism – and on occasion open hostility. 'On the whole I managed to feel detached about such criticism. If people say they strongly resent something, it means that one is really touching them.'

'What is your attitude to the professional art critics today?'

'Either they're right or wrong. If they're right, I learn something. If they're wrong, I'm right!' [. . .]

Mervyn Levy, 'Impulse and Rhythm: The Artist at Work – 9', *The Studio*, London, September 1962[1]

[Mervyn Levy visited Hepworth in St Ives in June 1962.]

'On a day like this the Cornish coast around St Ives and Zennor is just as miraculous as the Aegean.' [. . .]

'One moonlit night, I wandered into the garden. In the pale, clear, silver light, the sculptures presented quite different aspects of their being from any which I had seen before. Of course, they love it outside. They can live their own life in the open. In sunshine, by moonlight, or dreaming in the rain, they are always different. They have so many moods and faces.' We walked across to the tall block of Roman limestone on which she is currently at work.[2] Lying at its base, points, claws, and hammers, waited for her hands.

She is the most systematic and orderly of artists. Later, in her huge studios and workshops (she employs two full-time assistants, a woodworker and a metalworker) I noticed a number of smaller projects in various stages of growth. Around each piece were carefully set out the relevant chisels, gouges and mallets. [. . .]

'It isn't strength you need, but rhythm – rhythm of movement. A sculptor, of course, needs toughness of spirit since nothing comes easily, but that's quite a different sort of strength.'

She was working with a point as she spoke, roughing out. Already she explained the long rhythmic line that would flow through the finished work had been thought out. Now, with the point, she was feeling her way into the stone, searching for the first surfacing of the hidden line that lay buried at its heart. The preliminary roughing out with the point is pulled together with a claw. Chisels follow. She uses power tools as little as possible. Nothing can take the place of her strong, nervous, sensitive, exploring hands.

Her work is finished by hand, ground smooth, sometimes by rubbing stone on stone, sometimes with emery or glasspaper. [. . .]

'You have to work long unbroken hours in order to see any real progress. A block of stone like this, for instance, will not look very much different until a great deal of time has been spent on its carving. I like to start work around eightish in the morning and keep going until about six in the evening.' [. . .]

We spoke too of colour in relation to sculpture since she often colours her own work, having used brilliant blues and yellows on occasion. She agreed that more sculptors might consider the use of colour, even in relation to figurative work, and argued that the reason why so few sculptors today used colour was perhaps because many European artists live among the filth and grime of great industrial cities. They are acclimatized to dirt and can no longer think in terms of colour, as do painters, who anyway work more easily in reaction against their environment.

I asked her about her drawing, remembering in particular that superb series of hospital operating theatre studies. 'Periods and phases of drawing are most important,' she replied. 'One needs to record, endlessly, one's observations of the human form, and of nature. It is from these sources that my forms derive. I often involve myself in periods of drawing from the life, especially when I find a model that excites me. The impulses of human life and of nature absorb me. The impulses of growth that determine the changing shape and form of living things intrigue me. In the autumn for

instance one can already distinguish the character of next year's shapes and forms in principle.' [. . .]

She explained that her work often sprang from a turbulent desire to express some particular emotion, idea, or thought; a turbulence which, as the work proceeded, was gradually resolved into a rhythmic calm. These qualities she felt were communicated to the spectator. And not only to the initiate or the professional student of art, but to any man or woman who takes the trouble to look. 'The public have largely got over the shock of seeing new shapes and forms. It is easy now to communicate with people through abstraction, and particularly so in sculpture since the whole body reacts to its presence. You have only to watch people to see how, as they move around a piece of sculpture, their entire being is orientated in response. In this way they absorb the impulses and the rhythms that the sculptor has felt. They become themselves a living part of the work. One of the things that pleased me most after my recent show at the Whitechapel was to observe when my work came back to St Ives, how much the pieces had been touched by visitors to the exhibition. I could tell by the marks on them just where, and how they had been touched, felt, caressed. Their hands had followed the main rhythms and movements of the forms.' [. . .]

1 Mervyn Levy (1914–1996), painter, writer and broadcaster.
2 Probably *Pierced Monolith with Colour*, completed in 1965 (BH 388).

Tom Greenwell, 'Talking Freely: Barbara Hepworth Gives her Views to Tom Greenwell' in *The Yorkshire Post*, Leeds, 13 November 1962. Recorded interview appearing in two consecutive issues

GREENWELL: *If you want to get divine inspiration out of a pagan landscape, isn't the atmosphere in an artists' community a bit artificial?*

HEPWORTH: Well, I don't think there's anything particularly artificial about being able to go down the road covered in plaster of Paris and go to the shop to buy some more emery paper or some files without people thinking, 'How very odd'. They just know that I've stopped work and need another file. They're extremely sympathetic and nice because they are used to the way artists behave. And it's very nice to be near other artists with whom you can discuss or even argue when you feel the need. It makes a very nice feeling for work. I think an artist in an isolated community must find it awfully hard to work. He would be the only one who was working in that particular kind of way – perhaps late at night, or several days running – or resting from work. His behaviour pattern would be isolated.

GREENWELL: *Why did you leave Yorkshire?*

HEPWORTH: I had a scholarship to London and then I had a Travelling Scholarship to Italy, and I wanted to have my first show in London. I should dearly have loved to have been able to work in Yorkshire because, of course, when I go back I am really terribly homesick. I love the people – I love the feeling there. Unfortunately, being confined for a long time in the studio with stone dust, before I was able to work out of doors, I did get very troubled with my chest, and what with the cold and everything it got rather troublesome. Here, of course, I have something rather similar. I love the Cornish people, and I can also work out of doors, which I couldn't do anywhere else in England in the winter.

GREENWELL: *Do you think your development would have been very much different if, for some reason, you had had to work in Yorkshire, instead of down here?*

HEPWORTH: I don't think so, because I think it was all laid down in those early years in Yorkshire, which are so vivid.

GREENWELL: *Do you think this is a good period to work in?*

HEPWORTH: I have always been enormously optimistic, and I still am, over people in general, over human nature, over people's awareness, sensibilities and perception. But I think we're living in a perfectly terrible time. I can't imagine anything really worse. The whole world situation seems to me lamentable. I think it is terribly immoral, what is going on. I think people are being brainwashed by terribly horrible, dreary things being done and said over and over and over again, until people no longer even want to discuss them. I think that blunts the perceptions. I think we must all be feeling hideously guilty to have produced a situation which must be an agony for the young people.

GREENWELL: *But surely, the periods of the greatest art have not always been the periods of the greatest tranquillity?*

HEPWORTH: I quite agree. But in the past it has been possible to believe that one might be able to do something about it. But what we have done is to take away choice – and that, I think, is a terrible thing.

GREENWELL: *In other words, upheaval can stimulate the artist, but not if he thinks that both he and his work are about to be blown up?*

HEPWORTH: I don't think that any human being should think that his effort, or even his dying, is a hopeless event. It removes all dignity both from living and from dying. I think that ordinary people now are fully aware of this and are very horrified. They feel that there's nothing in the world they can do about it. When you get up in the morning, the one thing that matters is the absolute beauty of the whole world. But it isn't tolerable to think that we have

no safeguards against other people's interference with what we were brought up to think was an eternal manifestation. That is why I am pessimistic at the moment. I think artists have, for some time, been making very wonderful images, reaffirming faith in all the extraordinary revelations of beauty which we have experienced in the recent decades. Beauties we didn't know about – scientific and every other kind. But we must have the choice to make it what we wish, and the right to say that our children will live.

GREENWELL: *So the artist must feel free and secure in order to create?*

HEPWORTH: I don't think that the artist has to have any better climate than anybody else to make a useful life – no! What I mean is that the climate must be right if these works are to speak. I think we are in a very dangerous state of thinking materially – of thinking about success as an investment, and are becoming less and less occupied with the meaning behind it. This is mainly due to the hideous political situation. You can't live with horror too long without putting up a defence and trying to become immune. When that happens, you try not to go too deeply into anything – so that, for example, a marvellous exhibition of outdoor sculptures that people, given a better climate, would show by their hands, faces and gestures, that they were appreciating, wouldn't evoke a true response. They would be more inhibited; bound down, worried and less responsive to an idea. That is true of art in general – music, poetry – everything that matters.

GREENWELL: *But is it not true that art got its great stimulus during the war? People flocked to hear Myra Hess – they flocked to the opera.*

HEPWORTH: Yes, because they were face to face with the fact that their life might end. Individual life ending – any kind of individual life ending – might be a stimulus to greater awareness; but I don't think that the idea of civilisation, life itself, being exterminated can in any sense be a stimulus. I am shocked and horrified to find that people are not now supporting the United Nations as they did previously. If you don't support the finest things you've thought of in order to make life fuller, more secure, then you are definitely hurting yourself and everybody else.

GREENWELL: *Well, I support the UN ideal, but I certainly don't support everybody in it and everything it does. It's a bicker-shop, with every member nation seeking its own advantage and making compromises only when it has to.*

HEPWORTH: I can't agree with your complacency. It's our creation, and if it's like that, it's because we are at fault. We can make it right.

GREENWELL: *When you say 'we' you must mean Britain, Russia, Ghana, Indonesia et al. We can't do much about it unilaterally.*

HEPWORTH: But we can! Each man or woman or child can do something. We can all belong to the United Nations. We can insist that we pay our dues.

We can take an intelligent interest – never speak against it – fight to make it better.

GREENWELL: *Britain pays her dues. It's the nations who get the most out of it that don't.*

HEPWORTH: Well, by faith and example and generosity and compassion you can help younger nations, like younger people, to become mature people. You can't blame the children for behaving badly when we, the parents, created the situation they're grumbling about.

GREENWELL: *True. But there's chaos if the grown-ups give way to the children all the time.*

HEPWORTH: If you can give friendship, you will get faith back. I'm on very fierce ground now, because I feel that very strongly.

GREENWELL: *In the long run, I'm absolutely on your side. But we're in the middle of the short run now!*

HEPWORTH: I think the short run means dynamic action now. I believe that artists, writers and people who act rather like barometers, are aware that it is entirely the wrong climate. We have to say that this is a bad climate and that we will make it different – do something about it. But not just say that maybe tomorrow it will be better.

GREENWELL: *You yourself are politically committed as an artist. I always find it rather surprising that the artist who finds his own fiercely individual means of expression in his art, is often to be found at one with other artists on political issues. I find this rather alarming in a way. Why do artists rush to put their signatures to all sorts of resolutions that would appear to require, not artistic appreciation, but political appreciation?*

HEPWORTH: Because one does what one feels is right. If you're an artist, you're trained to trust your reactions, your instinctive judgment. It's the only way that an artist can live. He sees what goes on underneath. He may talk to somebody but see a gesture or something which reveals the inner meaning and the only way he can act is by saying: 'That feels right to me.' I think artists see eye to eye because it's a matter of perception of the underlying reality.

GREENWELL: *Of course, this underlying reality can't be discovered entirely on the emotional level. One must also have certain facts, which tend to be hard and even brutal facts; the brutal fact of politics – the £. s. d., the geography, the history, the broad and complicated context of a situation.*

HEPWORTH: It's so very faithless to imply that you can't do what seems right for materialistic reasons. But I am perfectly certain that there is a way. I think we underestimate many younger and growing people by not realising how much they can put up with in the way of suffering and starvation, and how

much work they can do, and are prepared to do, if the idea behind the sacrifice seems to them to be a good one. If they have the incentive it is worth dying for. We are not really using our philosophers and poets and psychoanalysts or psychiatrists in a cultured way, to advise on behaviour and reaction and interplay and so on. It's all so divorced from ordinary life. I don't think you can divorce politics from ordinary life. Everyone pays lip-service to, say, Schweitzer or Gandhi or Dag Hammarskjöld, but they don't try to emulate them. If the major Powers can't do one friendly act without following it up with another threat, then, surely, the smaller nations, the younger people, will do exactly the same.

GREENWELL: *So everybody has to be wicked out of self-defence?*

HEPWORTH: Yes. But, on the other hand, I have an enormous faith in people because I am sure that, given one ray of light, all people would react to it. Truly, I have absolute faith in humanity.

GREENWELL: *What would you say were the main influences in your development?*

HEPWORTH: People . . . related to their environment and their landscape – whether it was a cobbled street as black as ink near a pit, or whether it was on the moors or in the dales. It was the way people behaved and moved and thought in relation to this environment. And that is as near to me now as it ever was.

GREENWELL: *The main response to your work for me is wholly aesthetic. In other words, it strikes a chord as a piece of music would strike a chord. I don't even look for meaning, and don't feel in any way frustrated by my inability to offer an explanation or a description.*

HEPWORTH: I don't think that one *should* look for meaning. The meaning is there and it will speak anyway. It has, too, tactile, sensuous qualities, which are part of sculpture. You're implying that it's a cold sort of communication; but it oughtn't to be. I think it goes on talking to you when you are not looking, or when you just happen to touch it or catch sight of it.

GREENWELL: *My response is far from cold. On the contrary. I'm even surprised at myself – because I'm usually quite a reactionary, you know. I go for the old masters – in sculpture, music and painting.*

GREENWELL: *Are you able, as a general rule, to enjoy sculpture exhibitions?*

HEPWORTH: Very much.

GREENWELL: *The critical faculty is not such that it spoils enjoyment?*

HEPWORTH: No. What is so wonderful is the way work is so tremendously different. There could be an astronomical number of people making sculpture and they would all be different.

GREENWELL: *Is there anyone whose work you envy? Is there anyone whose work you look at and think 'I wish I could do that'?*

HEPWORTH: I don't think so, no. All one can do is to be oneself. It is impossible to imagine being someone else – but you can *enjoy* someone else. You don't say: 'I wish I were that person.' You can only say that you'd like to be as good as they are but in your own way.

GREENWELL: *You leave the pricing of your works to the dealers?*

HEPWORTH: In consultation. The work is all handled now by dealers and exhibitions. For the first time in the world's history it travels round and round and round like a travelling museum, which is marvellous in one way because the people can see it. But it has become rather precious. It would be very nice just to put sculptures on hill sides or in small valleys; or place them where you think it would be nice for them to be and for everyone to enjoy. I don't know why we should have such a lot of pretension and fuss. We won't one day. It will become more simple. I know lots of places where I should like to put a piece of sculpture.

GREENWELL: *Do you ever see a place where you would like a sculpture to be, that inspires you to create the piece that would fit it?*

HEPWORTH: Yes, very much so. Sometimes I get a completely new idea, just seeing a situation in the countryside. When that happens, I often give the work the name of the place the idea came from. It might be just the situation, or myself in relation to the situation. Or it could be I saw a human figure in this setting and, immediately, it became a form in my mind. Partly myself, partly external, partly internal . . . and then the whole sculpture was born – that moment. But then, if you could place sculptures in secret places, where people would come across them unexpectedly, it would be so nice.

GREENWELL: *Does your work present you with any special problems?*

HEPWORTH: Yes, I've an awful habit of walking backwards when I'm absorbed in work! It's quite likely that when I'm a bit uneasy, I shall walk backwards off

something. It is one of the most exciting experiences to walk backwards away from an object – a piece of sculpture. You try it! To keep on moving back . . . it's quite awkward to do. You've to get used to it, but it looks quite different as it diminishes – quite different from when you are approaching it. It is another experience altogether. It is a great pity we can't do it more easily.

GREENWELL: *Don't go putting any of your sculptures on Beachy Head! What do you think of the RA?*

HEPWORTH: I haven't been for so long. It has certainly been antagonistic towards new ideas; but I think it is much less so now.

GREENWELL: *Antagonism sometimes stimulates creative response.*

HEPWORTH: Oh, yes, it's a test for rejected artists, because either they are convinced they are right, which strengthens them; or they are deterred, which means that they wouldn't have gone on anyway.

GREENWELL: *Was there ever any time in your career as a sculptor when you thought of turning to something else?*

HEPWORTH: Never! Not since I was seven.

GREENWELL: *You decided to be a sculptor as long ago as that? What started you off?*

HEPWORTH: I was always very interested in the forms of everything, and at the age of seven I went to a lecture with slides of Egyptian art. I was so excited about it that I never really thought of anything else except being a sculptor.

GREENWELL: *And that went on even through your schooldays, when other little girls wanted to be nurses or marchionesses? Did you have any opportunities for sculpture at school?*

HEPWORTH: Not very much, because I had to do all the usual exams. I was always making things and doing portraits of my brother and sisters and always trying to do things in my spare time and in the holidays. Then I went to Leeds College of Art as soon as I left school.

GREENWELL: *When you were a housewife and bringing up children, did you find your work different from what it has been since? Does a domestic life have much influence?*

HEPWORTH: No, I don't think it was any different. I had to have a very strict discipline with myself so that I always did some work every day, even if it was only 10 minutes. It's so very easy to say 'Well, today's a bad day; the children aren't well, and the kitchen needs scrubbing . . . but maybe it will be better tomorrow.' And then you say to yourself that it may be even better next week, or when the children are older. And then you lose touch with your development. I think the ideas can go on developing behind the scenes if you keep in close touch with what you are doing even if you have

interruptions. You actually mature faster. You may do fewer carvings, but they could be maturing at the same rate as if you had all the time to work. There is still a great deal of difference in the general public's attitude towards the domesticated sculptor. They wouldn't dream of interrupting a man who was working, but they do dream of interrupting a woman who is working. It really is a fundamental oddity, that!

GREENWELL: *When you were married to Ben Nicholson, could you have carried on working if he hadn't liked your work?*

HEPWORTH: I should have carried on working, but it wouldn't have been very happy. It was a very splendid co-operation. We were very stern critics of each other's works, and yet felt absolute independence. We were clear about it, and liked each other's work. A hostile atmosphere would have created a need to choose, which would have been very difficult.

GREENWELL: *At Harlow New Town some of the people kicked up a bit about your work. Did you feel hurt?*

HEPWORTH: Actually, I haven't seen where they placed it, because I was told at the time that it was a temporary siting. I suspect that why I haven't been to look at it is because I'm afraid it's not well-placed. I'm nervous of having a look. It was supposed to come much more out in the open when the town was completed, and it is something I should like to see done. I'm sure it's out of scale, and I think it would worry me if I saw it. Probably the people who kicked up a fuss were quite right. It's probably too big – too lumpy for the situation. But frankly, I'm afraid to go and see it. I should upset myself.

GREENWELL: *Suppose they want to put your piece for the John Lewis store in a place where you wouldn't like it to be? Or is it going to be built into the structure?*

HEPWORTH: It's attached to the wall, high up. I hope it will appear fairly light. It is placed very asymmetrically. There was only one place for it, really, for it to function.

GREENWELL: *It's absolutely finished, isn't it?*

HEPWORTH: Yes, I built it in aluminium, but I built it hollow for easy handling, and now it's being cast solid. It must be solid to withstand wind-stress and everything else. But I hope it will be up by January.

GREENWELL: *What is your current work?*

HEPWORTH: I am just beginning a very big one for New York. It's not declared yet. It's about 21 feet.

GREENWELL: *You are doing that here?*

HEPWORTH: Yes. It's obsessing my mind very exclusively at the moment. It'll take me six months.

GREENWELL: *What form is it taking?*

HEPWORTH: It will be in the round and in bronze. Stone is not very suitable for a climate that is pretty severe in the winter.

GREENWELL: *Is this the first you've done for New York?*

HEPWORTH: As a commission, yes.

GREENWELL: *Is that rather a feather in the cap for a British sculptor?*

HEPWORTH: Well, I think it is very nice that British sculptors are being commissioned. Henry Moore is doing some very big work for New York, and I think there will be others too.[1]

GREENWELL: *Artists have a reputation for being a strange lot – shoddy morals and easy quarrels, and all that.*

HEPWORTH: Don't you think that's mainly due to a few very bad novels? People think it would be amusing if artists were very terrible, because they associate artists with freedom. They're projecting their own secret longings, perhaps! I think any artist has to be pretty well disciplined. He might do odd things, but he has to be disciplined.

1 Moore's commission for a unique bronze for the Lincoln Center for the Performing Arts in New York.

Nevile Wallis, 'The Hepworth Way', *The Observer Weekend Review*, London, 12 July 1964[1]

WALLIS: *Didn't you find the light harsh in New York?*

HEPWORTH: Radiant. But most thrilling is being in a jet eight miles up where the purest white, indigo, and violet are out of this world. The quality of light is vitally important to me. In St Ives it casts violet shadows from the stones. As to New York, it was rather an overwhelming occasion, you know. I had such tremendous regard for Dag. He owned several of my works. He had great discernment – had Picasso, Braque and Miró in his room at U.N.

WALLIS: *You have made a striking symbol of Hammarskjöld's far-sightedness and integrity. But the nature of this abstract shield must exclude any more personal feeling for him?*

HEPWORTH: Oh, surely not. There is the totally expressive *texture*, don't you see? Naturally I had assistants to weld the great sections together. But the whole surface is worked over with my impress of affection. You can't actually feel it up there by hand, in the way you can pass your hand over my smaller

carvings and feel the subtleties and sensuousness of the surfaces. Still, the scale is just right for the spectator's eye to pick on this expressive surface texture and pass the message to the heart.

WALLIS: *You'd agree you are essentially a carver, as Epstein was primarily a modeller?*

HEPWORTH: Carver, certainly. The thought process is nearer to musical composition. You must see the work complete before you begin. Sometimes I get a flash in the night of a future work completely in the round. I love carving, too, because of the peace. You acquire a rhythm, a rhythm with the heart-beat. I hold the tool very flexibly with the left hand, and tap with this little hammer – never give it a sharp whang. It's a primitive and timeless thing, sculpture, and I believe more young students are seeing it that way. Hard polishing, an individual accent, can make it eloquent. The mechanical tool never. You can't instil your thought into a whole lot of car-bumpers!

WALLIS: *And bronze – is that more difficult for you?*

HEPWORTH: Very much, at first. You see, I began my career with realist bronze portraits which I might sell for £250. Then when I turned to small abstract carvings after 1931 I was lucky to get £30. I had to recast my thought altogether when I returned more recently to bronze pieces. At first, perhaps, they had something of the character of carvings cast in bronze. But these forms have become generally more fluid, more flame-like, since I made the wavering bands of *Meridian* in Holborn.
Incidentally, I never produce a preliminary maquette unless an architect requires one. Then I tell him its form must be subject to change according to the scale. In New York I spent two days making trial mock-ups, judging the memorial's proportions in relation to the size of our bodies, as well as the environment.

WALLIS: *Tell me, didn't you find your family life interfered with your sculpture?*

HEPWORTH: Well, of course, I had triplets by Ben Nicholson, and then it was do or die! But being a mother enriches a sculptor's experience. I decided I must do some work each day. It went on in my head even when I was doing the chores. The result was fewer sculptures, but I believe more triumphs, and of course I made drawings at night. I never resisted things. If something in the kitchen was burning, or a child crying, I attended and continued my carving without feeling resentful. Only unnecessary engagements I resist. Even now I fight shy of attending my private views.

WALLIS: *And your future plans?*

HEPWORTH: I would like to do an abstract crucifixion some time.[2] But I expect to go over to Copenhagen before long for an exhibition of my work, which will be ending its European tour at the Kröller-Müller museum. I'll try to visit

Dag Hammarskjöld's museum on the way. It's what he stood for, all peoples and creeds, that means so much to me. My own sculpture is affirmative. Its message belongs, I believe, to society everywhere.

1 Hepworth had reservations about the accuracy with which her words were quoted here, characterising it as a re-interpretation of their conversation (letter to the editor of *Women Speaking*, Esther Hodge, 28 July 1964, TGA 965/2/17/120). She had just returned from the unveiling of the United Nations *Single Form*.
2 *Construction (Crucifixion)* 1966–7, bronze, BH 443.

Jeremy Hornsby, 'Bringing Art Into Everyday Life: Dame Barbara – Genius of the "Palais"', *Daily Express*, London, 9 December 1967

[. . .]
'I would like to have travelled more, but I get to somewhere in Greece, it gives me ideas, but there is no studio, so I have to come racing back. I am truly chained to my rocks.' [. . .]
'When I sell a piece I just plough the money back into a more expensive piece of marble or bronze.' [. . .]
'It's the same with giving those sculptures to the Tate.[1] People might say that I'd be wiser to sell them and keep the money for my old age. But I have all I need. The point is that, with so little money available to museums to acquire works of art, I believe artists *should* help by giving representative examples of their work . . . to fill in the gaps.' [. . .]
'You get an affection for particular pieces, and they go abroad and you never see them again. That's sad. I'd like to have works by other artists like Henry Moore, but you know I really can't afford them.'
But she is not poor, this fragile sculptress. She is one of the richest people I ever met, because she has *everything* she wants and needs.
'Like my lovely studio down by the sea at Porthmeor. All I can see is the Atlantic. It is a flat bay with the rollers coming in, and it is never twice the same. I can go there and spread things out on the floor and paint, and immerse myself in colour and depth. Music and dancing I also love, because they are all part of sculpture. I believe any artist should be able to appreciate other art. But now I don't play the piano because after eight hours at the stone the hands are tired, though I do do exercises to keep them supple.' [. . .]
'The strokes of the hammer on the chisel should be in time with your heartbeat. You breathe easily. The whole of your body is involved. You move around the sculpture, and the whole of you, from the toes up, is concentrated in your left hand, which dictates the creation. The whole of your emotion and your thought goes into that left hand. The right hand is the motor, the engine. And you must never let the form that the stone adopts run away with you. Like a musician, you wake up and you know what the finished creation

will be like. At some time along the way, the stone will have reached a form that suggests something different. You must never succumb to that. You must bend it back to the original concept.'

With pieces like her *Winged Figure* in Oxford Street, *Meridian* in Holborn, and the giant sculpture at the United Nations, Dame Barbara has shown her readiness to bring sculpture back into people's everyday lives.

'Of course, an artist should be influenced by his age. Most artists now are deeply interested in what science is achieving. Take my leg. Have you ever seen an X-ray of the head of the femur? It's just like Exeter Cathedral. Beautiful. Equally, an age should be influenced by its artists. I love art to be available and loved by everyone. Sailors and tin miners and builders come here and it's quite sufficient that they look at something and say "I like that shape . . . it reminds me of . . . "' [. . .]

1 Hepworth had just presented the Tate Gallery with nine sculptures: *Figure of a Woman* 1929–30; *Oval Sculpture* 1943/cast 1958; *Landscape Sculpture* 1944/cast 1961; *Orpheus (Maquette 2) (Version II)* 1956, edition 1959; *Cantate Domino* 1958; *Sea Form (Porthmeor)* 1958; *Image II* 1960; *Maquette, Three Forms in Echelon* 1961/cast 1965; *Hollow Form with White* 1965.

Atticus, 'Graven Image', *The Sunday Times*, London, 17 March 1968

[. . .]

'There are several pieces I can't do because of lack of sites. I have a big family group in mind, but it needs a hill side. You have to try not to think of the patron, or the site, just to concentrate on the idea, and get on with it.'[1] [. . .]

She's now embarking on a big programme of drawings, to be followed by more sculpture. 'It's all so exciting. When I look back on my work I feel that although it has changed, and I have changed, the mood remains the same. There is no division. I feel that sculpture is like playing poker. I don't actually play cards, but I gamble fearfully on my work. You have to play your hunch. You must have a passion, an obsession to do something. My idea is to play it hard. Nothing really matters except doing the next job.'

1 *The Family of Man* 1970–1, bronze, BH 513.

Susanne Puddefoot, 'A Totem, a Talisman, a Kind of Touchstone . . .',
The Times, London, 3 April 1968. Interview at the time of the opening
of Hepworth's Tate retrospective

PUDDEFOOT: *When you are working are you communicating with nature,
with other people or with yourself?*

HEPWORTH: The artist's experience all has to be digested and if it is to come
out in line and form which is preordained and recognizable then one has to
communicate – even to oneself. If I find a perfect piece of wood, then I have
to investigate why it's the most perfect piece of wood that ever was for what I
want; I think the feeling of space comes before anything else, then one begins
to look round it and analyse it in one's own being . . . then comes the great
thing of creating what was in the mind and if that is maintained, at the end
one can still communicate – but silently, through the form which gains in
intensity as you work at it. If I do a carving next week, as a result of experience,
it will include everything that happened in the past three weeks – what I've
learnt a great deal by, what I've rejected, what I've thought about past and
future and so it takes shape. And that shape is inevitable. I think the inevita-
bility is within oneself – it's how you respond to whatever happens. And we
don't know what's going to happen next – it may be terrible or wonderful.

PUDDEFOOT: *Your father was a civil engineer: do you think this gave you a feeling
for working with large masses and heavy materials?*

HEPWORTH: I certainly think it gave me great inspiration in structure and
the beauty of form out in the open. And I learnt a very great deal about the
anatomy of life rather than just the anatomy of the human figure – although
later at college the anatomy of the human figure was a delight to me. But
this structural thing – covering valleys and passing over water – was a great
excitement to me. I used to go with my father on his journeys through the
West Riding, so I was able to become aware of the hills and rivers.

PUDDEFOOT: *When, much later in your life, you went to live in Cornwall, was
this a deliberate move back to wild, natural surroundings?*

HEPWORTH: No – it was accidental. I took my four children for a holiday – it
was late August, just before war broke out.[1] When it did break out, I knew
they would not be happy in London – the studio had large, glazed windows –
so I set about trying to get settled there. I didn't feel at all well disposed to
start with about joining an artists' colony: but it was entirely different to what
I'd thought. I was entirely captured by the atmosphere of St Ives; it had had
artists there for 130 years at least and all the craftsmen – the boat-builders
and tin-workers – were used to them. I found it so wonderful – I'd never really
lived all the time in the country and I've never been able to leave it, although
I've made several attempts. I like the warmth and light which are very

important to a sculptor; and in Cornwall one has the feeling of being almost surrounded by sea which gives a heightened sense of colour, rather the way one experiences it in a jet-flight. You could almost believe you were in the Aegean. But I like too a life where one is aware of the community. One can be aware of the people and one's responsibilities up to about 25,000 but beyond that . . . When I lived in Hampstead the beauty of London was that it was like a constellation of stars, in a wonderful cluster, each with its individuality. But now there's hardly a village left in London.

PUDDEFOOT: *Some critics have said your feeling for landscape is not really romantic. Would you agree?*

HEPWORTH: In a way I think it is: when I look at landscape, see someone moving or standing or sitting on a cliff, or sit down on it myself, spread myself and look outwards, there's no sound except perhaps a bird singing . . . it's all so pure that one becomes detached, everything is blended into a kind of new form – but it comes inside as well as outside. Don't you find that you fall, as it were, into the landscape, the landscape enfolds you and you no longer remember even what day it is, or the fact that you might be sitting on a sharp rock? One is transported into an untroubled and very creative world. I think we're all very simple really – we haven't changed much in thousands of years. I find it very nice when I wake up in the morning to stretch and then go and find out which way the wind is blowing.

PUDDEFOOT: *You evoke very vividly the artist's enjoyment of the experiences which will then go into the work of art. But what about ordinary people, the spectators – how can they share in this sense of joy?*

HEPWORTH: I find that the people who come to see me and walk round my garden are quite remarkable: they wander round patting things and looking through holes and stroking them and then they often say to me, 'I don't know what this means, but I think it's terribly beautiful and it reminds me of . . .' and they're always right! They would perhaps be appalled at the thought of speaking in public galleries. But when I showed at the Whitechapel Gallery I used to watch people coming in the lunch-hour, so many, and they were quite free. They would stroke the sculptures, then they would see other people looking at them and be slightly embarrassed – then they might have a chat about it. But that's after all how it should be, moving round, touching, exploring colour, depths, distances.

PUDDEFOOT: *Writers have referred to the 'regard de la grotte' and the quality of 'mystery' of the holes in your work. What do they mean to you – a form of 'getting through', to put it crudely?*

HEPWORTH: Yes: when I pierced through a shape for the first time in 1931, I thought this really is a miracle. Now I can see what lies behind and what lies behind that; this is all incorporated in one movement and one is enticed to

go round and see if the vision is the same from any other point of view – which of course it isn't. The sort of holes I make depend entirely on what I want to see – the depth, the thickness, the curvatures, the back shape . . . they may be spiral, they may be straight, they may be oblique, or they may be very complicated or diminish. This is a sheer and very sensuous delight. Even my four cats delight in it. I'm always very interested in their sensitivity to sculpture. When I'm boring away prior to piercing, the very first thing that comes through the other side is a cat's paw: they've been sitting waiting. Then as I open it up, they'll get in, as though it were made for them – and actually I'm making it for myself.

PUDDEFOOT: *Your artistic life has been a very long and full one: would you say it has been a progression in a straight line, or exploring deeper and deeper in the same place or something different?*

HEPWORTH: I think it's been a steady flow of undulations according to experience and the times one is living in and, mainly, aiming for certain basic things which I feel very strongly about like single forms and oval forms and finding all the possible variations – one could really do with 10 lifetimes to express the variations and subtleties which one lifetime can give. But I think it's been constant, looking overall, with the rise and fall of things happening in life – such as children and war and peace and difficulties.

PUDDEFOOT: *Did you find that children and family life impinged on your work?*

HEPWORTH: No – they were wonderful! I think they were quite remarkably helpful. I learned early on to regard all the time spent with children as a nourishment – a plus rather than a minus.

PUDDEFOOT: *What do you think of private environments – houses and gardens – as places for art?*

HEPWORTH: I'd like to see houses more pliable in the sense that if someone wanted to acquire a work of art or an object he would be able to move it about, exercising his choice of where to put it, how to look at it and get that communication with it. But for the most part now there's nowhere to put anything. One thing I adore always is to have one bare table . . . if you've come in from shopping and want to examine something you've bought. Or, if you suddenly think, 'goodness me, I haven't moved that sculpture for ages', then bring it out and look at it and examine its shape. We're too tightly compressed for the imagination – I think it's bad.

PUDDEFOOT: *Do you ever find creating lonely or agonising?*

HEPWORTH: You have to be prepared for agony: if a carving is going to take months there are going to be some bad days. But the most agonising thing is not to be able to work at all. If I go to bed thinking, 'What have I done today? Nothing!', no amount of shopping would ever compensate for that.

Art is obsessive: each day, if you achieve something, you look forward to the next day.

PUDDEFOOT: *What do you want your work to be?*

HEPWORTH: A totem, a talisman, a kind of touchstone for all that is of lasting value . . . something that would be valid at any time, or would have been valid 2,000 or even 20,000 years ago. It doesn't matter when you live – the main thing is that life itself, as a principle, is so exciting, everything with its own growth and style and energy, coming from heaven knows where. This makes one feel very close to archaic civilizations. Whether it's neolithic or paleolithic, one doesn't feel any difference – the same kind of image would have to be created.

PUDDEFOOT: *And where do you see yourself going from here?*

HEPWORTH: It's obvious that putting this show together and seeing all my work will affect what I do. But I keep a perfectly open mind.

1 Her son Paul Skeaping was not with them.

Anne Matheson, interview with Hepworth in *The Australian Women's Weekly*, Sydney, 16 May 1973[1]

[. . .]

'*The Family of Man* has been in my head for a long time. I think, maybe, since I was a child.' All that time she had been watching and observing people of all kinds – and so the idea grew naturally . . . 'our ancestors, their children, marrying and their children right down the ages'. [. . .]

Had she any particular affection for *Ultimate Form*? 'Yes, I have indeed because it represents in my mind something of what I, personally, and I think everybody else, would like to achieve as an ideal. This could be expressed in thousands of different ways. This is my way. So I have a very special affection for it. [. . .]

'Twenty-five years ago I did drawings of groups of figures. But I had neither the space, nor the time, nor the money to do them to full scale. Then there was the challenge of breaking my thigh. I was so awfully aggravated I thought: "Now I am going to do something really big." And so I evolved ways of doing it on a big scale, with specially made tools on poles that I lifted up and down.' [. . .]

'I have always thought of it [*Ultimate Form*] as being slightly elevated. I would like it on a raised plinth, so that as you walk towards it, it rises and you get the top arc against the light in the sky.' [. . .]

1 A cast of *Ultimate Form*, Figure 9 from *The Family of Man*, had been purchased by the Adelaide Festival Centre Trust in March 1973.

Susan Bradwell, 'Barbara Hepworth', *Arts Review*, London, 30 May 1975. Obituary. Based on an interview with Hepworth shortly before her death

[. . .]

'At the moment I am having 15 tons of Carrara marble delivered,' she had told me.

'Some of the pieces are six foot high or more. They will wait in the yard like a flock of patient sheep. The funny thing is that sculptors need only see the materials, get to know the different blocks and their individual personalities to be able to see the work all round, finished, before even touching it, so long as they have an idea.'

'I go round day after day like a broody hen until I can tell the men to "cut right through, join this to that". It might take them two days and meanwhile I will work on another sculpture.'

She talked of the urge to start painting again. As marble dust and paint are not compatible she kept a studio at Porthmeor, one of St Ives' three beaches, only a few minutes away from Trewyn.

Despite 40 years of international success, culminating perhaps in the unveiling of the 21 foot high *Single Form* (commissioned by the United Nations) in New York in 1964, Dame Barbara was anxious to look ahead rather than back.

But I did ask her about 1931, the year when she first pierced a hole and began her abstract works, getting 'inside' as well as carving from the 'outside'. She summed up the feeling in a single word 'freedom', and maintained that that had lasted.

'Carving is very different from modelling. You must see what is inside, cut away and get at it. With modelling you can change it, push it – it is more like painting, whereas carving is like music' (she had played the piano in the past).

She explained that holes are more than holes, they show direction, movement, the inside. And she recognised that single and dual forms are inevitably related to the human form. For this reason Dame Barbara was unconcerned whether her work has a rural or urban setting, so long as it is appropriate. In St Ives a small rounded bronze, *Epidauros*, has a particularly fine setting, on a viewpoint high above the harbour and she expressed delight that visitors can view the lighthouse through it, and that gulls perch on top.

'My seven grandchildren, aged four to 14, know the names of all the sculptures.'

She loved children and adults to come to St Ives and put their hands on her sculptures, both those vast bronzes in the garden, and the marble, wood and slate works in the Palais. 'You need to have sensitivity to appreciate them, but most critics don't understand. They are too sophisticated and too

mechanical, looking for the new rather than the old. Children have more feeling.'

Dame Barbara spoke about St Ives ('for me it's been a living, working community, just the right size to comprehend') and the oldness of Cornwall ('Zennor, Wicca, Gurnard's Head, Cape Cornwall; it is so different here, so variable and exciting. I feel close to the early Britons living on the hill tops, fending off the wolves, protecting themselves with enormous stones').

The stones of Cornwall inspired her in form and finish. She spoke of the hard work in achieving a finish to resemble the look and feel of lichen growing on rock, the effects of a surface eroded by sea and rain or polished by the wind.

She thought being a sculptor was rather like being a sailor. 'When I wake up in the morning the first thing I notice is the wind – to see which way it is blowing. I love the sounds of storms and it is very important to know which direction they are coming from.'

Dame Barbara rarely wanted to travel or change her life-style. For her, success meant more material and more space, and time to work at her own speed in St Ives, which she said she never wanted to leave.

She enjoyed the numerous honours she received, but perhaps none as much as when in 1968 she was made a Bard and took the name Gravyor in a ceremony in fields outside St Just. In the same year both she and her friend the potter Bernard Leach were given the freedom of St Ives and Dame Barbara in turn presented *Dual Form* to the Corporation. It stands outside the Guildhall.

Dame Barbara was already aware that the young of today appreciate her work more than her own contemporaries. 'I feel I am handing on with a generating [generation] gap. I think one must do all one can in painting and carving and music to make a link which is handed on.'

This, she knew, she had achieved as completely as any artist ever could.

APPENDIX

This is the original French text published in *Abstraction-Création: art non-figuratif*, an English translation of which appears on pp.18–19.

Untitled text in *Abstraction-Création: art non-figuratif*, Paris, 1933, no.2

Notre époque prédestinée voit naître et s'affirmer un petit nombre 'd'initiés' qui, à leur tour, ayant définitivement 'compris', oeuvrent en véritables 'architectes de l'univers'.

Il ne s'agit là, comme il ne s'agissait auparavant, ni de Grèce, ni d'Allemagne, ni de France, ni d'ailleurs...

'Immense et neutre' fut Jean-Sébastien.

'Immense et neutre' sera toujours la pensée au-dessus des temps.

Et, la musique, étant l'art abstrait – par définition – il ne peut exister d'art véritable que tendant à des réalisations 'parfaites' de rythme (au commencement est le rythme), d'ordre, de composition, d'harmonie et surtout de lignes 'définitives'.

Les peintres d'aujourd'hui, rejoignent les musiciens, comme ceux-ci ont depuis toujours rejoint les architectes, – comme les architectes, à leur tour, se joignent aux machinistes constructeurs...

Et cela, non pour créer un art matérialiste, utilitaire et dérisoirement futile, – mais bien au contraire, par les formes issues de données scientifiques et de conjectures spirituelles, pour s'écarter en direction de l'absolu des nombres, et planer enfin dans la 'musique' de ces nombres.

Jean-Sébastien Bach, et les hauteurs sévères où son génie le mena, peut être même à son insu, appellent non seulement les musiciens, mais tous les artistes d'aujourd'hui à 'créer' 'en continuant', par un nouveau bond au-dessus des siècles, selon des visions d'autant plus généreuses, humaines et fécondes, qu'elles seront plus mathématiques et plus réfléchies.

Par ce chemin, peuvent venir en grande partie, la vérité et la justice: – Bach, en tant que 'message' étant moins un fait individuel, qu'un 'état' de l'esprit.

Les moments les plus abstraits de l'oeuvre de Richard Wagner – dont les réalisations furent en général romantiques, mais de l'esprit d'un révolutionnaire, en même temps que d'un initié, – à vrai dire plus conscient que Bach, – sont ceux où la musique volontaire et sans 'représentation' se charge de nous transmettre sa conception idéaliste-optimiste du monde, à travers un pessimisme négateur.

A côté de pareils désirs de l'idée pure – malgré un art si peu dépouillé, que peut valoir l'oeuvre uniquement impressioniste d'un Debussy, ou de tel de ses épigones?

Evocations des eaux, des clairs de lune, du frisson des arbres... Reflets et images, toujours inférieurs à la nature divinement insensible, supérieurement créatrice...

L'image d'une locomotive, ou son évocation sonore, pourront-elles jamais être préférées à la locomotive elle-même?

Alors?... Pourquoi?...

La ligne, la couleur, le son, le nombre ont leur beauté propre, leur beauté pure, éternelle et toute puissante, qui ne doit jamais s'abaisser jusqu'à servir d'autres fins que celles de l'esprit.

Il n'est de réalité que dans les idées; et, toute forme tangible, sonore, tend 'invisiblement' vers des dimensions que seul conçoit notre esprit. L'oeuvre précède la théorie.

Dégageons donc de la nature et de l'équilibre des sphères, leurs lois éternelles, aussi simples qu'innombrables d'aspect; 'créons' surtout les plans, le contrepoint figuré et expressif des idées et des lignes. Dans tous les arts, soyons les 'musiciens' des nombres et nous deviendrons de purs esprits, non seulement libérateurs, mais nécessairement et avant tout: libérés.

CHRONOLOGY

1903 Born 10 January in Wakefield, Yorkshire, the eldest child of Herbert and Gertrude (née Johnson) Hepworth. Her father is a civil engineer for the West Riding County Council, who in 1921 becomes County Surveyor. As a girl, Hepworth accompanies him on the car journeys he makes all over the West Riding in the course of his work.

1909-20 Attends Wakefield Girls' High School. Music scholarship, 1915. Open Scholarship, 1917. Summer holidays at Robin Hood's Bay, near Whitby, North Yorkshire.

1920-21 Leeds School of Art; Henry Moore is a fellow student.

1921-24 Studies sculpture at the Royal College of Art, London. Together with Moore and other students at the College, makes occasional trips to Paris. Awarded the diploma of the Royal College of Art in the summer of 1923; stays on an extra year to compete for the Prix de Rome (John Skeaping is the winner).

1924 Awarded a West Riding Scholarship for one year's travel abroad. October, Hepworth travels to Italy. Based in Florence, she spends the first months studying Romanesque and early Renaissance art and architecture in Tuscany. November, short visit to Rome.

1925 In Siena, February–March. Marries sculptor John Skeaping in the Palazzo Vecchio, Florence, in May. They stay in Florence for three months, then live at the British School in Rome, where Skeaping is a Rome Scholar in Sculpture, until November 1926. Hepworth learns to carve marble from the master-carver Giovanni Ardini. Visits Carrara.

1926 November, Hepworth and Skeaping return to London due to Skeaping's ill-health.

1927 Studio exhibition with Skeaping at their flat in St Ann's Terrace, St John's Wood, in December. The collector George Eumorfopoulos buys *Seated Figure* and *Mother and Child*.

1928 January, Hepworth and Skeaping move to 7 The Mall, Parkhill Road, Hampstead. Hepworth would remain in this studio until 1939. June, exhibition at the Beaux Arts Gallery, London, shared with John Skeaping and William Morgan.

1929 3 August, birth of son, Paul Skeaping.

1930 October–November, joint exhibition with John Skeaping at Arthur Tooth & Sons' Galleries, London.

1931 Meets the painter Ben Nicholson. Summer holiday at Happisburgh on the Norfolk coast with Skeaping, Nicholson, Henry and Irina Moore, Ivon Hitchens. Separation from Skeaping (they are divorced in March 1933).

1932 Shows with the Seven and Five Society; Hepworth is a member until the group is dissolved in 1935. Spring, Ben Nicholson begins to live and work with Hepworth in the Mall studio. Hepworth and Nicholson seriously consider moving to Paris. August, short visit to Dieppe with Nicholson. November–December, shared exhibition with Nicholson at Arthur Tooth & Sons' Galleries, London (catalogue foreword on Hepworth by Herbert Read). Hepworth's first holed sculpture, *Pierced Form*, probably carved in 1932, is exhibited there with the title *Abstraction* (it was subsequently destroyed in the war).

1933 In France with Nicholson in April, Hepworth meets Brancusi at his studio in Paris, visits Arp's studio at Meudon (Arp himself is absent), and travels to Avignon and Saint-Rémy-de-Provence; on their return, they visit Picasso in his Paris studio. Invited by Herbin and Hélion to become a member of the Paris-based group Abstraction-Création, with which she exhibits in 1934. September, short visit to Dieppe with Nicholson to see Braque at nearby Varengeville. October–November, shared exhibition with Ben Nicholson at Alex. Reid & Lefevre Ltd, London.

1934 April, exhibition of the group Unit One, of which both Hepworth and Nicholson are members, at the Mayor Gallery, London. This coincides with the publication of *Unit 1: The Modern Movement in English Architecture, Painting and Sculpture*, edited by Herbert Read. Hepworth contributes a statement to the book. The exhibition travels to Liverpool, Manchester, Hanley, Derby, Swansea and Belfast. 3 October, birth of triplets, Simon, Rachel and Sarah Hepworth-Nicholson.

1935 In Paris in January, meets Mondrian and Kandinsky. Travels to Luzern with Nicholson in February for the opening of the exhibition *Thèse Antithèse Synthèse*. July, meets Naum Gabo in London. October, final 7 & 5 exhibition at Zwemmer Gallery, London. Begins to contribute works to anti-fascist exhibitions.

1936 January, short visit to Paris. *Abstract & Concrete* exhibition opens in Oxford in February. It includes the work of Mondrian, Kandinsky, Arp, Giacometti, Miró, Calder, Moholy-Nagy, Hélion, Nicholson, Hepworth, Moore and Gabo, and travels to Liverpool, London (Alex. Reid & Lefevre Ltd) and Cambridge. Meets Arp in London on the occasion of the International Surrealist exhibition. The Museum of Modern Art, New York, acquires its first Hepworth, *Discs in Echelon* (1935, darkwood). Friendship with Moholy-Nagy, Gropius, Erni, Ozenfant.

1937 Publication of *Circle: International Survey of Constructive Art*, edited by the architect J.L. Martin, Ben Nicholson and the sculptor Naum Gabo, and designed by Hepworth and Sadie Martin. Hepworth's text 'Sculpture' is included in it. Publication of *Circle* coincides with the exhibition *Constructive Art* at the London Gallery. July–August, short holiday with Nicholson in Varengeville, near Dieppe, at the invitation of Alexander Calder; they see Braque and Miró there. October, first one-person exhibition held at Alex. Reid & Lefevre Ltd, London (catalogue introduction by the physicist J.D. Bernal).

1938 April, shows in the *Abstract Art* exhibition at the Stedelijk Museum, Amsterdam. September, Mondrian arrives in London: Nicholson and Hepworth help him to find a room near them in Parkhill Road, where he stays until his departure for New York in 1940. Marriage to Ben Nicholson in November, following his divorce from his first wife,

Winifred. At this time, Hepworth is interested in ideas for large-scale works: her first large carving is *Monumental Stele*, 1936. The *Project (Monument to the Spanish War)* (1938–9, wood, 178 cm in height, destroyed in war) reflects her commitment to the Republican cause.

1939 Participates in the exhibitions *Living Art in England* at the London Gallery and *Abstract and Concrete Art* at Guggenheim Jeune, London. Just before the outbreak of war, on 25 August, Hepworth and Nicholson arrive in St Ives, Cornwall, with their triplets, at the invitation of Adrian Stokes and his wife Margaret Mellis. Naum and Miriam Gabo soon join them, and stay until 1946. After Christmas, the Hepworth-Nicholson family moves to a house nearby, Dunluce. In these cramped conditions, and with little time to work, Hepworth draws and makes plaster sculptures at night. Unable to make major work until 1943.

1940 In November, bombs damage the Mall studio, destroying works left there.

1942 Exhibits in *New Movements in Art* at the London Museum, March–May. Hepworth, Nicholson and their family move to a larger house, Chy-an-Kerris, Carbis Bay, in July. Hepworth has a studio there and can carve in the garden.

1943 First retrospective exhibition, held at Temple Newsam, Leeds, April–June. Kathleen Raine's *Stone and Flower: Poems 1935–43* is published with drawings by Hepworth.

1944 February–April, exhibition at Wakefield City Art Gallery, travelling to Halifax.

1946 Exhibition at the Lefevre Gallery, London, in October. William Gibson's *Barbara Hepworth: Sculptress* is published by Faber and Faber. Hepworth's 'Approach to Sculpture' is published in the review *Studio* in October.

1947 Begins to draw operations in hospitals. Makes designs for four sculptures on the new Waterloo Bridge in London, in a limited competition organised by the London County Council (no commissions were given). Designs a scarf for textile company Ascher. Shows at the second *Salon des Réalités Nouvelles* in Paris.

1948 April, exhibition of paintings at the Lefevre Gallery, London. Shows at first *Open Air Exhibition of Sculpture* in Battersea Park, London, May–September.

1949 September, Hepworth buys Trewyn Studio in St Ives, where she lives permanently from December 1950 until her death (it is now the Barbara Hepworth Museum, opened by her family in 1976 and since 1980 an outpost of the Tate Gallery). Exhibition at Durlacher Bros., New York, in October. Founder member of the Penwith Society of Arts in Cornwall. Beginning of friendship with South African-born composer Priaulx Rainier. Takes on permanent assistants for the first time – the artists Denis Mitchell, John Wells and Terry Frost are the earliest of these.

1950 Exhibition *New Sculpture and Drawings by Barbara Hepworth* at the Lefevre Gallery in February. Shows in the British Pavilion at the XXV Venice Biennale: Hepworth visits Venice in June for the opening. The Tate Gallery acquires its first Hepworth sculpture, *Bicentric Form* 1949.

1951 At the Festival of Britain, Hepworth's sculptures *Contrapuntal Forms* (an Arts Council commission) and *Turning Forms* are shown on London's South Bank. Exhibits in the open-air sculpture exhibition in Battersea Park, May–September. Designs sets and costumes for Sophocles' *Electra*, directed by Michel Saint-Denis at the Old Vic Theatre, London. Retrospective at Wakefield City Art Gallery, travelling to York and Manchester. *Vertical Forms* commissioned for Hatfield Technical College, Hertfordshire. Marriage to Ben Nicholson dissolved in October.

1952 Publication of major monograph *Barbara Hepworth: Carvings and Drawings*, with an introduction by Herbert Read and statements by the artist. Exhibition at the Lefevre Gallery, London, in October.

1953 13 February, death of son Paul in RAF plane crash over Thailand. Awarded a second prize in Unknown Political Prisoner competition, organised by the Institute of Contemporary Arts. *Monolith (Empyrean)*, a memorial to Paul and his navigator, is sited by the London County Council outside the Festival Hall in 1954 (now at Kenwood). The St Ives Festival, of which Hepworth and the composers Michael Tippett and Priaulx Rainier are co-founders, is held in June. Film *Figures in a Landscape: Cornwall and the Sculpture of Barbara Hepworth* made by Dudley Shaw Ashton for the British Film Institute, with music by Priaulx Rainier.

1954 April–June, major retrospective at the Whitechapel Art Gallery, London. *Madonna and Child*, carved in memory of her son Paul, is unveiled in St Ives Parish Church. In August, visits Greece with her friend and patron, Margaret Gardiner (Athens, Epidaurus, Mycenae, Delphi, Crete, Rhodes, Cos, Patmos, Delos, Santorini) on the first Swan Hellenic cruise. Receives a large consignment of guarea wood from Nigeria.

1955 January, first performances of Michael Tippett's opera *The Midsummer Marriage* at the Royal Opera House, with sets and costumes by Hepworth.

1955-57 Exhibition organised by Martha Jackson opens at the Walker Art Center, Minneapolis; travels to Nebraska, San Francisco, Buffalo, Toronto, Montreal, Baltimore, Washington DC and, with additions, the Martha Jackson Gallery in New York, December 1956–January 1957.

1956 First one-person exhibition at Gimpel Fils, London, in June. Begins to work in sheet metal and bronze. *Orpheus (Theme on Electronics)* commissioned for Mullard House, London. Joins Labour Party at time of Suez Crisis.

1958 Created C.B.E. in New Year's Honours List. Ben Nicholson leaves St Ives for Switzerland. April, meets Dag Hammarskjöld, Secretary General of the United Nations, in London. Exhibition at Gimpel Fils, London, in June. Major bronze sculpture, *Meridian*, commissioned for State House, London. The project architect is Harold Mortimer of the firm Trehearne & Norman, Preston & Partners.

1959 Exhibition organised by the British Council opens at the fifth São Paulo Bienal in September: Hepworth is awarded the major prize. The exhibition travels throughout South America in 1960. Visits New York for the first time in October for her exhibition at the Galerie Chalette. To Paris to complete work on *Meridian* which is being cast by Susse Frères. Begins to work with the Morris Singer foundry in London.

1960 *Meridian* is unveiled at State House, Holborn, London, in March (4.6 m in height; following the demolition of State House in 1990, the sculpture was acquired by the Donald M. Kendall Sculpture Gardens, PepsiCo Headquarters, Purchase, New York). October, to

Zurich for her exhibition at the Galerie Charles Lienhard. December, acquires the Palais de Danse, a former cinema and dance hall, opposite Trewyn Studio, for use as an additional studio and workshop, especially for works to be cast in bronze, and as a display space and store (purchase completed in February 1961).

1961 *Barbara Hepworth: Life and Work* published, with a text by J. P. Hodin and a catalogue of the sculptures compiled by her son-in-law Alan Bowness. BBC television film *Barbara Hepworth* directed by John Read. Exhibition at Gimpel Fils, London, May–June.

1962 May–June, second exhibition at the Whitechapel Art Gallery, London, of work made between 1952 and 1962.

1963 *Winged Figure* is unveiled on the John Lewis department store, Oxford Street, London (commissioned 1961, aluminium, 5.8 m in height). Hepworth wins the Foreign Minister's Award at the 7th Tokyo Biennale. Michael Shepherd's monograph, *Barbara Hepworth*, is published. Exhibition in Zurich at the Gimpel Hanover Galerie, November–January 1964.

1964 June, Hepworth attends the unveiling of the monumental *Single Form* at the United Nations Secretariat in New York, commissioned in memory of her friend Dag Hammarskjöld, Secretary General of the United Nations, who had been killed in a plane crash in 1961. Exhibition at Gimpel Fils, London, in June. Visits Copenhagen in September for the opening of her exhibition organised by the British Council; it travels throughout Scandinavia.

1965 May, attends opening of her retrospective exhibition in the Rietveld Pavilion, Rijksmuseum Kröller-Müller, Otterlo, Netherlands. Made a Dame Commander of the British Empire. Appointed a Trustee of the Tate Gallery (until 1972), the first female trustee. Cancer of the tongue is diagnosed; Hepworth is treated at Westminster Hospital, London.

1966 *Barbara Hepworth: Drawings from a Sculptor's Landscape* is published, with Hepworth's text 'A Sculptor's Landscape' and an introduction to the drawings by Alan Bowness. Exhibitions at Marlborough-Gerson Gallery, New York, and at Gimpel Fils, London.

1967 Breaks femur in Scilly Isles in June: this was to cause her lasting mobility problems. Film made on Hepworth by Westward Television.

1968 Major retrospective exhibition at the Tate Gallery, London, April–May. A. M. Hammacher's *Barbara Hepworth* is published by Thames and Hudson (revised edition, 1987). Receives honorary degree from Oxford University in June. Made a Bard of Cornwall in a ceremony at St Just-in-Penwith in September: takes the bardic name of 'Gravyor' ('sculptor' in Cornish). Honorary Freedom of the Borough of St Ives conferred on Hepworth and her friend the potter Bernard Leach, accompanied by exhibitions of their work in the town.

1970 *Barbara Hepworth: A Pictorial Autobiography* published. *The Family of Man*, a major nine-part bronze, is completed. Exhibition at Marlborough Fine Art, London, in February–March. Exhibition at the Hakone Open-Air Museum, Japan, June–September. Awarded Grand Prix at Salon International de la Femme, Nice.

1971 *The Complete Sculpture of Barbara Hepworth 1960–69*, edited by Alan Bowness, is published, including an interview with the artist. Hepworth creates three important groups of prints between 1969 and 1971, culminating in *The Aegean Suite*, a set of nine lithographs published by Curwen Prints in 1971.

1972 *Theme and Variations*, a three-part bronze relief, is unveiled on façade of Cheltenham & Gloucester Building Society Head Office in Cheltenham, Gloucestershire. Exhibition at Marlborough Fine Art, London, in April–May, including *The Family of Man*.

1973 Hepworth celebrates her 70th birthday in St Ives. Elected Honorary Member of the American Academy of Arts and Letters.

1974 Exhibition at Marlborough Gallery, New York, in March–April.

1975 20 May, Hepworth dies in an accidental fire at Trewyn Studio, aged 72.

1976 April, opening of the Barbara Hepworth Museum, St Ives.

NOTE
This Chronology is partly derived from that compiled by the artist herself and used in her late catalogues.

BIBLIOGRAPHY
WRITINGS AND CONVERSATIONS

In chronological order, by date of writing.

Text in the series 'Contemporary English Sculptors', *The Architectural Association Journal*, London, April 1930, vol.XLV, no.518, pp.384–5.

'The Aim of the Modern Artist: Barbara Hepworth, Ben Nicholson', *Studio*, London, December 1932, vol.104, pp.332–3. Interview with Hepworth, subtitled 'The Sculptor carves because he must', p.332 (interview with Nicholson, p.333).

Untitled text in *Abstraction-Création: art non-figuratif*, Paris, 1933, no.2, p.6.

Statement in *Unit 1: The Modern Movement in English Architecture, Painting and Sculpture*, edited by Herbert Read, London 1934, pp.17–25.

'Sculpture', *Circle: International Survey of Constructive Art*, edited by J.L. Martin, Ben Nicholson and Naum Gabo, London 1937, pp.113–16.

Poem '1938–39', unpublished manuscripts.

'Approach to Sculpture', *Studio*, London, October 1946, vol.132, no.643, pp.97–101.

Text on Ascher scarf design, *Landscape Sculpture*, June 1947, manuscripts (reproduced in Hepworth's *Pictorial Autobiography*).

Letter to Sigfried Giedion in reply to Giedion and Arp's questionnaire concerning collaboration between artists and architects, for the 1947 CIAM VI conference at Bridgwater, Somerset; published in Giedion (ed.), *A Decade of New Architecture*, Zurich 1951, pp.30–5, and Giedion, *Architecture, You & Me: The Diary of a Development*, Cambridge, Mass., and London 1958, pp.70–4.

Report submitted with Hepworth's designs for sculptures for Waterloo Bridge, 1947, unpublished manuscript (not in Hepworth's hand).

Extract from a letter to Herbert Read, 6 March 1948, quoted in Read's article 'Barbara Hepworth: A New Phase', *The Listener*, London, 8 April 1948, vol.39, no.1002, p.592; and in Read's *The Meaning of Art*, Harmondsworth, revised 1949 edition, p.184. (A longer quotation from the letter was included in Read's essay 'Realism and Abstraction in Modern Art', *Eidos: A Journal of Painting, Sculpture and Design*, London, no.1, May–June 1950, p.36.)

Quotations from Hepworth in J.P. Hodin, 'Portrait of the Artist, No.27: Barbara Hepworth', *Art News and Review*, London, 11 February 1950, vol.II, no.1, pp.1 and 6.

Text for a broadcast to the USA, 1950-51, unpublished in part; manuscript drafts and typescripts, together with a recording.

Conversation with Reg Butler recorded on 28 September 1951 and broadcast on 26 August 1952 on the BBC Third Programme, 'Artists on Art'; unpublished.

Statements by Hepworth in six autobiographical sections in *Barbara Hepworth: Carvings and Drawings*, with an introduction by Herbert Read, London 1952.

Diary item by John Carpenter on Hepworth's Lefevre Gallery exhibition, *Evening News (Night Special edition)*, London, 2 October 1952. Includes a quotation from Hepworth.

'Ideas and the Artist: An Interview with Barbara Hepworth', *Ideas of To-Day*, London, November–December 1952, vol.2, no.4, pp.91–9.

Statement by Hepworth in exh. cat. *International Sculpture Competition: The Unknown Political Prisoner: International Exhibition of Grand Prize Winner and other Prize-Winning Entries and Runners-up*, sponsored by the Institute of Contemporary Arts, exhibition held at the Tate Gallery, London, March–April 1953.

Letter from Hepworth on the St Ives Festival to the editor, *The St Ives Times*, St Ives, 9 October 1953, p.4.

Lecture to surgeons in Exeter, untitled typescript with handwritten additions, c.1953 (published in Nathaniel Hepburn, *Barbara Hepworth: The Hospital Drawings*, London 2012, pp.81–117, with reproductions of the images used to accompany the lecture).

Texts by Hepworth in exh. cat. *Barbara Hepworth: A Retrospective Exhibition of Carvings and Drawings from 1927 to 1954*, Whitechapel Art Gallery, London, April–June 1954, pp.10–11, 12, 13–14, 16, 20–1, 26–7, 29 (including some earlier writings). (Manuscript drafts and typescripts are in the Tate Archive.)

Text on the sculpture *Image* (1951–2, BH 173) in exh. cat. *Sculpture in the Open Air: London County Council Third International Exhibition of Sculpture*, Holland Park, London, May–September 1954.

'Epidaurus', written in Greece, 1954, unpublished manuscript (Dunluce notebook).

'Greek Diary: 1954–1964', *J.P. Hodin, European Critic: Essays by Various Hands Contributed in Honour of his Sixtieth Birthday*, edited by Water Kern, London 1965, pp.19–24. Taken from Hepworth's 'Greek Sketchbook' of 1954.

'Barbara Hepworth asks, "Have you read …?" *The Story of an African Farm* by Olive Schreiner', *News Chronicle*, London, 1 December 1955, p.6.

'Towards an Open Architecture', response to a UNESCO questionnaire on contemporary relationships between painting, sculpture and architecture, 1955, unpublished manuscript.

Letter to *The Times* on the Hydrogen Bomb, dated 24 January 1956, unpublished typescripts.

Statement in *Témoignages pour la Sculpture Abstraite: Arp, Bloc, Descombin, Gilioli, Hepworth, Jacobsen, Lardera, Schnabel, Schöffer, Lippold, de Rivera, David Smith*, with a text by Pierre Guéguen, Paris 1956, p.22. Typescript of English original in Tate Archive.

Text on the sculpture *Curved Form (Trevalgan)* (1956, BH 213), dated December 1956, in exh. cat. *Sculpture 1850–1950*, organised by the London County Council, Holland Park, London, May–September 1957.

Poem in exh. cat. *Statements: A Review of British Abstract Art in 1956*, Institute of Contemporary Arts, London, January–February 1957.

Text on the sculpture *Image* (1951–2, BH 173) in exh. cat. *Contemporary British Sculpture*, An Open Air Exhibition arranged by the Arts Council of Great Britain, at Leamington Spa, Shrewsbury Festival and Cardiff, May–August 1958, p.12.

Contribution to 'Why Cornwall?', *Monitor*, BBC TV, broadcast 14 September 1958.

Unpublished text on new developments in art and society, dated 1958, manuscript and typescripts.

Interview by Margaret Tims, 'A Sculptor's Philosophy: A PN Profile of Barbara Hepworth', *Peace News*, London, 16 January 1959, no.1,177, p.2.

Note on hands, April 1959, unpublished manuscript and typescript, sent to Cornel Lucas in connection with his photographs of Hepworth's hands.

Text on the figure in the landscape in exh. cat. *Sculpture Exhibition*, Trewyn Gardens, St Ives, 1–6 June 1959.

Statement in exh. cat. *Moments of Vision*, with an introduction by Herbert Read, Rome-New York Art Foundation, Rome, July–November 1959. Text on the nature of art, dated 19 June 1959, typescripts.

'Two Conversations with Barbara Hepworth: Art and Life; The Ethos of Sculpture', August 1959, in J.P. Hodin, *Barbara Hepworth*, London 1961, pp.23–4; also p.10.

Text on the sculpture *Torso I (Ulysses)* (1958, BH 233) in exh. cat. *Sculpture in the Open Air*, organised by the London County Council, Battersea Park, London, May–September 1960. Typescript written for the LCC in October 1959.

Text sent to John Russell, December 1959, unpublished manuscript and typescript.

Text of 22 December 1959 on the new decade, unpublished manuscript and typescript.

Text on working practice, c.1959, unpublished typescript.

Text on women's art, c. late 1950s, unpublished manuscript and typescripts.

Edouard Roditi, 'Barbara Hepworth' (interview), in *Dialogues on Art*, London 1960, pp.91–101.

Interview in *The Bradford Telegraph and Argus*, Bradford, 19 October 1960.

Contribution to the film *Barbara Hepworth* directed by John Read, BBC TV, 1961; and manuscript draft for the film (and typescript).

Quotations on *Meridian* in J.P. Hodin, 'Artist and Architect: Recent Monumental Works Produced in England', *Quadrum: Revue Internationale d'Art Moderne*, Brussels 1961, no.10, pp.24–6.

Tribute to Dag Hammarskjöld on his death, September 1961, unpublished manuscript.

Speech at the opening of the new Penwith Gallery, St Ives, introducing its president, Herbert Read, 23 September 1961, unpublished typescripts.

Statement on nuclear weapons, 29 September 1961, quoted in *The Sunday Times*, London, 1 October 1961, p.8, and *The Times*, London, 2 October 1961, p.6. Manuscript and typescripts.

Interview by Sally Vincent, 'Woman to Woman: Barbara Hepworth', *Daily Express*, London, 3 October 1961, p.6.

'The Sculptor Speaks', recorded talk for the British Council, 8 December 1961.

Michael Williams, 'Barbara Hepworth', *Cornish Magazine*, Falmouth, August 1962, vol.5, no.4, pp.108–10; and the related article by Michael Williams, 'Barbara Hepworth Talks to Michael Williams', *The Guardian*, London, 17 April 1963, p.6.

Mervyn Levy, 'Impulse and Rhythm: The Artist at Work – 9', *The Studio*, London, September 1962, vol.164, no.833, pp.84–91. Includes an interview with Hepworth.

'Artist's Notes on Technique' (1962) in Michael Shepherd, *Barbara Hepworth*, London 1963.

Texts on *Curved Reclining Form (Rosewall)* (1960–2, BH 291), 3 November 1962, unpublished manuscripts and typescripts.

Tom Greenwell, 'Talking Freely: Barbara Hepworth Gives her Views to Tom Greenwell' in *The Yorkshire Post*, Leeds, 13 and 14 November 1962. Interview appearing in two consecutive issues.

'Statement about the meaning of Chûn for Professor Allan Edwards', 11 March 1963, typescript.

Statement to Inquiry on proposed mine development at Carnelloe, near Zennor, 18 March 1963, unpublished typescript and manuscript.

J.P. Hodin, 'Barbara Hepworth and the Mediterranean Spirit', *Marmo*, Milan, December 1964, no.3, pp.58–65. Quotations from Hepworth of June 1963.

Text on *Winged Figure* (1961–3, BH 315), 4 July 1963, unpublished typescript.

Warren Forma, 'Barbara Hepworth', in *5 British Sculptors (Work and Talk)*, New York 1964, pp.7–27. Interview/statement recorded in St Ives in July 1963.

Tribute to Herbert Read on his 70th birthday, January 1964, unpublished manuscript and typescripts.

Quotations from Hepworth in J.P. Hodin, 'Quand les artistes parlent du sacré', *XXe siècle*, Paris, December 1964, vol.XXVI, no.24 (new series), pp.17–27. Hepworth's contribution was written in January 1964 (pp.23–4); typescripts in Tate Archive.

Tribute to Michael Tippett, January 1964, in *Michael Tippett: A Symposium on his 60th Birthday*, edited by Ian Kemp, London 1965, pp.58–9.

Speech made at the unveiling of the United Nations *Single Form* on 11 June 1964, published in *The Unveiling of* Single Form *by Barbara Hepworth, Gift of Jacob Blaustein after a Wish of Dag Hammarskjöld*, New York, United Nations, 1964.

Nevile Wallis, 'The Hepworth Way', *The Observer Weekend Review*, London, 12 July 1964. Interview.

Tribute to Peter Lanyon, *St Ives Times and Echo*, St Ives, 4 September 1964, p.1.

Notes for Paul Hodin, 1 February 1965, unpublished manuscript and typescript.

Short note on *Sphere with Inner Form* (1963, BH 333) included in *Contemporary British Sculpture* (open-air Arts Council touring exhibition), written for the *Northampton Chronicle & Echo*, Northampton, 14 June 1965.

'The Artist on his Work – 4: "Sculpture – An Act of Praise"' in *The Christian Science Monitor* (London edition), 13 July 1965, vol.57, no.192, p.8.

Robert Hughes, 'About Nothing Except Love: Visiting Barbara Hepworth in Cornwall', *The Bulletin*, Sydney, 19 March 1966, pp.42–3. Includes quotations from Hepworth.

'A Sculptor's Landscape', *Barbara Hepworth: Drawings from a Sculptor's Landscape*, with an introduction by Alan Bowness, London 1966, pp.7–13.

Edwin Mullins, 'Hepworth at Home', *The Daily Telegraph Supplement (Weekend Telegraph)*, London, 20 May 1966, pp.32–5.

'The Sun and Moon', June 1966, unpublished manuscript and typescript text on the *Sun and Moon* sculptures of 1966.

'Mondrian in London: Reminiscences of Mondrian' by Miriam Gabo, Naum Gabo, Barbara Hepworth, Ben Nicholson, Winifred Nicholson, Herbert Read, introduction by Charles Harrison, *Studio International*, London, December 1966, vol.172, no.884, pp.285–92; text by Hepworth pp.288–9; also manuscript and typescripts.

Catalogue note on *Rock Form (Porthcurno)* (1964, BH363), March 1967, for *International Sculpture* exhibition, Pittencrieff Park, Dunfermline, April 1967; not published there (known from typescripts only).

Conversation with Peggy Archer for 'Woman's Hour' on the BBC's Home Service, 28 July 1967 (recording in British Library Sound Archive).

'Barbara Hepworth, Sculptor', *Viewpoint*, BBC 1, broadcast 13 September 1967; quotations from Hepworth on *Oval Sculpture*, 1943, in *Radio Times*, London, 7 September 1967.

Jeremy Hornsby, 'Bringing Art into Everyday Life: Dame Barbara – Genius of the "Palais"', *Daily Express*, London, 9 December 1967. Interview.

Edwin Mullins, 'Scale and Monumentality: Notes and Conversations on the Recent Work of Barbara Hepworth', *Sculpture International*, Oxford, 1967, issue no.4 overall (second of the year), pp.18–27.

Atticus, 'Graven Image', *The Sunday Times*, London, 17 March 1968, p.11, refers to imminent Tate retrospective; includes quotations from Hepworth.

Susanne Puddefoot, 'A Totem, a Talisman, a Kind of Touchstone . . .', *The Times*, London, 3 April 1968, p.13. Interview.

Conversation with Edwin Mullins for the programme 'The Lively Arts', broadcast on BBC's Third Programme (Radio 3), 8 May 1968. Recorded in St Ives to mark her Tate Gallery retrospective.

Contribution to 'Icons of the Sea – Recollections of Alfred Wallis', *The Listener*, London, 20 June 1968, no.2047, pp.798–9.

Based on the radio programme 'Alfred Wallis: A Portrait', broadcast on the BBC's Third Programme (Radio 3), 29 May 1968 (recording in British Library Sound Archive).

'In Memoriam Herbert Read June 15th 1968', unpublished manuscript and typescripts.

'Frances Hodgkins', typescript dated 14 March 1969 related to a BBC Third Programme broadcast of 11 February 1970, unpublished.

Arnold Whittick, 'Power for the Sculptor', *Stone Industries*, Slough, September–October 1969, pp.20–3. Quotation on power tools, pp.22–3.

Edwin Mullins, 'Barbara Hepworth', in exh. cat. *Barbara Hepworth Exhibition 1970*, Hakone Open-Air Museum, 1 June–15 September 1970, n.p. Includes quotations by Hepworth from letters to and conversations with Mullins, 1969–70.

Women and Men's Daughters: Portrait Studies by Zsuzsi Roboz, compiled and edited by William Wordsworth, London 1970. Contribution by Hepworth, pp.80 and 82.

'Alan Bowness: Conversations with Barbara Hepworth', 1970, published in *The Complete Sculpture of Barbara Hepworth, 1960–69*, edited by Alan Bowness, London 1971, pp.7–16.

Interview with Robert Sharpe at Trewyn Studio, St Ives, August 1971, for the Central Office of Information (recording in British Library Sound Archive).

Edwin Mullins, 'Barbara Hepworth's *"Family"*', *Daily Telegraph Magazine*, London, 7 April 1972, pp.28–9, 31–2, quotations from Hepworth.

Tribute to Desmond Bernal, 1972, typescript. Extract published in the J.D. Bernal Peace Library brochure, 1973.

Cindy Nemser, 'Conversation with Barbara Hepworth', *Feminist Art Journal*, Brooklyn, Spring 1973, vol.2, no.2, pp.3–6, 22 (reprinted in *Art Talk: Conversations with 12 Women Artists*, New York 1975).

Anne Matheson, interview with Hepworth in *The Australian Women's Weekly*, Sydney, 16 May 1973, pp.8–9.

Susan Bradwell, 'Barbara Hepworth', *Arts Review*, London, 30 May 1975, vol.27, no.11, p.308. Obituary. Based on an interview with Hepworth shortly before her death.

(Hepworth's *Pictorial Autobiography*, first published in 1970, extended edition 1978, is available from Tate Publishing and has not been included.)

Catalogues of Hepworth's Work

Hepworth's sculptures up to 1970 were catalogued in two volumes:

J.P. Hodin, *Barbara Hepworth*, with a catalogue of sculptures by Alan Bowness, London 1961 (sculptures up to 1959)

The complete sculpture of Barbara Hepworth 1960–69, edited by Alan Bowness, London 1971 (sculptures of the 1960s)

Sculptures made from 1970–75 were comprehensively recorded under Hepworth's supervision, and the complete, revised catalogue raisonné is currently in progress. (A set of Hepworth's sculpture records for the final years is in the Tate Archive and can be viewed online.)

See also especially:

Matthew Gale and Chris Stephens, *Barbara Hepworth: Works in the Tate Gallery Collection and the Barbara Hepworth Museum St Ives*, London 1999

Barbara Hepworth: The Plasters: The Gift to Wakefield, edited by Sophie Bowness, Farnham and Burlington VT 2011

INDEX

CREDITS

Every effort has been made to trace the copyright holders and to obtain their permission for the use of copyright material. The publisher apologises for any errors or omissions in the below list and would be grateful to be notified of any corrections that should be incorporated in future reprints or editions of this book.

Text Credits

All text by Barbara Hepworth © Bowness
© J.P. Hodin p.46, pp.125–8, pp.146–7, pp.167–71, p.178, pp.183–4
© Warren Forma pp.174–6
© Telegraph Media Group Limited pp.197–200, pp.248–50
© Guardian News and Media Ltd pp.269–70, pp.280–2
© Edwin Mullins pp.208–11, pp.212–15, pp.222–5

Photographic Credits

Unless otherwise stated, photographs were supplied by the Hepworth Photograph Collection, and photographed by David Lambert and Rod Tidnam, Tate Photography.

Copyright

All works of art by Barbara Hepworth © Bowness
Estate of Reg Butler p.48
© Estate of David Farrell p.147
© Warren Forma p.182 bottom
Copyright © The de Laszlo Collection of Paul Laib
Negatives, Witt Library, The Courtauld Institute of Art,
London p.12, p.18, front cover
© Cornel Lucas Collection p.123 top
Hepworth: Carvings and Drawings, Lund Humphries,
London 1952 p.57

Ben Nicholson © Angela Verren Taunt 2015.
All rights reserved, DACS p.21 bottom, p.100 left
© Estate of Houston Rogers p.180
© Tate p.218

Photography

Courtesy Hazlitt Holland-Hibbert p.38, p.43
Hepworth Photograph Collection /Photograph by
Aerofilms p.196; /© Alpha Press p.48; /Barratts/S&G
Barratts/EMPICS Archive/Press Association Images p.179;
/Ronald A. Chapman/London Metropolitan Archives,
City of London: SC/PHL/02/1039 (4762/4) p.115 top; /UN
Photo/Teddy Chen back cover; /Photograph by David
Farrell p.147; /Photograph by Warren Forma p.182 bottom;
/Photography by Barbara Hepworth pp.16-17, p.22, p.25,
p.235; /© Peter Keen/Pictorial Press Ltd /Alamy p.2; /
Photograph by Peter Kinnear p.220; /Photography by
Paul Laib p.12, p.18, front cover; /London Metropolitan
Archives, City of London: SC/PHL/02/1037 p.129; /
Photograph by Cornel Lucas p.123 top; /Photography
by Anthony Panting p.77, p.173; /Photo Studios Ltd p.97
right; /Photograph by Houston Rogers p.180; /
Photography: Lee Sheldrake/Penwith Photo Press p.193; /
Copyright: St Ives Archive: Sheldrake Collection p.177; /
Photography: Studio St Ives © Bowness p.6, p.35, p.44,
p.82, p.96, p.97 left, p.166, p.185, p.201, p.247; /© TopFoto
p.99; /Photograph by John Webb p.164; /Photograph by
Hans Wild p.30
National Portrait Gallery, London p.47
The Pier Arts Centre Collection, Stromness/Photograph
by Robert Paskin p.209
© Tate Photography, London 2015 p.218; /Photograph
© Lucy Dawkins p.42
Courtesy Whitechapel Gallery, Whitechapel Gallery
Archive p.95